Memory

Remapping Cultural History
General Editor: Jo Labanyi, New York University and University of Southampton

Published in association with the Institute of Germanic & Romance Studies, School of Advanced Study, University of London

The theoretical paradigms dominant in much of cultural history published in English tend to be derived from northern European or North American models. This series will propose alternative mappings by focusing partly or wholly on those parts of the world that speak, or have spoken, French, Italian, Spanish or Portuguese. Both monographs and collective volumes will be published. Preference will be given to volumes that cross national boundaries, that explore areas of culture that have previously received little attention, or that make a significant contribution to rethinking the ways in which cultural history is theorised and narrated.

Cultural Encounters: European Travel Writing in the 1930s
Edited by Charles Burdett and Derek Duncan

Images of Power: Iconography, Culture and the State in Latin America
Edited by Jens Andermann and William Rowe

The Art of the Project: Projects and Experiments in Modern French Culture
Edited by Johnnie Gratton and Michael Sheringham

Locating Memory: Photographic Acts
Edited by Annette Kuhn and Kirsten Emiko McAllister

Locating Memory
Photographic Acts

Edited by

Annette Kuhn and Kirsten Emiko McAllister

Berghahn Books
New York • Oxford

First published in 2006 by

Berghahn Books
www.berghahnbooks.com

Library of Congress Cataloging-in-Publication Data

Locating memory : photographic acts / edited by Annette Kuhn and Kirsten
Emiko McAllister
 p. cm. — (Remapping Cultural History ; v. 4)
 Includes bibliographical references and index.
 ISBN 9781845452193 (hardback : alk. paper) 9781845452278 (pbk. : alk.
 paper)
 1. Photography --Philosophy. 2. Photography --Social aspects. 3. Space
and time. 4. History --Sources. I. Kuhn, Annette. II. McAllister, Kirsten
Emiko.

TR183.L63 2006
770 22
 2006019693

British Library Cataloguing in Publication Data

A catalogue record for this book is available from the British Library.

Printed in the United States on acid-free paper

978-1-84545-219-3 (hbk), 978-1-84545-227-8 (pbk)

Contents

Part III: Reframings

List of Illustrations

Acknowledgements

The initial inspiration for *Locating Memory: Photographic Acts* came from a symposium of that title co-organised by us in the Institute for Cultural Research at Lancaster University. A number of the contributors to this volume took part in that event as speakers or respondents. We are greatly indebted to them for their continued enthusiasm for, and support of, the 'Locating Memory' project.

The symposium was supported by funding from the British Academy; Canada Council for the Arts; and the University Research Committee, the Faculty of Social Sciences and the Institute for Cultural Research (ICR) at Lancaster University. The Social Sciences and Humanities Research Council of Canada funded the postdoctoral fellowship which enabled Kirsten McAllister to pursue her research on photography and Canadian Second World War internment camps at Lancaster. Students and members of the academic and administrative staff in the ICR who contributed to the organisation of the symposium included: Rachel Clarke, Joanne Mitchell, June Rye and Scott Wilson. We owe a special debt of thanks to all the speakers, as well as to the respondents and symposium participants. In particular, alongside the contributors to this volume, we would like to acknowledge the assistance of Canada House, London and Folly Gallery, Lancaster; as well as Rosemary Betterton, Anne-Marie Fortier, Gerald McMaster, Maureen McNeil and Jackie Stacey. In conjunction with the symposium, the Scott Gallery at Lancaster University hosted a reception and an installation, 'Concerning Memory', by video artist Cate Elwes.

In producing this book, we have enjoyed support and assistance from many organisations and individuals, among them the Office of Research Services at Simon Fraser University, The Faculty of Arts and Social Sciences Research and Enterprise Fund Committee at Lancaster University, Kate Hodgkin, Kate Milberry, Glen Lowry and Zoe Druick. We are grateful to the authors, artists, and individual and institutional owners of rights who gave us permission to reproduce the photographs and poems discussed in the chapters that follow: see the List of Illustrations for credits. For permission to reprint poems discussed in Chapter 5, thanks to Farrar, Strauss and Giroux (U.S.) and Faber (U.K.). Photographs in Chapter 8 for Michelangelo Pistoletto's 'LE STANZE' are by Paolo Mussat Sartor with English translation of the text by Malcolm Skey. 'LE STANZE' was first published in Italian and English by TAU/MA in Bologna. This version was subsequently reprinted by Routledge in Nick Kaye, *Site-Specific Art:*

Performance, Place and Documentation (2000). Michelangelo Pistoletto retains copyright over 'LE STANZE'.

We would like, finally, to extend special thanks to two colleagues whose support and encouragement have remained unfailing throughout. Through their example as dedicated and generous scholars of cultural memory, as well as in innumerable practical ways, Jo Labanyi and Susannah Radstone have been the 'angels' of the 'Locating Memory' project.

Annette Kuhn
Kirsten Emiko McAllister
August 2005

Chapter 1

Locating Memory
Photographic Acts – An Introduction

Annette Kuhn and Kirsten Emiko McAllister

As a visual medium, the photograph has many culturally resonant properties that it shares with no other medium. Above all, the photograph is widely held to be a record, a piece of evidence that something happened at some time, somewhere – in the time and the place in front of the camera. Unlike cinema, the photograph holds this recorded moment in stillness, capturing and offering up for contemplation a trace of something lost, lending it a ghostly quality. In this sense, the photograph confronts us with the fleeting nature of our world and reminds us of our mortality. In seeming to capture times and places lost in the past, the photograph can disturb the present moment and the contemporary landscape with troubling or nostalgic memories and with forgotten, or all too vividly remembered, histories.

The essays in this collection develop innovative strategies for reading photographs: strategies that capture the shadowy presence of what has been forgotten, lost or eradicated in contemporary landscapes. The authors work with war photographs, family snapshots, images of colonised landscapes and art photography, examining them *in situ*: where they were found in archives, private collections, art galleries; or as they circulate intertextually and internationally across time and across multiple media. The authors literally locate – *place* – the images in the social world, bringing them 'to life'. They outline the ideological and institutional systems through which the photographs are produced, ordered and stored for future generations. They trace the movement of the images across time as they pass between family and community members and between different audiences, accruing meaning and affect even as the details of names and places begin to fade. Some of the authors use

photographs as a means to return to a moment or place in the past that troubles their own memories. But in such attempts to return, photographs do not always disclose clues, nor lead us to the sites we imagine, nor release us from what lies in the silences and the ambivalent traces imprinted onto their surfaces.[1] Other contributors examine photographic installations by postcolonial and conceptual artists that work as 'provocations',[2] intervening in the relations of looking through which we locate ourselves in, as well as construct, our social landscapes, unravelling the collective forms of remembering and denial that lodge us in place.

As the photographs are brought 'to life', we are brought closer to them. Even when they are disturbing, they appear familiar. Faded snapshots of unknown families and portraits of long-dead soldiers can be found in many an old family album, local museum or fleamarket. Landscape photographs, whether records of a Nazi concentration camp in Eastern Europe, archival records of landmarks from pre-industrial England, or images of the marginal urban zones occupied by displaced Aboriginal people, make us wonder about similar sites in the places we now inhabit. Could the ruins of a factory or the neat rows of shacks in a nearby town be the remains of a concentration camp or a detention centre? Do the contours of a town mark the presence of an older settlement obliterated in the process of colonisation? Iconic photographs of the Vietnam War, images of sites of violence in Northern Ireland and of monumental modern architectural spaces also elicit a sense of recognition, but for other reasons. War photographs are part of our everyday mediascape, just as modern architecture can be found in cities across the globe. Once we begin to question their ubiquity, the insidious flow of capital and knowledge across borders begins to emerge into consciousness.

The chapters in *Locating Memory: Photographic Acts* address a number of key questions. As a medium of representation, in what ways does photography recover or, alternatively, repress forgotten histories that shape our social landscapes? As a visual practice, can photography be deployed to interrupt the processes of reification, commodification and the colonial gaze that position us in the social world? Following from this, can photographs be the locus of corporeal – embodied – memories, or do they privilege a disembodied gaze? Underlying these questions are issues prominent in early twentieth-century discussions about the properties of photography as a medium in relation to 'human sense perception'. In his influential essay, 'The Work of Art in the Age of Mechanical Reproduction', Walter Benjamin wrote that

the mode of human sense perception changes with humanity's entire mode of existence. The manner in which human sense perception is organised, the medium in which it is accomplished, is determined not only by nature but by historical circumstances as well.[3]

Those historical circumstances, as Benjamin himself demonstrated, include not only the rapid expansion of industrialisation, the commodification of culture and the rise of fascism, but also the efforts of writers and artists to create innovative ways to employ, as well as to read, visual media such as the photograph.

Writing during the 1920s and 1930s, in the period of catastrophic economic and political change following the Great War, Siegfried Kracauer and Walter Benjamin described how photography was in many ways paradigmatic of the dual potential of modern memory.[4] On the one hand, with regard to mass culture, Kracauer noted that the

aim of the illustrated newspapers is the complete reproduction of the world accessible to the photographic apparatus … [The photographs might appear to] remind us of the original object …. But the flood of images sweeps away the dams of memory. The assault of this mass of images is so powerful that it threatens to destroy the potentially existing awareness of crucial traits.[5]

On the other hand, both Kracauer and Benjamin were fascinated by the properties of photography as deployed by avant-garde artists.[6] Kracauer claims that photographic images differ from 'memory images', which 'retain what is given only insofar as [they have] significance', but their meaning will be 'opaque' as long as the images remain 'embedded in the uncontrolled life of the drives'.[7] In contrast, photographic images can present 'the inert world in its independence from human beings … . [allowing us to recognise] the provisional nature of all given configurations, and perhaps even to awaken an inkling of the right order of the inventory of nature'.[8] Likewise, Benjamin claimed that '[photography] makes aware for the first time the optical unconscious, just as psychoanalysis discloses the instinctual unconsciousness': the invisible structures of seeing through which we view our worlds and through which they have been in part constituted.[9] Benjamin describes how the photographic records of Paris made by Eugène Atget during the early twentieth century make us aware of these invisible structures of seeing. Atget refused to draw on established structures of seeing – bourgeois genres and aesthetic forms – and instead 'sought to strip reality of its camouflage'[10] in order to generate new modes of perception.

What of visual culture today? Is the way that photography is deployed in contemporary visual culture paradigmatic of the complexities of postmodern memory? Does the proliferation of photographic images of

people and places from other times and places offer a pleasurable retreat into endless re-fabrications of one's own past and self-identity? Or is there potential for a radical politics with, for example, tactics for recognising the fragmented, contradictory, stories and the excluded voices amidst the plenitude: stories and voices that demand that we acknowledge multiple ways of seeing and that, in turn, question the basis for our own subject positions and social order?

In this volume, developing tactics for recognising other voices and ways of seeing is particularly important for contributors who are working with photography and memories of violent events. They explore how photographs may be creatively employed in (post)memory projects of reworking the traumatic experiences of past generations: experiences that continue to haunt the present. 'Postmemory', a concept developed by Marianne Hirsch specifically with respect to the children of Holocaust survivors,

> characterises the experience of those who grow up dominated by narratives that preceded their birth, whose own belated stories are evacuated by the stories of the previous generation shaped by traumatic events that can neither be understood nor recreated.[11]

The ability to recognise the layers of other voices and gazes in the painful and often confusing postmemories that trouble the children of survivors is crucial in their struggle to mourn, and so to transform their relations to the violence of the past. This brings to the fore the ethical issues raised by the uses of, and the relations of looking implied in, the very varied photographs discussed in these essays; and indeed many of the authors self-reflexively question the methods they develop for interpreting photographs and for presenting their texts as memory work.

Locating Memory: Photographic Acts contributes to a growing debate around cultural memory, a debate in which 'cultural memorialisation [is viewed] as an activity occurring in the present, in which the past is continuously modified and re-described even as it continues to shape the future'.[12] At the same time, it is a contribution to the study of visual culture, where the field of the cultural takes into account the history, infrastructures and effectivities of visual technologies, as well as the material and social resources at work in their operation.[13] Distinctively, however, it brings research on cultural memory and visual culture to bear on the analysis of photographs and photography, drawing on three strands of analysis.

First, a concern with vision and with relations of domination draws, on the one hand, on Foucault's studies of knowledge/power and, on the other, on postcolonial studies of the gaze.[14] This strand focuses on the role of photography in the production of modern knowledge, where sight operates as the foundation of a system of classification and control; and, relatedly, on the role of photography in producing colonial knowledge

structured by the desire and the gaze of the coloniser. Secondly, the collection draws on the contributions of feminist theorists and Holocaust scholars who, in the process of analysing the discourses deployed through photography, interrogate their own investments in the images they study.[15] These scholars create new methods of analysis, novel narrative strategies, and ways of engaging with photographs that fundamentally challenge existing power structures. The third strand, as suggested above, draws on earlier phenomenological studies of photography by Roland Barthes, Walter Benjamin and Siegfried Kracauer,[16] the last two writing when electronic communication technologies began to capture the public's imagination, superseding the wonder that older mechanical technologies, like the camera and phonograph, once held.[17] While Benjamin mourns the loss of aura in the age of science and mechanical reproduction, both he and Kracauer note that photographs still bear material traces of the phenomena recorded by the camera. This work is concerned with the way photography, as a visual technology, raises existential and epistemological questions – questions about the nature of existence and about how we can know the world, questions about how photography can become implicated in our knowing the world.[18]

In common with recent studies that consider the cultural, as well as the institutional and social, uses of photography,[19] the essays which follow are concerned with how images operate in specific locations. Paying close attention to the settings in which the photographs were made and have subsequently been used – whether these be family collections, public archives, museums, political campaigns, newspapers, or art galleries – they consider how meanings in photographs may be shifted, challenged and renewed over time and for different purposes, from historical inquiries to quests for personal, familial, postcolonial and national identities.

All these essays develop distinctive innovative strategies for working with photographs – not only as texts, but also as visual practices, mnemonic devices, repositories of collective knowledge and powerful imagery that mediates social realities. Nick Kaye, Andrew Quick, Andrea Walsh, and Jerry Zaslove and Glen Lowry all focus on the practices of recent and contemporary visual artists who use photographs to intervene in the modern gaze that classifies and orders, as well as commodifies, the very event (and/or the image itself as art) being recorded. The 'ocular mastery'[20] that permits possession of and control over subjects, events and territories is challenged in different ways in the work of such varied artists as Jeff Wall, Vito Acconci, Greg Staats, Jeffrey Thomas and Willie Doherty.

The contributions by Marianne Hirsch and Leo Spitzer, Marlene Briggs and Kirsten McAllister approach the photograph as a visual object

that can be incorporated into imaginative (post)memory projects as a mnemonic device. These authors describe how those haunted by 'family secrets',[21] political persecution and the wars of previous generations can use photographs in memory work, to challenge, critically and creatively, silences and collective myths and create new stories and relations to the past. In the contributions by Elizabeth Edwards, Martha Langford, Andrea Walsh and Kirsten McAllister, the role of photographic archives as repositories of collective memory is examined: photographs are analysed both as visual documents and as sets of records collected and preserved by institutional bodies (structured by similar contradictions of the institutional politics and interests which are also inherent in national projects of remembrance). While colonial and state institutions have used photography as a means to accurately monitor, assess and either 'improve' or isolate deviant subjects in projects to produce modern populations, these authors show that as a medium, photographs are far from transparent documents that can offer veracity. Like memory, they provide only partial, incomplete narratives. Both Edwards and Walsh show that photographs used in national projects ultimately fail to capture their 'subject matter', whether heritage sites or indigenous people. Walsh, Langford and McAllister explore how these records can be critically reread years later and how new generations of artists can appropriate photography to re-member the shadowy presence of those violently extricated from the social landscape.

Patrick Hagopian, Andrew Quick, Marlene Briggs, Marianne Hirsch and Leo Spitzer, Nick Kaye, and Jerry Zaslove and Glen Lowry consider how photographs mediate our apprehension of reality. Hagopian and Briggs artfully trace the changing meanings of war images and memories of senseless battlefield carnage, as the images move across different media over time. In the poetic memory work of Hirsch and Spitzer, a photograph operates less as a representation than as a threshold on their journey to find a Nazi concentration camp, opening up an entry to a route across unknown territory. Zaslove and Lowry, and Quick, examine art that disrupts the dominant ways of seeing typified by photorealism and by neoclassical pictorial genres which position us as voyeurs in relation to scenes of violence and exploitation. By contrast, Kaye considers how photographic records of work by conceptual artists function in effect to refuse access to the original works, not only to subvert their commodification but also, at a metaphysical level, to question established notions about the nature of presence.

As inspiration for new creative, scholarly and curatorial activities, all the essays in *Locating Memory: Photographic Acts* explore the emancipatory potential for reframing, through photographic acts, our 'normative'

narratives of gender, nationhood, 'race' and ethnicity, our conventional understandings of the relationship between the past and present and the ways in which our fields of vision are structured by relations of control.

* * *

In Part I (Identities), Andrea Walsh, Elizabeth Edwards and Kirsten McAllister explore relationships between photography, memory and identity. Andrea Walsh's 'Re-placing History: Critiquing the Colonial Gaze through Photographic Works by Jeffrey Thomas and Greg Staats' offers a postcolonial analysis of visual culture that goes beyond a critique of constructions of First Nations people as a 'vanishing race' and 'primitive others'.[22] Instead, Walsh turns to innovative work by First Nations photographers Jeffrey Thomas and Greg Staats, work that seeks to reconfigure the present and the future through visualisations of place. Walsh notes that late nineteenth-century and early twentieth-century photographs of First Nations people made by anthropologists, government officials and non-aboriginal artists in Canada constructed their subjects as homogeneous groups, reifying them as signifiers of 'Indian-ness'. In terms of their use, contends Walsh, these images were part of a larger discourse of modernisation that subjected First Nations to assimilation programmes (educational and religious 'reform') and aimed to integrate them into the workforce as wage-labourers. By contrast, the work of contemporary artists Thomas and Staats is concerned with 'private' experiences and explorations of postcolonial space. She describes how their work incorporates visual strategies for negotiating the overlooked living presence of First Nations people within and along the borders of urban landscapes in their historical homelands. Without being didactic, the work of both artists engages viewers through the particularity of living bodies and places for living. As such, they are exemplary dialogic media – media through which intercultural understandings may emerge.

Elizabeth Edwards's 'Photography, "Englishness" and Collective Memory: The National Photographic Record Association, 1897–1910' looks at the formation of the National Photographic Record Association (NPRA) in Britain at the turn of the twentieth century and examines its modernist project to record and preserve English traditions that (ironically) modernity itself was destroying. More specifically, the aim of the NPRA was to generate a memory bank of images documenting English traditions for future generations. In the context of anxieties about definitions of English identity and about maintaining a distinctive

national past in the face of the 'contaminations' of Empire, the NPRA's photographic records aspired to act as a basis for, and a means of, protecting the nation's collective memory. Edwards shows how the medium of photography was regarded as particularly suited for such a project. At an ideological level, the capacity of photography 'objectively' to inscribe traces of places and events on its surface meant that it met the positivist criteria of scientific discourse, and thus promised to give the NPRA's project credibility and institutional authority. Insofar as the NPRA strove to make photography the new medium of collective memory, Edwards argues, the characteristics of the medium (its capacity to inscribe evidential traces and the way it acted as an objective observation/record) resulted in a prosthetic memory that adhered to an 'archaeological imagination' concerned with 'cultural salvage'. In a detailed and fascinating analysis of the NPRA's photographic records and of the institutional practices, discourses and affiliations surrounding them, Edwards exposes the tensions inherent in this project and the reasons for its ultimate failure. Of particular significance is her analysis of the inability of photographic records to capture the auratic power of the loci of English identity in rural and urban locations.

In 'A Story of Escape: Family Photographs from Japanese Canadian Internment Camps', Kirsten McAllister analyses the role of the archive in repositioning and recreating the meanings of photographs, in this case family photographs taken in the Second World War internment camps. She reads her own family's photographs, taken in the Lillooet camp, through other family photographs she finds in the Japanese Canadian National Museum, all of them images that reference migration and re/dis-location – changing places. In engaging in this project, McAllister discovers that it also involves a quest to 'find' her own mother as a young girl – a fantasy of plenitude, but also a desire to be part of her mother's particular story. In the process, she realises that her mother's story is (part of) a larger, more difficult, history: one mediated by stories of trauma and their refiguration across generations. Insofar as the author imaginatively invests her narrative with stories from older generations, the concept of postmemory is central to her essay. It successfully engages, at both an affective and an analytical level, with its material, tracking the relationships between the apparently personal, on the one hand, and wider histories, on the other. McAllister's essay also raises difficult questions concerning the ethics of interpreting family photographs across generations and of putting into the public sphere readings of other people's photographs.

In Part II (Dis/locations), Marlene Briggs, Marianne Hirsch and Leo Spitzer, Andrew Quick and Nick Kaye address issues surrounding photography, dislocation and memory. In 'The Return of the Aura: Contemporary Writers Look Back at the First World War Photograph', Marlene Briggs examines post-World War II writers who enact 'encounters with visual remains' – notably photographs – of the First World War. She argues that creating these visual texts is a 'performative intervention' in the obliteration of millions of young men in that first war of mass destruction. The work examined in this compelling essay includes belated commemorations of dead soldiers and photo-narratives that circle self-consciously around the myths and silences surrounding individual soldiers – narratives that continue to haunt the lives of their creators, some of whom have personal ties to the soldiers and the events of the First World War, while others do not. Nevertheless, all are deeply affected by the carnage, horror and loss of individual lives signalled in a handful of photographs. Briggs frames her study through Marianne Hirsch's concept of postmemory and Walter Benjamin's work on aura. Both postmemory and aura offer ways to conceptualise the power of objects and images as well as their (after) effects. Briggs is particularly interested in how aura, like postmemory, involves a reciprocal gaze, which offers a possibility of transformation for the creators of these belated commemorations and photo-narratives, and infuses life into individual young men who were part of a generation obliterated by the mass destruction of industrial warfare.

Marianne Hirsch and Leo Spitzer create an evocative piece of memory work in '"There Never Was a Camp Here": Searching for Vapniarka'. They narrate a journey to the Ukraine that they undertook in an attempt to return to the site of the Vapniarka camp, a Nazi concentration camp where Hirsch's parents were almost sent and which has remained a 'place of horror' in her memories. The author-travellers interweave their narrative with the memory fragments of their travelling companion, David Kessler, whose father was an inmate doctor in the camp. With them, the three travellers carry facsimiles of visual clues that they hope will lead them to the camp: notably a photocopy of a photograph of a cardboard model of the camp made from memory by one of the survivors. Like the intangible presence of the camps throughout their own lives as children of Holocaust survivors, these facsimiles are like distant shadows of places and events they have never seen and cannot fully describe. Neither the camp nor Transnistria, as the region was known before the Second World War, are easily located: the place they seek is a '"forgotten cemetery" – nowadays, a geographical "no-place" that cannot be found in any contemporary geographical atlas'.

Hirsch's and Spitzer's essay recalls the sensation of wandering through a dreamscape in the aftermath of a nightmare. The facsimiles of the forgotten place, 'the place of horror', initially seem inert. But somehow, as if by magic or chance, at the right moment they open a threshold that finally leads the travellers to the site of the Vapniarka camp. In the end, though, the authors suggest that photographs in themselves are inadequate because of the instability of their images. Their meanings, imagery and material forms shift, fade and disappear over time, underlining the intangible nature of visuality.[23] Instead, Hirsch and Spitzer turn to their own bodies and to rituals as ways of re-membering loss. Paralleling Jewish rituals that help the departed rest, they collect stones from the site of the camp and bring them home to the United States. This act parallels the Jewish exodus to the Americas as thousands fled the Nazi regime to places where they hoped a 'future' would be possible.

Rather than analysing photography, memory and place, Hirsch and Spitzer produce what Hirsch, in her book *Family Frames*, calls 'imagetext' or 'prose picture':[24] 'text and image, intricately entangled in a narrative web, or in collaboration to tell a complicated story of loss and longing'.[25] The concept of postmemory[26] is key in this essay, as it is in a number of contributions to this book. Moreover, Hirsch and Spitzer question the very trust we place in photographic images as part of the postmemory process. They trace how their facsimiles of Vapniarka promise but often fail to give clues to the locations, the places, that are not fully explained in family stories.[27]

In 'The Space Between: Photography and the Time of Forgetting in the Work of Willie Doherty', Andrew Quick explains how the artist Willie Doherty's photographic installations on Northern Ireland break down any authoritative position from which viewers may classify and order spaces of occupation and conflict. Quick begins his essay with his own encounter with Doherty's work while overseas in the 'unfamiliar familiarity' of postcolonial Australia. As a British subject, Quick describes his experience of 'fracture and dislocation' while viewing Doherty's work. In this way, Quick performs what he describes as Doherty's 'staging' of a 'spectatorial practice', submitting himself as 'an active participant … within the frame of the scenes'. In images of vacant landscapes and discarded everyday objects, Quick discerns the eerie imprint of absent bodies. Within these scenes, argues Quick, corporeality is in a state of crisis. Bodies are 'evacuated'; their presence is stripped from old mattresses, burned-out cars and empty stairwells. Where they are present, bodies appear only as fleeting glimpses, blurred figures or fragmented body parts. Drawing on the writings of Michel de Certeau and Elizabeth Grosz, Quick shows how this undermines the integrity of

the viewer's own body as the central position from which it may secure its place, through 'ocular mastery'. Thus Doherty's work makes it impossible for the viewer to distinguish 'Us' from 'Them', pursuer from escapee, assassin from victim. Doherty's work, Quick argues, not only breaks down viewers' ocular mastery but also subverts photography as a medium which functions to objectify the social and political world. Photography consequently fails to capture and retrieve, replaying the failure of memory rather than replicating its process. In this way, Quick contends, Doherty's work instils a 'radical forgetting', or anamnesis, where 'one must attempt to account for the remainder that is suppressed' in memory.

Nick Kaye's 'Displaced Events: Photographic Memory and Performance Art' examines the use of photographic images as 'provocations' in European and American conceptual art and performance in the 1960s. This work used photography both to document the ephemeral nature of space and activity and to disrupt the assumptions of contemporary art. Using Daniel Buren's site-specific practices to frame his discussion of photographic images, Kaye focuses on the conceptual art and body art of Vito Acconci, Dennis Oppenheim and Michelangelo Pistoletto. The only access to the artworks and performances discussed in the essay is through photographic images, or 'photo-souvenirs', which, as reproductions, can only be 'betrayals of the original'. As traces, fragments and relics of a 'larger scheme', these photographs radically question the assumptions of conventional art practices, since at the most basic level you 'can't see the art', 'you can't buy the art' and 'you can't have the art'. Work of this kind plays on the very nature of photography as a medium, with its ambivalent relation to 'reality' – a relation which always foregrounds the absence of whatever it records. In this context, these artists use photographs as metaphysical trajectories or acts that disrupt and dislodge assumptions about presence, about being 'placed' or 'fixed'. Insofar as Kaye's discussion of the photographic images draws out the impossibility of knowing, recovering, and ultimately of 'having' and 'being', it questions places (land and bodies) as the location of memory and also proposes a radical revision of memory as it enacts, performs, and alludes to, reification.

In Part III (Reframings) Patrick Hagopian, Martha Langford, and Jerry Zaslove and Glen Lowry address issues surrounding the reframing of photography and memory. In 'Vietnam War Photography as a Locus of Memory', Patrick Hagopian examines the immediate impact of Vietnam War photographs on public consciousness; and also, hinting that photographs can be a place (a locus) for shared memory, considers the

subsequent instrumentality of these photographs in cultural memory. He analyses Vietnam War photographs as part of a larger discursive field, contrasting the impacts of different media, including photography, film and written reports. Notably, he argues, photography as a medium is more powerful than both film and written text, because of its distinctive characteristics: its reproducibility, the way it endures and its 'stillness'. It is these characteristics that make it possible for photography to be reproduced and recirculated repeatedly across different media. At the same time, photographs become meaningful only in relation to other media representations and discourses: in the context of the Vietnam War, for instance, political discourses provided evidence that questioned the actions of the U.S. military in Vietnam. Hagopian argues that the photographs subsequently 'expressed' this evidence in evocative imagery. Many of the images have acquired increasing cultural resonance as they continue to recirculate across different media over time, becoming in effect, iconic.

Martha Langford's 'Speaking the Album: An Application of the Oral-Photographic Framework' explores innovative methods for reading a photograph album (1920–1940) selected from an archive located in the McCord Museum of Canadian History. The album was compiled by a girl living in the city of Montreal. Langford argues that the photograph album's primary function is a mnemonic device through which memories are elicited through the 'conversations' it prompts. Practising her 'oral-photographic' method, Langford tests this contention by showing the album to five women. She discovered that the album compelled each woman both to tell the story of the girl in the photographs (whom they did not know) and to recount their own family memories. In this way, Langford argues that the album is a medium that is most evocatively read 'through conversation' or dialogue. At a methodological level, what the 'conversations' reveal are the structures through which memory and meaning are encoded in albums. Langford argues that these structures are specific to oral rather than to literate forms of communication, marked as they are by such discursive devices as repetition and formulaic patterns. At an analytic level, she reads the museum's system of indexing against both the women's 'conversations' and her own visual analyses of the images in the album. She groups the images into genres that mark different stages in a process of 'coming of age', each genre marked implicitly by changing gazes and social relations. Towards the end of the essay, Langford directs us back to the girl, the compiler of the album, who in producing her own memoir fabricates her 'story' as a way to 'perform' her subjectivity. At this point, the author makes an intriguing discovery ….

Jerry Zaslove's and Glen Lowry's 'Talking Through: This Space Around Four Pictures by Jeff Wall' focuses on four large-scale conceptual photographs of the artist Jeff Wall. They represent a shift away from Wall's earlier, meticulously choreographed scenes involving actors and film-like sets towards images of empty architectural and urban spaces occupied, if at all, by lone marginal figures. Set up as a dialogue between its authors, Zaslove's and Lowry's contribution explores the relationship between memory and the medium of photography, situating Wall's work within the broader context of modernism and late modernity. Wall's work, they contend, may be understood within the tradition of early twentieth-century modernism. Early modernist work aimed to break down bourgeois aesthetics as well as to provide shelter from the totalising commodification of daily life. This work acted on the perceptions of the viewer, seeking to change how the viewer saw the world, bringing into question the very basis of the act of judgment. The authors describe how Wall's work heightens the confused boundaries between the life of the spectator and 'the magical world of representation'. His backlit lightboxes blur the boundaries between the space of the gallery and the space of the image. This implicates the viewer, placing her or him uncomfortably *inside* the scenes, especially those showing the typical objects of voyeuristic peering: women and racial others.

Rather than simply blurring boundaries, however, suggest Zaslove and Lowry, photography breaks into the processes of memory and dreams. In contrast to paintings, they say, photographic images are marked by their very nature with the passage of time, starting with the disjuncture between when the photograph was taken and the moment when it is subsequently viewed. A painting immortalises its subject not so much by replicating its appearance as by grasping its subject's character and rendering it into an aesthetic form. In contrast, viewers assume that the photograph records how a place or person looked at a particular moment and place. Viewers are immediately aware of the passage of time that distances them from what was there when the photograph was taken and what has subsequently changed or no longer exists. The temporal gap introduces anxieties about change and loss in our engagement with these photographs, disrupting the plenitude we seek in the images. As with the photographs discussed by Quick and Kaye, there is an aggressive quality in Wall's strategies: they violate the integrity of the viewer and instil disorientation. This strategy arguably continues the modernist aim of rending asunder bourgeois aesthetics in order to expose how reification and commodification form our perceptions. By bringing the spectator/reader into the work in a critical and dialogic manner, argue

Zaslove and Lowry, the strategy is to re-form our perceptions and transform the very act of judgment through which we engage with reality.

While the contributors to this volume recognise that photography can operate as a technology of visual control, they are all concerned with how artists and users can develop strategies to dismantle the structures of seeing embedded in the medium. In consequence, they challenge the assumption that the accumulation of accurate records should increase our ability to know the world. The very compulsion to record the present points to an insecurity: the urge to preserve is driven by a fear of loss. Rather, these essays show how, in fact, the nature of photographic records undermines any certainty about what it is possible to know. Specifically, the very act of taking a photograph involves the creation of a record of something that has, in the passage of time, either altered or no longer exists. In this way, the photograph embodies an unbridgeable juncture between 'now' and the earlier moment when the photograph was taken. By presenting us with images of what no longer exists, photographs highlight the unstable, tenuous nature of the postmodern present. As Roland Barthes and Christian Metz conclude, rather than enshrining the certainty of scientific knowledge, photography presents us with loss.[28] If, as the authors of the essays in this collection argue, the present – 'now' – cannot be circumscribed, it becomes impossible to determine conclusively the nature of the present, or for that matter, the nature of the past or the future. Without a stable position, how is it possible to assert knowledge of anything at all? Moreover, insofar as any photograph can provide only a partial record of any one event at any one time, the specific point of view of every photograph reminds us that all vision is from a particular standpoint. As points of view proliferate, how are we to determine which one is the most accurate? What can we then turn to? As Annette Kuhn has written,

> memory work is a method and practice of unearthing and making public untold stories, stories of 'lives lived out on the borderlands, lives for which the central interpretive devices of the culture don't quite work' As an aid to radicalised remembering, memory work can create new understandings of both past and present, while refusing a nostalgia that embalms the past in a perfect irretrievable moment. Engaging as it does the psychic and the social, memory work bridges the divide between inner and outer worlds. It demonstrates that political action need not be undertaken at the cost of the inner life, nor that attention to matters of the psyche necessarily entails a retreat from the world of collective action.[29]

So, too, the contributors to *Locating Memory: Photographic Acts* suggest, the recognition of multiple points of view, of partiality and instability, requires of us an ethics of engagement.

At the same time, the contributors to this volume do not reach the conclusions of those contemporary cultural theorists who find themselves unable to look to the past or the future for a sense of hope. True, it is almost romantic now to say that as the present unfolds it leaves in its wake a confusing profusion of what-has-been in a trail of perpetual loss.[30] One can envision the past piling up, as Benjamin might have put it, in an overwhelming mass of debris. But this mass is overwhelming only for those who seek to impose on it an all-encompassing line of sight that can guarantee a single Truth – asserting complete(d) knowledge. In contrast, the very nature of photography as a medium disrupts the possibility of asserting a final and single Truth. As mentioned above, the temporal disjuncture between the moment when the photograph was taken and subsequent moments when it is viewed, entails recognition of, at the very least, two different points of view: that of the photographer and that of the viewer. Finding a way to read each point of view, as they are situated in different places and temporal moments, calls for an ethics of reading. The question is not 'who is right' but, rather, how might each point of view tell us something different or feel compelled to keep certain things 'off screen'. In addition, the way that the photograph mediates our distance from the past invokes uncertainty about what it is possible to know from the images. As such, the photograph evades the closure of complete(d) knowledge. As viewers, if we can not be certain about what happened in the past, then neither can the photographer be certain about how her or his photographs will be read in the future. This uncertainty instills hope, an openness to what is yet to come: that the future is not determined by the past. The contributors to this volume take on this ethical dimension of the photograph. They seek out the partial views that have been eradicated from the social landscape; they search for temporal disjunctures that evade linear time; they look for the instabilities that show that power is not as pervasive as it seems. Their work with photography is critical, and it is creative. They take risks, not only asking questions that lay bare their own investments in their own relations of looking but also pointing to the locations where they believe memories and hope do reside.

Notes

1. Marianne Hirsch and Leo Spitzer offered this insight while corresponding with the editors of the volume.
2. See Nick Kaye, Chapter 8 in this volume.
3. Walter Benjamin, 'The Work of Art in the Age of Mechanical Reproduction', in *Illuminations: Essays and Reflections*, trans. Harry Zohn, ed. Hannah Arendt, New York: Schocken Books, 1969, p. 222.

16 Annette Kuhn and Kirsten Emiko McAllister

4. This period was characterized by, for example, the fall of imperial world powers; the rapid spread of industrialisation to regions outside of the European heartland; the spread of new electronic communication technologies across the globe; the formation of socialist states and the rise of fascism. See Eric Hobsbawm, *Age of Extremes: The Short Twentieth Century, 1914–1991*, London: Abacus, 1995.

5. Siegfried Kracauer, *The Mass Ornament: Weimar Essays*, trans. and ed. Thomas Y. Levin, Cambridge and London: Harvard University Press, 1995, pp. 57–58.
6. Kracauer, *Mass Ornament*, pp. 61–63; Walter Benjamin, 'A Short History of Photography', *Screen* 13, trans. Stanley Mitchell, Spring 1972, pp. 7, 20.
7. Kracauer, *Mass Ornament*, pp. 50–51.
8. Kracauer, *Mass Ornament*, p. 62.
9. Benjamin, 'A Short History of Photography', p. 7.
10. Benjamin, 'A Short History of Photography', p. 20.
11. Marianne Hirsch, *Family Frames: Photography, Narratives and Postmemory*, Cambridge, MA and London: Harvard University Press, 1997, p. 22.
12. Mieke Bal, 'Introduction' in *Acts of Memory: Cultural Recall in the Present*, eds Mieke Bal, Jonathan Crewe and Leo Spitzer, Hanover, New Hampshire: Dartmouth College Press, 1997, p. vii; also see Susannah Radstone and Kate Hodgkin, eds, *Contested Pasts: The Politics of Memory*, London: Routledge, 2003; Annette Kuhn, *An Everyday Magic: Cinema and Cultural Memory*, London: I.B. Tauris, 2002; Susannah Radstone, ed., *Memory and Methodology*, Oxford: Berg, 2000; John R. Gillis, *Commemorations: The Politics of National Identity*, Princeton: Princeton University Press, 1994; Raphael Samuel, *Theatres of Memory: Volume 1: Past and Present in Contemporary Culture*, London: Verso, 1994; Paul Connerton, *How Societies Remember*, Cambridge: Cambridge University Press, 1989; Pierre Nora, 'Between Memory and History: Les Lieux de Mémoire', *Representations* 26, 1989, pp. 7–25; Maurice Halbwachs, *On Collective Memory*, Chicago: University of Chicago Press, 1992; and Frances Yates, *The Art of Memory*, Chicago: University of Chicago Press, 1974.
13. Richard Howells, *Visual Culture*, Oxford: Blackwell, 2003; Nicholas Mirzoeff, ed., *The Visual Culture Reader*, London: Routledge, 1998; Jessica Evans and Stuart Hall, eds, *Visual Culture: The Reader*, London: Sage, 1999; Chris Jencks, ed., *Visual Culture*, London: Routledge, 1995; Jonathan Crary, *Techniques of the Observer: On Vision and Modernity in the Nineteenth Century*, Cambridge, MA and London: MIT Press, 1990.
14. David Green, 'Classified Subjects: Photography and Anthropology: The Technology of Power', *Ten 8* 14, 1984, pp. 30–37; John Tagg, *The Burden of Representation*, Minneapolis: University of Minnesota Press, 1993; Suren Lalvani, *Photography, Vision, and the Production of Modern Bodies*, Albany: State University of New York Press, 1996; Anne Maxwell, *Colonial Photography and Exhibitions: Representations of the 'Native' and the Making of European Identities*, London: Leicester University Press, 1999; Eleanor Hight and Gary Sampson, *Colonialist Photography: Imagining Race and Place*, London: Routledge, 2002.
15. Marianne Hirsch, ed., *The Familial Gaze*, Hanover, NH and London: University Press of New England, 1999; Leo Spitzer, *Hotel Bolivia: The Culture of Memory in a Refuge from Nazism*, New York: Hill and Wang, 1998; Hirsch, *Family Frames*; Ernst van Alphen, *Caught by History: Holocaust Effects in Contemporary Art, Literature, and Theory*, Stanford, California: Stanford

University Press, 1997; Annette Kuhn, *Family Secrets: Acts of Memory and Imagination*, London and New York: Verso, 1995, [2nd edn, 2002]; Jo Spence and Patricia Holland, eds, *Family Snaps: The Meanings of Domestic Photography*, London: Virago Press, 1991; Lawrence Langer, *Holocaust Testimonials: The Ruins of Memory*, London: Yale University Press, 1991; Art Spiegelman, *Maus: A Survivor's Tale, II, And Here My Troubles Began*, New York: Pantheon Books, 1973; Art Spiegelman, *Maus: A Survivor's Tale, I, My Father Bleeds History*, New York: Pantheon Books, 1986.

16. Roland Barthes, *Camera Lucida: Reflections on Photography*, New York: Hill and Wang, 1972; Walter Benjamin, *One Way Street and Other Writings*, London: Verso, 1985; Walter Benjamin, 'A Short History of Photography'; Benjamin, *Iluminations*; Kracauer, *Mass Ornament*.

17. See Asa Briggs and Peter Burke, *A Social History of the Media: From Gutenberg to the Internet*, Cambridge: Polity Press, 2002.

18. Most of the essays in this book focus on photographs that were originally produced analogically, although digital imaging technology has been used in order to reproduce the images. The implications of digital technology for the future uses of photography in invoking, or erasing, memory and location have yet to be explored.

19. Elizabeth Edwards and Janice Hart, eds *Photographs Objects Histories: On the Materiality of Images*, London: Routledge, 2004; Elizabeth Edwards, *Raw Histories: Photographs, Anthropology and Museums*, Oxford: Berg, 2001; Martha Langford, *Suspended Conversations: The Afterlife of Memory in Photographic Albums*, Montreal: McGill-Queen's University Press, 2001.

20. See Andrew Quick, Chapter 7, in this collection.

21. See Kuhn, *Family Secrets*.

22. See Government of Canada, 'Report of the Royal Commission on Aboriginal Peoples', http://www.ainc-inac.gc.ca/ch/rcap/sg/sgm9_e.html, accessed 17 October 2004; Marcia Crosby, 'Construction of the Imaginary Indian', in *The Vancouver Anthology: The Institutional Politics of Art*, ed. Stan Douglas, Vancouver: Talon Books, 1991, pp. 267–294.

23. Marianne Hirsch and Leo Spitzer offered this insight while corresponding with the editors of the volume.

24. Hirsch, *Family Frames*, pp. 3–5, 8–10.

25. Ibid., p. 4.

26. Hirsch and Spitzer bring their secondary, belated memories – memories mediated by stories and images with which they grew up, but which never added up to a whole picture – back to the historical sites of memory. See Hirsch, *Family Frames*, p. 244.

27. Correspondence from Marianne Hirsch and Leo Spitzer with the editors of this volume.

28. Barthes, *Camera Lucida*; Christian Metz, 'Photography and Fetish', in *The Critical Image*, ed. Carol Squiers, Seattle, WA: Bay Press, 1990, pp. 155–164.

29. Kuhn, *Family Secrets*, p. 8; for the quote within the quote see Carolyn Steedman, *Landscape for a Good Woman: A Story of Two Lives*, London: Virago Press, 1986, p. 5.

30. See Walter Benjamin, 'Theses on the Philosophy of History', in *Illuminations*, pp. 253–264.

Part I

Identities

Re-placing History

Critiquing the Colonial Gaze through Photographic Works by Jeffrey Thomas and Greg Staats

Andrea Walsh

Contemporary First Nations artists are increasingly turning to photography to re-view and re-vision colonial and postcolonial spaces and places in North America. This essay focuses on the photographic work of two Iroquoian artists, Jeffrey Thomas and Greg Staats, whose images subvert dominant colonial and postcolonial narratives as well as visual representations of First Nations peoples. My intention is to demonstrate the value of looking at these contemporary images in terms of their individualised perspectives on First Nations identity, history and experience of place. I situate this discussion against colonial representations of First Nations people that often depict individual subjects as representative of collectives.

Photographs by Thomas and Staats intersect and challenge generic narratives of cultural loss, discovery and/or renewal typical of First Nations art production in Canada during the 1990s. Unlike much of the work created by First Nations artists during this time, the work of Thomas and Staats in which I am interested here does not communicate identity using visual signs of 'Indianness' (feathers, beads, carving, face paint, buckskin, animal fur, teepees, horses, canoes and so on) that are easily read as signs of difference by viewers. I believe this lack of symbolism disrupts the manner in which many viewers have become accustomed to looking at First Nations art and people.

Two types of colonial-era imagery of First Nations peoples in Canada produced by non-natives are significant in considering how the work of Thomas and Staats contributes in new ways to intercultural understandings of history, identity and place. They are early paintings

and photographs produced by artists whose project was to document the 'disappearance' of aboriginal peoples at the turn of the twentieth century; and the body of photographic works, produced largely by lay photographers, that depicts aboriginal peoples as a homogenous group of people (identified in the photographs most commonly by their nation rather than by individual names). This imagery played into the colonial narrative of economic expansion and assimilation of First Nations into Canadian society. I shall discuss these images briefly to provide a context for discussing the photographs of Thomas and Staats.

The association of aboriginal people with certain signs of cultural identity has occurred largely because of non-native narratives of First Nations people and their cultures as vanishing during the late nineteenth and early twentieth centuries. Images produced and circulated out of these narratives tend to focus on the portrayal of aboriginal life before contact with Europeans. This perspective is most immediate in the photographs of Edward S. Curtis and paintings by artists such as Emily Carr, Frederick Verner and Paul Kane. A large portion of this imagery consists of portraiture of aboriginal peoples in traditional regalia, or depicts aboriginal people in (and of) the natural landscape. Such images of native people have been subjected to what is now a standard critique of their alleged authenticity and value. Rather than being factual data about native cultures, it is argued that they speak more about the producers and consumers of the images than their subjects. Nonetheless, these early images of aboriginal peoples continue to inform popular non-native experiences and understandings concerning aboriginal people to this day.

Aside from rare individual portraits of First Nations subjects taken during this time (1870–1945), much of the historical photographic imagery of First Nations peoples circulated in Canada has signified aboriginal peoples' identity as collective or stemming from a certain Nation. These photographs depict people either in the process of assimilation into Canadian society (through images of work and education) or as remaining distinct from it (through images of cultural practices and beliefs). In either case, these images signify generic aboriginal experiences much more than they address the individual lives at certain historical moments. The typically non-native photographers who created this body of imagery range from government officials to professional and lay photographers, as well as tourists. Despite the photographer's background or specific agenda in making the images, all these photographs fit into narratives of colonial expansion, the growth of a national (and provincial) economy, and the assimilation of aboriginal people in the process.

I have chosen images from the British Columbia archives as examples of these themes. With few exceptions, all of the images, whether they

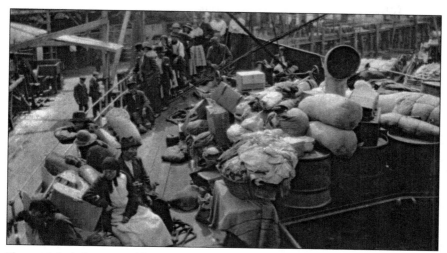

Figure 2.1 *Indians Bound for Cannery Work Boarding SS Princess Macquinna.* Courtesy: British Columbia Archives and Records Service, D-06893.

connote sameness or difference, depict groups of people from the perspective of the photographer who stands at a distance away from his subjects. He is a bystander or onlooker and he photographs a situation or an activity. This is demonstrated in the image entitled 'Indians Bound for Cannery Work Boarding SS Princess Macquinna' (figure 2.1). The photograph has an approximate date of 1910–1920 and its author is unknown. The image depicts aboriginal people boarding a ship, most likely on the west coast of Vancouver Island (Macquinna is a 'chiefly' name for the Nuu-Chah-Nulth Nation and their territory is in this locale), to travel to one of the many salmon canneries along the coast of British Columbia. Aboriginal people in British Columbia were the primary source of seasonal workers in the fishing industry during the early twentieth century. A picture similar to this one shows men and women boarding the ship, but all of the people in the photograph have their backs facing the photographer and his camera. In the photograph reproduced here, none of the people in the image are looking towards the camera as if they were having their photograph taken as documentation of their personal journey on this ship. The people in this image signify aboriginal people as a collective becoming part of (being assimilated into) British Columbia's labour pool based on its natural resource-driven economy.

A significant part of the colonial narrative of aboriginal existence emphasised aboriginal peoples' (children in particular) scholastic and religious education. Many photographs document the mass conversion of aboriginal peoples to Christianity, as in the image entitled 'Chehalis

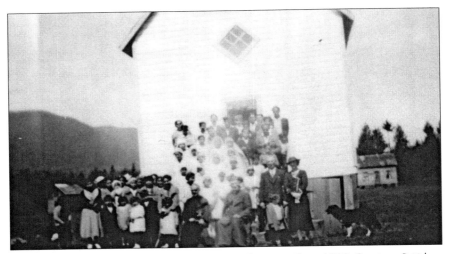

Figure 2.2 *Harrison River. Chehalis Indians Confirmation Class, 1938.* Courtesy: British Columbia Archives and Records Service, F-00267.

Indians Confirmation Class' (figure 2.2). Taken on 16 May 1938, this image shows a group of approximately one dozen aboriginal youths on their day of Confirmation. Seated at the front of this crowd are a non-native priest and perhaps a bishop of the church. To the left of this group assembled on the church's steps is a younger group of children, perhaps signifying the next generation of converts. An important part of this image is the church building in the background, as it too carries weight as a sign of colonial domination. Again, the image connotes aboriginal peoples becoming members of Western society en masse as part of a broader agenda of assimilation.

Different from photographs that connote 'sameness' under a colonial agenda of progress, are images like the one entitled 'Cowichan Indians Performing Whale Dance' (figure 2.3). It depicts a group of young men dancing in regalia with drummers in the background, and it appears that the group has gathered in a cedar plank longhouse. This photograph was taken in 1945 by the British Columbia government. Around this time, the provincial museum in Victoria was experiencing huge increases in visitors to the institution that prided itself on the documentation of aboriginal peoples, history and culture in British Columbia. This kind of photograph is typical of the attempts to document current conditions of aboriginal peoples. Curators of anthropology and history strove to collect information on aboriginal traditions that survived colonialism and assimilation policies. The 'Whale Dance' featured in this photograph would be one of the traditions that interested curators, as would the

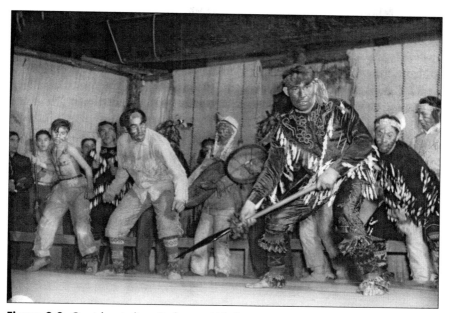

Figure 2.3 *Cowichan Indians Performing Whale Dance, 1945.* Courtesy: British Columbia Archives and Records Service, I-27569.

drumbeats and songs that accompanied the dance. The latter were most likely audio-recorded. Although this photograph (as opposed to the two earlier images of assimilation) depicts the continuity of aboriginal cultural beliefs and knowledge, it does so again under the guise of representing aboriginal people in the form of a collective. There is no documentation to accompany this image about the individual people who are depicted, nor of the specifics of the event at which the dance was performed. I read the image as equating the dance with a tribe of people, rather than depicting individuals who might have owned the rights to the dance or clarifying the particular reasons they agreed to let the photographs be taken. The photograph is as much, or more, a document of neocolonial government agendas and perspectives on aboriginal history and identity as it is a document of Cowichan peoples.

Photographs by Jeffrey Thomas and Greg Staats lack easily recognisable (read stereotypical) visible signs associated with First Nations identity. As such, their photographs do not immediately signify everyday aboriginal experiences of space and place for many viewers, thereby obscuring the cultural specificity of the images. The types of colonial photography discussed above may be accurate representations of day-to-day experiences of First Nations peoples; however, they portray

the identities of the people based on a presupposed collective experience of assimilation into a Canadian society rather than on the experiences of individuals and their histories. Photographs by Thomas and Staats address this void of individual voices about First Nations experiences.

The contemporary predicament of looking at photographs from different cultural perspectives necessarily raises questions about the contexts in which such photographs are viewed and the kinds of knowledge and experience viewers must have in order to comprehend fully the photographer's intentions for the images. Finally, one must consider the success of these images as interfaces for intercultural spectatorship and understanding. There are no singular or simple responses to these points. It is my hope that the discussion presented in this essay will serve to reinforce the validity of pursuing questions of intercultural spectatorship and provide departure points for future inquiry.

My perspective on contemporary photographs by Thomas and Staats is derived from a combination of viewing the images and examining texts from interviews that I have conducted over the years with each artist. Of course, without these two sets of data it would be very possible to interpret the images in a manner different than I do here.[1] I believe this method of working with photographs that engages artists in ethnographic interviews is in line with current social science research that uses the image as a medium or node between cultural agents. I want to follow Elizabeth Edwards's lead by thinking about photography as a 'site for the articulation of other frames and other forms of expression and consumption'.[2] Here I am interested in how artists create photographs that signify intercultural understandings of place and space in Canada. How do aboriginal photographers challenge native and non-native uses of dominant signifiers of aboriginal identity to direct them to new intercultural understandings of aboriginal identity and history? Can these strategies direct not only how spectators see their art but also what they see in their art?

The act of looking to the past or into history as part of any investigation about identity is often complicated by a sense of nostalgia. Nostalgia is commonly associated with a longing and a desire for something that has faded or disappeared and is no longer attainable. The photographic work of Thomas and Staats steers clear from any lament over the loss of something to history, or to the past. Rather, the images articulate the continuing power of things no longer present, be these intangible like knowledge and spirit, or tangible like physical places or people. Concepts of resistance to dominant narratives of colonial or postcolonial history, as well as renewal of personal and cultural strength, come to the fore in their work. This sense of intent in the work of Staats

and Thomas situates their photographs in a larger discussion of the contributions of First Nations artists to private postcolonial histories in Canada, rather than to the public postcolonial History of the Nation.[3]

Until the latter decades of the twentieth century, a dominant metanarrative of Canada's history and aboriginal peoples' involvement in its development was presented to the Canadian body politic in a fairly uncritical manner. This narrative was largely presented from a Euro-Canadian viewpoint of history, and often cast aboriginal peoples under a detrimental veil of homogeneity[4] Rarely were individual people's lives considered as part of these representations, as they tended to focus on cultural traits and histories of groups of aboriginal peoples, such as 'the Haida', or worse, 'Our Native Peoples'.

My reading of photographic works by Thomas and Staats is set against the rise in awareness of space, place, identity and history in the year 1992. This year marked in history the five hundredth anniversary of the arrival of Columbus and his ships to the Americas. Public reaction in Canada to events that celebrated this quincentenary were mixed. Indigenous peoples from Canada and the U.S.A. who protested against the quincentenary did so under a common banner of '500 Years of Resistance'. The story about the nautical error made by Columbus in 1492 and the ensuing legacy of colonialism is well known. For many aboriginal people, the year 1492 marks the beginning of generations of oppression and displacement, while many non-tribal peoples in places like the United States continue to celebrate Columbus's inauguration of 'The Age of Discovery' on 10 October of any given year.

In 1992, two of Canada's principal public cultural institutions, the National Art Gallery (NAG) in Ottawa, Ontario and the Canadian Museum of Civilization (CMC) in Hull, Quebec, exhibited for the first time shows by exclusively native artists. The shows were entitled *Land, Spirit, Power* (NAG) and *Indigena* (CMC). Both of these shows were impressive in their size, the number of artists involved, and the extensive media (catalogue texts and documentation) budgets supported by the institutions.

These 1992 exhibitions are still considered pinnacle points in Canadian art history because of the manner in which they focused upon issues pertaining to the legitimacy of historical narratives of European 'discovery' of the Americas and of the peoples who have lived there since time immemorial. A principal aim of the art and writing by aboriginal artists and writers participating in these exhibitions was the public re-visioning of history and the acknowledgement of both shared and parallel histories between native and non-native people living in Canada. This broad conceptual and public mandate of resistance framed the viewing and consumption of art made for these exhibitions.[5]

Contemporary aboriginal photographers in Canada like Thomas and Staats have not abandoned making work based on issues of decolonisation, contested public histories and cultural self-determination that were set in motion in 1992. However, they have increased the particularity of their subject matter and become subtler in their critiques of colonial and postcolonial conditions for aboriginal peoples. Notably, they are taking more risks in their art by increasing the exposure of private memories and desires in their photographs about historical relations and their lives in the present. Photographs produced in this context take on the curious role of nodal points referring to memories of the past while simultaneously providing the viewer with glimpses of present realities for the artists.

Jeffrey Thomas currently lives and works in Ottawa as a photographer and freelance curator. Thomas began his career as a photographer while living in Buffalo, New York. My initial interest in Thomas's work came about after hearing him speak about what he calls 'Memory Landscape'. The Memory Landscape incorporates elements of temporal and geographical frameworks and places; its foundations are modes of juxtaposition, construction, and practised spaces and places.[7] The work is reminiscent of those images produced by French photographer Eugène Atget, who devoted his career to documenting the disappearing

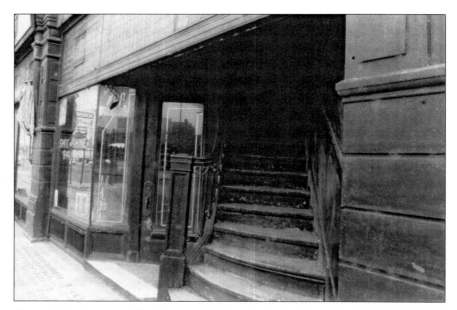

Figure 2.4 *Staircase.* Jeffrey Thomas. Buffalo, New York, 1981. Courtesy: Jeffrey Thomas.

Parisian landscape of the nineteenth century, particularly public monuments. The photograph entitled 'Staircase' (figure 2.4) was taken while Thomas was taking pictures in an area of Buffalo, New York that he knew his grandfather (who died a week before Thomas was born) had frequented. As Thomas tells the story, just after he took this image of the staircase a man came out of the building and asked what he was doing. Thomas explained that he was a photographer and the man asked him in. Thomas followed this unknown man to a bar upstairs in the building, and there he found out that his grandfather used to come to that place regularly to place bets and gamble. Through this encounter and through his photograph of the place, Thomas became fascinated with the exposure of layers when sense of place is experienced multiple times; in this case by two generations of Iroquoian men. In the photograph representing these experiences for Thomas he poses the question to his viewers of what the image of that space means to them and to their own experience of place.

The photographs produced by Thomas from his Memory Landscape visually document his experience of urban spaces at historical moments of his making and recognition. So being, the Memory Landscape is a combination of tangible and intangible referents for which Thomas alone can provide particular context for his viewer about the images. Most of the audience for Thomas's photographs are urban dwellers themselves, and they see his work in contemporary art galleries that are located in urban centres. Hence they will be familiar with the imagery in Thomas's Memory Landscape. Without the aid of any additional text, however, I believe viewers can work through and reflect upon the urban landscape or the city as a contested or negotiated sign of place connoting dwelling, habitation and territory. The last of these meanings provides the most poignant departure point for viewers to consider Thomas's experience in a postcolonial urban landscape from his perspective as a First Nations person.

The images in Thomas's Memory Landscape impart a sense of transience and human mobility on small and large scales (abandoned buildings, closed shops, graffiti by gangs passing through, families who have themselves, or in previous generations, migrated to this place). The images connote a sense of place in which human activity has occurred and the photographs document what remains in the wake of such activity. The photographs 'Warrior Symbols', 'Graffiti in a Winnipeg Alley' and 'Kam Lee Laundry' (figures 2.5, 2.6 and 2.7) signify the contested and negotiated spaces that have had an impact upon Thomas's life. The images reference the constant negotiation of identity and place through the layering of spray paint or the multiple uses of out-of-the-way or

hidden space such as that of a loading dock, for retail exchange, for storage, for drinking, for sleeping, for shelter. For many urban First Nations peoples, the threats of gang activity (particularly for youths), of life on the street and of homelessness are very real. The fallout of colonial policies of assimilation towards aboriginal peoples has created the reality that over 50 percent of aboriginal people in Canada live in urban spaces, with many living well below the poverty level. In the struggle for self-determination experienced by First Nations people at the level of the individual and nation, the ability to separate themselves from the 'multicultural' fabric of Canada as distinct and original peoples is often difficult and complex.

My reading of the Memory Landscape by Thomas includes how he sees non-native society moving around him, and how he moves his own body through these contested and negotiated spaces made visual by 'other' people's architecture, signage and refuse. Unlike the colonial photographs that literally view aboriginal people as participating in non-native worlds (see figures 2.1 and 2.2), Thomas's photographs indicate the view from his perspective as a postcolonial aboriginal participant in that North American society.

The significance of these Memory Landscape photographs is twofold. First, they impart a sense of particularised knowledge/experience from the viewpoint of an aboriginal person living in contemporary urban society. Second, the images produce contemporary meanings that

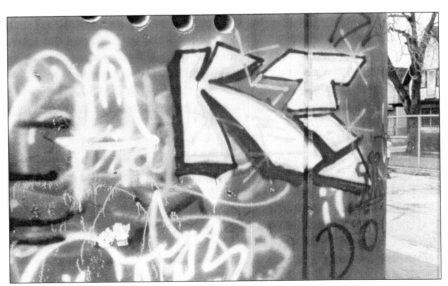

Figure 2.5 *Warrior Symbols*. Jeffrey Thomas. Buffalo, New York, 1983. Courtesy: Jeffrey Thomas.

Figure 2.6 *Graffiti in a Winnipeg Alley.* Jeffrey Thomas. Winnipeg, Manitoba, 1989.
Courtesy: Jeffrey Thomas.

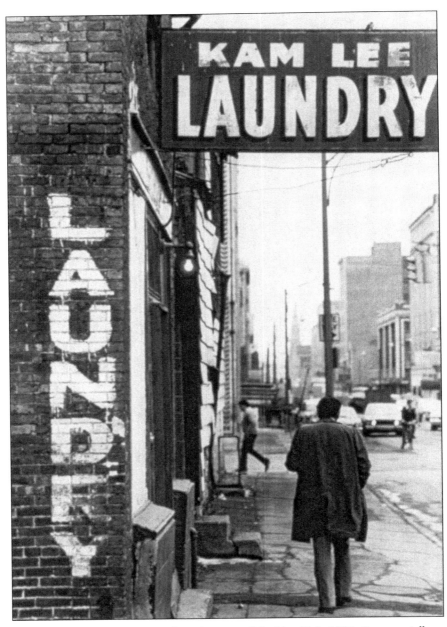

Figure 2.7 *Kam Lee Laundry*. Jeffrey Thomas. Buffalo, New York, 1981. Courtesy: Jeffrey Thomas.

connote the diversity of experience and knowledge that one place, such as the city, can represent for the many different people who live there. Viewers look at what these spaces mean to them as individuals, and then contemplate the artist's reasons for creating the image. At what point do these two sets of experiences, viewpoints and perspectives intersect? Where and when are they divergent?

Questions concerning why and how these photographs act as nodal points for intercultural spectatorship are important parts of these visual exchanges. Hence, the visual strategies at play in Thomas's work are at once subtle and complex, and they are not located on the surface of the work. Indeed, Thomas's art can change the way his viewers see art about First Nations identity and sense of place, but it also changes what they see if they can avoid frustration from the lack of immediately legible symbols associated with Indian identity.

Thomas's Memory Landscape signifies postcolonial urban spaces that are experienced through conflict, dispossession and migration, all of which bring about a sense of impermanence. He has created a series of portraits of his son Bear Thomas that documents the boy's growing up as a third-generation urban aboriginal person. Unlike the Memory Landscape pictures, this series of photographs suggests the continuity of aboriginal presence and identity in urban spaces. Thomas avoids the use of strategic essentialism by not using overt symbols of Indianness that connote either sameness or difference in the manner of the previously discussed colonial images. Moreover, the portraits of Bear subvert and disrupt many colonial narratives of progress, history and aboriginal identity. Thomas accomplishes this latter point by situating Bear in front of visual referents of colonialism. This deliberate placement of Bear's body sabotages a direct sightline of the viewer to that reference, thus symbolically interrupting its meaning or narrative.

The portraits document the process of a father transferring his own ideas of subjectivity, identity, history and sense of place onto his son. Thomas told me in an interview, 'I use my son as a way of putting myself into the landscape. I am saying that there is nothing here that says that there were Indian people here before, or even that had been by there recently. I use Bear as a way to leave a mark on the landscape'.[6] The portraits of Bear date from the early 1980s and move away from Thomas's Memory Landscape work that depicts urban spaces largely devoid of human bodies. The sense of impermanence imparted by earlier Memory Landscape photographs is countered by a sense of permanence in the portraits of Bear. Thomas's exploration of individual histories of First Nations peoples began with his grandfather, who was born and raised in the Iroquoian longhouse. Later, Thomas's grandfather also spent

a great deal of his life in urban centres. In his photographs of Bear, Thomas explores how this urban existence continues through the grandson.

The early portraits of Bear show a young child obeying his father and standing in a certain place to have his photograph taken. However, in later images, there is evidence that Bear develops his own sense of purpose and history, and his own reasons for documenting these places on film. This intergenerational experience of space and history by a father and son contributes to a body of particular knowledge concerning how these men have chosen personally to challenge master narratives of history, place and identity for aboriginal peoples in Canada, and the issues within these categories that are worthy of their critique.

The portraits of Bear deal largely with the legacy of colonial interruption of aboriginal cultures and the demand that some aboriginal peoples continue to feel are placed on their identity as a result of living in 'two worlds'. For Jeffrey Thomas, the portraits of Bear are also points of reflection on his own life growing up as an urban aboriginal person and on the experience he had of finding a place where he was comfortable between his urban existence and traditional Iroquoian beliefs. The following quotation, taken from an interview, makes clear the questions Jeffrey Thomas has about his own experience of postcolonial spaces as an aboriginal person and his understanding of how one deals with the history of colonialism.

> I had been going around to different communities and talking to chiefs and bringing up issues like how do you deal with having these old time ideas in your mind and live in the modern world and how do you reconcile these two frameworks? I realised that after a certain point it's not about going back to that, it's about defining a new space. And of course, I'm a product of that evolution, of the urban Indian. I did not ask to be there, but I have to deal with being born and raised in the city. So what do I do? Do I have a constant fight with this my whole life or do I find a way to deal with these elements that make up who I am? So that's been the driving force behind the work. I want my son to look and see the process that I have gone through and hopefully it will help him deal with his life. Certainly his life is different from mine; he did not grow up around the same people I did. So the idea is not about staying in one place. It is always about moving and adapting. Certainly, that has been the history of First Nations peoples since Europeans arrived. It has been about assimilating certain aspects and culture continues to grow onward. Certainly, the Iroquoian people in the eighteenth century were nothing like the ones in the sixteenth century. That is always how it has been. However, when you have this compartmentalised life, everything is shuffled into these little areas and it is seemingly easily explained. I just do not think that you can do that. It is the exploration of the new landscape that really determines how well we are going to survive it. We have to become explorers, and if you do not, you will vanish.

The portraits Thomas has produced of his son resonate with several points made by the artist in the above quotation. The 'new landscape' to

which Thomas refers is the urban landscape within which we see Bear, and these images denote issues that stem from colonial encounters and history that have had profound effects on aboriginal peoples' identity. The images discussed below avoid representation of the 'compartmentalised life' to which Thomas refers, if one understands this term to be about strict boundaries around identity and lifestyle (traditional versus contemporary, urban versus reserve, and so on). I want to argue that the next set of photographs depicts Bear's identity as existing *between* categories created out of colonial imagery of sameness and difference, and as such reveal a particular and negotiated reality.

The photograph entitled 'Culture Revolution' (figure 2.8) depicts Bear as a little boy wearing a baseball hat that has on it a reproduction of Edward Curtis's photograph of the man called Two Moons. The image portrays Bear as a compliant young boy, standing in front of a graffiti-sprayed wall bearing the words 'culture' and 'revolution'. These spray-painted words on the wall in front of which Bear stands are evidence of a previous act of resistance that defied the law and order of society. The spray-painted text connotes the deeply complex aspect of human existence that is culture, and the human struggle for culture to be either maintained or, at times in violent ways, challenged. The strategic placement of the young boy at the outset of his life, and understanding of

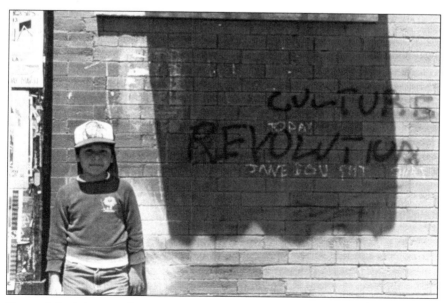

Figure 2.8 *Culture Revolution.* Jeffrey Thomas. Trent, Ontario, 1984. Courtesy: Jeffrey Thomas.

his own cultural values, stands against the violence inherent in the spray-painted words.

However, it is important to go beyond binary categories to see that the meaning of the photograph develops for each viewer in the space between Bear's body and the spray-painted text. A superficial reading of the image may signify departure points for discussing Bear's identity that include issues of innocence, hope, strength and resistance. A deeper reading is possible if one considers the significance of Thomas's inclusion of the reproduction of the Curtis photograph (read colonial imagery of aboriginal peoples) depicted on Bear's baseball hat. I read this small visual detail as important to understanding Thomas's culturally specific challenge to the historical representation of aboriginal peoples. This portrait is the beginning of a visual culture revolution of Thomas's own making, using the body and identity of his son.

In the triptych of photographs 'I Don't Have to be a Cowboy' (figure 2.9), Bear's image is juxtaposed with signs of the frontier cowboy/Indian dialectic of consumer culture. Bear is shown in the foreground wearing a T-shirt, jacket and baseball cap, typical of contemporary fashion for a young boy of his age in North America. The mannequin wears 'traditional' cowboy attire of a cowboy hat, bandana and button-down shirt. Meaning for this photograph is again developed in the space between Bear's body and that of the colonial referent, the cowboy. Issues of traditionalism and authenticity, development of the boy's identity, constitution of subjectivity and understanding of histories are all central to discussions of this portrait. In the narrative of the Wild West, the cowboy is always declared the winner of the battle. This outcome of the battle is so ingrained in the minds of children playing the game of 'Cowboys and Indians' that every child wishes to be the victor, the cowboy. This childhood game is made complex by the reality of growing up under such narratives and stereotyping as a native person. With knowledge from the interviews about Thomas's own struggle to overcome racial stereotyping, his act of taking his son's portrait signifies the construction of identity against colonial ideas of Indianness as an ongoing dilemma in each person's life. Adding to this cultural concern, the images in the triptych also point to issues of consumer culture, peer pressure and violence, as is made evident by the graffiti-painted skull. By entitling this triptych with a negative, Thomas signifies the possibilities for Bear to choose his own identity; he empowers the boy with room to manoeuvre and to find his place between binaries of traditional and contemporary lifestyles, urban and reserve existence, the cowboy and the Indian.

In the images of Bear as a young child, we see him looking directly into the camera lens. Moreover, I would argue, the boy is looking past the

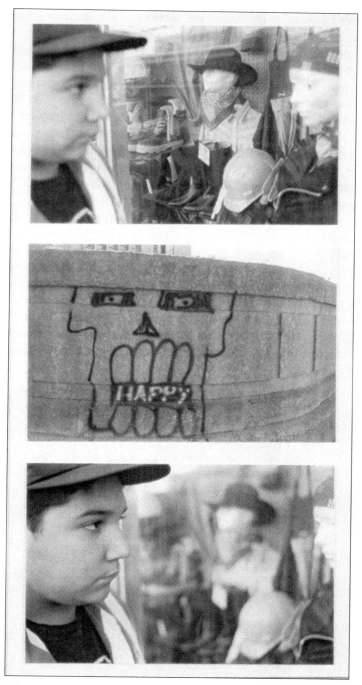

Figure 2.9 *I Don't Have to be a Cowboy.* Jeffrey Thomas, assembled 1996. Courtesy: Jeffrey Thomas.

camera and directly at this father taking the picture. As Bear grows older, he continues to look straight into the camera lens, showing little emotion. In the later photographs, sunglasses hide his eyes, and his agenda for having his photograph taken continues to be hidden from us as viewers. Nonetheless, these images are markedly different from pictures taken by non-native photographers in the early twentieth century in that they exhibited no special relationship between the photographer and his subjects. The recognition of the relationship between father and son is important to the shift in meaning and context for the production of these portraits, distinguishing them from the colonial photographs documenting collectives of people engaged in daily activities.

Thomas directly confronts his viewers with Bear's body in 'Indian Treaty no.1' and 'Founder of the New World' (figures 2.10, 2.11). In the former, Bear's body directly interrupts the viewer's ability to read through a non-native-written text of the history of Indian Treaty no. 1 in Manitoba. The juxtaposition of the living body and the historical text connotes resistance to the story told on the monument about aboriginal peoples' place and history in Canada. The young man who stands in front of that text, disrupting its interpretation, signifies for the viewer contemporary lives of aboriginal individuals since these treaties were signed between nations. The monument speaks to Canada's history as a

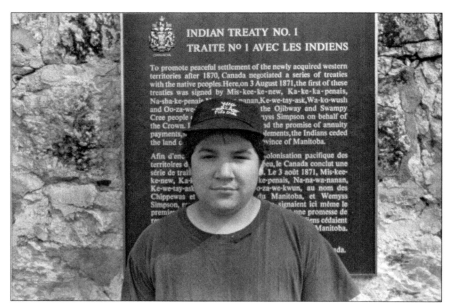

Figure 2.10 *Indian Treaty no. 1.* Jeffrey Thomas. Lower Fort Garry, Manitoba, 1989. Courtesy: Jeffrey Thomas.

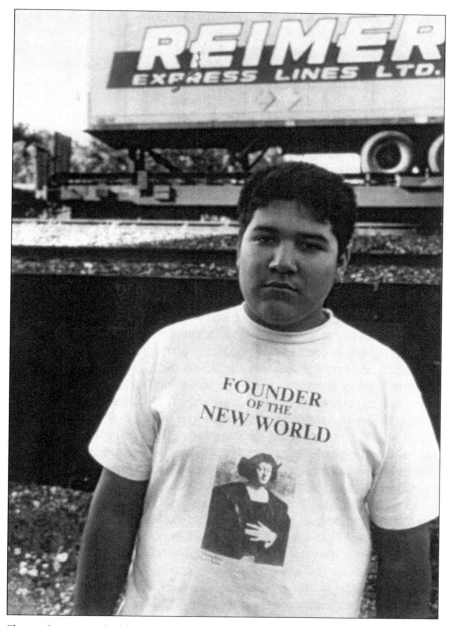

Figure 2.11 *Founder of the New World.* Jeffrey Thomas. Winnipeg, Manitoba, 1988. Courtesy: Jeffrey Thomas.

nation interacting with First Nations as collectives. Thomas's portrait of Bear questions the validity of metanarratives of history by inserting the image of an individual person in front of the monument dedicated to the actions of collectives. In so doing, he inserts into the act of remembering Indian Treaty no. 1, the particularity of embodied knowledge that comes from living in the shadow of such narratives.

'Founder of the New World' also uses found text to signify the tension between narratives of history and the reality of lives lived. I would like to compare this photograph to that of figure 2.1, which shows aboriginal people on the north-west coast of Vancouver Island boarding a ship en route to the cannery. Again, the cannery boat photograph signifies aboriginal participation (read assimilation) in a growing provincial economy based on natural resources, resources that before contact were considered their own. In the postcolonial portrait (figure 2.11) Bear stands in front of the railway track on which sits a Reimer container car. I liken the train in this image to the ship transporting anonymous people and goods as part of economic expansion. However, in this photograph, Thomas's point is to question the economic expansion that arose from Columbus's 'discovery' of the New World, expansion that eventually saw aboriginal people dispossessed of their lands and resources and made wards of the federal government. He does this by juxtaposing the particular body of Bear against a dominant signifier of nineteenth- and twentieth-century capitalism, the railway. I would argue that the image asks us to consider the daily realities for Bear as a young aboriginal man growing up in the context of dispossession and displacement.

Arguably, one could say that at his age in these photographs, Bear might not fully comprehend the complex social, political and economic facets of colonialism and settlement in Canada. However, I would argue that he understands his own life and place within a postcolonial context, even if he does not himself use that specific terminology.

As such, these last two images (figures 2.10 and 2.11) depart from the photographs of Bear as a small boy simply standing where his father tells him. Looking at the age of Bear in these later images, I would suggest that he is beginning to develop his own sense of self, his individual identity as a First Nations person living in postcolonial spaces, and that this is significant to his participation in his father's project of creating his portraits. In the photograph 'Indian Heads' (figure 2.12), Bear appears to share with his father the joke created by his standing under a General Store's picture of a stereotypical Indian in a feathered headdress. In the discussion of racial stereotyping, consumer culture and authenticity, the question raised by the portrait of Bear is: who is the real Indian here?

In the portrait, simply entitled 'Bear' (figure 2.13), the bottom half of the image depicts Bear facing the camera in an ambiguous manner.

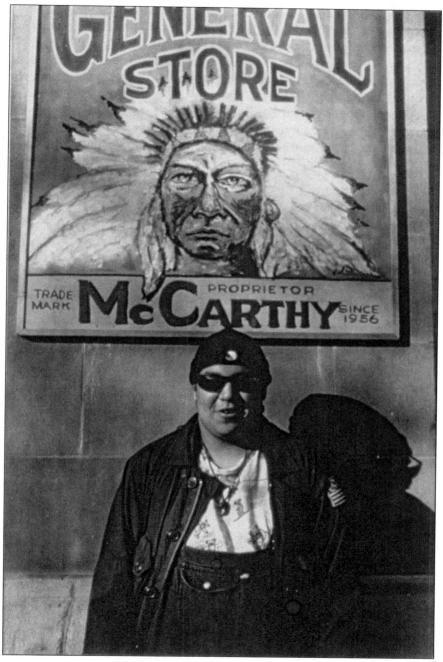

Figure 2.12 *Indian Heads*. Jeffrey Thomas. Toronto, Ontario, 1994. Courtesy: Jeffrey Thomas.

Sunglasses cover his eyes and his arms hang casually by his sides as he stands against a stark black background. In this portrait Thomas has repeated imagery used in one of his earliest portraits of Bear (figure 2.14), taken in 1984 and showing a carved panel of voyageurs in a canoe along river rapids. We do not know if Bear and his father have physically returned to the spot where his portrait was taken many years earlier. Regardless, the repeated use of the exact image of the voyageurs implies that history may be recursive. Viewed together, these two portraits trigger a discussion based more on the act of (re)discovery than on that of

Figure 2.13 *Bear.* Jeffrey Thomas. Toronto, Ontario, 1995. Courtesy: Jeffrey Thomas.

repetition. In Thomas's words, 'the idea is not about staying in one place. It is always about moving and adapting. It is the exploration of the new landscape that really determines how well we are going to survive it. We have to become explorers, and if you do not, you will vanish'. The two images of Bear (as a little boy and as an adult) juxtaposed against the repeated imagery of the voyageurs document and record the attempt of a father and son to make their mark on a landscape that is continually rediscovered. The pictures convey visual fragments of shared family, or private, embodied knowledge/experience of place.

Figure 2.14 *Untitled.* Jeffrey Thomas. 1984. Courtesy: Jeffrey Thomas

All the photographs of Bear taken by his father, Jeffrey Thomas, allude to a larger conversation about the aboriginal body in public history. These photographs are departure points for a growing public knowledge and awareness of the culturally diverse experiences of place and space from the perspective of these two Iroquoian men. Thomas's critical use of Bear's body, which carries the boy's individual and private experiences of history, creates new visual narratives of shared postcolonial space and place.

In making the portraits of his son, Thomas engages intellectually and artistically with the work of colonial-era photographer Edward S. Curtis. In spite of this intersection of interests, however, Thomas's photographs differ greatly from the portraits of aboriginal peoples taken by Curtis in the early years of the twentieth century. Thomas goes to great lengths to depict the body of his son in cultural and physical landscapes, whereas Curtis took pains to delete any reference to modern surroundings. He often left black or white spaces around his subjects in their photographs, so as to isolate their images from any influencing context. It is the juxtaposition or relationship of the body and place that makes Thomas's work so relevant to a discussion of history, place and identity. The placement of Bear's body in front of colonial referents sabotages the viewer's sightline and interrupts the telling of colonial narratives of history and place.

Like Jeffrey Thomas's portraits, Greg Staats's photographs also make constant reference to the human body, frequently through its deliberate absence from the images. The photographs in the series 'Memories of a Collective Reality – Sour Springs' (figures 2.15 and 2.16 are selected images from the series) focus on 'traces' of experience, remembrance and desire. The images communicate ideas about human absence and presence, and of longing and belonging, within particular landscapes. The series is composed of fourteen black-and-white photographs installed in a single row along a gallery wall. During an interview discussion about this piece, Staats read to me from his notebook two quotes that he felt inspired him while creating the series. They refer to both loss and renewal. The first is by T.S. Eliot and the second by Martin Heidegger. He read: 'We shall not cease from exploration. The end of all our exploring will be to arrive where we started and know the place for the first time' and 'If you were to experience your own being to the full, you would be experiencing the decay of that being toward death as a part of your experience'.

The places that occur in 'Memories of a Collective Reality – Sour Springs' are locations on the Six Nations Reserve near Brantford, Ontario where Staats was born. Staats created the series upon a return visit to Sour Springs in 1995. For him, the reserve is a physical site that triggers memories of loss and renewal. Although he has placed only one

photograph of himself in the line of images, Staats describes the entire fourteen-photograph piece as 'a portrait of myself'. The majority of the images portray the inside and outside of a house, and the exterior landscape (close-up and distance shots). Overall, the series of photographs references the integration between the living and the dead in the landscape (loss and renewal). One of the photographs depicts an

Figure 2.15 *Memories of a Collective Reality – Sour Springs.* Greg Staats. 1995. Courtesy: Winnipeg Art Gallery.

abandoned house that connotes past lives carried out in that space (figure 2.16). The trees in the exterior shots appear without leaves, an image readable as either the dead of winter or the coming of spring. The shadows of buildings and plants that Staats uses throughout his pictures document a living natural landscape over which time passes in a dynamic way. The images of Sour Springs also refer to human manipulation of that environment in search of creature comforts (the house, the light post, tyre

Figure 2.16 *Memories of a Collective Reality – Sour Springs.* Greg Staats. 1995. Courtesy: Winnipeg Art Gallery.

tracks). The images prompt questions from the viewer: How are these spaces and places culturally experienced, known and remembered by their former occupants?

These images are reminiscent of Thomas's Memory Landscape, where the viewer is able to fix her gaze on aspects of the photograph that resonate with her own particular experience and knowledge. The lack of stereotypical signs of Indianness allows for a wider interpretation of meaning in connection with the place of the Six Nations Reserve. I agree with Elizabeth Edwards about the importance of working through images that, in part, are ambiguous, for the purpose of critical cultural inquiry. She writes: 'the viewer has a space and is conscious of the ambiguity of the image which allows access to the *experience of* a situation in all its complexity rather than the pretence of surface understanding'.[8] These photographs provide room for such play of signification.

Unlike Thomas's portraits of his son, where viewers create a relationship between the boy and his environment and where the photographs promote a 'this is how it is' narrative, Staats's images are not so politically charged. Rather, Staats revels in the poetics of photographic representation, and focuses his attention on creating visual metaphors for the postcolonial space of the Indian Reserve. Writing about Staats's work, Janet Clark states: 'this is a narrative that is at once both specific and generic, extending beyond the immediate representation to layers of meaning in which others can share. It is a collective reality to which Staats makes reference with the intention of communicating the idea of memory to others'.[9] If the visual content of each portrait by Thomas provides departure points for understanding particular experiences of aboriginal identity, then it is the composition and rhythm of imagery in Staats's photographs that demonstrate the artist's intention of visually representing his experiences of loss and renewal through a balance of form and content. Thus, the formalist tendencies of Staats's images do not necessarily conflict with realist interests; on the contrary they may help substantiate and fulfil it'.

As an urban photographer working in the city of Toronto, Staats focuses much of his work on the loss and renewal of objects and narratives found within the borders of the city. In a series of colour photographs created in 2001 (figures 2.17 and 2.18 from this series are reproduced here in black and white), Staats turned his attention once again towards his home on the Six Nations Reserve near Brantford, Ontario. In this series Staats again brings forth the relationship between memory, loss and renewal in his photo-documentation of old house sites where log and frame houses formerly stood. As a small child, Staats visited the homes that once occupied these places while his mother

Figure 2.17 *Untitled.* Greg Staats. Six Nations Reserve, Brantford, Ontario, 2001.
Courtesy: Indian Art Centre, Hull, Quebec.

interviewed the older people who lived in them. His mother, who worked
as a librarian, considered it important to record the collective histories of
rural experiences that she felt were not being passed on at that time.
Recently, as part of the process of creating of these photographs, Staats
has picked up his mother's work of researching and recording the
histories of the former occupants of these house sites.

These photographs by Staats test the viewer's sense of objectivity, of
understanding the medium of photography as a device for recording
'facts' that influence our understanding of the human condition. I would
argue that Staats has documented the space of the Six Nations Reserve in
a way that purposefully slips between fact and fiction, between

Figure 2.18 *Untitled.* Greg Staats. Six Nations Reserve, Brantford, Ontario, 2001.
Courtesy: Indian Art Centre, Hull, Quebec.

objectivity and subjectivity, between representing the reserve as a place of individual experience and as one of collective identity, between loss and renewal. This representation of states of 'in-betweenness' is Staats's contribution to particularised knowledge and experience of space and place as a First Nations person.

Rather than thinking of the photographs by Staats and Thomas discussed here as vehicles to 'fix' histories and identities, I have argued for viewing them as sites of slippage in arenas of intercultural spectatorship between private experience and knowledge of postcolonial spaces and public histories of First Nations peoples. Looking at photographs in this way is not an innocent act of spectatorship. In such an act, notions of truth and power,[10] objectification and subjectivity, intertwine to create contested meanings for the identity of the producer and that of the viewer. I have discussed the photographs by Thomas and Staats presented here as representations of particular and individual experiences of space and place. In so doing, I am arguing that we read these images using a process that constantly slips and moves between moments of suture[11] where the viewer recognises signs in the pictures and brings meaning to them through her own experiences; and loss where the viewer lacks a recognition of signs and experiences confusion. It is this slipperiness around our reading of these photographs and their content that can engage and challenge the way we see them entering into circulation with contemporary theories of production and reception of visual culture and art. By revelling in such indeterminate processes of meaning-making, we can truly appreciate the complexity of the artists' images.

The importance of critically examining the work of photographers like Thomas and Staats lies in the possibility of producing new understandings of the shared colonial and postcolonial histories of native and non-native peoples. These types of investigations into visual culture have far-reaching political, economic and social implications for the present and the future. Notably, the work of Thomas and Staats deconstructs modernist texts founded upon the dialectical relation between observers and observed. To date, the critique of this relationship has placed emphasis on the fact that, in Canada, the power inherent in the position of the observer has historically rested with people who held colonial authority over aboriginal peoples in colonial contexts – from government officials to anthropologists, for example. It is often stated that contemporary aboriginal photographers (and aboriginal artists in general) work against such determinism and against the visual strategies of power proposed by the dialectic of the observer and observed. One also reads on a regular basis that aboriginal artists create art that effectively 'returns the gaze' of the observer, historically the likes of non-native government officials or scholars of aboriginal cultures. I take the position that the concept of 'returning the gaze' oversimplifies the

visual politics of representation and identity between aboriginal artists, their art and their spectators. By limiting critical analysis of First Nations art to factors that relate only to the return of colonial gazes, the agency of these artists is reduced to that of response to rather than of initiation of a visual dialogue.[12] The consequence of such analysis is to perpetuate the dialectic of observer and observed that maintains a simplified linear concept of vision which only works through a back-and-forth motion on a line of vision established through colonial contexts of representation and knowledge.

Photographs by Jeffrey Thomas and Greg Staats provide entry points to alternative points of view, to different perspectives. Their work needs to be seen as existing beyond simple counternarratives to dominant images of Native peoples and history, as something more than products created out of response to colonial images of aboriginal peoples through history. I see the photographs discussed here as original starting points for telling both private and individual as well as public and collective First Nations histories, histories that run parallel with, while at times intersecting, dominant North American narratives of history, identity and place. Although both photographers are aware of the history of aboriginal images (and their politics) of which their own work is part, the weight of their agenda in creating photographs seemingly rests on present conditions, and on those of the future rather than of the past. In other words, neither photographer sets out to 'set the record straight' or expose the 'falseness' of previous photographs of aboriginal people and their circulation and consumption. Both photographers refuse to engage in well-worn debates over authenticity, where the point is to counter 'inaccurate' historical images with 'accurate' visual portrayals of First Nations people. In so doing, these two artists and their art provide much-needed points of departure for considering new strategies of vision and fresh ways of representing experiences of space and place, histories and identity in postcolonial Canada.

Notes

I am very grateful to the artists Jeffrey Thomas and Greg Staats for giving me their time and attention, as well as slides and photographs with which to work; and not least, their permission to reproduce their work for this essay. They are generous colleagues indeed. An earlier version of this chapter appeared in *Visual Studies* 17: 1, 2002, under the title: 'Visualizing Histories: Experiences of Space and Place in Photographs by Greg Staats and Jeffrey Thomas'.

1. My own ethnic background is Canadian. My ancestors are Irish, English, Scottish and First Nations (Nla'kapamux). My initial academic training was as

an artist specialising in intaglio and lithographic printmaking. My graduate school research was in visual anthropology, and I am currently a faculty member in the department of Anthropology at the University of Victoria in Canada.

2. Elizabeth Edwards, 'Beyond the Boundary: A Consideration of the Expressive in Photography and Anthropology', in *Rethinking Visual Anthropology*, eds M. Banks and H. Morphy, New Haven, Connecticut: Yale University Press, 1997, p. 53.

3. Dr Gerald McMaster uses this distinction in his article, 'Towards an Aboriginal Art History', in *Native American Art in the Twentieth Century,* ed. Jackson W. Rushing, London: Routledge, 1999. McMaster notes the origin of the distinction between History and histories in the writing of Thomas McEvilley. Following McEvilley, McMaster writes that Eurocentric History (upper case H) has been called into question by aboriginal artists, and its 'dominant intellectual space is now coming into contact with, and being perforated by, other histories (lower case), especially by those which do not count Europe as part of their lineage'. See McMaster, 'Towards an Aboriginal Art', p. 82.

4. See, for example, Province of British Columbia, *Our Native Peoples*, British Columbia Heritage Series, Victoria: Province of British Columbia, 1951.

5. Of the thirty-four artists represented in both exhibitions only one artist, Edward Poitras, exhibited photographic work. There were three artists who presented film or video work.

6. My use of the term 'practised space' refers to the work of Michel de Certeau, *The Practice of Everyday Life,* Berkeley: University of Berkeley Press, 1984.

7. All quotations by Jeffrey Thomas in this chapter are taken from an interview conducted with the artist on 7 August 1998.

8. Edwards, 'Beyond the Boundary', p. 60.

9. Janet Clark, *Greg Staats: Memories of a Collective Reality – Sour Springs*, Thunder Bay, Ontario: Thunder Bay Art Gallery, 1995, np. All quotations by Greg Staats in this chapter are taken from an interview conducted with the artist on 11 February 1998.

10. See Michel Foucault, *Power/Knowledge: Selected Interviews and Other Writings 1972–1977*, trans. Colin Gordon, New York: Pantheon Books, 1980.

11. For more information on the concept of suture, see Kaja Silverman, *The Subject of Semiotics*, New York: Oxford University Press, 1983.

12. Andrea Walsh, 'Complex Sightings: Active Vision in Artists' Personal Narratives and Institutional Texts', in *On Aboriginal Representation in the Gallery*, eds L. Jessup and S. Bagg, Hull, Quebec: Canadian Museum of Civilization, 2000, pp. 247–270.

Chapter 3

Photography, 'Englishness' and Collective Memory

The National Photographic Record Association, 1897–1910

Elizabeth Edwards

This essay will explore the relationship between photography, the idea of a 'collective memory' and Englishness as it is inflected through the National Photographic Record Association (NPRA). Active between 1897 and 1910, the Association aimed to create a centralised archive of photographs of the traditions and monuments of the British Isles which would preserve these material traces of the past for future generations. It was founded by Sir J. Benjamin Stone, Member of Parliament for Birmingham East. A lone Conservative in the stronghold of the Liberal Chamberlain caucus, he was a wealthy industrialist, passionate photographer, and compulsive and obsessive collector. Although Stone's various enthusiasms are fascinating in themselves and his ebullient character certainly had an impact on the NPRA and the way in which it was perceived, he, himself, is not the focus of this study. Rather, I am concerned more especially with the way in which photography operated as a form of externalised or prosthetic collective memory in recording a Britain, or more especially an England, which was conceived as being patterned by survivals of its past, namely in its antiquities, architecture and folk customs. Central to my interest is the way in which the nature of photography itself reinforced these ideas, and here it is instructive to explore the NPRA through the registers of photography and the social processes which enmesh it.

The values associated with customs and antiquities are, of course, intimately linked to the construction of a sense of the past – the legitimation of cultural ideologies, social values and social practices.[1]

The past employs a notion of precedent and thus historical sense which is embodied in the material environment and the practices enmeshed within it. In the course of the nineteenth century this sense of the past worked with more formal and conscious elaborations of history in a way that was both multiple and complex and also symptomatic of the widening gap between academic history and a popular interest in the articulation of a collective historical consciousness.[2] It is the process of transmission and maintenance of these values which, for the sake of this argument, I am terming 'collective memory'. The way in which I am using this term owes more to Fentress and Wickham's 'social memory' as a memory held by a specific group in which individuals 'remember'[3] than to Halbwachs's definition, which privileges the collective over individual memorialising action.[4] His definition does not fully allow for the tensions between individual, local and national perceptions of how the memorialising functions of photography should be developed and controlled. These tensions constituted an important element in the history of the NPRA. The NPRA can also be said to constitute a 'collective memory' because, in formulating photography as a memory bank, it was conceived precisely to counter the fragmentation of memory processes which beset the historical record,[5] even if, as we shall see, it failed in its universalising and all-encompassing agendas.

The NPRA is part of a much larger and complex cultural matrix which both constituted and demonstrated a concern for the emerging and shifting identity of the British.[6] While the project was conceived of as national, in fact a large majority of it was concerned with English records. Those photographs that were made of Scotland, Ireland and Wales were, by default, defined by the dominant English concerns. With its powerbase in England, the NPRA turned out to be a largely English project.[7] Tradition, and its material marks in rural and urban landscapes, was seen as retreating not only in the face of the homogenising advance of 'the modern', manifested through the loss of monuments and practices of the past, but also through the regulatory practices of state policing, education and control of leisure through working practices of the factory.[8] It was in this period, the last quarter of the nineteenth century, that the Folklore Society (1878), the Society for the Protection of Ancient Buildings (1877) and the National Trust (1895) were founded; Cecil Sharp was collecting folk songs and introducing them into schools' curricula;[9] local dialect societies and the arts and crafts movement flourished; and Sir Edward Elgar was writing about the grandeur and pomp of the imperial landscape in music.[10]

As Krishan Kumar has argued, the late nineteenth century saw what might be described as 'a moment of Englishness', manifested through

clear concern for, and consciousness of, the nature of Englishness, but stopping short of 'full-blooded' nationalism.[11] There was mobilisation at both national and local levels to undertake a 'salvage ethnography' of both the English and the peoples of the Celtic 'margins'.[12] The Empire and definitions of home and abroad, and of self and other in relation to Empire, were also major cultural influences at the time. Moreover, the sense of centrality enjoyed by the British at this period was inflected with concerns with national and local identities.[13] The position might be summarised in Baucom's words: 'The struggle for English identity becomes ... a dual struggle of defining the national past and preserving this invented past from the contaminations of Empire',[14] which itself was constituted through modernist anxieties about authenticity, history, race and culture.[15] It is significant that the NPRA was founded in the year of Queen Victoria's Golden Jubilee – a festival of intense imperialist and nationalist sentiment. Local manifestations of this sentiment were something the NPRA was keen to record: 'In the present jubilee year there must have been many thousands of photographs taken of local celebrations which, if brought together, would form a most valuable chapter of national history'.[16]

From the start the NPRA's project was conceived as a form of collective memory, as a 'holding' of the past, in both its real and metaphorical roles. This was a past still alive in the rural areas and beneath the thin surface of modernity. The object of the NPRA was, to quote the introduction to Stone's published photographs *Sir Benjamin Stone's Pictures: Records of National Life and History*: 'to leave to posterity a permanent pictorial record of contemporary life, to portray for the benefit of future generations, the manners and customs, the festivals and pageants, the historic buildings and places of our time' and with a view to 'showing those who will succeed us not only the buildings and places which have a history or which are beautiful in themselves – but the everyday life of the people'.[17]

The NPRA grew out of the country survey movement which had been gathering momentum since the mid-1880s. It was integrally linked with the broader survey movement, an exercise in archival desire which flourished at multiple levels throughout society in the period. It included a wide range of archiving endeavours, from national surveys of race and geology by the British Association for the Advancement of Science to local surveys of the historical buildings of localities for posterity. 'The Society of the Recording of the Relics of Old London' was one of the earliest, and by 1910 county and city surveys had been attempted in, for example, Edinburgh, Yorkshire, Cambridgeshire, Worcester and Kent. There were also small specialist clubs of antiquarian enthusiasts such as

that for the exchange of lantern slides of architectural details.[18] All were concerned, in their different ways, with the precise role of photography as a prosthetic memorialising apparatus which could construct an externalised historical consciousness.

Of particular importance to the NPRA was the Warwickshire Survey which had been founded by W. Jerome Harrison in 1889 and organised through the Birmingham Photographic Society, of which Benjamin Stone was President. While Harrison's role was not fully recognised, and there were disagreements between Harrison and the Photographic Society, Harrison anticipated Malraux's 'Museum Without Walls'[19] in calling for a universal museum of photographs which would contain the traditions and historical architecture of Europe if not the world. In this connection, he was invited to give a lecture on survey photography at the Chicago World Fair of 1893.[20]

While the NPRA had national ambitions (echoing those of Harrison), the movement was in practice driven by local concerns. This provided a crucial tension between the NPRA and local interests in the objectives and procedures in the making of history and the archive. This, I would argue, was the root of the ultimate failure of the project, a point to which I shall return. For what is significant is that while the NPRA may have had a committee of notable and distinguished men from the archaeological and photographic community, the survey on which it depended was rooted firmly in the Photographic Societies, Camera Clubs and photographic sections of local societies of naturalists and antiquaries. Such local associations, which blossomed throughout the nineteenth century, had been both a symptom of and a response to local historical identities.[21]

The NPRA project was premised on the assumption that material would be fed from the local surveys into a central resource which would deposit the records at the British Museum, that national treasure house and symbol of national identity.[22] Although it was made clear from the outset that the NPRA did not wish to usurp local functions,[23] considerable political weight was put behind its establishment as Stone, with the authority of a Member of Parliament, lobbied the Trustees of the British Museum to accept what was conceived as a national memory bank:[24] 'The Trustees are in full agreement with you that such a records survey collection, if carefully and systematically brought together, cannot fail to be of the greatest value and interest both to the present and to future generations'.[25] The project was launched to extensive national and regional press notice at a meeting on 8 July 1897. Yet in the thirteen years of its existence it yielded only 5,883 prints. A vast majority of the photographs are of architectural subjects, especially parish churches, manor houses and old inns, while the folk

custom material is very limited. Seen as problematic by contemporary commentators, the coverage was extremely uneven and the intended systematic approach never materialised. For instance, owing largely to the activities of the NPRA honorary secretary George Scamell, Essex has three whole boxes, whilst Devon has only nine cards, presumably due to lack of local support or infrastructure for such a project.[26] Nevertheless, despite its failure, or perhaps because of it, the NPRA makes an instructive prism through which to explore the way in which at this period ideas of photography were related to historical consciousness to form a collective prosthetic memory.

While historical consciousness and an imagined past were key, it was photographic values themselves which saturated the NPRA. Its agendas were premised on a positivistic reading of the indexical traces of photography. Indeed, as John Tagg has argued, the meanings of both 'History' and 'Photography' were developed in the nineteenth century 'under the sign of the Real'.[27] The NPRA was thus based on the assumption that photography could, if properly regulated, deliver pure 'fact' without and beyond stylistic convention.[28] Subjects were treated 'in the best and most realistic way – by means of absolutely "unfaked" photographs. It is impossible ... [f]or the best written description to convey to the imagination so accurate an impression of a scene or an object as that given by a photograph. The one is interpreted according to the mental capacity of the reader; the other is the same to every eye'.[29] Stone himself also expressed the opinion that 'the only kind of photography which would be tolerated in the near future would be that class that expressed the truth, the whole truth and nothing but the truth'.[30]

The NPRA drew up rules for the production of photographs. Negatives were to be whole plate or 10" × 8" in size: capable that is, of registering a detailed image which could produce a direct contact print. There were to be no interventions, such as drawing or retouching on the negative. There was enormous concern with permanence. The standard silver-based chemistry was seen as flawed, as prints too often faded as the silver compounds deteriorated. Silver-based photographic prints therefore did not have the permanence required of a material object that was to be preserved for posterity. Prints deposited with the NPRA were instead to be in permanent processes not involving silver-based chemistry, preferably platinum prints or carbon prints. The prints were to be placed in cut mounts so as to withstand handling and so that the surface would not be abraded. In protecting the image-carrying surface of the photograph, this material insistence might be read as a safeguard against the loss of any element of the indexical trace printed on the paper.

Most important of all, the aesthetic was to be rigorously suppressed in survey or record photography: '[on] no account should any print be included that owes any sort of "pictorial" effect to photographic "dodging" of any description. The effects must be natural ones, due only to Nature *plus* Architecture'.[31] This caused enormous tensions as camera club members were often exponents of a pictorialist aesthetic, a discourse which filled the pages of photographic publications and the exhibition salons of the period. Indeed, because of the concern at the destabilising potential of the 'aesthetic', the NPRA was anxious to work with amateurs rather than professional photographers, whom they saw as irredeemably aesthetic: 'a striving after pictorial effects will be rejected as records, for fear of what appears to be a photograph is not really a photograph, but partly a painting done by hand'.[32] As such the discourse of a positivist, 'unmediated' photographic practice was seen as central to the creation of a stable form of memory narration. It linked photographic practices and technical processes to the quality of observation and inscription.

Importantly, while the modernist scientific values of the project's objectivity were articulated through the preservationist photographic discourse, its inherent anxieties about decay, disappearance and destruction expressed moral values which were concerned responses to modernity. These values, which emerge in the late eighteenth and early nineteenth centuries,[33] were often expressed through a nostalgic picturesque aesthetic which merged an Arcadian pastoral vision with the myths of the golden age of 'Merrie England'. Thus there is an ambiguity present in the NPRA's view of photography. As I have suggested, the NPRA eschewed the picturesque. Its photographs lack the inflection of nostalgic sentimentality which can be found in some of the surveys of the period;[34] the styles of the photographs are completely different, stressing factual description.[35] In many ways, like the project itself (which might be compared with record projects of fifty years earlier),[36] the NPRA's photographic agendas, and indeed, those of the survey movement in general, were intensely conservative. The NPRA eschewed instantaneous photography as too random and unstructured and did not, until nearly ten years later, show any interest in cinema. This failure to use moving film as a primary recording device was commented upon by the newspaper, *The Sheffield Telegraph*, in response to the founding of the NPRA. 'To preserve the continuity of records it is desirable that an early start should be made with them [living pictures (film)]. The Photographic Record Collection will certainly not be complete unless it includes "living pictures" ... which have assuredly come to stop'.[37]

The intellectual bases of the project are also significant because they delineated the manifestation of divisions within the archival endeavour.

Although the Royal Geographical Society and the Archaeological Institute were involved in a limited manner, in that both were represented at the founding meeting of the NPRA in July 1897 and their representatives served on its committee, there was little or no contact with the learned societies concerned with 'cultural description', notably the Anthropological Institute and the Folklore Society. Indeed, neither society acknowledged the NPRA in any shape or form, although it must have been known to them from the extensive press coverage and the fact that individual members rubbed shoulders. For instance, Cambridge anthropologist Alfred C. Haddon showed ornaments from New Guinea at the same *conversazione* at the Royal Society in May 1902 at which Stone showed photographs of the customs of Hungerford, Corby and Knutsford (figure 3.1).[38]

This distance between the NPRA and the learned societies is perhaps part of the process of professionalisation and institutionalisation of anthropology which, as an emerging discipline, was at this period anxious to distance itself from the 'amateurism' of such as the NPRA. Similarly the Folklore Society was making bids to be a 'science' like anthropology, a battle they lost, given the almost complete

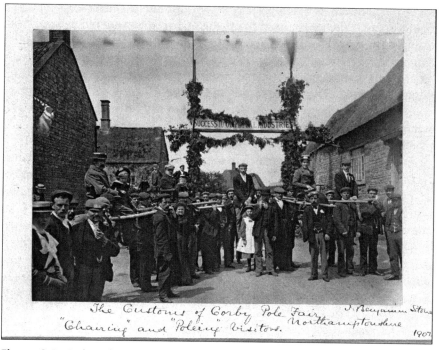

Figure 3.1 *Corby Pole Fair, Northamptonshire: Chairing and Poling the Visitors.* Sir Benjamin Stone. May 1902. Platinum print mounted on card. Courtesy: V&A Images/Victoria and Albert Museum, E4557-2000.

marginalisation of folklore studies in relation to academic anthropology after the First World War. Nevertheless the NPRA to some extent modelled itself on the British Association for the Advancement of Science's 'Racial Survey of the British Isles', which was collecting data from a broader base (it also included physical anthropology) at precisely the same time as the NPRA was collecting data. It is here that we see Harrison's influence. He was better connected scientifically than Stone, having been one of the schoolteacher scientists trained in geology and evolutionary theory by T.H. Huxley in the latter's drive to improve teaching science in schools.[39]

The practice of photography at this period was saturated with the anxieties of cultural disappearance and what I shall term an 'archaeological imagination'. This idea, common to a broad range of preservationist discourses, including anthropology, involved recognizing how a salvaged dying past was essential to reading the present, which was, in its turn, based on evolutionary models of race and culture. In a cultural environment concerned with flux, disappearance and progress, record and survey work was presented as a duty. It is a sentiment repeatedly voiced in the rhetoric of the NPRA: 'To take such records is a duty – and it is not a great one – to secure that which is worth preserving for the future generations. I cannot coin words to urge you to record the present, as did Stow and Dugdale,[40] and doing so you will become a credit to yourself and your country'.[41] The Photogram described 'record photography', as it became popularly named, as 'one of the most useful and most unselfish tasks ever set before photographers'.[42] This echoes Haddon's anthropological call in the pages of Nature in 1897 (the year of the foundation of the NPRA) that it was 'our bounden duty to record the physical characteristics, the handicrafts, the psychology, ceremonial observances and religious beliefs of vanishing peoples, this is also a work which in many cases can alone be accomplished by the present generation'.[43] The English, unlike the Torres Strait Islanders of whom Haddon was writing, might not have been perceived as 'dying out', but the memory of what made them English was. Like contemporaneous debates in anthropology, the NPRA stressed intellectual engagement and the quality of observation. Survey work was for 'any man of liberal education' and it was a 'mistake to suppose that it is one that appeals only to practical photographers. The man with the camera may know how to photograph but it is impossible that he should always know what is worth photographing'.[44]

The archaeological imagination, and specifically the salvage agenda, resonates through much photography of the late nineteenth century. Photography was the salvage tool par excellence, with its indexical insistence and spatial and temporal projection which presented the past in

the present. As we have seen, the concern for the disappearing object was, as elsewhere, articulated through representational strategies. Undoubtedly the NPRA was informed by what James Clifford has termed the 'ethnographic pastoral', with its emphasis on the resonances of historical association and the 'relentless placement of others in a present becoming past'.[45] Yet photography itself works against this. While it carries with it, at least in the Western tradition, an ineffable pastness, through its temporal slippage it also presents the there-then as the here-now, in Barthes's famous phrase.[46] While the past was embedded in the referent of the photograph, the photographs themselves were about the present and the future. 'The object of the Collection is to show how great is the service which photography may render to the future historian by recording passing events and by preserving aspects of things as they are.'[47] Consequently I would argue that the NPRA photographs are temporally complex, working out the relationship between past, present and future, all simultaneously inscribed on the surface of the photograph.

Thus the NPRA cannot be cast solely in terms of registering the disappearing, but rather its whole *raison d'être* was making the collection of photographs work for the future. Through repeated engagement with the photographs, the past would impact on the consciousness of both the present and the future. Thus access to the photographs was an important part of the agenda of the NPRA. Not only was a set deposited in the British Museum as part of the national cultural memory bank, but more important were the sets of photographs from the county surveys which were deposited in local museums and free libraries, exhibited as lantern slide lectures in church halls, or prepared as educational materials for schools. Indeed, the NPRA itself had access to only a small proportion of the images being produced as records: for instance, in 1897 Warwickshire selected a mere hundred out of over two thousand for submission.[48] The introduction to the popular 1906 edition of *Sir Benjamin Stone's Pictures: Records of National Life and History,* which published a selection of Stone's own photographs in fortnightly parts[49] and then in two volumes, states that 'While it will appeal specially to some classes of the community, it has been planned for all'.[50] The annual exhibitions of some local photographic societies, like those at Birmingham and in Worcestershire, had special survey sections which also displayed these images to a wide audience.[51]

As Benedict Anderson has argued, communities are not necessarily constituted directly through collective experiences, but rather through values articulated through shared sets of images and styles of imagining held in the minds of fellow members.[52] Such a grouping forms an 'imagined community' which is made visible through a 'print culture', that is the circulation of those styles of imagining. The NPRA, and its

memory functions, operated precisely in such a manner: it was part of a wider imagined or interpretative community which exchanged images that cohered common values. Perhaps the major manifestation of this imagined community was the 'Photographic Record and Survey' column which ran in the weekly magazine *Amateur Photographer* from 1902. With close links to the NPRA, it offered readers membership in The League of Record Photographers, kept an index of photographers with antiquarian interests who could be put in touch with one another and published their photographs of antiquities on its weekly page. Here the belief in indexicality and the truth of the mechanical transcriptions of photographs preserved and maintained the idea and memory of Englishness as an expression of shared values.

This of course raises the following question: whose imagined community? There was also a strong class element at work in both the NPRA and the survey movement more generally. While the emerging discipline of anthropology, as Kuklick has demonstrated, was based on the new university-educated, scientific elites, the higher echelons of the professions and the colonial service[53] – with exception of the Royal Photographic Society, the photographic societies and camera clubs, which were meant to undertake the work of the NPRA – were often comprised largely of self-made men from the lower echelons of the professions or tradesmen. As Megan Price has shown in her study of the Oxford grocer, Mr E. Underhill, who was a pillar of the Oxfordshire Photographic Survey, there was some overlap between the two groups at a local level in the local naturalists and antiquarian societies, but this did not characterise the national scene.[54] Despite Stone's personal status, the camera clubs and the like were outside the social and intellectual circles of both the Anthropological Institute and the Folklore Society, and this was perhaps another reason why the NPRA was not taken up by the institutions concerned with 'cultural description'.

A number of commentators, notably John Taylor, have argued more generally that the surveys' particular vision of England and Englishness was a middle-class, nostalgic one premised on the stable formations of the golden age of 'Merrie England' – a construction which saturated popular historical consciousness through much of the nineteenth century.[55] If we are to apply this model, it casts the NPRA as having the unconscious and unformulated purpose of positioning the emerging middle-class against those they considered their social inferiors in an environment of the social mobility of rapid modernisation and industrialisation.[56] This manifested itself as 'a regret at the disappearance' of what was considered to be the quaint, unspoilt lifestyle of different, lower-class, people, especially in the rural areas.

There are certainly strong elements of this, and the discourse of the quaint, the picturesque and the disappearing saturates the pages of the contemporary photographic literature.[57] But two problems arise. First, while espousing the concept of disappearance and the value of tradition, the NPRA opposed the stylistic rhetorics of picturesque discourse in, as we have seen, its vehement rejection of pictorialist aesthetics in favour of a realist and positivist style. Second, the values attached to the sites photographed suggest more nuanced processes at work. A close examination of what was actually photographed for the NPRA, especially the first sets of photographs to be deposited at the British Museum, reveals that, as a statement of collective identity and memory, the NPRA activated the very reverse of a domestic 'colonial gaze' that objectified and 'othered' in order to maintain hierarchies. Particularly significant were Stone's photographs of Westminster Abbey, of the House of Commons and of Members of Parliament (figure 3.2). These were followed later by sets of photographs of Westminster Public School and, in the English 'margins', the Tynwald in the Isle of Man.[58]

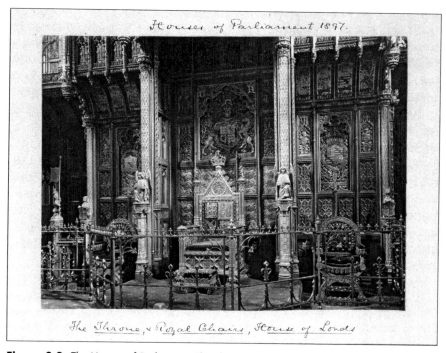

Figure 3.2 *The Houses of Parliament: The Throne and Royal Chairs in the House of Lords.* Sir Benjamin Stone. 1897. Platinum print mounted on card. Courtesy: V&A Images/Victoria and Albert Museum, E3834-2000.

These are, instead, sites saturated in the power of tradition, places that bestowed and secured English identity and memory. Englishness was conceived of as being rooted in the soil of locale, and was understood as being transmitted through exposure to England's authentic and auratic spaces. Consequently the way in which photographs reproduced these sites was very important. They offered repeated exposure to the mythic seat of democratic and just government evolved from freedom under the law of the peoples of England. This was not merely a concern for 'folk' and 'tradition' but rather a particular rendition of the 'people' of a sovereign nation. Making such records had 'an important bearing on the earlier history of our country, and indicate in a remarkable manner, the true source of many an epoch-making incident in the story of British freedom and progress'.[59] In the words of Sir J. Cockburn at the closing meeting of the NPRA in 1910, 'these "Archives of history" … would have a great part in giving continuity and solidity to our national life'.[60]

Ian Baucom has argued that through the late nineteenth and early twentieth centuries Englishness had been defined by 'appeals to the identity-endowing properties of place'.[61] Whatever else Englishness has entailed, it can generally be understood to reside in some kind of imaginary, an abstract or actual locale whose spaces were marked with that Englishness. Indeed, Ford Madox Ford argued that Englishness could be acquired by virtue of having come into contact with English soil and English customs. 'It is not – the whole of Anglo-Saxondom – a matter of race but one quite, simply, of place and of spirit, the spirit of being born in the environment'.[62] Further, as Pierre Nora has suggested, such a space is dynamic not static, being occupied by living subjects who, as they visit, inhabit or pass through, leave their marks upon it.[63] Locale acts as a sort of contact zone in which the present recreates the past.

What thrived in this environment, and were nurtured by it, were the ancient buildings steeped in the comings and goings of English people and their English customs.[64] This position echoed Ruskin, for whom inviolable English space was represented through architecture, architecture having become the nation's memory house. Such a past so expressed had a redemptive quality, in its restorative potential, and thus a concern for the future:

> It belongs as much to those who are to come after us; and whose names are already written in the book of creation, as to us, we have no right, by any thing that we do or neglect, to involve them in unnecessary penalties, or deprive them of benefits which it was in our power to bequeath.[65]

This is articulated in a report on a lantern slide lecture about Westminster Abbey given by Stone to the East Worcestershire Camera Club in 1896. It was a subject

of considerable interest to any freeborn Englishman and Englishwoman when they walked through the aisles of the abbey, pictured the different scenes that had occurred there at different times of our history ... the memorials within its walls were an inspiring influence to their young people.[66]

The identification of Englishness with the locale was premised on local knowledges. Dialects, traditions and memories that were understood to emerge from that locale were embraced by the folklore revival of the late nineteenth century, a movement with which the NPRA was integrally connected, at least at the level of cultural formation. This stress on the relationship between locale and memory is especially clear in the photographs of parish churches and their fittings which dominate the NPRA collection (figure 3.3). The parish church was often the oldest and most historic building in a community, standing as it did for the continuity of cultural experience and the power of the local. In the writing of local histories it was often the starting point for the story of a community and its customary performances.[67] It was not only a place of religion but a place where the community gathered regularly, consolidating and reproducing its values, for instance affirming hierarchies in seating arrangements.[68] The continuity and reproduction of

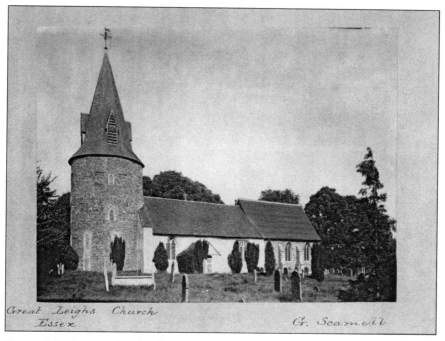

Figure 3.3 *Great Leighs Church, Essex.* George Scamell. 1908. Platinum print mounted on card. Courtesy: V&A Images/Victoria and Albert Museum, E2218-2000.

communal memory was also stressed by the attention given by NPRA photographers to the material manifestations of these processes, such as baptismal fonts and monuments of the gentry (figure 3.4).[69] Certainly, as Taylor argues, there were class elements at work in the representation of social order, but the subject matter of the NPRA photographs suggests that the dominant concern was with the traces of continuity and stability, expressed through antiquities, which included but extended beyond concerns of class.

The impetus for the NPRA came, as I have suggested, from the sense that it was not the English as a race with its long celebrated ancient and culturally diverse roots,[70] that was under threat from rapid urbanisation but the 'locale of English' – the places that marked the land. It is significant that some of the most successful surveys and the largest concentrations of contributions to the NPRA are from those connected with the photographic societies in large cities, like Birmingham (Warwickshire Survey) and Leeds (Yorkshire Survey).[71] The teeming masses of the urban slums were seen by some commentators as devoid of

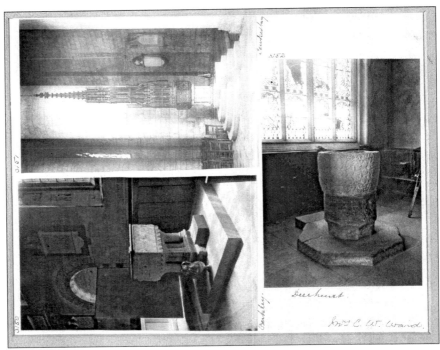

Figure 3.4 *Fonts from Gloucestershire Churches: St. Mary's Church, Berkley, Tewkesbury Abbey and Holy Trinity Church, Deerhurst.* Mrs Catherine Weed Ward. 1903. Platinum prints mounted on card. Courtesy: V&A Images/Victoria and Albert Museum, E2285-2000.

Englishness – their inhabitants living like 'savages', gypsies or 'Arabs'.[72] Consequently it is significant that the NPRA not only includes rural customs but also some of those customs and buildings that had survived within the great cities, such as street hawkers (figure 3.5) or the ancient buildings which were located in London slums.[73] Stone himself photographed the custom of 'picking up sixpences' in the churchyard of St Bartholomew, Smithfield, on Good Friday. These photographs implied that the survival of locales of Englishness could be found even in the modern city. Significantly, many of these urban customs and buildings, like those of the Tower of London and the City of London, are connected to law and order. Indeed, throughout the NPRA there are many photographs of stocks and whipping posts,[74] sites of ducking pools and, from Leominister in Herefordshire, a ducking stool itself (preserved in the church). The same concerns and cohering forces of these photographic representations found in the larger cities are replicated in the smaller urban spaces, where the civic ceremonies, invented traditions and ancient regalia of small English market towns, such as Hungerford or Ripon, are photographed. Here custom, Englishness and civil order are

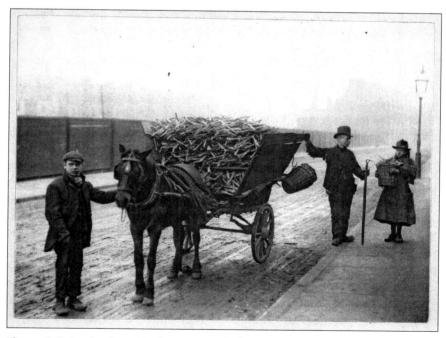

Figure 3.5 *London Street Hawkers: Firewood.* Photographer: Edgar Scamell, 1895. Platinum print mounted on card. Courtesy: V&A Images/Victoria and Albert Museum, E3603-2000.

played out as a cohesive force for the camera, making visible the values that constituted English identity.

In the context of this history, I want to consider briefly two formative strands that resonate through the NPRA, and indeed, throughout survey photography more generally. By the late nineteenth century, progressivist ideas, premised on the concept of cultural evolution from the primitive and savage to the civilized, were well established. These ideas were fully articulated within the emerging disciplines of scientific biology, anthropology and archaeology, and by the late nineteenth century had been fully integrated into historical thinking in general.[75] Like Darwin's theories of evolution, theories of cultural survival, which identified past practices alive in the present, had permeated deep into the consciousness of at least the educated classes. These ideas were articulated in anthropologist Edward B. Tylor's book *Primitive Culture*, published in 1871, which was very influential and laid down the model for his later work including his popular and widely read *Anthropology*, published in 1881.[76] Given shape by Darwinian theory, Tylor's works cohered scientifically ideas of cultural evolution and survival which had been in circulation for some time: for instance, ideas of survival resonated through eighteenth and early nineteenth-century antiquaries such as Brandt's *Popular Antiquities*.[77] The broad shape of contemporary debates in anthropology enjoyed a wide circulation. Meetings of the Anthropological Institute were reported in the daily press and were often picked up to be syndicated to the regional press.

This model of evolutionary survival resonates through the language of the NPRA. Tylor's idea was that the cultures of advanced peoples, or indeed, any peoples, contained within them survivals from earlier stages of their cultural development. These survived as customs, rituals and festivals which had no apparent purpose but were nonetheless adhered to rigorously. 'Looking closely into the thoughts, arts and habits of any nation, the student finds everywhere, the remains of older states of things of which they [contemporary practices] arose'; and indeed, Tylor specifically draws attention to 'the history of parliamentary government [which] begins with the old-world councils of the chiefs and tumultuous assemblies of the whole people'.[78] Further, it was a history vested in belief, customary observance and ancient sites which gave rise to an alternative history, broadening the base of historical consciousness. In the words of folklorist George Laurence Gomme, belief and observance 'point to some fact of history of the people which has escaped the notice of the historian'. Thus the folk customs and ancient sites of England represented a form of folk memory with the attributes of 'native uncivilisation' and 'immemorial custom sanctioned by unbroken succession'.[79]

However, in contrast to Tylor and the project of anthropology as the great, liberal, reforming science which identified and purged cultural survival as a force that restrained civilisation and thus progress,[80] the surveys and the NPRA were intrinsically conservative in their preservationist discourses. Rather than being the Tylorian volcano under the smooth veneer of civilised culture, survivals of customs and cultural practices were intrinsic to a conservative vision of England. They were, as I have suggested, the site of a positively inflected 'primitive' culture, the memory of which was perceived as crucial to building and maintaining a stock of English identities and to the reproduction of English values in the future.

If Tylorian influences can be traced in the conception of the surveys, another strand can also be extrapolated. This, for sake of argument, I shall call neo-Lamarckian, although it is not as formally constituted as this.[81] In the Larmarckian view, evolution was premised not only in the dynamic biological development of the organism itself but also in the inorganic, the external and the disembodied. It followed, in this argument, that evolution, and thus identity, progressed in a teleological fashion through external forces, namely though the heredity of acquired characteristics. This was the major departure from the internal and mechanical Darwinian model. As Peter Bowler has argued, by the late nineteenth century these ideas had a massive circulation outside science, especially their theological implications for the divine design for humankind – through the writings of, for example, Samuel Butler, who wrote four books of popular anti-Darwinian evolutionary science.[82] In addition at one level, like the theory of survival, there was a popular, scientific, common sense belief that external forces must have some bearing on human development and progress. These ideas link strongly with ideas of Englishness being rooted in locale, in the environment of England itself, in that national character was built through the acquisition of these externally generated values. In the words of Ford Madox Ford quoted above, Englishness was 'the spirit of being born in the environment'.[83] If Englishness emerged from the soil and the absorption of the characteristics of locale, its reproduction might also be seen to operate in a neo-Lamarckian frame. In this model, the consciousness of photographic observation which the NPRA demanded, in that moment of recognition or enquiry, constituted a design or recognition of a constructed memory reflecting teleological theories of memory acquisition.

The relationship between past and future captured in photographs became a formative strand in the thinking of later theorists, in particular Walter Benjamin and Siegfried Kracauer, writing in the mid-twentieth

century. Crucial for my argument is a quasi-Lamarckian cultural dynamic, saturated with ideas of what we might term externalised, prosthetic, collective memory which is realised through photography as it projects its inscriptions into the future, becoming a form of inherited memory. Photography, with its reproductive and repetitive qualities, is a form of externalised memory *par excellence*, fulfilling the inscriptional and performative qualities of memory and cultural habit. In *Life and Habit*, Samuel Butler states: 'The greatest proof of memory is by actual repetition of the performance'.[84] Photography performs the past in the future, multiplying it and disseminating it. As Barthes puts it: 'What the Photograph reproduces to infinity has occurred only once: the Photograph mechanically repeats what could never be repeated existentially. Through it we know most intensely those things we have consciousness of knowing'.[85] The performative habit of photography, especially its dynamic potential for repeated engagement, mirrors the performativity of memory which, in a neo-Lamarckian mode, becomes inherited identity. Latent memories, manifested through 'traditions', become conscious through engagement with the photographic image as people engage with their past and thus with what it is to be English. The stress laid by the NPRA on exhibitions, lantern slide shows and, more especially, public access to photographic records deposited in the British Museum and local libraries, emphasises the way in which the photographs were intended to function. The reproducibility of the photographs and the repeated engagement with them was meant to perform that repetition which constitutes memory.

If the NPRA was the most high-profile archival project employing the archaeological imagination to generate collective memory, it is collective memory that informs a wide range of debates on photography, the past and the future. In a series of essays in the *British Journal of Photography* in 1889 entitled 'The Whole Duty of a Photographer', the use of the camera, including the new detective camera, was advocated for recording all aspects of life. The role of the photographic archive as collective memory becomes apparent. For the preservation of these records,

> they ought to be inserted in great albums, sacred from the polluting touch of the silver print, kept at the Royal Photographic Society of the future. Such a society would have one of its highest and most trusted officials as 'keeper of albums' on whom would devolve the responsibility of choosing photographs and seeing them mounted and fully labelled with every precaution for their preservation.[86]

While here, as elsewhere, the permanence of photographic prints is paramount, the suggestion is that memory should be inscribed and archived through the institutional structures of photography itself. In fact,

as we have seen, it was the British Museum which was chosen as the holder of the national memory – the 'keeper of albums'.

One of Butler's notebook entries on memory describe the intentions for photography: 'It is the business of memory and heredity to conserve and transmit from one generation to another that which has been furnished by design or by accident designedly turned to account'. [87] As the Westminster Abbey example quoted above suggests, this is echoed through the NPRA countless times. For instance, 'it is pleasant to think that we are providing persons who will look back upon this age from as remote a period as that which we dimly imagine when we think of the days of Caractacus and Boadicea, [88] absolutely exact representations, in all but colour, of the scenes of today'. [89] The photographs would 'hand down actual facts to our children', [90] for 'the aim of all these surveys is to establish for the future a provision against similar unfulfilled wishes in the days of the generation that is still now but a child in arms'. [91] The rhetoric of future remembrance and social solidity is constant and unshakable.

This archaeological imagination and salvage impulse, articulated as a form of collective memory, were among the cohering ideas of late nineteenth-century record photography. Hoyt identifies this archaeological imagination with the old-style evolutionary anthropology of the middle years of the nineteenth century. [92] Yet photography embodies the intellectual ambiguities of the shift from an archaeological to a vitalist model in the late nineteenth and early twentieth centuries. This emerging vitalist model stressed the duration of human consciousness and the social continuity of the historical past in a dynamic model, rather than placing 'the primitive' as inert and passive relics. [93] Photography stills the moment in apparent timelessness whilst simultaneously performing the past actively in the present. The NPRA operated precisely within this space. The archaeological imagination was thus embraced within a dynamic historical consciousness, and photography was intentionally applied to it to fill the emerging void left by modernity's destruction of the practices of memory in everyday life, from work observances to celebrations, in what McQuire has termed the 'crisis of memory'. [94] In the meta-narratives of photographic observation of the period, photographs became an externalised backstop against the anti-historicism of modernity and the disappearance of a collective memory. What is significant is the intensity and the consistency in which photography as a medium comes together with cultural excavation, salvage and the archaeological imagination. From these emerge the material and metaphorical rhetorics which informed both the NPRA and the survey movement more generally.

The NPRA project was, as I have noted, a failure. Despite repeated appeals to the duty and sentiment of photographers and to the desirability

of building a national memory through photography, the NPRA resulted in only 5,883 photographs produced by only ninety-four photographers. Of these over 3,000 photographs were produced by just three photographers, Sir Benjamin Stone being by far the largest contributor.[95] The British Museum was resistant to the project throughout, worrying about its potential size and its appropriateness for their collections.[96] There was also a feeling that if there were to be such a project it should be centrally funded by a government department and undertaken systematically. The resulting archive of the NPRA is at best serendipitous and random, and this indeed appears to be one of the objections to the project: 'are the best examples which can be found of each subject added to the collection, or only those which chance throws in the way of the Association?'[97] Moreover, as the comment in relation to film (living pictures) quoted above from the *Sheffield Telegraph* suggests, the NPRA was conservative not only in its intentions and vision but also in its technology. Many photographers no longer used full plate as a matter of course, and the less affluent – who by this date made up a sizeable proportion of members of camera clubs – could not afford the equipment to fulfill the demands of the NPRA. Local survey sections were much more inclusive than the NPRA in terms of photographic technologies, and they would consider other formats and printing processes. For instance, Mr F. Armytage of the Shropshire Photographic Society noted of the record photographs going to the local Free Library: 'so few of them [local photographers] worked in carbon or platinotype, and still fewer had cameras larger than half-plate, [so] bromide prints would be accepted, printed either direct or in the form of enlargements'.[98]

However, this failure is not, I would argue, simply because the survey project was flawed in itself. Nor is it – given that in such massive visual thesauri meaning could not, in practice, be fixed or controlled – because faith in photographic truth and photographic taxonomies was misplaced.[99] Rather it was because the cultural impetus for such projects was, like Englishness, held to be in the soil, in the locale. The imperialist society of spectacle, with confidence of Empire and its outward manifestations, from coronations and Indian Durbars to majestic architecture, offered people other ways of being 'national'. While such were, of course, observed at a local level, they constituted only one facet of identity and one which did not require sacrificing local identities and memories. Indeed, it has been argued that there was an intensification of regional and local identities during the second half of the nineteenth century.[100] This is clearly articulated by the Manchester correspondent of *Amateur Photographer* in 1898:

There are several societies in the North-west who are endeavouring to carry out certain survey schemes and, as far as I can gather, they are making little progress. Should it not be

one of the great aims of the National Photographic Record Association to help forward these to a successful issue? As far as my information goes, what the Association requires is a subscription, and also prints submitted for selection for the British Museum. This is all very well, but what use will these local prints be to the future local historian if they are buried away in London? They would be of much more value if deposited in local municipal libraries, such as at Darwen, Manchester, Oldham and other societies intend [sic]. What can be gained by societies joining such a scheme? They have everything to lose and nothing to gain.[101]

At the end of the day, the photographs which contributed to the construction of identity and memory were those tied to local memory and civic pride available in the local, free libraries,[102] not those in the British Museum. Indeed, arguably the NPRA founders precisely in the space between national 'Britishness', as a facet of increasing centralisation played out through imperial greatness, and the Englishness of locale.[103]

There is also a sense, never fully articulated, that there was resistance to the dominant character of Sir Benjamin Stone and the way his project effectively appropriated and refigured people's local histories and identities at a national level. For instance, in an effort to drum up support for the NPRA in 1902, Stone orchestrated a competition for record photography through *Amateur Photographer*, the winning entries of which would be deposited with the NPRA. However, there was only one entry in the class for a group of record photographs by a photographic society, that from Shropshire Photographic Society, and only fourteen entries in the class for individuals. Extending the closing date garnered only a few more entries. This, the journal commented, was considerably below the normal response to their competitions.[104]

In weaving around the NPRA the strands of archaeological imagination, salvage ethnography, discourses on the roots of national identity, the inheritance of acquired characteristics and the expectations of photography as both a medium and a social act, I hope to have delineated the cultural and intellectual environment in which the NPRA, and indeed, the local county surveys, operated. Most important is the way in which these strands inform dynamic local and national identities and memory practices. The NPRA was finally disbanded in May 1910, unable to realise its goal of building a photographic memory of national history and, by implication, character. A few days later the Federation of Photographic Record and Survey Societies was established, and this took over the functions of the NPRA, absorbing them into the flourishing local survey activities.[105] With this, the survey movement was formally constituted at the local level with the Federation acting in an advisory and facilitating capacity.[106] Nevertheless, this body perpetuated the memory-values of the NPRA: 'the value of adequate photographic records, kept as the common heritage of all, fostering civic spirit is not to be overlooked'.[107] Local constructions of memory and identity had

triumphed over the national. In all this, I hope I have demonstrated the way in which the photographs, along with the discourses which are both embedded in them and which they themselves generated, can be used to gauge the uses of the past in the construction of ideas of Englishness: not only in the content of the photographs necessarily, but in terms of how photography and its constitutive powers operated within the relationships between past, present and future.

Notes

I am grateful to Kaushik Baumik, Chris Gosden, David Harris, Alison Petch, Megan Price and especially Peter James for their invaluable comments and support, and to Annette Kuhn and Kirsten McAllister for their constructive editorial comments. I should also like to thank Martin Barnes and Kate Best at the Victoria and Albert Museum, London, for all their help with the NPRA collection, and to the University of the Arts, London, whose Research Fellowship has allowed me space to work on this ongoing project. My interest is in the relationship between photography and issues of communal memory. I am aware that key discourses on, for instance, the nature of Englishness in relation to Britishness, 'national' memories or identity and Empire are far from fully developed, and I apologise to specialists in that field who might find this frustrating.

1. Eric Hobsbawm and Terence Ranger, eds, *The Invention of Tradition*, Cambridge: Cambridge University Press, 1983.
2. Patrick Joyce, *Visions of the People: Industrial England and the Question of Class, 1848–1914*, Cambridge: Cambridge University Press, 1991, p. 145; John Tagg, 'The Pencil of History', in *Fugitive Images: From Photography to Video*, ed. Peter Petro, Bloomington: Indiana University Press, 1995, p. 287; Susan A. Crane, ed., *Museums and Memory*, Stanford: Stanford University Press, 2000, p. 6.
3. James Fentress and Chris Wickham, *Social Memory*, Oxford: Blackwell, 1992.
4. Ibid., p. ix.
5. Ibid., p. 90.
6. A detailed consideration of the nature of Britishness and Englishness itself is beyond the scope of this essay. The two are not interchangeable terms and should not be conflated. Their various histories, origins, processes, shifts and nuances are energetically debated and there is now a very substantial literature on the subject. See, for example: Ian Baucom, *Out of Place: Englishness, Empire and the Locations of Identity,* Princeton, New Jersey: Princeton University Press, 1999; Linda Colley, *The Britons: Forging the Nation 1707–1837*, London: Pimlico, 1994; Patrick Joyce, *Democratic Subjects: The Self and the Social in Nineteenth Century England*, Cambridge: Cambridge University Press, 1994; Krishan Kumar, *The Making of English National Identity,* Cambridge: Cambridge University Press, 2003; Robert Colls and Philip Dodd, eds, *Englishness: Politics and Culture 1880–1920*, London: Croom Helm, 1986; and Robert Colls, *The Identity of the English*, Oxford: Oxford University Press, 2002.

7. Whilst English counties were given their own box or boxes as the archive grew, Scotland, Wales and Ireland received little coverage and had only a partially filled box each, undifferentiated by county. Ireland, especially its archaeological and Celtic remains, attracted the largest number of non-English photographs, many taken by English visitors.

8. Joyce, *Visions of the People*, p. 148.

9. Georgina Boyes, *The Imagined Village: Culture, Ideology and the English Folklore Revival*, Manchester: Manchester University Press, 1993, p. 127.

10. Tim Barringer, 'Sonic Spectacles', in *Sensible Objects*, eds Elizabeth Edwards, Chris Gosden and Ruth B. Phillips, Oxford: Berg, 2006.

11. Kumar, *The Making of English National Identity*, p. 176.

12. Similar patterns of salvage ethnography, especially in peasant communities and in the rural regions could be found all over Europe at this period. See for example, Karin Becker, 'Picturing Our Past: An Archive Constructs a National Culture', *Journal of American Folklore* 105, 1992, pp. 3–18.

13. Robert MacDonald, ed., *The Language of Empire: Myths and Metaphors of Popular Colonialism*, Manchester: Manchester University Press, 1994; David Cannadine, *Ornamentalism: How the British Saw their Empire*, London: Allen Lane, 2001; Baucom, *Out of Place*; Stephen Haseler, *The English Tribe: Identity, Nation and Europe*, London: Macmillan, 1996.

14. Baucom, *Out of Place*, p. 47.

15. The imperial counterpoint is one of the significant unarticulated elements in the NPRA. The language of the latter is surprisingly free of overt imperialist language and posture. Within the contexts of Empire, the NPRA is profoundly inward-looking.

16. *Yorkshire Post*, 26 October 1897 in Stone Papers: Cuttings, vol. 4, Birmingham City Library.

17. Michael MacDonagh, 'Introduction', in *Sir Benjamin Stone's Pictures: Records of National Life And History*, 2 vols, London: Cassell, 1906, p. v.

18. For instance, the Ecclesiological Lantern Slide Club (founded c. 1895) run by Rev. Walter Marshall, Minor Canon of St George's Chapel, Windsor, for enthusiasts of church architecture.

19. André Malraux, *Museum Without Walls*, trans. Stuart Guilbert and Francis Price, London: Secker and Warburg, 1967.

20. For details of Harrison's career see Peter James, 'Evolution of the Photographic Record and Survey Movement, c.1890–1910', *History of Photography* 12, no. 3, 1988, pp. 205–218.

21. See John Taylor, *A Dream of England: Landscape: Photography and the Tourist Imagination*, Manchester: Manchester University Press, 1994, pp. 50–63; James, 'Evolution of the Photographic Record and Survey Movement'.

22. The photographs, stored in over eighty large green drop-fronted boxes, were held at the British Museum. There were plans to classify and index the photographs during the lifetime of the NPRA but this was never done, although the honorary secretary, George Scamell, kept an index of prints. The collection remained uncatalogued until 2000 when it was transferred to the Victoria and Albert Museum's Department of Prints, Drawings and Photographs, and fully registered.

23. *The Times*, 25 October 1897, 3 col. 6.
24. In this Stone fits the model of the articulation of national memories belonging to political or social elites. See Fentress and Wickham, *Social Memory*, p. 127.
25. Letter from the Trustees of the British Museum to Sir Benjamin Stone. Quoted in *The Times*, 4 April 1897, 6 col. 6.
26. Essex: Boxes 13a-c, NPRA Collection, Victoria and Albert Museum; Devon: Box 9, NPRA Collection, Victoria and Albert Museum.
27. Tagg, 'The Pencil of History', pp. 286–287.
28. Taylor, *A Dream of England*, p. 59.
29. MacDonagh, *Sir Benjamin Stone's Pictures*, p. vii.
30. *Amateur Photographer* 26, 8 October 1897, p. 308.
31. C. Welbourne Piper, 'A Photographic Architectural Survey', *Amateur Photographer* 36, 10 July 1902, p. 33.
32. Unidentified newspaper cutting, 1897, in Stone Papers: Cuttings, vol. 5:16.
33. Kumar, *The Making of English National Identity*, p. 178.
34. Taylor, *A Dream of England*, p. 69.
35. This is demonstrated through the selections of photographs by Henry Snowden Ward and his wife, Catherine Weed Barnes Ward, who contributed over 120 images to the NPRA, some of which are related to their nostalgic literary travel books. The NPRA photographs are devoid of people and, in the case of Mrs Ward's substantial series of photographs of fonts, devoid of self-conscious aesthetic.
36. For instance, in the 1850s the French government had instituted Le Mission Héliographique to record architectural monuments. See Christine Boyer, 'La Mission Héliographique: Architectural Photography, Collective Memory and Patrimony in France, 1851', in *Picturing Place: Photography and the Geographical Imagination*, eds Joan M. Schwartz and James R. Ryan, London: I.B. Tauris, 2003.
37. *Sheffield Telegraph*, 19 April 1897, in Stone Papers: Cuttings, vol. 4.
38. 'Invitations 1899–1903', in Stone Papers, n.p.
39. James, 'Evolution of the Photographic Record and Survey Movement', p. 15; Adrian Desmond, *Huxley: Evolution's High Priest*, London: Michael Joseph, 1997, p. 135.
40. Sixteenth- and seventeenth-century antiquaries John Stow (c.1525–1605) and Sir William Dugdale (1605–1686). Stone owned books by both these writers.
41. Sir Benjamin Stone retiring from the presidency of Birmingham Photographic Society. Reported in *Amateur Photographer* 29, 27 January 1899, p. 64.
42. *The Photogram,* January 1907, pp. 30–31.
43. Alfred C. Haddon, 'The Saving of Vanishing Knowledge', *Nature* 55, 1897, pp. 305–306.
44. W. Jerome Harrison, 'The Desirability of Promoting County Photographic Surveys', *British Association for the Advancement of Science: Annual Reports*, 1906, p. 59 [original emphases].
45. James Clifford, 'On Ethnographic Allegory', in *Writing Culture: The Poetics and Politics of Ethnography*, eds James Clifford and George E. Marcus, Berkeley: University of California Press, 1986, pp. 110–115.
46. Roland Barthes, *Image Music Text*, trans. Stephen Heath, London: Flamingo, 1977.
47. Unidentified newspaper cutting, c. 1898, in Stone Papers: Cuttings, vol. 5: 16.

48. Letter, 12 November 1897, Birmingham Photographic Society, Birmingham City Archives.
49. 'the number published will depend on the reception of the work by the public'. See *Amateur Photographer*, 19 August 1905, p. 221.
50. MacDonagh, *Sir Benjamin Stone's Pictures*, p. vii.
51. Significantly, images in survey classes were judged not on their aesthetic merit (as in other classes) but on the depth of their indexical veracity and historical import; for instance, a member of the committee of the Birmingham Photographic Society was deputed to explain to the judges of the annual exhibition 'the necessity of judging the Survey classes from the value of the photographs as records as distinct from their pictorial merit'. See Birmingham Photographic Society Council Minutes, 23 April 1897.
52. Benedict Anderson, *Imagined Communities: Reflections on the Origins and Spread of Nationalism,* London: Verso, 1983.
53. Henrika Kuklick, *The Savage Within: The Social History of British Anthropology*, Cambridge: Cambridge University Press, 1991.
54. I am very grateful to Megan Price at Wolfson College, University of Oxford, for sharing her unpublished Ph.D. research with me.
55. Taylor, *A Dream of England*.
56. Ibid., p. 57.
57. For instance *Amateur Photographer* ran a regular column on picturesque haunts for the tourist photographer. Like the guidebooks discussed by John Taylor, the key rhetoric is that of the quaint, charming and picturesque waterfalls, cottages and ancient places. See Taylor, *A Dream of England*, p. 67. In the 1890s *The Photogram* ran a column entitled 'Doomed and Threatened' while in 1902 *Amateur Photographer* started the 'Photographic Record and Survey' column. Much writing on architectural photography in these journals was also linked to the agendas of survey.
58. The Tynwald is of Viking origin and therefore representative of one of the racial and cultural strands which make up an English identity.
59. 'Afternoon Tea with Sir Benjamin Stone and the National Photographic Record Association', *Amateur Photographer* 31, 9 March 1900, p. 183.
60. *Amateur Photographer* 51, 7 June 1910, p. 556.
61. Baucom, *Out of Place*, p. 4.
62. Ford Madox Ford, *The Spirit of the People*, London: Alston Rivers, 1907, p. 43.
63. Pierre Nora, 'Between Memory and History: Les Lieux de Memoire', *Representations* 26, 1989, pp. 7–25.
64. The English were, and still are, a people of celebrated hybridity. See Haseler, *The English Tribe*, pp. 9–16. The discourse of Englishness embraced and absorbed invaders and immigrants through the power of its locale. Such a model had absorbed not only immigrants but an essentially Norman-French aristocracy and, more latterly, a German monarchy.
65. John Ruskin, *The Seven Lamps of Architecture*, 2nd edn (1880; reprint, New York: Dover, 1989), pp. 185–186.
66. *Bromsgrove Messenger*, 3 December 1896, in Stone Papers: Cuttings, vol. 4. Prints of these photographs were amongst the first to be deposited by the NPRA in the British Museum.

67. Boyes, *The Imagined Village*, p. 30.
68. The practice of letting pews was established by the late Middle Ages. The lord of the manor and local gentry rented their pews from the church. These were often 'boxed', that is, physically separated from the rest of the congregation. Pews near the front were let to middle-class churchgoers. Servants sat at the back or behind their employers. One of the reforms of the nineteenth century, urged by the London Free and Open Church Society for instance, was to increase the amount of 'free seating' in churches, especially in newly built churches. See Andrew Saint, 'Anglican Church Building in London, 1790–1890: From State Subsidy to Free Market', in *Victorian Church: Architecture and Society*, eds Chris Brooks and Andrew Saint, Manchester: Manchester University Press, 1995, p. 41.
69. Baptismal fonts welcomed and initiated the newly arrived; monuments to the gentry celebrated the continuity and hierarchies of landholding and thus the social order.
70. Haseler, *The English Tribe*, pp. 9–16.
71. For instance, Godfrey Bingley of Leeds contributed some 525 images to the NPRA. His major interest however was in geology and he contributed to the BAAS Geological Photographic Survey.
72. Baucom, *Out of Place*, pp. 55, 61.
73. Photographed by Edgar Scamell. Indeed, in 1902 *Amateur Photographer* ran an article entitled 'Picturesque Slums'; see *Amateur Photographer* 36, 1902, pp. 352.
74. Large numbers of photographs of stocks were also sent to the Photographic Record and Survey pages of *Amateur Photographer*.
75. Peter J. Bowler, *Biology and Social Thought 1850–1914*, University of California Berkeley: Office for History of Science and Technology, 1993, p. 37.
76. Edward B. Tylor, *Primitive Culture*, London: J. Murray, 1871; Edward B. Tylor, *Anthropology*, London: Macmillan's Manuals for Students, 1881.
77. Colls, *Identity of the English*, 249.
78. Tylor, *Anthropology*, p. 15.
79. George L. Gomme, *Ethnology in Folklore*, London: Modern Science Library, 1892, p. 6.
80. George Stocking, *After Tylor: British Social Anthropology, 1888–1895*, Madison: University of Wisconsin Press, 1995, p. xiv.
81. I am using 'neo-Lamarckian' as a useful catch-all for a range of ideas about evolution which departed from the materialist Darwinian model of natural selection. In this model the construction of a collective memory becomes a progressivist force.
82. Peter J. Bowler, *The Eclipse of Darwinism: Anti-Darwinian Evolution Theories in the Decades Around 1900*, Baltimore: Johns Hopkins University Press, 1983, pp. 80–81.
83. Madox Ford, *Spirit of the English*, p. 43.
84. Samuel Butler, *Life and Habit,* London: A.C. Fifield, 1910 [first published 1877; but dated 1878], p. 130.
85. Roland Barthes, *Camera Lucida*, trans. Richard Howard, London: Flamingo, 1984, p. 4.

86. Cosmo Burton, 'The Whole Duty of a Photographer', *British Journal of Photography* 18, October 1889, p. 682.
87. Samuel Butler, *The Note-Books of Samuel Butler*, ed. Henry Festing Jones, London: Jonathan Cape, 1921, p. 62.
88. Both Caractacus and Bouadicea were of course, in nineteenth-century eyes, heroes of stout British (pre-English) resistance to invaders, in this case the Romans.
89. *Western Press*, 15 April 1897, in Stone Papers: Cuttings, vol. 4.
90. *Morning Post*, 9 July 1897, in Stone Papers Cuttings, vol. 4.
91. Report on the newly formed Warwickshire Survey. See *Amateur Photographer* 26, 19 November 1897, p. 428.
92. David Hoyt, 'The Reanimation of the Primitive: Fin de Siècle Ethnographic Discourse in Western Europe', *History of Science* 39, no. 3, 2001, pp. 331–352.
93. I use the term 'vitalist' to mean an active cultural dynamic rather than in the sense of nineteenth-century theories of biological vitalism which positioned that dynamic within the organism, not externally. Although the concepts are clearly linked they should not be conflated in my usage here.
94. Steve McQuire, *Visions of Modernity: Representation, Memory Time and Space*, London: Sage, 1998, pp. 119–122.
95. Sir Benjamin Stone contributed 1,532 photographs; George Scamell, 1,035 photographs; and Godfrey Bingley, 525 photographs.
96. Sidney Colvin, 'Report to the Trustees', 6 June 1898. See Papers of the Dept of Prints and Drawings, British Museum.
97. Frank Meadow Sutcliffe, 'Letter', *The Photogram*, June 1900, p. 204.
98. *Amateur Photographer* 35, 24 April 1902, p. 328. Armytage was an official of Shropshire County Council.
99. Taylor, *A Dream of England*, p. 59.
100. Joyce, *Visions of the People*, p. 148; Colls, *Identity of the English*, pp. 226–228.
101. *Amateur Photographer*, 7 January 1898, p. 15.
102. In 1907 the 2,500 photographs of the Surrey Photographic Survey, deposited in Croydon Town Hall, attracted an astonishing 7,477 users. See *The Photogram*, May 1907, p. 157.
103. Colls, *Identity of the English*.
104. *Amateur Photographer* 36, 20 November 1902, p. 402.
105. James, 'Evolution of the Photographic Record and Survey Movement', p. 214.
106. It continued in this capacity for some decades. In 1916 members of the Surrey Survey published an influential book *The Camera as Historian*, which defined methodologies. See H.D. Gower, L. Stanley Jast and W.W. Topley, *The Camera as Historian*, London: Sampson, Lowe and Marston, 1916. Also see Tagg, 'The Pencil of History'.
107. Gower, Jast and Topley, *The Camera as Historian*, p. 4.

Chapter 4

A Story of Escape

Family Photographs from Japanese Canadian Internment Camps

Kirsten Emiko McAllister

It was one of those damp winter days in Vancouver. Amorphous, low-lying clouds had engulfed the city, reducing visibility to a few blocks. I spent the morning poring over the photograph collection in the Japanese Canadian National Archive and Museum, searching for images of the internment camps where the Canadian government incarcerated thousands of Japanese Canadians from 1942 to 1945. I was familiar with

Figure 4.1 *Scene from the Lillooet Camp.* Circa 1944. Courtesy: Nakashima family.

photographs of the internment camps. As a child I spent hours studying well-worn black and white images of scenes of life in the desolate mountainous terrain where the government incarcerated my mother's family (figure 4.1). The photographs were carefully pasted into the family albums kept in the teak sideboard two drawers above the silverware in *Obaasan*'s[1] house. They were arranged on the thick black pages of the family albums with as much care as the snapshots of idyllic picnics in Stanley Park and the family portraits taken in stylish studios in Vancouver (figure 4.2). Like the prewar photographs, the images from the camps were intimate records of family life, showing little of the emotional duress, anxieties and material hardships.

The internment camps were one phase in a systematically deployed plan to remove over twenty-two thousand people of 'Japanese racial origin' from the province of British Columbia.[2] The photographs of the camps, along with (heavily censored) letters, were among the few records that Japanese Canadians made during their four years of incarceration.[3] Even though the government confiscated their cameras, internees illicitly took hundreds of photographs with smuggled cameras. These were the photographs I wanted to find. Rather than focusing on institutional photographic records that discursively construct and control 'deviant

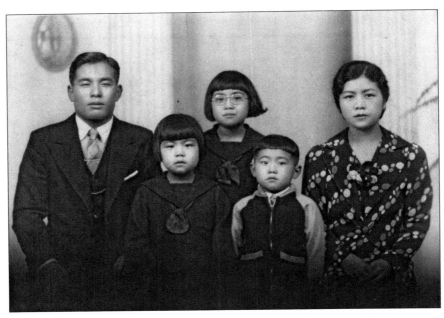

Figure 4.2 *Nakashima Family in Vancouver Photography Studio.* Circa 1937. Courtesy: Nakashima family.

subjects' in modern populations, I sought photographic records produced by incarcerated subjects themselves.[4] These records promised to provide glimpses of attempts by Japanese Canadians to configure their experiences through photography as a visual practice, ordering and giving meaning to their life in the camps. As visual texts that circulate between the private domain of individual homes and the public domain of the archive, the photographs also raise questions about the way archival images reiterate and fix or disrupt Japanese-Canadian identities over time.

In the archive, I found that looking through the photograph collection differed from looking at my family's albums. I was overwhelmed by the sheer mass of photographic images. Here, thousands of lives were condensed into flat surfaces. As an unknown historical landscape began to emerge, there was an eerie sense of dislocation. It was as if I had been absorbed into a murky spectral world of images '[wandering] ghost-like through the present'.[5] Embedded in realities that have long since disappeared, these images seemed to hold the potential to 'conjure up anew ... disintegrated [unities]' of once intact modes of living.[6] Formal family portraits arranged new immigrants and their Canadian-born children into still-life studies of bourgeois life in the New World. I was whisked away by the stylish ease and confidence exuding from candid street snaps of young men and women, arms locked in the camaraderie of youth, striding along Granville Street just before the outbreak of the Pacific war. Photographs of the proud owners of shiny motor cars, well-stocked dry goods stores and trim houses with English gardens were testaments to their investment in a future in Canada.

Fuelled by a dose of watery coffee from the local *7-Eleven*, I made my way through the thick reference binders that plot the collection into rows of carefully itemised photocopied images arranged chronologically in order of acquisition. Scattered amongst the prewar photographs, I found hundreds of images of the camps. Like the prewar photographs, there were pictures of church groups, school children, landscapes, friends and community events. Yet in striking contrast, there were only a handful of family photographs. As intimate records of the strangers' lives, these images were difficult to read. It was as if once donated to the archive they were torn from their social contexts: the homes, family stories and memories that made them meaningful.[7] At a more personal level, I discovered that my attempts to read the photographs reminded me of my own family stories and began to make me wonder about the stories' veneer of cohesion and harmony. As Marianne Hirsch suggests, 'the family photograph ... can reduce the strains of family life by sustaining an imagery of cohesion, even as it exacerbates them by creating images that real familes cannot uphold'.[8] The family portraits I found in the

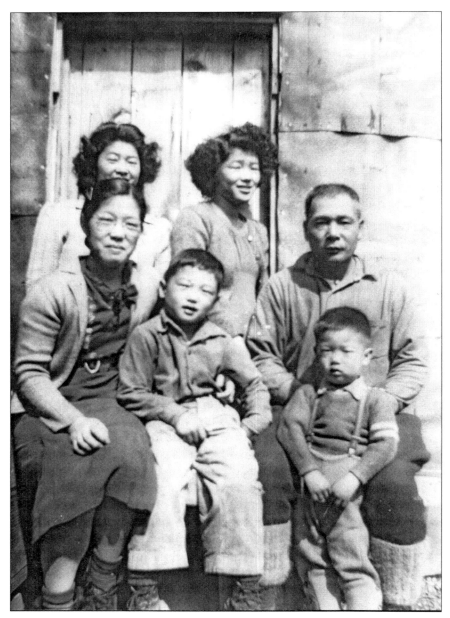

Figure 4.3 *Okada Family in Front of Tar Paper Shack.* Circa 1943. Courtesy: Japanese Canadian National Museum, JCNM 94/45.005

archive made me question my investment in repeating the story of internment that I had unknowingly constructed for my mother.

'Okada Family in Front of Tarpaper Shack' was the first family portrait I found in the archive (figure 4.3). It was taken sometime in 1943, probably during the family's second year in the Tashme camp. It looks like a typical family portrait with the mother and father figures, in their mid-fifties or early sixties, seated facing the photographer and surrounded by children figures. Two daughters, apparently in their early twenties, stand behind the parents, while two young boys, approximately six and four years old, are tucked protectively between the mother and father.

A closer inspection reveals signs of tension. The older boy sits prominently on the left knee of the mother, indicating that he is the first son or grandson. His head tilts towards the mother and away from the father, suggesting an intimate bond that excludes the father. Head uplifted, he looks confidently towards the photographer. He is clearly (in) the centre of the photograph. The mother leans towards the boy with her left hand around his waist, securing his position. Yet the boy's left elbow extends towards the father, surreptitiously touching his arm, suggesting a desire for connection. Together the mother and son lean towards the father, suggesting that their bond was not made to usurp the father, but because of his emotional distance. The father sits upright, squarely facing the camera, looking sternly into the camera, exuding an air of authority. At the same time, the angle of his body makes him seem oblivious to everyone in his family except the young boy standing between his legs. He seems to be intimately bonded to the boy. Rather than holding the boy's hand or using the distant 'hand of authority' to grasp his shoulder, the father supports the loose-kneed boy between his legs. The boy appears as an extension of the father rather than a separate subject who seeks the reassurance of the father's hand or needs to be controlled with a firm grip. While the boy pouts and holds his hands protectively in front of himself as if resisting the father's overpowering presence, he still leans into the father, allowing the father to keep him upright.

The scene hints at the rarely discussed emotional difficulties for men coping with internment. Long periods of absence from their families and/or unemployment must have undermined their abilities to fulfil their roles as the heads of their households. This would have been devastating if a father's sense of self relied, at least in part, on fulfilling the material needs of his dependents and maintaining order in the family household. The age of the father in the Okada family photograph would have made it difficult for him to find employment, especially if, like many other internees, he was not a labourer or to trained to operate heavy machinery.[9] As a result it is likely that the family relied on the daughters

for income, pointing to the erosion of patriarchal authority that began to occur in the camps. The isolation of the father from everyone but the youngest boy suggests the feelings of inadequacy, shame and anxieties associated with the inability of men to 'take care' of their families. At the same time, it is still safe to bond with the youngest boy whose needs can be easily fulfilled and who, unlike the other members of his family, cannot yet see the father's vulnerabilities.

The daughters stand behind everyone, part of the background but also signifying 'the backbone' of the family. The daughters are the only members of the family who smile, as if they are nervously aware of what viewers might see. The mother's head partly obscures the face of the daughter behind her. The other daughter turns away from her sister (and the mother) and faces the father. It is as if the family has isolated the daughter on the left, suggesting she is a source of anxiety. So, while the composition adheres to the basic conventions of family portraits, with the parents in the centre, older children supportively surrounding them and the younger children in the front, it also suggests a drama of family exclusions and emotional factions: mother and oldest boy; father and youngest boy; one daughter isolated but still looking over her parents. The unfortunate composition could be the result of a quickly taken photograph without the usual instruction to 'stand closer' and 'look towards mother'. Yet the result suggests that the conventions of family photography can no longer make members perform as a unified unit. The photograph cannot contain the tensions, shame and anxieties of life in the camps. This is evident at a number of other levels as well.

The identities of the subjects in the photograph are not apparent, which creates an anxiety in the viewer about the nature of the relations holding this group together. Are the young boys children or grandchildren? If grandchildren, then their father is missing. Are they the sons of the older parent figures? It was common to have a set of older children from before the war and a younger set conceived in the camps. The 'camp babies' increased demands on older parents barely managing to adequately clothe and feed their prewar children. Since this photograph is from 1943 and the oldest boy is at least four years old, he was definitely born before they were sent to the camps in 1942. So, while the age of the boys suggests 'camp babies', they are more likely grandchildren. There must be a missing son or son-in-law. Amongst the seven photographs donated to the archive by Kayo Okada, there is one photograph of a 'road camp' (unnamed), one of the camps where the government sent able-bodied Japanese-Canadian men at the beginning of the war, separating them from their families for over eight months. The Nisei Mass Evacuation Group, a group of young, second-generation men, openly protested

against the government's policy to send family members to different camps. Fearing a large uprising, the government reunited men with their families in the winter of 1942 (protestors were sent to POW camps).[10] In this context, the photograph of the road camp indicates that a son or son-in-law is missing from the family photograph. Either way, the presence of the young boys suggests both 'camp babies' and a missing son – and recalls the material and emotional pressures entailed by both.

Another noteworthy feature of this photograph is the casual clothing worn by the parents and boys. The (grand)father wears a loose-fitting shirt, with his thick trousers tucked into his boots, while the mother wears a cardigan over a dark dress, her hair tied back in a bun. For family portraits, more formal attire is expected.[11] Again, the photograph might have been taken impromptu – everyone quickly gathered without time to prepare themselves. But given the formal conventions regarding public appearance during this period, the clothing nevertheless signals a 'letting go' of social formalities and the care of the self. This 'letting go' of social propriety is also suggested in the representation of their internment shack. Like many prewar portraits, the family is arranged in front of the entrance to their 'house'. But unlike the prewar photographs, the shack is not proudly displayed as their 'home'. The photograph tightly frames the family so we only see the bare wooden door and a little of the brittle tarpaper covering the exterior of the wooden shack. The way their 'home' is hidden from view recalls the thousands of houses that Japanese Canadians lost during the war. Believing the government's assurance that their removal from the coast was temporary, they left their houses, businesses and properties in the care of the Custodian for Enemy Aliens. What was not vandalised was liquidated by the government without the owners' permission and for prices far below market value. The proceeds were used to cover the costs of their internment.[12] In this context, while the two boys on the knees of their (grand)parents might normally recall the pleasure of bedtime stories, the line from the children's story of the Three Pigs, 'I'll huff and I'll puff and I'll blow your house down' comes to mind.

As a social practice, photography is one of the 'family's primary instruments of self-knowledge and representation – the means by which family memory [is] continued and perpetuated, by which the family story [is] henceforth … told'.[13] So while the government confiscated cameras from Japanese Canadians, supposedly fearing espionage, this policy also restricted an important social practice by which Japanese Canadians constituted their social identities. The fact that Japanese Canadians brought cameras into the camps and continued prewar traditions underlines how integral photography had become in constituting the self

in relations to others. In this context, taking photographs suggests both efforts to reiterate prewar identities and the extreme difficulty in upholding the cohesive image of family and self.

To further understand the significance of family photographs, I asked Midge Ayukawa and Marie Katsuno about their recollections regarding the conditions of photography in the camps.[14] I learned that in addition to internees who ignored the ban and kept their cameras, the government permitted a number of Japanese-Canadian professional photographers to bring their equipment to the camps. With film and darkroom supplies from the government, they were responsible for documenting institutional life in the camps. Most photographs of the camps are these 'official photographs', which include class photographs of students, United Church congregations, sewing clubs and evening entertainment such as plays or musicals performed by the internees.

As yet, documents specifying the terms of the agreement between the government and these 'official photographers' have not been found, and unfortunately, these photographers have passed on, making it very difficult to reconstruct the way they negotiated the official relationship. If the government kept their photographs or negatives, none have been found in the Library and Archives Canada where most of the records regarding the 'Japanese Problem' have been deposited. The only documents referring to photographs found thus far involve correspondence about the itineraries for special International Red Cross inspection tours. Usually arrangements were made for a photographer from the National Film Board (NFB) to accompany the entourage and take illustrations for various reports on the living conditions of the camps.[15]

With regard to the other photographs taken in the camp, Ayukawa and Katsuno claim that the restrictions on the use of cameras began to loosen in 1943. Again, no references to changing policies regarding the more lax regulations have been found. Yet according to the interviewees, after the first year in the camps, adolescents started using Brownie cameras, openly taking snapshots of friends and mailing their film for processing. When I asked why so few people took evidential records of the harsh living conditions, the interviewees described the social dimension of taking photographs, explaining that no one wanted to humiliate individuals and families. Their accounts indicate how photographs as visual practices place the photographer, subjects and viewers in social relations. Their accounts also suggest how photographs are cultural objects that their subjects expect future generations to view. Most of the evidential records were made by NFB photographers during inspection tours. Documenting the camp facilities and living conditions, they probably viewed Japanese Canadians as 'foreign nationals' or as subjects

undergoing reform in one of the government's wartime programs. The one exception is the Japanese Canadian Tak Toyota, a prominent prewar photographer, who produced records of the different phases of internment. Most of his photographs available today document the last phase after the end of the war in 1945 when the government shipped four thousand Japanese Canadians to Japan and relocated the rest outside of British Columbia.[16] Like the NFB photographers, taking the photographs probably required distancing himself from the subjects. But, by contrast, he was concerned with producing evidence of what happened for future generations.

If photography in the camps continued a prewar social practice, why are there only two formal family portraits and a handful of family snapshots? Is it possible to argue that the disappearance of the family photograph is a sociological indicator of the success of the measures taken to dismantle the family unit in a larger programme of assimilation?[17] If the family photograph is viewed as a social practice, this explanation is too simplistic, foregoing the challenge of examining these images both as social practices and as visual texts. At one level, the small number of family photographs can be explained by the social relation between the photographers and their subjects. As Katsuno and Ayukawa have underlined, most people took photographs of happy memorable moments, carefully avoiding photographs that might humiliate their subjects. It is also possible that Japanese Canadians are hesitant to donate personal family records to the archive where others can view them. Most of the (very few) photographs of individuals in the archive have restrictions on their use, indicating that the material is still sensitive. At another level, the organisation of the images into fonds donated by different 'families' suggests that many families have photograph collections. In other words, collecting photographs that trace the life of individual families has continued. The disappearance of the family photograph, then, does not necessarily indicate the government's success in dismantling the Japanese-Canadian family. Japanese Canadians went to tremendous efforts to keep family units intact, for example, by protesting against the separation of families during the first year. Rather, understood as a social practice where the photographer and subjects are capturing a moment for future recollection, the disappearance of the family photograph suggests that – as an intimate object to be passed between generations – it could not bear the distress that the family underwent in the camps. The distress, even if disguised by the conventions of family photography, was not something the internees could bear to record.

'Homma Family: Slocan Valley' (figure 4.4) is the second family portrait that I found in the archive. Like the portrait of the Okada family,

it was taken outside their internment shack. Snow covers the ground, indicating that it is winter; but nevertheless everyone has gathered outside, suggesting that it is a special occasion. Adhering to the conventions of family portraiture, like the Okada family, the primary parental figure, Mrs Homma, is in the centre of the photograph surrounded by her offspring. The Homma family is much larger than the Okada family, with a total of fifteen adult children, husbands, wives and grandchildren. The adult male children form a protective 'backbone' of support, standing in a semi-circle encompassing the mother figure and her daughters, daughters-in-law and grandchildren.

In contrast to the Okadas, it appears that all the men in the family are present, since for every adult female, with the exception of Mrs Homma, there is an adult male. This is astounding under the circumstances. When the government reunited men with their families after eight months of separation, they were then usually forced to accept temporary jobs outside the camps in order to earn wages to cover the costs of their internment (including 'rent') when the funds generated from the liquidation of their properties ran out.[18] As such, the camps were typically marked by an absence of men. Moreover, it is surprising to see

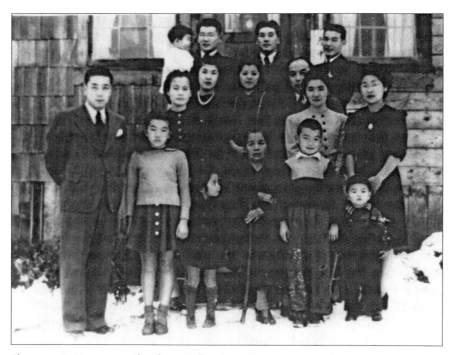

Figure 4.4 *Homma Family: Slocan Valley.* Circa 1945. Courtesy: Japanese Canadian National Museum, JCNM 94/88.3.005.

so many members of an extended family gathered together since they would rarely be assigned to the same camp.

The number of family members assembled impresses the viewer with their strength as a family – both the economic potential of the wage earners and the unity suggested by everyone's attendance. But the assembly of an entire family in this context does not just signify strength and unity. Since the government permitted families to reunite if they were being shipped out of the country, the gathering also ominously recalls the impending expulsion of families to war-torn Japan in 1945, even though the Homma family stayed in Canada.

The father is the only figure that is absent. The archival notes state that he died in the Slocan internment camp in 1945 at the age of eighty. The notes indicate that Mr Tomekichi Homma was a prominent member of the Japanese-Canadian community. In 1897 he was the first chairman of the Japanese Fishermen's Association, a formidable lobby group that challenged the government's discriminatory fishing policies. He started the first Japanese-language daily newspaper in Vancouver, among other civic duties, went as far as the Privy Council in England to fight for Japanese-Canadian enfranchisement in 1902, which in the end was denied.[19] Given his dedication to civil rights during his long years in Canada, spending his last years in an internment camp is cruelly ironic. While we know that his family would be shortly released from the camp and that the government lifted all legal restrictions on Japanese Canadians in 1949,[20] Mr Homma died with only the knowledge of the entrenched discriminatory policies in Canada. In fact, the formal dark suits and dresses worn by the adults suggested to me that the photograph was taken on the occasion of Mr Homma's funeral: Ms Homma, Mr Homma's granddaughter, subsequently confirmed this. His funeral adds a layer of bitter poignancy. We witness the family witnessing his funeral. They know even more than the viewers about his commitment to democracy. We know that this photographic record will always remind them that, in the hands of his government, he died stripped of his rights.

The framing of the photograph is significant. The photographer has taken the portrait from a distance to ensure that everyone fits into the frame. The distance adds an element of formality, not permitting the intimate proximity granted in the Okada family's photograph. Yet with the poor outdoor lighting, the distance also diminishes the mother figure, Mrs Homma, emphasising how her children and even her grandchildren tower over her small stature. In a photography studio, her significance could have been elevated with lighting or by placing her in a heavy, throne-like chair, endowing her with the weight of maternal authority. Instead, the viewers see that, despite the way her family has flourished

with so many children, in her old age she stands in the snow outside a shack in an internment camp. Yet at the same time, the distance permits us to see more details of their shack. The addition of cedar shakes to improve insulation and the white curtains framing the windows reinforce the image of a materially secure family.

The composition of figures suggests that a new figure of authority has literally come forward. All the adult children stand behind Mrs Homma except one son who is on the extreme left of the front line. Because he is closest to the camera, he is the largest figure in the photograph. Yet his position in the family is ambivalent. He is in the front line with the grandchildren and Mrs Homma, not with his brothers and sisters standing behind their mother. If he took up the traditional position of authority he would be standing over his family or they would be gathered in support around him. The composition recalls the tensions and disagreements between members of the same family,[21] even though the Homma family might not have experienced conflicts. It is important to remember that the composition could be the result of a hastily taken photograph with little time to arrange everyone properly. At the same time, this makes multiple readings possible. Filial deference and the caring regard of the son are signalled in the way he folds his hands respectfully behind his back and angles himself slightly towards his mother, Mrs Homma.

A daughter figure stands beside the son, wearing a skirt and jersey that she has outgrown. Her thin bare legs stretch out below the hemline of her skirt, her growing body a painful sign of the literal containment of life in the camps. Yet at the same time she holds the hand of a younger sister or cousin who looks anxiously up at her grandmother, Mrs Homma. The young girl is the only one who dares look, drawing our eyes to Mrs Homma and suggesting a strong intergenerational link between the females in this family. Even though Mrs Homma is diminished through the optics and composition of the photograph, the concerned look of the young girl emphasises the way Mrs Homma remains the central figure in the family. All her adult children are organised around her. At the same time, she looks fragile and we sense her passage and wonder how her family will cohere once she is gone, a fear that many members of the younger generation in the Japanese-Canadian community face with the passage of their grandparents. So while the photograph presents the strength and unity of the Homma family, the photographic conventions cannot contain signs of tensions, grief and feelings of loss.

My reading thus far focuses on the inability of the conventions of family photography to impose cohesion. By using historical information about the camps and analysing photographic details – for example, about the setting and comportment of the subjects – a range of readings is possible without

knowing the precise histories of each family. Given how photographs construct 'a reality' that conforms to an ideal, there is no certainty that my readings describe the actual families with any accuracy.[22] From my readings, I cannot, for example, conclude that the Okada family was emotionally fractured into separate units. I could attempt to check my reading against 'reality'. But even 'factual' information would not alter what the compositions signify, as all families are acutely aware when they attempt to control how they 'look' to outsiders.

It is significant that initially I was not particularly interested in the family portraits I found in the archive. It was only because friends kept asking why my response was so disengaged that I slowly realised that these photographs '[bore] a huge burden of meaning and of feeling'.[23] As Hirsch writes, photographs that mediate memory and postmemory in the 'face of monumental loss … carry an emotional weight that is often difficult to sustain'.[24] Unable to cope with the meaning they bore, the way they disturbed my own sense of a cohesive, continuous, 'unending' family,[25] I made myself numb to the images, making them appear inert – so inert that it was uncanny. After working with the images over several years, I realised that there was something about them that made me feel claustrophobic, that terrified me.

My reaction was peculiar given my childhood fascination with my family's photographs from the internment camps. Every time I visited *Obaasan*'s home, I would spend hours studying the family photographs, gleaning every detail they proffered, quizzing adults for recollections. The photographs offered windows into a mysterious world that only existed in family stories. No one hid the fact that the government sent the family to an internment camp, but their accounts foregrounded – or perhaps I selectively foregrounded – adventurous stories about life amongst the tumbleweeds and ponderosa pine with the freezing winters and searing hot dusty summers vibrating with the ring of cicadas.

Why was I not disturbed by my family's photographs? Was it because they went to Lillooet, one of the 'self-support' camps where select groups of Japanese Canadians were permitted to lease land and buildings if they agreed to directly pay for the costs of their internment? Unlike Japanese Canadians who went to government-run camps, these families were not separated and there were fewer restrictions. But as Miki and Kobayashi point out, they were still categorised as 'enemy aliens' and 'threats to national security'; they were removed from their homes and stripped of their rights.[26] Yet what I remember about Lillooet are the stories, reassuring stories told by a mother to a child. Yet these are stories that are full of silences. They are silences that as a child I 'could not understand' but 'at some level knew something about and wanted to resolve'.[27]

Looking back, this was evident in my fascination with the camps. I felt compelled to return to the albums and repeat the family story, the important events, the details of my uncles' and aunts' lives, each time I visited *Obaasan*'s house. Was I searching for something or was I repeating a narrative to ward off underlying disorder and anxiety?

Marianne Hirsch's work on postmemory, a concept she developed in relation to the children of Holocaust survivors, offers a way to understand the investment that younger generations have in stories from preceding generations:

> [Postmemory] characterises the experience of those who grow up dominated by narratives that preceded their birth, whose own belated stories are evacuated by the stories of the previous generation shaped by traumatic events that can neither be understood or recreated.[28]

I cannot know the extent to which my experiences have been directly 'dominated by narratives that preceded [my] birth'. Yet, even as a child, I was intrigued by the family's stories, especially the story of Lillooet. It was a story of unity and strength: bad times were made memorable by recounting them as good times, highlighting the ingenuity of *Ojiisan*,[29] with his quick wits, strong sense of ethics and ability to provide his growing family with their material needs. In the family story, *Ojiisan* was the central figure, a larger-than-life patriarch.

According to Hirsch,

> photographs in their enduring umbilical connection to life are precisely the medium connecting first- and second-generation remembrance, memory and postmemory. They are leftovers, fragmentary sources and building blocks shot through with holes, of the work of postmemory.[30]

Postmemory is powerful precisely because of its connection to its object through 'imaginative investment and creation' rather than 'recollection'.[31] Imaginative investment and creation pose dangers as well as transformative possibilities. Since I was not 'there' with others who can challenge my recollections, there are few limits to what I can 'creatively' imagine. Yet imagination also opens the possibility for loosening investments fixed by conventions that reproduce the established social order. In *Family Secrets*,[32] Annette Kuhn shows the possibilities for creatively reworking the powerful hold that the conventions of family photography have on identity and for generating new narratives that release mother-daughter-father from its grip.

When I was a child, the imaginative work of postmemory involved first retelling my family stories. When I was old enough to recognise the tendrils of racial hostility in the everyday world, I sought the political

narratives of Japanese-Canadian history.[33] Both allowed me to secure a sense of self in the unity and plenitude of the family and a community that survived to seek justice from the government for violating their rights as Canadian citizens. This perhaps explains why I avoided the family photographs in the archive. They brought up anxieties about the family and community that I could not articulate.

Within the domestic domain, family photographs are confined to narrating the life of an individual family. In the archive they are released from the 'obligations' of ensuring the unity of the family and sustaining a coherent plot line across their successes and hardships. Despite being 'liberated' from individual family stories, I still felt awkward reading the family portraits in the archive. Family photographs 'are about memory and memories: that is, they are about stories of a past, shared (both stories and past) by a group of people that in the moment of sharing produces itself as a family'.[34] It feels intrusive to read the intimate memory objects of another family, to question 'the pleasure and held-off closure – happy beginnings, happy middles and no endings'.[35] Without knowing the details of their stories and histories, I submit their images to a misreading, writing a script for them that others will read as if the truth. From the start, my script cannot be anything but inaccurate. Yet my intent is not to describe the dynamics of particular families but rather to read the different constructions of 'the family' produced through the composition, lighting, setting and comportment of the different figures. The different constructions mean different things in different contexts. Unless I interview the subjects in the photographs, I cannot suppose that I am writing 'their' family stories. Instead I am reading the possible meanings produced by the photographic texts that, in the context of the camps have ambivalent and, in some cases disturbing, affective resonances across different generations.

Reading the family photographs from the archive forced me to see similarities with my own family photographs. What I pushed into the foreground in the photographs of the Okada and Homma families was precisely what was in the background of my family photographs. Like the parents in the Okadas' photograph, my grandparents were visibly ageing, reaching and then passing their 'prime' in the camps. They also had 'camp babies' and adult children. The contrast between the ageing parents and the energetic small children made me wonder how they managed to feed and clothe the increasing numbers of young children. Without their older daughters to care for younger siblings, how would they have managed? What I could not face in my family, I finally faced in the records of other families: the family as a site of distress and the

bleak existence and the uncertainty, but also the determination to continue and a belief in a future beyond the camps.

Only once before had I experienced the shock of viewing family photographs outside the safety of family stories: this was in a multimedia installation collaboratively produced in 1990 for Vancouver's Powell Street Festival. Ana Chang, the artist working on the visual component, [36] created two separate narratives from images of prewar and postwar life. Using a number of tactics, Chang[37] disrupted the linear historical narrative entrenched in the community.[38] She explored visual continuities and discontinuities between photographs that she took of the contemporary community and photographs she found in archives and albums, and also traced slippages between images that foregrounded a history of loss and suffering underneath what appear to be veneers of happiness and success. Using multiple slide projectors, the narratives were unleashed simultaneously in adjoining rooms temporarily constructed in the local Buddhist hall and synchronised to a sound track with different voices from the community. An example of her creative 'slippages' involved a series of my family's images. In one small visual flow she integrated three portraits, which in the family albums were separated by pages of photos that marked transitions in time and place.

All three photographs were similar at the formal level of composition, making it possible for the images to morph together. The images moved

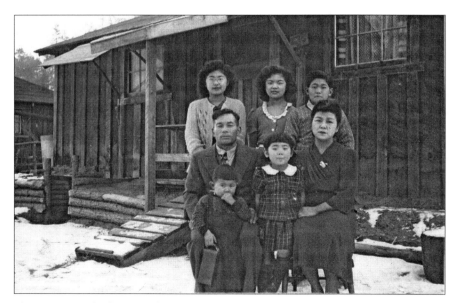

Figure 4.5 *Nakashima Family outside their shack.* Circa 1943. Courtesy: Nakashima family.

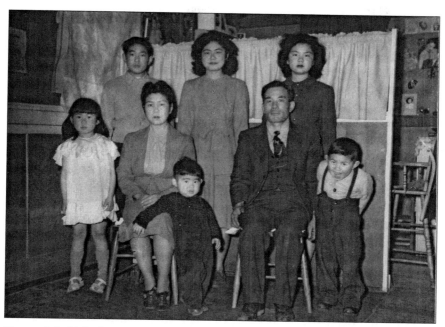

Figure 4.6 *Nakashima Family inside their shack.* Circa 1945. Courtesy: Nakashima family.

immediately from a prewar photography studio to the internment camp. *Ojiisan* and *Obaasan*, stylishly dressed in the studio portrait, relaxed and youthful with their three confident, perfectly groomed prewar children, rapidly aged in the space of seconds. The plumpness of health and youth dissolved and they were suddenly sitting in rickety chairs on the muddy ground in front of a decrepit shack (figure 4.5). In the last image they were inside its dark, cramped interior, surrounded by their growing number of children (figure 4.6). In the past I simply marvelled at my ability to recognise my mother as a teenager and my heroic uncles as cherubic toddlers. This was the first time I could see the distress in my family. Chang's work hit me with what I call 'synchronic shock', collapsing discrete moments once separated by time and place into one visual moment.

The archive offered another type of shock: the diachronic movement across different families in the same period. The resemblance between the Okada photograph and my family's portraits from Lillooet was remarkable. According to the conventions of family photography, like the Okada daughters, my adolescent mother and her sister Lillian stood dutifully behind my grandparents, stiff and straight along with gentle, dependable uncle Bob. In contrast, their younger siblings, like the Okada

boys, are animated and constantly in motion. Like the mother and father figures in the Okada photograph, my grandparents seem stiff, showing signs of ageing and fatigue in contrast to their exuberant young children (figure 4.6). My uncle Rick, aged two, confidently drapes his arm over *Obaasan*'s lap with surprising ease and affection while she appears tense, sitting upright, in a tailored suit and high heels. At her side, aunt Margaret stands self-consciously, awkwardly balancing on the sides of her feet and grasping the flounces of her hemline. Several years older than Rick, she would have been more aware of unspoken tensions in the family. While *Ojiisan* sits confidently wearing a suit with a waistcoat, he looks gaunt and his shoes are coated with dust, as if signalling that he is slowly being worn down. Uncle Frank, aged four, stands at his side eyeing the camera and squirming gleefully. The scene recalls stories of parents and older siblings who bore the weight of creating the semblance of secure, safe 'homes' in the camps in British Columbia and the beet farms in the prairie provinces where the government sent approximately four thousand people as family units to work as labourers to boost wartime sugar production.[39]

While intellectually I was aware of the distress that Japanese-Canadian families underwent, it was shocking to encounter it within the symbolic space of the family photograph. Both reading factual accounts and listening to the individuating force of 'personal narratives' safely distances and contains the distress of the family. What distinguishes family photographs in the archive is that, outside the private domain of the family, the distress of the family cannot be overridden with accounts that narrate the 'bad times' into the larger family story of success.

Returning to the installation described above, while I could always try to re-narrate the three photographs back into the family story, the breach had occurred. Nor could I re-narrate the photographs from the archives back into their family stories, in part because I did not know the stories (and if I did, I would not have the same investment in resolving their narratives).[40] Kuhn argues that the series of pictures in a family album constructs a family story like a classical narrative insofar as it is linear and chronological. At the same time, she describes how its cyclical repetitions and climatic moments such as births, weddings and deaths are 'more characteristic of the open-ended narrative form of soap operas than the closure of the classical narrative'.[41] The cyclical repetitions of the open-ended narrative ensure that the life of the family continues.

The photographs I selected from the archive were not from a series of pictures with cycles of repetition. There are seven Okada photographs, all from the war period. There are also seven Homma photographs: three from Tashme, three from before 1922, and a 1991 sketch of a school

named after Mr Homma. There are no postwar photographs, except for the sketch of the school commemorating Mr Homma's contributions to society. Without photographs from the postwar period, each family remains trapped in the internment camps.

Kuhn describes in more detail the relation of what she calls the 'poignant' quality of photographs to their temporality.[42] In seizing a moment in time, photographs always assume loss in the very hope they attempt to instil. The photograph as a record 'looks towards a future time when things will be different, anticipates a need to remember what will soon be past'.[43] Poignancy comes from the failure to completely fulfil this hope for things to be different. The photographs from the camps not only point to the impending failure of hope, they are also marked with immediate signs of mortality. The bodies of the parental figures are consumed by signs of ageing; the absence of Mr Homma signifies the actual death of the father and even the young adults and children are tinged with dying. In the camps life does not 'go on': everyone is held in stasis while the world outside spins onwards. In the meantime, the potential of their young bodies and dreams dwindles as the months and years pass by. Thus death is not just structured into an inevitable future; rather these photographs capture the social death imposed by the internment camps.

I have argued that the conventions for the family (photographs) were breaking down, unable to contain the distress and chaos Japanese Canadians underwent as the government implemented measures to break down the structure of their families and community. In this context, as a visual practice that constitutes one's identity as a daughter or mother, photography can be seen as an effort to reiterate a self under the threat of dissolution.[44] It is a practice used in the struggle to maintain self-integrity. But how does this figure with the way in which 'photography's social functions are totally integrated into the ideology of the modern family. The family photo both displays the cohesion of the family and it is an instrument of its togetherness; it both chronicles family rituals and constitutes the prime objective of those rituals'.[45] Given the normative identities constituted through family discourses, my anxieties involved more than the breakdown of family conventions and loss of self-integrity.

One of the strongest feelings I had in relation to the family portraits was claustrophobia. The way the photograph tightly framed the families and the dim lighting recalled descriptions of the cramped (16 by 28 feet) shacks that housed two families with a minimum of eight people through the furnace-hot summers and the freezing winters.[46] But the close framing (possibly to remove the unpleasant signs of the shack) was not the only disquieting element. There was also something about the daughters that drew my attention. I realised that I was looking for my

mother amongst the photographs. As a child whenever I looked through the family albums, I always looked for my mother, feeling relief and pleasure when I found her. I would even practice finding her amongst large groups of children where the distance made her face almost indistinguishable from the faces of other children.

According to Hirsch, family photographs constitute the family through a series of 'familial looks' that 'consolidate familial relations among the individuals involved'.[47] The individuals can include the viewer, the subjects in the photos and the photographer. As Hirsch argues, familial looking is an 'exchange of looks' where the look of the viewer is returned by, for example, the subject in the photograph. The familial look is structured with *the need for* the look to be returned. In the look that is returned, one seeks recognition from another family member. The look of recognition secures one's identity, for example as the daughter or mother.

But this look is far from a simple 'embrace' that secures one's identity, as Kuhn so adeptly demonstrates in *Family Secrets*. Likewise Hirsch questions whether this look can be a 'nonappropriative form of affiliation' or whether it always cannibalises the other, incorporating the other into the self.[48] For example, the desire for recognition that becomes a demand for unconditional acceptance from a member of the family, no matter what one does or says, threatens to engulf them, obliterating their distinct needs and their bonds to other individuals. Unconditional acceptance is something that only the mythical mother can give. It perpetuates an 'illusion of the self's wholeness and plentitude'.[49] Another risk is in that one is inevitably misrecognised. For example, there is the anxiety that one will not be recognised as the 'good' daughter wanted by the parents. Conversely, being recognised exclusively as the 'good' daughter might also mean that the parents cannot accept their daughter outside the terms of their own desire. As an exchange essential to the constitution of the self that is scored with anxieties and infantile desires, it is important to bring its hidden impulses into the open.

In the family photographs I return the look of my mother *in need* of her fierce recognition *in* me of something beyond what is prescribed by my/her gender and the fading marks of the 'yellow race'. This is the hope that her generation had in their country, Canada, as a democratic nation that promised to fulfil their dreams of equality and freedom.[50] At the same time, like the *Nisei*,[51] the fear of being misrecognised overwhelms me. While their fear was of being misrecognised as 'enemy aliens', mine is of being confined to the dutiful daughter in this mother-daughter bond where relations outside the family pose a threat to the constitution of the family. Here the dangerous element of postmemory comes into play. What limits are there on my imaginative investment and creation? Is there

anything to check the impulsive drive to repeat and fix my own fears in postmemory?

Returning to the photographs, I found my mother's resemblance to the Okada daughters startling. There they stood, dutifully behind the parental figures, good daughters in the background so carefully poised, their hair swept into permed Bette Davis coiffures surreptitiously signalling an escape route into the daydreams of popular culture.[52] The parental figures focus on the animated boys held in their laps. In as much as the young boys were animated – alive – the daughters appeared to be tensely holding themselves in (their) place(s), inert. Likewise, in the last family portrait in Lillooet, my mother and aunt Lillian stand with my uncle Bob behind their parents. Seeing my mother in the Okada daughters, I realised that I was replaying my mother's story, a story that I have made for her. I felt the suffocating restrictions that squeezed the life out of the daughters in the camps. As the government swiftly imposed restrictions on Japanese Canadians, the responsibilities of the dutiful daughter (and son) doubled. Suddenly there was no room to indulge the whimsical dreams of adolescents who were old enough to contribute to the domestic economy of camp survival. The claustrophobic grip of the family over the adolescent daughters tightened.

Postmemory ties me to the past through the creation of my mother's story. In my version of her story, through hard work and determination (like her father) she escapes the patriarchal family (her father, the restrictions of Japan) and the aftermath of the internment camps by winning a scholarship to the University of British Columbia in the early 1950s. At the University of British Columbia she excels, leaving chemistry for biochemistry. Winning more scholarships and working at Essendale Mental Hospital in the summers, she achieves independence. One conclusion to this story of escape ends with the marriage – the end of her university research career and her final capture: she gets a husband, as was the case with many young women in the 1950s. In another, more open, ending she pursues her creative and intellectual work as a teacher, anti-racist activist and skilled potter.

This is the story of escape, capture and creation that I have constructed for my mother and realise I have internalised for myself. The claustrophobic fear of being confined and restricted by family is evident in my reaction to family photographs from the camps. Until recently it drove me to move away from my family and 'home place' while at the same time idealising both, much like my mother's idealisation of family and internment camp. Yet, through finding my mother in the photographs from the archive, I found not simply my mother but my mother as one of many young women who were thrown into the camps each with different stories of escape, capture and creation. The exchange of looks shifts as I

see them seeing me, the daughter of another young woman like themselves in the camps.[53] I wonder what their stories might be and how they might tell my mother's story differently. There is a release from the mutual look that locks mother and daughter into a pact of identification that does not allow either to release the other from her place.

It is a pact that protects two contradictory storylines: it is a story of escape and also a story of the idyllic family as a place of security and happiness. One way to see the separation of the two storylines is as a means to protect both possibilities. In my mother's rendition, I interpret 'escape' as the story of an independent, intelligent and adventurous young woman (like her own mother) – who refuses to acknowledge the family as a place that threatens to suffocate her in the role of dutiful daughter. At the same time, the story of the happy family protects the family from a further 'death' and also from her death as a daughter. One way to free herself from the restrictions and responsibilities of the dutiful daughter that have become suffocating within the incarceration camps would have been to have symbolically 'killed' them, cutting herself off and rejecting her role as dutiful daughter. She does not do this and instead protects them in a story of idyllic family life in the camps. To refuse to return the look from her family – struggling as best they could to survive the social and economic devastation as well as humiliation of being treated like traitors and criminals by their government – was something that she could not do. At the same time, she was driven to escape – yet not at the expense of severing herself from the deep bonds of love and loyalty.

Postscript

Looking through the photographs in the archive, I came across a snapshot of a group of children bundled up in mitts and toques. It was as if they had quickly assembled in front of a small alpine log cabin, dishevelled and laughing, perhaps after sledding or a snowball fight. Arranged affectionately around a small boy and family dog, they were the picture of happiness. The photograph is part of a series of three snapshots from the Slocan camp pasted into a photograph album (figure 4.7). Inscribed in the space between the images was a haiku that remained inaccessible to me until it was translated by an acquaintance of my mother's.

Of all the family photographs from the internment camps, I was the most attached to these images, especially the photograph pasted in the centre of the page (figure 4.8). The children appeared free from a strict, regimented family order. Even though the children were arranged according to age, with the oldest boy standing behind everyone, they

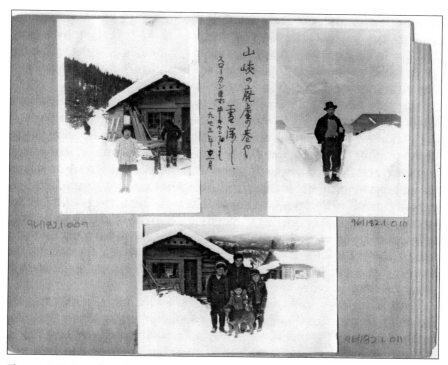

Figure 4.7 *Page from the Ezaki photograph album.* Circa 1943. Courtesy: Japanese Canadian National Museum, JCNM 96/182.1.009, JCNM 96/182.1.010 and JCNM 96/182.1.011.

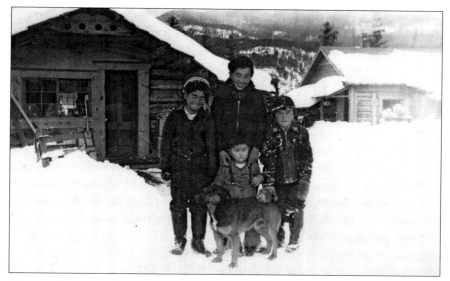

Figure 4.8 *Detail of the Ezaki photograph album.* Circa 1943. Courtesy: Japanese Canadian National Museum, JCNM 96/182.1.011.

stood closely, affectionately leaning towards each other (albeit the smallest boy looks a little wary of the three children leaning over him). The girl in her boots and trousers, covered in chunks of snow with a big mitt placed on the haunches of the dog, was clearly not restricted to a domestic role nor confined in a feminine pose.

The only adult figure on the page is a man, perhaps an uncle or a father. He appears on his own in the second snapshot. Did he photograph the children? The archival notes describe him as an avid recreational photographer. Standing on the margins of the scene where happy animated children are free to play and work, he does not have the role of an authoritative adult. In the third photograph on the page, the girl casually stands in the snow with her hands tucked into the pockets of her smock, mouth slightly open as if caught in the midst of saying something to the photographer. It perfectly reproduces the scene from my mother's stories about the Lillooet camp. Yet the more I search for details, the more the resemblance falls apart. My familial look can no longer keep in place the camp scene as the scene of adventure.

First, it is questionable whether this is a family. Initially it looks as if the children are related and the man, a father or uncle. Clues from the archival notes and a telephone conversation with the donor, Mrs Ezaki, suggest otherwise.[54] The notes explain that her husband was sent to a work camp in Decoigne Alberta, joining her a year later in the Lemon Creek camp. From the photographs of the work camp, it looks as if the man in the snapshot is Mr Ezaki. If this is the case, the snapshots must have been taken in the following winter of 1942 when he was reunited with Mrs Ezaki. But it is not clear whether they are the parents of the children. Since she was born in 1917, she would have been twenty-five when the photos were taken in 1942. She would be too young to be the mother of the oldest teenage boy, making it unlikely that the second boy, who shares his dark eyebrows, wavy cowlick and high cheekbones, is her son. Perhaps the girl and the little boy with similar button noses are Ezaki children? But they do not seem to be in the later photographs when the government shipped the Ezakis to Japan.

If the features of the children suggest that they are not necessarily members of the same family, could they be related? Are they friends? And where are they now? The archival notes explain that the Ezakis were interned in Lemon Creek but the accompanying haiku refers to the Slocan camp, which is at least five miles to the north. This further suggests that the children are not Ezaki children but are from another camp. When I finally have the opportunity to meet Mrs Ezaki and her sister, I discover that I am wrong. The man is not Mr Ezaki (or rather, Reverend Ezaki, a Buddhist missionary from Japan who at the time still

had the family name of his first wife, Hukazawa). They did not have children until they left the camps, and they went with them to Japan in 1949. There they stayed for seven years while Mr Ezaki fulfilled his duties as a missionary. However, Mrs Ezaki can remember nothing about the children and the cabins.[55]

The cabin is not a typical shack, as indicated by the log construction, porch and large windows (see figure 4.8). There are even skis on the porch. Is it their cabin? Does it belong to one of the non-Japanese-Canadian residents still living in the 'ghost town', the term for abandoned mining towns where many camps were built? Is it their dog? Few families in 1942 would have been able to feed a large family dog. The well-fed dog suggests the presence of non-Japanese Canadians. The boys are working – cutting wood (see figure 4.7): are they working for one of the local residents, or are they doing family chores? The fact that the girl in the photograph pasted on the top left of the page stands in the snow wearing just a smock and shoes suggests that she has been inside one of the cabins: does this mean she lives there? The inability to answer these questions destabilises the appearance of happy scenes of family life in these snapshots, snapshots that a number of my friends with little knowledge of the camps have argued could be mistaken for winter holiday scenes in the rustic Canadian outdoors. In turn, the surfaces of my own family myths begin to lose stability.

The haiku further undermines the appearance of the snapshots as a series of happy moments stolen from the camps and later kept as mementos during the harsh years spent in war-torn Japan. Inscribed in the space between the images, it echoes moments literally frozen in memory, painfully expressing the opposite of appearances:

> Springtime in ghost town among mountains
> Snow deep[56]

The haiku is followed by the inscription, 'at Slocan Concentration Camp, November 1943'. The Japanese characters resonate with 'emptiness', 'harshness' and 'perseverance'. Like the haiku, many accounts describing what happened in the camps have been inaccessible to most members of the postwar generation. This is not only because we do not understand Japanese (translations mean delayed understandings). In addition, we still struggle to create new narratives and imagery to translate their articulations into meaningful forms that exceed the fixity and repetition of our own postmemories.

The photographs of families taken in Second World War internment camps for Japanese Canadians show the efforts of Japanese Canadians to

resist the government's measures to dismantle not just social institutions but social identities. If the photographs are read as social practices, on the one hand, they indicate the effort to instil continuity between prewar and wartime life. The small number of photographs does not necessarily indicate the disappearance of the family *vis-à-vis* the supposed disappearance of the practice of taking family photographs. As Ayukawa and Katsuno have pointed out, the paucity of family photographs in fact points to the social dimension of photography: people with cameras were careful not to record families in difficult circumstances, further humiliating them. The way in which the archive is organised around donations by families is a better indicator of both the continuity of Japanese-Canadian families and the continuity of the social practice of family photography.

At one level, my reading of the family photographs shows that conventions of family photography were unable seamlessly to instil cohesion, gender roles and positions of authority. Instead, tension, conflict, alienation and grief are evident. The family photograph cannot conceal the distress the family undergoes during internment. At another level, as a member of the postwar generation, in order to write this chapter I had to contend with the way the family photograph bears 'a huge burden of meaning and of feeling'. To read these photographs, at stake is a sense of self that is sustained both through my employment of personal narratives and the deployment of institutional discourses in the constitution of myself as part of a family and a community. This makes the analysis both gratifying – as I retrace familiar images and enact the powerful force of normative discourses – and terrifying, as my investments in the family as a site of unity and security are brought into question.

It is painful to prise apart the seamless surfaces of the photographs that are locked into family narratives. When the narratives are protected by the mutual looks between daughter and mother, it is terrifying to question their underlying impulses. In attempting to do so, I found my own complicity in the impulse to repeat my version of the story of escape, passed from mother to daughter to lovingly protect the bonds of a caring and loyal family. As I looked through the archive, as a daughter I searched for my mother, wanting to *secure her* in my look of recognition. I found her as one among many young women thrown into the camps. Suddenly her story was not the only story, just as her look was not the only look. Would my recognition of these other stories help ease the grip of the familial look? Would it allow her the freedom I always imagined she sought in the story of escape? Would it allow her to escape the story that I so carefully and loving crafted for her?

Notes

This chapter owes much to the creative and intellectual inspiration, as well as the steadfast encouragement and insightful feedback, of Annette Kuhn. I would also like to thank Glen Lowry for his incisive and thoughtful feedback in composing the piece. Were it not for ongoing discussions with Jackie Stacey and her thoughtful questions, I would not have considered writing about the family photographs. I must also thank Grace Thompson, the former Executive Director of the Japanese Canadian National Museum (JCNM), Daien Ide, the former research assistant at the JCNM and Reiko Tagami, the JCNM assistant archivist – all were tremendously helpful in researching the photographs. I would also like to thank, Midge Ayukawa, Mrs Fumiko Ezaki and her sister, Mrs Kimiko Nasu, as well as Ms Tenney Homma and my family for thoughtful input and support. A postdoctoral fellowship from the Social Science and Humanities Research Council of Canada generously supported my research.

1. *Obaasan* is the formal Japanese term used for 'grandmother'.
2. The political history of Japanese Canadians was extensively researched and then written by political activists in the 1970s and 1980s as part of the movement to seek redress from the Canadian government for the violation of their rights. See Ken Adachi, *The Enemy That Never Was: A History of the Japanese Canadians*, Toronto: McClelland and Stewart, (1976) 1991; Anne Sunahara, *The Politics of Racism: The Uprooting of Japanese Canadians During the Second World War*, Toronto: James Lorimer, 1981; National Association of Japanese Canadians, *Democracy Betrayed: The Case for Redress*, Winnipeg: National Association of Japanese Canadians, 1985; Roy Miki, ed., *This is My Own: Letters to Wes and Other Writings on Japanese Canadians, 1941–1948*, Vancouver: Talonbooks, 1985; Audrey Kobayashi, 'The Uprooting of Japanese Canadians After 1941', *Tribune* 5, no. 1, 1987, pp. 28–35. In 1988 the National Association of Japanese Canadians negotiated a redress settlement with the Canadian government that included an official apology for violating their rights and funds for community projects. For the details of the agreement see Roy Miki and Cassandra Kobayashi, *Justice in Our Time: The Japanese Canadian Redress Settlement*, Vancouver: Talonbooks, 1991.
3. See Miki, ed., *This is My Own*.
4. For examples of studies of photography that examine the construction and control of 'deviant subjects' see David Green, 'Classified Subjects: Photography and Anthropology: The Technology of Power', *Ten 8* 14, 1984, pp. 30–37; John Tagg, *The Burden of Representation*, Minneapolis: University of Minnesota Press, 1993; Suren Lalvani, *Photography, Vision, and the Production of Modern Bodies*, Albany: State University of New York Press, 1996; Anne Maxwell, *Colonial Photography and Exhibitions: Representations of the 'Native' and the Making of European Identities*, London: Leicester University Press, 1999; Eleanor Hight and Gary Sampson, *Colonialist Photography: Imagining Race and Place*, London: Routledge, 2002. For examples of critically reading the perspective of others in colonial photographs see Elizabeth Edwards, *Raw Histories: Photographs, Anthropology and Museums*, Oxford: Berg, 2001. For an example of photographs taken by racialised subjects see Faith Moosang, *First*

Son: Portraits by C.D. Hoy, Vancouver: Arsenal Pulp Press, 1999 and Richard Chalfen, *Turning Leaves: The Photograph Collections of Two Japanese American Families*, Albuquerque: University of New Mexico Press, 1991.

5. Siegfried Kracauer, *The Mass Ornament: Weimar Essays*, Cambridge, Massachusetts: Harvard University Press, 1995, p. 56.

6. Ibid.

7. Allan Sekula, 'Reading an Archive: Photography Between Labour and Capital', in *Visual Culture: The Reader*, ed. Jessica Evans and Stuart Hall, London: Sage, 1999, pp. 181–192.

8. Marianne Hirsch, *Family Frames: Photography, Narrative and Postmemory*, Cambridge, MA: Harvard University Press, 1997, p. 7.

9. Sunahara, *Politics of Racism*, pp. 70–76; Kiyokoi Takahara, Interview with Kirsten McAllister, New Denver, British Columbia, 23 August 1996.

10. Sunahara, *Politics of Racism*, pp. 70–76; Miki and Kobayashi, *Justice in Our Time*, p. 71.

11. Grace Eiko Thomson, 'Afterward, Archival Photographs from Cumberland, BC', *West Coast Line* 43, no. 38.1, Spring 2004, p. 83.

12. Sunahara, *Politics of Racism*, pp. 102–111.

13. Hirsch, *Family Frames*, pp. 6–7.

14. Midge Ayukawa, Interview with Kirsten McAllister, Vancouver, British Columbia, 14 September 2000; Marie Katsuno, Interview with Kirsten McAllister, Burnaby, British Columbia, 12 September 2000.

15. A series of exhibits in 2003 at Presentation House, a photography gallery in North Vancouver, British Columbia, with photographs of Japanese-American concentration camps by Ansel Adams included a selection of photographs of the camps taken by the National Film Board photographer, Leonard Frank. See, Presentation House Gallery, 'Past Exhibits 2003', accessed 10 December 2004, http://www.presentationhousegall.com/past2003.html.

16. Sunahara, *Politics of Racism*, pp. 117, 143.

17. Policies and programmes aimed at 'assimilating' Aboriginal people over the last century also rely on separating families, but the methods have been much more coercive and abusive. See Suzanne Fournier and Ernie Crey, *Stolen From Our Embrace: The Abduction of First Nations Children and the Restoration of Aboriginal Communities*, Vancouver: Douglas and McIntyre, 1997.

18. Sunahara, *Politics of Racism*, p. 72; for an important study on the separation of families and labour policies for Japanese Canadian internees see Mona Oikawa, '"Driven to Scatter Far and Wide": The Forced Resettlement of Japanese Canadians to Southern Ontario, 1944–1949' (M.A. thesis, Toronto: University of Toronto, 1986, pp. 1–146); Mona Oikawa, 'Cartographies of Violence: Women, Memory, and the Subjects of "Internment"', *Canadian Journal of Law and Society* 15, no. 2, 2000, pp. 39–69.

19. Japanese Canadian National Museum Photograph Collection Notes for the Homma Photographs, 2000.

20. Adachi, *Enemy That Never Was*, p. 346.

21. Shoichi Matsushita, Interview with Kirsten McAllister, New Denver, British Columbia, 15 August 1996; Rolf Knight and Maya Koizumi, *A Man Of Our*

Times: The Life-History Of A Japanese-Canadian Fisherman, Vancouver: New Star Books, 1977, pp. 73–82.

22. Roland Barthes, *Image, Music, Text*, London: Fontana Press, 1977, pp. 18–25.
23. Annette Kuhn, *Family Secrets: Acts of Memory and Imagination*, London: Verso, 1995, p. 19.
24. Hirsch, *Family Frames*, p. 14.
25. Kuhn, *Family Secrets*, p. 19.
26. Miki and Kobayashi, *Justice in Our Time*, p. 41.
27. Kuhn, *Family Secrets*, p. 19.
28. Hirsch, *Family Frames*, p. 22.
29. *Ojiisan* is the formal Japanese term used for 'grandfather'. The family stayed in Lillooet despite the government's efforts to remove all Japanese Canadians from British Columbia in 1945. A few years after the government lifted all restrictions in 1949, they returned to Vancouver with many others who had livelihoods in the fishing industry. By 1951, only 7,100 of the original 23,000 Japanese Canadians remained in British Columbia. See Miki and Kobayashi, *Justice in Our Time*, p. 32.
30. Hirsch, *Family Frames*, p. 28.
31. Ibid., p. 22.
32. Kuhn, *Family Secrets*, 1995.
33. Kirsten McAllister, 'Captivating Debris: Unearthing a World War Two Internment Camp', in Jackie Stacey and Sara Ahmed, eds., *Cultural Values: Special Issue on Testimonial Culture* 10, no. 1 (2001), pp. 97–114.
34. Kuhn, *Family Secrets*, p. 19.
35. Ibid.
36. Thomas Lisgar, a sound artist, and Mari-Jane Medenwaldt, an oral history worker, were the other collaborators. Jason Hart, Barbara Worth and Jane Ferry also made significant contributions.
37. Chang typically works with the materiality of found objects, handcrafted materials and visceral imagery to explore projections of the shifting boundaries of voices-bodies displaced across different histories and cultural territories.
38. Kirsten Emiko McAllister, 'Narrating Japanese Canadians In and Out of the Nation: A Critique of Realist Forms of Representation', *Canadian Journal of Communication* 24, Winter 1999, pp. 76–103.
39. Miki and Kobayashi, *Justice in Our Time*, p. 31.
40. For examples of reading photographs of unknown families see Martha Langford, *Suspended Conversations: The Afterlife of Images in Photographic Albums*, Montreal: McGill-Queen's University Press, 2001; for a collection of innovative readings of family photographs, see Marianne Hirsch, ed., *The Familial Gaze*, Hanover and London: University Press of New England, 1999.
41. Kuhn, *Family Secrets*, p. 17.
42. Ibid., p. 42.
43. Ibid.
44. The idea of photography as a visual practice that helps subjects undergoing persecution maintain their self-integrity – to reiterate their sense of self under chaotic and threatening circumstances – must be credited to Gabriele Schwab

who made a comment at the Unconscious and Culture II Conference organised by the University of East London and held in London in 2004.

45. Hirsch, *Family Frames*, p. 7.
46. Matsushita, Interview with Kirsten McAllister; Senya Mori, Interview with Kirsten McAllister, New Denver, British Columbia, 5 September 1996; Pauli Inose, Interview with Kirsten McAllister, New Denver, British Columbia, 16 August 1996; Sunahara, *Politics of Racism*, p. 76.
47. Hirsch, *Family Frames*, p. 2; for a study of intergenerational memory and story-telling relations between Japanese Canadian daughters and mothers see Mona Oikawa, *Cartographies of Violence: Women, Memory, and the Subject(s) of the 'Internment'* (Ph.D. diss., Toronto: University of Toronto, 1999, pp. 1–404); also see Roy Kiyooka, *Mothertalk: Life Stories of Mary Kiyoshi Kiyooka*, ed. Daphne Marlatt, Edmonton: NeWest Publishers 1997; and Roy Miki, *Broken Entries: Race, Subjectivity, Writing*, Toronto: The Mercury Press, 1998.
48. Hirsch, *Family Frames*, pp. 276–277.
49. Ibid., p. 84.
50. See Miki, *This is My Own*.
51. *Nisei* is the term used for second-generation Japanese Canadians.
52. See Jackie Stacey, *Star Gazing: Hollywood Cinema and Female Spectatorship*, London: Routledge, 1994.
53. Hirsch, *Family Frames*, pp. 80–83.
54. Fumiko Ezaki, Phone Conversation with Kirsten McAllister, Burnaby, British Columbia, 12 September 2000.
55. Meeting with Mrs Fumiko Ezaki (nee Saito) and her sister, Mrs Kimiko Nasu, arranged by Reiko Tagami at the Japanese Canadian National Museum, Burnaby, British Columbia, 12 November 2004.
56. Haiku translated by Ayaka Yoshimizu, honours student at Simon Fraser University with consultation from Kyoko Kadokura of Nanaimo, British Columbia, July 13, 2005.

Part II

Dis/Locations

Chapter 5

The Return of the Aura

Contemporary Writers Look Back at the First World War Photograph

Marlene A. Briggs

> To perceive the aura of an object we look at means to invest it with the ability to look at us in return.
> (Walter Benjamin)[1]

As the centenary of the First World War (1914–1918) approaches, photographs from the period – especially recruiting images, group snapshots and formal portraits – continue to hold a special fascination for scholars and writers. Ted Hughes, Philip Larkin, Alan Bennett, Geoff Dyer and Terry Castle, an accomplished and eclectic group of poets and essayists, situate the photograph at the centre of their recursive preoccupation with the First, rather than the Second, World War. Despite their generational distance from the desolate landscapes of the Western Front, faded pictures of British infantry soldiers compel their belated acts of witness. In different ways, they exemplify what Marianne Hirsch describes as 'postmemory', reconstructive practices after massive trauma 'distinguished from memory by generational distance and from history by deep personal connection'.[2] The myriad losses of the Holocaust impact on successive generations, prompting consideration of the variable circumstances and staggered challenges which motivate its reception. Yet while Hirsch designates this tragic event an 'exemplary site of postmemory', commentators have thus far devoted little attention to the complex legacies of the First World War.[3] Accordingly, this discussion highlights the transgenerational impact of the conflict for descendants of veterans and other invested parties as well as the decisive role of visual media in its cultural afterlife. Complementing Hirsch's focus on the photograph in self-conscious memory work after the Nazi genocide, then,

this essay both builds on her research and departs from it in order to address the shifting significance of the photograph in the under analysed genres of writing which explore First World War postmemory.

Throughout the second half of the twentieth century, period photographs enthrall a range of canonical and non-canonical writers, including celebrated poets Hughes and Larkin, renowned playwright and screenwriter Bennett, novelist and critic Dyer, and Stanford University literature Professor Castle. Yet old photographs belong to an immobilised realm: as John Berger aptly remarks, they cannot move us; rather, 'it is we who *move* them'.[4] Writers who profess to find photographs of First World War soldiers *moving* must in fact employ specific narrative strategies to *move* and *re-move* these images. Hughes contributed 'Six Young Men' to his first collection of poetry, *The Hawk in the Rain*, over forty years after the battle of the Somme (1916);[5] Larkin included his frequently anthologised lyric 'MCMXIV' in *The Whitsun Weddings*, a volume whose year of publication coincides with the fiftieth anniversary of the outbreak of the hostilities.[6] Unlike the volatile first-person speaker of 'Six Young Men', who voices the contradictions which shape his conflicted response to a private snapshot of young soldiers, 'MCMXIV' gives only muted expression to the contexts and strategies which animate its reading of a public photograph. As if taking their cues from Hughes and Larkin, Bennett and Dyer also divide their attention between private and public photographs. But in contrast to the two poets, Bennett, Dyer and Castle reveal an increasing self-consciousness about their memorial activities in light of their distance from the experiences they seek to narrate. While *The Missing of the Somme*[7] is a book-length photographic essay in which Dyer juxtaposes image and text, 'Uncle Clarence' and 'Courage, mon amie' are lively prose works by Bennett and Castle, respectively, which both appeared in *The London Review of Books*. Bennett, Dyer and Castle engage the persons and places of the First World War era with obvious difficulty: battlefield pilgrimages, combat testimonies and secondary works by military and cultural historians supplement their discussions of photographs. Dyer and Castle, in particular, illuminate the distinct dilemmas of the third generation, demonstrating the laborious work of reconstruction fundamental to First World War postmemory at the end of the century.

Photographs haunt all five of these talented authors: the appeal of period pictures exceeds the factual or explanatory narratives which situate them in their historical context. More specifically, I argue that the complex relationship between the belated witness and the visual remainder of collective trauma warrants a reconsideration of Walter Benjamin's suggestive writings on aura.[8] In *Spectral Evidence: The*

Photography of Trauma, Ulrich Baer supports this agenda: 'we need to return to a concept of *aura* that may permit us to partially recover the troubling realities potentially lingering in photographs of historical trauma'.[9] But as Baer implies, the aura is an overdetermined word in Benjamin's oeuvre, giving rise to protracted debate on the meaning, or even the utility, of the term.[10] For example, in 'Little History of Photography', Benjamin offers an opaque definition of the aura which hinges on the tense interaction of subjective attitudes: 'What is aura, actually? A strange weave of space and time: the unique appearance or semblance of distance, no matter how close it may be'.[11]

In view of the contingencies which determine Benjamin's formulation of the aura here and elsewhere, Eva Geulen is persuasive when she ventures that the 'ephemeral' aura 'is less a concept than a performative intervention': thus, the aura is neither a stable attribute nor an object, but an index of a dynamic, fraught relationship between the beholder and the artefact.[12] The flickering of the aura derives from a self-reflexive awareness of antithetical conditions: distance (uniqueness, difference) and proximity (repetition, similarity) signify changeable co-ordinates rather than absolute values. In keeping with this approach, conscious and unconscious ambivalence heightens cross-generational involvement with antique photographs; Hughes, Larkin, Bennett, Dyer and Castle articulate non-synchronous perspectives on First World War images which embody, rather than resolve, spatial and temporal contradictions. Their reconstructive yet non-redemptory practices of postmemory aspire to, yet necessarily fail to achieve, an ethical ideal of reception which Benjamin develops in a late essay: 'To perceive the aura of an object we look at means to invest it with the ability to look at us in return'.[13] The return of the aura thus marks a mode of imaginative and affective receptivity to aspects of extreme events which is both self-conscious and historical in its orientation. Even as 'aura' retains heterogeneous associations and contradictory applications, then, the term potentially enriches the speculative vocabulary of trauma studies because it accentuates the pivotal role of affect, imagination and invention in the ongoing afterlife of visual media.

The late British poet laureate Ted Hughes (1930–1998) was the son of William Henry Hughes (1894–1981), a veteran who survived the notorious Allied military offensives at Gallipoli (1915) and the Somme. Although Hughes does not openly acknowledge his family's connection to the First World War in 'Six Young Men', its 'faded and ochre-tinged' group photograph reportedly belonged to his father.[14] As the first stanza establishes, the picture shows six childhood friends, all of whom die during the course of the conflict. By withholding the photograph from the

reader even as the poem selectively recreates the image as a charged object of emotional investment, Hughes demonstrates a canny appreciation of the dynamics of proximity and distance which produce the aura. On the one hand, the speaker celebrates the photograph because it fosters an illusion of proximity. Specific features of its West Yorkshire setting remain the same after forty years. Moreover, the nuances of facial expression allow him to differentiate between men he has never met:

> One imparts an intimate smile
> One chews a grass, one lowers his eyes, bashful,
> One is ridiculous with cocky pride – [15]

On the other hand, the speaker is emphatic in his insistence that the image merely represents the likenesses of local men who actually died violent deaths overseas forty years before: 'their faces are four decades under the ground'.[16] Thus, the visible bodies in the photograph bear an ironic relationship to the imaginatively gripping yet unseen realities of indiscriminate industrial warfare. Although generational distance limits the speaker's second-hand knowledge of the battlefield, his grim catalogue provides a jarring counterpoint to the pastoral setting glimpsed in the picture:

> This one was shot in an attack and lay
> Calling in the wire, then this one, his best friend,
> Went out to bring him in and was shot too [.][17]

Anecdotal stories regarding the whereabouts of three of the six friends prior to their deaths actually underline the dearth of information about their peers who went missing in action: 'The rest, nobody knows what they came to ... '[18] The six young men in the picture, unlike the speaker who beholds them, possess no knowledge of the future: the photograph transmits trauma by excluding, rather than including, images of mutilation and wounding. By restaging a partial encounter with the dead through an anguished poem about a convivial photograph of the living, 'Six Young Men' exemplifies the paradoxes of postmemory.

In contrast to Hughes, Philip Larkin (1922–1985) has no family connection to the First World War. Rather than a private photograph, 'MCMXIV' pays tribute to a recruiting image. Ekphrases, word pictures which describe rather than accompany group photographs, qualify the poems of both authors as mixed mode projects.[19] Larkin evokes the basic elements of the recruiting genre – crowds of young men, an urban setting, a holiday atmosphere – in his first stanza:

Those long uneven lines
Standing as patiently
As if they were stretched outside
The Oval or Villa Park,
The crowns of hats, the sun
On moustached archaic faces
Grinning as if it were all
An August Bank Holiday lark[.][20]

The demonstrative pronoun 'Those', the first word of the poem, presumes an audience familiar with recruiting pictures. Larkin draws on a general store of knowledge to embellish his memory of their prosaic details. 'Queuing to Recruit' (figure 5.1), a black and white photograph in which men from different classes eagerly assemble outside Southwark Hall, South London, to enlist in the army, epitomises the social comedy of the recruiting genre which Larkin portrays in his abbreviated lyric. It might resemble thousands of other late-Victorian photographs of urban recreation, were the prominent recruiting sign absent: dark clothing enhances the reflected light of hundreds of pale, upturned faces; some women and children also appear in the foreground on the periphery of the

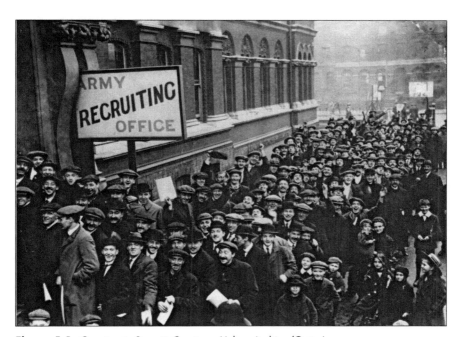

Figure 5.1 *Queuing to Recruit.* Courtesy: Hulton Archive/Getty Images.

queue. As Larkin points out in 'MCMXIV', many of the men have moustaches; nearly all wear bowler hats or cloth caps. Furthermore, in 'Queuing to Recruit', some men dress in their work clothes, as if they made the decision to enlist on impulse; others stand outside in their Sunday best; a few volunteers clutch documents or proudly hold them up for inspection; others wave their arms, gleefully hailing the spectator. Because the members of the crowd stand shoulder to shoulder, their boisterous good humour indicates common purpose if not necessarily intimate acquaintance. This public image depends on careful timing and contrivance rather than documentary observation; as in Larkin's poem, smiles signal the welcome presence of the photographer.

In both style and structure, 'MCMXIV' emulates the visual media to which it refers, namely official pictures and monuments. The title is an important graphic element: as Peter Krahé observes, it is 'meant to make a visual, not an auditory impact'.[21] Larkin discloses the assumptions and investments that inspire his title, and by extension, his poem, in a BBC radio broadcast (3 July 1964):

> The next poem is about the First World War, or the Great War as I still call it; or rather about the irreplaceable world that came to an end on 4 August 1914. It is called '1914', but written in roman numerals, as you might see it on a monument. It would be beyond me to write a poem called '1914' in arabic numerals.[22]

Perceived relationships of proximity and distance organise the poet's charged reactions to particular codes for the year nineteen-fourteen, an auratic date in his First World War calendar. Whereas Arabic numerals symbolise his disquieting proximity to historical trauma, he submits that roman numerals embody the indirection he practices. Just as the monument shows the location of a grave but should not be confused with the body, so his title indicates that his understated poem mediates a violent, unresolved history from a distance. For example, its typography resembles a page from a photographic album: three of its four stanzas offer image-texts of urban and rural England. Thus, Larkin confidently reconstructs the outline of an era from the shapes and patterns of one photographic genre. The fourth stanza of 'MCMXIV', moreover, returns to the picture with which the poem began, as if to supply it with a caption: 'Never such innocence again'.[23] Larkin assumes that the first month of the first year of the First World War bears a unique significance for those born later. In fact, many recruiting pictures conform to Larkin's synoptic reading of the genre even though they postdate the first year of the conflict. 'Queuing to Recruit', for instance, was taken in December 1915 during the final phase of Lord Edward Derby's campaign to amass a volunteer army, a drive which formally ended with the introduction of

conscription in January 1916. Larkin cultivates the iconic properties of photographs and monuments as a means to position himself at an oblique angle to historical trauma; however, he performs a slanted reading of the past when he envisages the recruiting photograph as a primal scene of modern origins in which an unwitting populace stands poised on the brink of shattering events.

Because 'Six Young Men' incorporates a private rather than a public photograph, Hughes neither generalises about the picture nor does he assume that his audience shares the depth of his emotion. Instead, the transference of the speaker is an explicit subject of the poem: in each stanza, opposing perspectives destabilise the meaning of the image. Despite the fatal 'shot' of the bullet, the negative 'shot' produced by the camera remains unaltered. In response to this provocation, Hughes collapses the discrete spaces and distinct times which agitate his conception of the artefact, as if compelling the reader to witness the eruption of heavy artillery and mortar fire within the still frame of the photograph itself:

> And on this one place which keeps him alive
> (In his Sunday best) see fall war's worst
> Thinkable flash and rending, onto his smile
> Forty years rotting into soil.[24]

In this excerpt, the speaker conflates the insentient photograph and the vulnerable human body, effectively dis-figuring the picture. Isolating the smile of one man as the target of sudden violence, Hughes simulates the technique of the visual close-up, consolidating the commonplace comparison between the camera and the gun. In order to 'see' suffering in a succession of graphic images, the speaker commands his reader simultaneously to regard and disregard the snapshot. Accordingly, in the final stanza, it seems to possess an unpredictable explosive charge:

> To regard this photograph might well dement,
> Such contradictory permanent horrors here
> Smile from the single exposure and shoulder out
> One's own body from its instant and heat.[25]

The photograph poses a psychological threat to the speaker because its aura, its exhalation of breath, derives from his visceral connection to the dead. 'Six Young Men' is a sophisticated example of First World War postmemory at mid-century which achieves neither closure nor catharsis. The lyric attests to the abiding impact of mass death on the second-

generation descendants of veterans as well as to the centrality of the photograph in the transmission of secondary trauma.

Hughes reflects on his proximity to catastrophic events while Larkin ponders his distance from historical trauma in 'MCMXIV'. Unlike Hughes, then, Larkin never refers directly to the violence of the War itself. Arguably, recruiting photographs capture a collective exhilaration in the face of armed conflict which had become unimaginable by the early 1960s. Critics impugn Larkin's investment in the recruiting genre when they maintain that 'MCMXIV' is a nostalgic expression of displaced mourning for the supremacy of the British Empire.[26] Yet a close reading of his poem qualifies these claims. Looking back from an anxious distance, Larkin tacitly distinguishes between the violence of everyday life, which takes the forms of inequality and hierarchy, and the extreme violence of state mobilisation and mass death, which looms just beyond the frame of the photograph. The 'long uneven lines' of the first stanza monitor the asymmetries of social inequality even as they communicate the self-reflexive gesture of a belated poet.[27] Another careful phrase, children '[c]alled after kings and queens', concisely conveys how social reproduction replicates social hierarchy.[28] 'MCMXIV' minds both subtle and obvious tokens of status; in order to survey the 'dust behind limousines', one must occupy a point of view on the periphery of privilege.[29] Finally, the invasion of England (1066) still marks the landscape: 'Domesday lines' anticipate the underground trenches crisscrossing Belgium and France.[30] These tensions indicate that both continuity and difference inform Larkin's mediation of the photograph. He dwells on his distance from the Edwardian period even as he ascertains its proximity to destruction, enabling his lyric reading of the photograph to shimmer with auratic light. As August 1914 recedes in time, allusions to 'MCMXIV' recur with notable frequency in the literature of First World War postmemory. Second and third generation descendants Alan Bennett and Geoff Dyer, respectively, remember this landmark with the same assurance that the poet recalls pictures of the grinning volunteers central to his poem.

In 'Uncle Clarence', Bennett (b. 1934) gazes back at a photograph of his uncle, Rifleman Clarence E. Peel, King's Royal Rifle Corps, who died in the third battle of Ypres in 1917. He does not duplicate the family picture but instead provides his readers with its reception history. Ironically, the author details how the familiarity of the image ensured that it became inaccessible as a historical object. A reverential attitude towards Peel eventually becomes a stifling household custom: 'He was always twenty all through my childhood, because of the photograph on the piano at my grandmother's house in Leeds. He was her only son'.[31]

Bennett's mother describes her brother as a 'grand fellow', revealing, in fact, that Clarence has been forgotten: 'What job he did in the few years given to him to have a job, whether he had a dog or a bike or a girlfriend, none of this I know or bother to ask, and with both my aunties dead there is no one now who does know'.[32] Over time, as specific recollections cease to enliven the picture, the frozen image and the historical person become interchangeable. As Susan Sontag maintains, 'The problem is not that people remember through photographs, but that they remember only the photographs'.[33] Although Bennett deems 'Clarence' a 'silly-ass kind of name, a name out of farce', older family members invoke it like 'the name of a saint'.[34] Perched upon a doily, the disembodied miniature of Peel wears the halo of a martyr. Yet Bennett unsettles Peel's status as a household fixture by retracing the unspoken customs and memorial protocols which shaped family genealogy. He reassembles inconclusive fragments of souvenir and story into a partial narrative by revisiting childhood memories with a critical eye. Modest and pragmatic in his mission to re-envision the private heirloom, Bennett reconstructs a microhistory of his ancestor in 'Uncle Clarence'.

In contrast, Dyer (b. 1958) discredits the productive dissonance between family lore and cultural myth which drives Bennett's work of postmemory. *The Missing of the Somme* supplies illustrations of commemorative sculptures and monuments but dismisses family photographs as a genre. Dyer invalidates efforts to reclaim private portraits and snapshots in the belated reception of the First World War:

> Dusty, bulging, old: they are all the same, these albums. The same faces, the same photos … . Each of these photos is marred, spotted, blotched; their imperfections make them seem like photos of memories. In some there is an encroaching white light, creeping over the image, wiping it out. Others are fading: photos of forgetting. Eventually nothing will remain but blank spaces.[35]

Instead of preserving the textures of history, he argues, family albums, portable records of genealogical continuity, embody forgetting and therefore deserve to be forgotten. In Dyer's opinion, the genre repels close engagement, permitting no creativity in the exercise of (post)memory. In the same vein, he challenges the unique status of oral histories in the midst of powerful cultural myths about the trench experience; he dubs his grandfather, former Private Geoffrey Tudor, No. 201334, 'anyone's grandfather' and 'everyone's grandfather'.[36] The third-generation descendant enumerates the disparate contexts which intercede between period photographs and their belated viewers: 'We look at the pictures as if reading a poem about the experience of seeing them'.[37] To anchor his argument, he invents a photograph by superimposing stock associations

from trench lyrics: 'Sepia weather The sky sagging over damp shires. The names of stations. Dead men's faces'.[38] He surmises that harrowing or poignant details derived from combat testimonies have become post-auratic clichés for contemporaries. Dyer's extended essay manoeuvres in the crowded margins of his cultural predecessors, anatomising 'second-order pastiche: pastiche of pastiche', where the 'conventions of the genre are more powerful than the original experience'.[39] Like other novels and films from the 1990s, *The Missing of the Somme* resorts to 'sedimented images' of the First World War, even though its author offers a critical perspective on the cultural entropy which attends the loss of living memory.[40]

According to Dyer, perfunctory responses to visual media supplant the tense interaction between proximity and distance which should invigorate the reception of the First World War. He reproduces only one human figure in his book, a nameless soldier visibly traumatised by his exposure to alarming and numbing sights (figure 5.2). In this photograph, the metal hat designed to protect the skull against shrapnel replaces the decorative cloth cap featured in studio portraits. Visible lines of debilitating exhaustion mark the soldier's otherwise youthful face: although he stares directly at the viewer, his eyes are both dilated and unfocused. As Dyer's eloquent gloss on the image suggests, indifference to the photographer and, by extension, the viewer, gives this combatant his arresting authority: 'there is the most intense appeal for compassion – and an utter indifference to our response; there is reproach without accusation; a longing for justice and an indifference to whether it comes about It is immune to our gaze'.[41] Unlike the historical subjects who preoccupy Hughes and Larkin, Dyer's soldier does not smile for the camera. Mingling horror and endurance, his 'blindfold look' bewilders the conventions which typically govern intimate close-ups.[42] For example, the photographer shows no interest in the uniform or its insignia and no caption provides the details of name or rank. The actual provenance of this image is uncertain; it may be part of a collection of German official photographs of British prisoners of war captured in 1918. Dyer, however, is not the first commentator to appreciate its cultural resonance. *Death's Men: Soldiers of the Great War,* a social history of the ordinary British 'Tommy', displays this photograph on its cover; instead of a general on horseback or a reserved officer from a family album, an anonymous figure bears tragic witness to the appalling conditions on the Western Front.[43] Dyer selects a picture of a man in thrall to flashback as an exemplary subject for postmemory because it prompts disturbing questions rather than rote responses: the stare of the Tommy encapsulates the challenges which confront retrospective efforts to look back at the First World War.

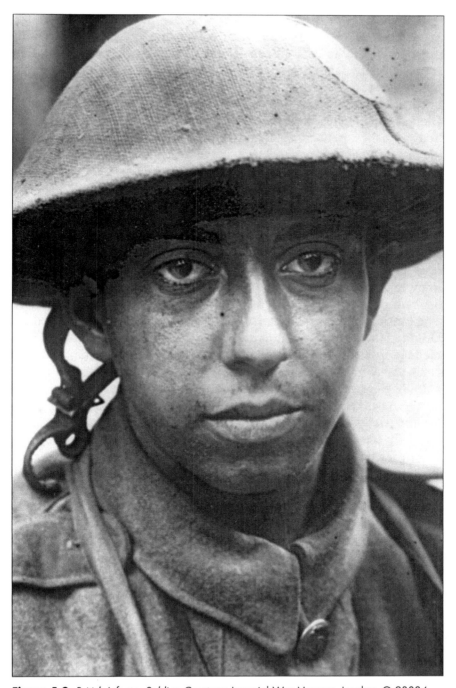

Figure 5.2 *British Infantry Soldier.* Courtesy: Imperial War Museum, London, Q 23834.

Bennett and Dyer pursue distinct approaches to battlefield pilgrimage, approaches which complement their contrasting attitudes to the family photograph. As he indicates in 'Uncle Clarence', Bennett is the first member of his family to visit Peel's grave in a Belgian cemetery. The journey provides arbitrary rather than meaningful closure, however, as the grandiloquent inscription on the headstone, 'Their Glory Shall not be Blotted Out', belies the realities of the war: 'the exact location of his body is lost'.[44] Bennett rightly suspects both family legend and official history; official versions of Peel's fate resemble the sanitised stories his nephew receives from his maternal relatives. Meanwhile, Dyer's ideal historical subjects defy both photographic representation and historical investigation: the aggregate body of the missing – men whose bodies were never recovered, or whose names were never identified – motivates his pilgrimage. At the Thiepval Memorial to the Missing at the Somme, a monument designed by Edwin Lutyens (1932) which commemorates over seventy-three thousand deaths, Dyer relinquishes his trademark irony to enthuse on the aura of the dusk: 'Scarves of purple cloud are beginning to stretch out over the horizon, light welling up behind them. The sun is going down on one of the most beautiful places on earth'.[45] Despite his geographical proximity to a site of massive carnage, Dyer meditates on the tranquillity of his natural surroundings. On the other hand, the dramatic silhouettes of an Ypres sunset neither captivate nor console Bennett. Just as he rebels against the stifling hierarchy which subordinates the individual to the group in his family, Bennett deplores the artificially imposed 'military formation' of the cemetery.[46] He attends carefully to other unique names of the dead, Gunner Hucklesby and Private Oliver, for example, precisely because they lack images as well as stories. Although the pilgrimage clarifies few of the lacunae which shadow his uncle's life, Bennett assumes that the portrait of Peel is neither self-explanatory nor hopelessly entangled in myth. By repositioning the photograph at the unstable threshold of private and public stories, he embraces partial truths as sources of insight preferable to the mystifications of the false aura, or artificial halo, that Peel wears on the mantel.

Like Bennett, Terry Castle (b. 1953) searches for the grave of a man she never knew, Rifleman Lewis Newton Braddock, 1st/17th (County of London) Battalion (Poplar and Stepney Rifles), the London Regiment, her great uncle. Few facts distinguish him from nearly one million others from Britain and its colonies who died on active service. In the absence of personal details, Castle draws on popular myths of the Victorians and the Moderns to reconstruct a narrative sequence for two surviving pictures:

There are two photographs of him in uniform – one from the beginning of the war, the other from the end. In the first he looks pale, spindly and rather stupid: a poorly-fed, late Victorian adolescent overfond of self-abuse. In the second, the one with the moustache, he is stouter, tougher, dreamier, and looks distressingly like both my mother and my cousin Toby. My companion Blakey says he looks like me. I don't see it. I've been fascinated by him – and the Great War – since I first heard of him, at the age of six or so. I'm now forty-eight.[47]

She archly mocks the first image by invoking the nineteenth-century discourses of eugenics and perversion before recapitulating the truism that violence rather than sexual repression is a defining characteristic of the Modern. Thus, the two photographs correspond to specific cultural constructions of distance and proximity, respectively: Castle interprets the Edwardian man posed in military dress as a split subject, a hybrid of Victorian and Modern history, who is simultaneously quaint and ominous, anachronistic and prophetic. Unlike her predecessors Hughes and Bennett, who also write about family pictures, Castle reproduces the second image of her relative, if not the first, for her readers (figure 5.3). In the brightly-lit commercial portrait, the details of military dress command attention, including the peaked cap, the brass tunic buttons and the leather belt. Despite his humble rank, Braddock poses with his hands behind his back, a posture which emphasises his authority. He stands at an oblique angle to the camera, showing a studied lack of expression more solemn than triumphal. While Braddock's aloofness is consistent with his formal pose, his proximity to mortal danger heightens Castle's belated investment in the picture. She both shuns and desires a redemptive narrative of Braddock's death, intuiting that the dream of recuperation is also a fantasy of self-rescue: 'I have a great deal invested, I realise, in the image of him not being wasted'.[48]

Castle agonises over her obsession with the First World War, a self-diagnosed pathology which approximates 'fixation', 'folie' and 'temporary insanity'.[49] She is acutely conscious of her distance from boredom and fear, cold and mud, random shelling and sudden death. Her estrangement from the great-uncle she never knew makes her transference seem intractable to logic; her investment in the past inspires the profound ambivalence which once attached to the bodies of the dead. In fact, Castle seeks and locates Braddock's headstone in Franvillers Cemetery only to ridicule herself in the humourless role of battlefield pilgrim: 'Bridget took a photograph of me by the grave – glum and fat and respectful – and that was that'.[50] Castle ritualistically documents the geographical terminus of her pilgrimage even though it does not coincide with any expectation of formal closure. Her proximity to the grave only heightens an awareness of her temporal distance from the War. Increasingly disaffected with her morbid preoccupations, she insists that

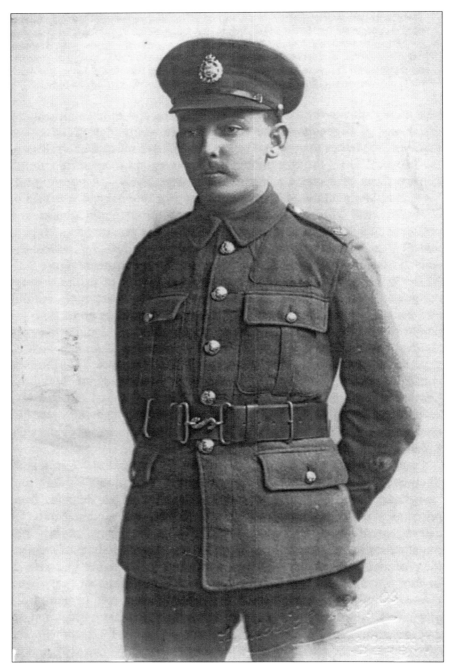

Figure 5.3 *Rfn. Lewis Newton Braddock, 17th (County of London) Bn., London Regiment, 1894–1918.* Courtesy: Terry Castle.

a wayward snapshot of herself may explain the origins of her eccentricity: 'Somewhere, it seems, there *must* be a lost baby picture of me – at my father's perhaps? – in which I look just like Mel Gibson in *Gallipoli*'.[51] In a wry flight of fancy, Castle spoofs an empirical approach to her complex preoccupations. By comparing an imaginary snapshot of herself with the handsome face of a popular actor who plays an Australian soldier in this wellknown film, directed by Peter Weir in 1981, she divulges the expansive cultural field which maps her dispersed relationship to the First World War. In 'Courage, mon amie', Castle sets out to plumb the depths of her obsession, only to drift from one association or cultural representation to another. An array of high and low media such as tattered postcards, postwar novels, Hollywood movies and key chains embossed with Earl Kitchener multiply rather than restrict her field of identifications with the First World War. Just as she combines commodities and heirlooms, so her irreverence coexists alongside a mood of heightened gravity; her superb facility with spatial and temporal juxtaposition exacerbates rather than alleviates her sense of psychic disequilibrium.

Like Dyer, her generational counterpart, Castle both fabricates and superimposes images which showcase her canny familiarity with the visual canon of the First World War. Her photographic acts reveal how affect, invention and self-reflexive awareness determine the work of (post)memory. For example, she alters the second photograph of her ancestor, adding a sepia wash to the black and white image by means of digital technology.[52] Traditionally, the reddish brown hue of sepia signifies historical distance and documentary authenticity. But the belated application of sepia marks both technological proximity and psychological intimacy. When Castle retouches the image, then, she deliberately renders the photograph inauthentic. At the same time, its artificial aura serves as a graphic index of her profound emotional connection to the First World War. In yet another strategic intervention, she acclaims Braddock her contemporary double, figuratively cutting and pasting her Edwardian predecessor into the jagged cityscape of New York after 9/11: 'I sometimes feel I could call him up on the phone. He lives in the same world as I do – the familiar vale of sorrows, fuck-ups and relentless, chain-reaction human disasters'.[53] When she entertains the fiction that Braddock may be able to take her calls, Castle neatly translates the reciprocal gaze of the aura into the terms of the telephone exchange. At first, she resists the suggestion that there are hereditary resemblances between herself and Braddock; yet she concludes her essay by staging a scene of unexpected recognition. As she scans a crowd of new recruits dating from August 1914, she suddenly discerns her own features: 'all I could really see – staring crazily upward …

was my own once-boyish face'.[54] Projection and identification serve as psychoanalytic analogues for the oscillating registers of distance and proximity as Castle negotiates the indeterminate boundaries between self and other which are hallmarks of postmemory.

Disfigured soldiers and dead bodies, however, disrupt Castle's adroit facility for photographic montage. After looking at 'tight, nauseous close-ups of men with ghastly facial injuries: jaws and mouths gone, rubbery slots for noses, an eye or an ear the only human thing left', her own predilection for First World War texts and images becomes an object of overwhelming aversion.[55] Notably, Sontag also classifies pictures of facial wounds as the 'most unbearable' photographs from the conflict among those expressly 'designed to horrify and demoralise'.[56] *War Against War!*, an international collection of censored photographs from 1914–1918 compiled by Ernst Friedrich, provides the stimulus for these strong reactions. In his polemical introduction, Friedrich contributes an analysis of identification which is germane to Castle's essay as well. He links the popular enthusiasm which sustained the war to the glowing face of the beaming recruit: 'opponents of military service must finally destroy the halo … and tear down the gaudy tinsel of the soldiery'.[57] Purposely assailing the aura of the heroic soldier in the name of peace, Friedrich published images of disfigured veterans which testify to the terrible forces of modern war. For example, he includes a photograph of one man missing his lower jaw, mouth, nose and sinuses (figure 5.4). The picture profiles a gaping wound; harsh lighting makes the shocking injuries more conspicuous. Although he wears a military uniform, the details of name, rank and regiment are absent. Blurring the boundaries between diagnostic illustration and studio photography, the picture is a disturbing composite of a medical document and an intimate portrait. Group snapshots, family portraits and official recruiting pictures typically depict men in their uniform or formal attire so that violence shadows the image but does not mar the integrity of the face or body: *War Against War!* highlights the bodily injury which these pictorial media exclude.

In 'Courage, Mon Amie', for instance, the absence of suffering recorded by the camera fuels Castle's desire to embed the family photograph in a narrative framework. Yet as her incomplete account of Braddock's truncated life confirms, the destructive capabilities of industrial weapons dwarf the imagination. Even the most creative feats of postmemory cannot overcome the distances – historical, geographical and psychological – which actually separate the contemporary viewer from the front line, no-man's-land or the field hospital. Perhaps images of disfigured veterans expose the virtual nature of time travel occasioned by

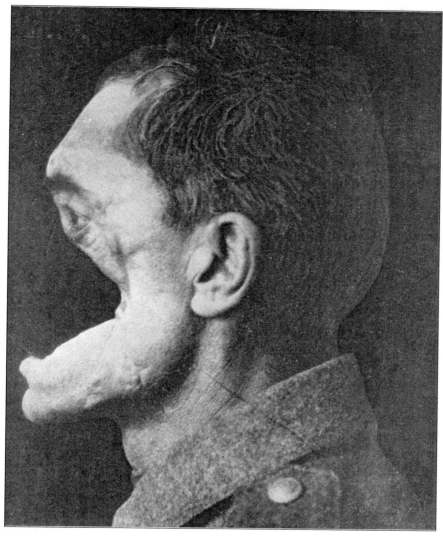

Figure 5.4 *Soldier with Severe Facial Injuries.* Courtesy: Bettmann/CORBIS.

the practices of postmemory, wherein 'the fantasy of disembodiment' which enables identification may be 'dispelled by abjection', evidence of the corruptible body.[58] In this connection, Sontag echoes Benjamin's words on the aura in order to repudiate them in relation to photographs of atrocity: 'Why should they seek our gaze? What would they have to say to us?'[59] Such sentiments might also apply to photographs of disfigured soldiers from the First World War, scarred survivors whose proximity to trauma positions the belated viewer in the position of a powerless

spectator. The suffering of stigmatised veterans serves as a limit-case for postmemory because it constitutes a challenge to the fiction of reciprocal recognition which animates acts of belated witness. Castle, however, looks back at these pictures to the extent that they precipitate a crisis of self-identification: rather than wrestling with Sontag's questions, she scrutinises her own motivations, as if to ask, 'Why should *I* seek their gaze? What would *I* have to say to them?' Castle acknowledges that her emotional investments both constrain and galvanise her reactions to the visual remains of historical trauma; by upholding her obligations as an ethical agent, she honours the ideal of reciprocity which Benjamin formulates in his writings on the aura.

Even as First World War photographs engross Hughes, Larkin, Bennett, Dyer and Castle, their distinct returns to period images provide evidence of the changeable, precarious conditions which sustain the contingent performances of postmemory. Whereas Larkin and Dyer address public artefacts, the image from the family archive motivates the creative and scholarly reconstructions of Hughes, Bennett and Castle. The generic range of these writers also varies widely. While Hughes and Larkin both announce the solemn nature of their subject matter with formal verse, Bennett, Dyer and Castle alternate between high and low registers in formally unstable prose works which merge biography, autobiography, travelogue, literary criticism and photographic essay. These image-texts reclaim the photographs of anonymous or ordinary soldiers who play at best a marginal role in official histories; 'Six Young Men', 'MCMXIV', 'Uncle Clarence', *The Missing of the Somme* and 'Courage, mon amie' contribute to a makeshift public forum on unassimilated aspects of the First World War. The appeal to collective destiny which once justified individual sacrifice in that war has lost its explanatory power – hence, the aura of First World War photographs is increasingly linked to their surplus of meaning, their resistance to instrumental use. Belated investments in soldier portraits undermine rather than reaffirm the aura of heroic masculinity which Friedrich condemns in *War Against War!*

Writers ranging from Hughes to Castle, moreover, do not merely question established interpretations of the trench soldier in the First World War. As they uncover evidence of the states of emergency, boredom, abjection and unredeemable loss which often punctuated the brief life of the infantry private, their idiosyncratic acts of reclamation conserve aspects of the past and also risk the certainties of the present. When Benjamin muses that 'every image of the past that is not recognised by the present as one of its own concerns threatens to disappear irretrievably', he stresses how dialectical perceptions of

distance and proximity propel cultural reconstruction, implicating past, present and future.[60] Nancy Wood, on the other hand, suspects that forgetting explains the widespread fascination with this conflict: 'is it perhaps easier as we approach the end of the millennium to identify with combatants of a war whose ideological stakes are only recalled faintly – if at all?'[61] Given the overwhelming traumatic losses of persons and places which followed the 1918 Armistice, the visual archive of the conflict formerly known as the Great War undoubtedly bears a symbolic relationship to other unresolved stories and interrupted destinies which scar the century. Quests for uncanny proximity with the First World War generation must measure the distances between 1914 and subsequent events. Yet as they look back at photographs of Edwardian soldiers, enigmatic figures of pathos and aggression, gifted writers Bennett, Castle, Dyer, Hughes and Larkin must also confront the fragility and instability of their own improvised historical locations.

Notes

1. Walter Benjamin, 'On Some Motifs in Baudelaire', in *Illuminations: Essays and Reflections*, trans. Harry Zohn, ed. Hannah Arendt, New York: Schocken, 1968, p. 188.
2. Marianne Hirsch, 'Family Pictures: *Maus*, Mourning, and Postmemory', *Discourse* 15, no. 2, 1992–1993, p. 8; also see Andrea Liss, who resorts to 'postmemory' in her book, *Trespassing Through Shadows: Memory, Photography, and the Holocaust*, Minneapolis: Minnesota University Press, 1998. Geoffrey Hartman coins 'witnesses by adoption' in his book, *The Longest Shadow: In the Aftermath of the Holocaust*, Bloomington: Indiana University Press, 1996; James E. Young prefers 'received history' in his article, 'Toward a Received History of the Holocaust', *History and Theory* 36, no. 4, 1997, pp. 21–43; Froma Zeitlin invokes 'vicarious witness' in her article, 'The Vicarious Witness: Belated Memory and Authorial Presence in Recent Holocaust Literature', *History & Memory* 10, no. 2, 1998, pp. 5–42.
3. Marianne Hirsch, 'Surviving Images: Holocaust Photographs and the Work of Postmemory', *Visual Culture and the Holocaust*, ed. Barbie Zelizer, New Brunswick, New Jersey: Rutgers University Press, 2001, p. 221. Paul Fussell offers the first extended discussion of the conflict's transgenerational impact: 'Indeed, a striking phenomenon of the last twenty-five years is this obsession with the images and myths of the Great War among novelists and poets too young to have experienced it directly'. See Paul Fussell, *The Great War and Modern Memory*, London: Oxford University Press, 1977, p. 321.
4. John Berger, 'Drawn to That Moment', in *John Berger: Selected Essays*, ed. Geoff Dyer, London: Bloomsbury (1976) 2001, p. 421.
5. Ted Hughes, 'Six Young Men', in *The Hawk in the Rain*, New York: Harper & Brothers, 1957, pp. 47–48.

6. Philip Larkin, 'MCMXIV', in *The Whitsun Weddings*, London: Faber (1964) 1990, p. 28.
7. Geoff Dyer, *The Missing of the Somme*, London: Phoenix, 2001.
8. Marianne Hirsch develops Benjamin's notion of the 'optical unconscious' rather than the aura, which receives a passing mention. See Marianne Hirsch, *Family Frames: Photography, Narrative and Postmemory*, Cambridge, Massachusetts, and London: Harvard University Press, 1997, pp. 118–119.
9. Ulrich Baer, *Spectral Evidence: The Photography of Trauma*, Cambridge, Massachusetts and London: MIT Press, 2002, p. 173.
10. See Jürgen Link, 'Between Goethe's and Spielberg's "Aura": On the Utility of a Nonoperational Concept', in *Mapping Benjamin: The Work of Art in the Digital Age*, eds Hans Ulrich Gumbrecht and Michael Marrinan, Stanford: Stanford University Press, 2003, pp. 98–108.
11. Walter Benjamin, 'Little History of Photography', in *Selected Writings: Walter Benjamin*, vol. 2, eds Marcus Bullock and Michael W. Jennings, Cambridge, Massachusetts: Belknap, 1996, p. 518.
12. Eva Geulen, 'Under Construction: Walter Benjamin's "The Work of Art in the Age of Mechanical Reproduction"', trans. Eric Baker, in *Benjamin's Ghosts: Interventions in Contemporary Literary and Cultural Theory*, ed. Gerhard Richter, Stanford: Stanford University Press, 2002, p. 135. Also see the essay collection, *Benjamin's Blind Spot: Walter Benjamin and the Premature Death of Aura*, ed. Lise Patt, Topanga, California: Institute of Cultural Inquiry, 2001. 'The Work of Art in the Age of Mechanical Reproduction' remains the central point of departure for postmodern discourse on the aura. Notably, in this essay, Benjamin links the advent of chemical weapons in the First World War to the decline of the aura: 'through gas warfare the aura is abolished in a new way'; see Walter Benjamin, 'The Work of Art in the Age of Mechanical Reproduction', in *Illuminations*, p. 242. Shoshana Felman engages the significance of the 1914–1918 conflict for Benjamin's biography: 'His own suicide will repeat … and mirror, the suicide of his younger friend, his alter ego, at the outbreak of the First World War'. Felman both indicts and consolidates the aura attaching to the reception of his work when she argues that 'the task of criticism today is not to drown Benjamin's texts in an ever growing critical noise but to return to Benjamin his silence'. See Shoshana Felman, 'Benjamin's Silence', *Critical Inquiry* 25, no. 2, Winter 1999, pp. 228, 234.
13. Benjamin, 'On Some Motifs in Baudelaire', p. 188. In the same essay, Benjamin maintains that 'photography is decisively implicated in the phenomenon of the "decline of the aura" … . [because] the camera records our likeness without returning our gaze'. See Benjamin, 'On Some Motifs in Baudelaire', pp. 187–188.
14. Hughes, 'Six Young Men', line 3. Dennis Walder attributes the photograph to William Hughes in *Ted Hughes*, Milton Keynes and Philadelphia: Open University Press, 1987.
15. Hughes, 'Six Young Men', lines 6–8.
16. Ibid., line 18.
17. Ibid., lines 19–21.
18. Ibid., line 25.

19. For further discussion of both images and texts as mixed media, see W. J. T. Mitchell, *Picture Theory*, Chicago & London: University of Chicago Press, 1994.
20. Larkin, 'MCMXIV', lines 1–8. Larkin also wrote several reviews on First World War subjects; see 'Down Among the Dead Men', in *Further Requirements*, ed. Anthony Thwaite, London: Faber (1959) 2001, pp. 215–221. See also 'The War Poet' (1963) and 'The Real Wilfred' (1975), in *Required Writing: Miscellaneous Pieces, 1955–1982,* New York: Farrar, Straus, Giroux, 1984, pp. 159–163, 228–239. For relevant commentary, see Patrick Swinden, 'Larkin and the Exemplary Owen', *Essays in Criticism* XLIV, October 1994, pp. 315–332.
21. Peter Krahé, 'Poetical Reflections: The 1914–1918 War Seen from Hindsight', *AAA – Arbeiten aus Anglistik und Amerikanistik* 26, no. 1, 2001, p. 30.
22. Philip Larkin, 'The Living Poet' (1964) in *Further Requirements,* Anthony Thwaite, ed., p. 85.
23. Larkin, 'MCMXIV', line 32.
24. Hughes, 'Six Young Men', lines 33–36. For a discussion of photography and trauma in his work, see Paul Bentley, *The Poetry of Ted Hughes: Language, Illusion and Beyond*, London and New York: Longman, 1998.
25. Hughes, 'Six Young Men', lines 42–45.
26. Neil Corcoran offers an opposing view of 'MCMXIV' as a reactionary poem driven by 'the compulsions of nostalgia' in its 'idea of organic English community'. See Neil Corcoran, *English Poetry Since 1940*, London and New York: Longman, 1993, p. 92. Steve Clark dissents from this opinion, however, remarking that the 'complexity' of Larkin's 'self-fashioning has been consistently underestimated'; accordingly, he reads 'MCMXIV' as 'a commemoration of the dead that brings them back to life as a conscious fiction'. See '"The Lost Displays": Larkin and Empire', in *New Larkins for Old: Critical Essays*, ed. James Booth, Houndmills: Macmillan, 2000, pp. 171, 175.
27. Larkin, 'MCMXIV', line 1.
28. Ibid., line 13.
29. Ibid., line 24.
30. Ibid., line 20.
31. Alan Bennett, 'Uncle Clarence', in *Writing Home,* London: Faber, 1994, p. 22. His reading, 'My Uncle Clarence', accompanies *The Lady in the Van*, London: BBC Audiobooks, 1994.
32. Bennett, 'Uncle Clarence', p. 23.
33. Susan Sontag, *Regarding the Pain of Others*, New York: Farrar, Straus, and Giroux, 2003, p. 89.
34. Bennett, 'Uncle Clarence', p. 23.
35. Dyer, *The Missing of the Somme*, p. 2. This book, retitled 'A Shadow into the Future', was adapted for BBC radio on the eve of the eightieth anniversary of the Battle of the Somme and featured Dyer himself and John Berger. See Geoff Dyer, *Ways of Telling: The Work of John Berger,* London: Pluto, 1986. In this book he discusses the significance of Benjamin's analysis of the decline of the aura for John Berger's influential book, *Ways of Seeing,* London: BBC and Penguin, 1972.
36. Ibid., p. 3.
37. Ibid., p. 2.
38. Ibid., pp. 114–115.

39. Ibid., pp. 79, 81.
40. Barbara Korte, 'The Grandfathers' War: Re-imagining World War I in British Novels and Films of the 1990s', in *Retrovisions*, eds Deborah Cartmell, I.Q. Hunter and Imelda Whelehan, London: Pluto, 2001, p. 131.
41. Dyer, *The Missing of the Somme*, pp. 39–40.
42. Owen, quoted in Dyer, *The Missing of the Somme*, p. 40.
43. Denis Winter, *Death's Men: Soldiers of the Great War*, London: Penguin, 1979.
44. Bennett, 'Uncle Clarence', pp. 27, 26.
45. Dyer, *The Missing of the Somme*, p. 130. Julian Barnes also depicts the waning memory of the First World War as a setting sun: 'Might there be one last fiery glow of remembering? Might there not be, at some point in the first decades of the twenty-first century, one final moment, lit by evening sun, before the whole thing was handed over to the archivists?' See Julian Barnes, *Cross Channel*, London: Jonathan Cape, 1996, p. 111.
46. Bennett, 'Uncle Clarence', p. 28.
47. Terry Castle, 'Courage, mon amie', *London Review of Books* 24, no. 7, 4 April 2002, p. 3.
48. Ibid., p. 11.
49. Ibid., pp. 3, 5, 7.
50. Ibid., p. 6.
51. Ibid., p. 11.
52. Terry Castle, private communication.
53. Castle, 'Courage, mon amie', p. 11.
54. Ibid.
55. Ibid., p. 6. Mark Dugain writes about a community of veterans disfigured in the First World War in his novel *The Officers' Ward*, trans. Howard Curtis, London: Phoenix, 2001.
56. Sontag, *Regarding the Pain of Others*, p. 15.
57. Ernst Friedrich, *War Against War!*, ed. Douglas Kellner, London: Journeyman Press, (1924) 1987, p. 27.
58. Hal Foster, *The Return of the Real*, Cambridge, MA and London: MIT Press, 2001, p. 222.
59. Sontag, *Regarding the Pain of Others,* p. 125.
60. Walter Benjamin, 'Theses on the Philosophy of History', in *Illuminations*, p. 255.
61. Nancy Wood, *Vectors of Memory: Legacies of Trauma in Postwar Europe*, Oxford and New York: Berg, 1999, p. 198.

Chapter 6

'There Was Never a Camp Here'
Searching for Vapniarka

Marianne Hirsch and Leo Spitzer

Claude Lanzmann's film *Shoah* begins with the scene of a return: in the 1980s, on his journey to Chelmno, the first extermination site of the Second World War, the filmmaker is accompanied by one of only two survivors of that camp, Simon Srebnik. 'It's hard to recognise but it was here', Srebnik says softly. 'Yes, this is the place. No one ever left here again. ... I can't believe I'm here. No I just can't believe it. It was always this peaceful here. Always. ... It was silent. Peaceful. Just as it is now'.[1]

In his nine-and-a-half hour documentary about the extermination of the Jews of Europe, Lanzmann uses no archival camera images. Yet, through the testimony of survivors, the film is built around the confrontation of past and present. The past is recalled often at the very sites of past crimes – places such as Chelmno, Sobibor or the train station in Berlin from which Jews were deported. Or, at other times, survivors' voices, recorded in Israel, or Switzerland, or New York, are heard while the camera pans over the present views of Birkenau or Treblinka. 'Yes, this is the place: ... It was always this peaceful here. Always'. Srebnik's unequivocal statement of identification and recognition haunts the entire film. As we look at other sites – sunny fields, dark forests, endless train tracks – we project onto them past scenes of destruction that they both reveal and conceal. Lanzmann makes this palimpsestic structure explicit when, in the second sequence of the film, filmed in an Israeli forest, he focuses on a narrative about the mass graves in the Ponari forest in Poland where Motke Zaidl and Itzhak Dugin, the narrators, were made to dig up the corpses of the Jews of Vilna and burn them. Even then in Ponari, trees and grass hid the signs of extermination. As Jan Piwoski of Sobibor says: 'When [I] first came here in 1944, you couldn't guess what had happened here, that these trees hid the secret of a death camp'.[2] The act of identification and

familiarity is thus time and time again offset by incredulity and the assertion of change: 'It's hard to recognise'; 'I can't believe I'm here'. It *is* here, it is *the same*, it *was always* this peaceful and, at the same time, *it is different*, hard to recognise, concealed: it has to be dug up. And in being dug up, literally before our eyes through the testimony of survivors, empty, unreadable landscapes are reinscribed with a memory that the Nazis worked hard to erase. In the words of Motke Zaidl: 'The head of the Vilna Gestapo told us: "There are ninety thousand people lying here, and absolutely no trace must be left of them"'.[3]

By juxtaposing the past with the present site of memory, Lanzmann undoes two sets of erasures: the deliberate erasure by the Nazis and the more gradual and ordinary fading caused by the passage of time. In attempting to keep the past alive, he employs a familiar trope in the memorialisation of war and historical trauma. He returns to the place of perpetration and uses it to reveal the effects of time on memory and forgetting. His cinematic act of secondary witnessing illuminates the process of receiving and transmitting historical trauma – the transgenerational act of postmemory.

We refer to Claude Lanzmann's 'return to site' in *Shoah* to introduce our very different journey in the summer of 2000 across the river Dniester in the Ukraine to the region that during the Second World War was known as Transnistria (figure 6.1). Transnistria, as Julius Fisher so aptly observed in the title of his book, is indeed a 'forgotten cemetery' –

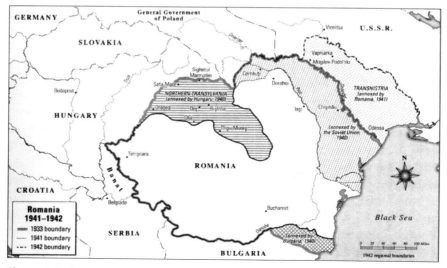

Figure 6.1 *Romania, 1941–42, showing Transnistria.* From Radu Ioanid, *The Holocaust in Romania: The Fate of Jews and Gypsies in Fascist Romania, 1940–1944.* Washington, 1999.

nowadays, a geographical 'no-place' that cannot be found in any contemporary geographical atlas.[4]

Nor, for that matter, was it ever anything more than an artificial geographical designation, invented during the Second World War for the region in the Ukraine across ('trans') the river Dniester (Nistru in Romanian) – extending west to east from the Dniester to the Bug river, and south to north from the Black Sea and Odessa up to the proximity of the rivers Row and Ljadowa. German and Romanian forces conquered this area in the summer of 1941 following the German invasion of the Soviet Union. In the aftermath of the slaughter of tens of thousands of its native Jewish inhabitants by Nazi-German *Einsatzkommandos* and their Romanian allies, Transnistria was placed under Romanian control and used as a dumping ground and killing field for the more than 150,000 Jews that were deported there after their expulsion from the recently reconquered Romanian provinces of Bessarabia, Bukowina and northern Moldavia.[5]

From the memoir of Dr Arthur Kessler, one of the deportees:

> There's a big table and at one end sits the chief of the secret police, Cojocariu, the most feared man in the city. The lists are typed, with different rubrics … they enter our names here, erase them there … Without judge or trial, years of detention are ordered. … The reserved freight car is already standing at the freight railway station. It is night, dark, our guards are standing in groups, smoking cigarettes. … We already know that we're not going to a nearby Lager, but across the Dniester to Transnistria and that that can mean extinction for us.[6]

We travelled to what had been Transnistria for two reasons. We are working on a book focusing on a number of Jewish families from Czernowitz (now Chernivtsi, Ukraine), before, during and after the Holocaust, and members of two of these families had been deported to this region in 1941 to 1942. Marianne [Hirsch]'s parents just barely evaded this deportation by getting official authorisations permitting them to remain in their native Czernowitz.[7] For them and others in her family, Transnistria was that place of horror to which they were *almost* sent, and from which they might never have returned. As a child of Jews who survived the war in Eastern Europe, Marianne was thus making a journey that her parents had never made, driven by a pull to see and know that dreaded place they had so often spoken about – by nightmarish images of a fate that could have been theirs, and that might have resulted in her never having been born.

We were also travelling with David Kessler, the son of Arthur Kessler, a medical doctor and member of one of 'our' four families who had been sent to Transnistria and who had spent almost two years there, one of them in the notorious Vapniarka concentration camp. We wanted to see

the area that had been Transnistria – to view some of its towns and places, and to establish some concrete physical connection with them. We especially wanted to locate the Vapniarka camp (in or near the present town of Vapniarka, now in the Ukraine). This desire (or, perhaps, *need*) had become especially powerful for David Kessler ever since his father, Arthur, had developed Alzheimer's disease and steadily lost touch with the world. David had grown up with the legacy of Vapniarka as an inherited postmemory – a secondary, belated memory mediated by stories, images and behaviours among which he grew up, but which never added up to a complete picture or linear tale.[8] Although his father had written a lengthy memoir in German, based on notes taken in the camp and detailing his experiences there as an inmate-doctor, David had been unable to read it: their common language in Israel, where he had grown up, was Hebrew. And yet for David, the camp's existence had been constituted fragmentarily in numerous other ways: through his father's fractured stories, his encounters with other survivors, and through the whispers and silences that had surrounded him and fuelled his own imagination and fantasies:

> I knew about this mysterious place called Transnistria and that there is some place called Vapniarka there, that it was a camp. But nothing specific. You could not not hear about it. There was a string of people coming to our house on crutches. I knew the people. We were surrounded by them. They had special cars, built especially for them. My dad took care of them. It was all part of my surroundings. And my father would say in German, 'There are some things children should be spared knowing. One day the story will be told' ... In my imagination it was someplace over there that doesn't exist any more. It was always in black and white of course, very unreal, it belonged to the old old past. It had to do with old people.[9]

Our journey to this long-ago abandoned camp in the no longer existent Transnistria thus sought to link postmemory to place – to transform a black-and-white image and to endow it with colour, reality, concreteness. In addition to living out mediated familial and cultural postmemories, we also hoped to create memories of our own, in the present, at the present site of the past.

But our journey to place and past was different from that taken by Claude Lanzmann, or by other second generation 'returnees'. In the absence of *an actual survivor* who could guide us through the former ghettos and camps of this region – now composed of bustling towns and bucolic villages replete with geese, chickens, goats and cows – the three of us were accompanied only by a Ukrainian driver, Russlan and a translator, Luda, a young Ukranian university student from Chernivtsi. David Kessler had also brought along some visual materials on our trip that he hoped would help us in our search: a photocopy of a copy of a detailed German Luftwaffe map of the region that Dr Arthur Kessler had

acquired from a historical archive after the war; and a photocopy of a photograph of a cardboard model of the Vapniarka camp that had been built from memory by a survivor (figure 6.2; the model was displayed at Kibbutz Lohamei Hageta'ot in Israel – a kibbutz museum dedicated to the memory of the Holocaust).

While Claude Lanzmann had Simon Srebnik to tell him that 'yes, this is the place', our own journey had to depend on photocopies of images and objects that themselves were already mediated by memory and imagination. Children of survivors often find themselves having to rely on such artefacts and facsimiles – some, seemingly only indirectly connected – in order to imagine a past that is not theirs, but which nevertheless has impacted on and affected their life history. Our photocopy of a photograph of a cardboard model was about as far removed from the 'real' as one can get, but we considered it as a potentially appropriate guide to identify whatever might remain of the Vapniarka camp, a place to which no survivor seems to have made a recorded visit since it was abandoned by the Romanians in 1944. Indeed, this mechanically reproduced facsimile, with its attenuated indexicality,[10] became both a *vehicle* and a *figure* of postmemory for us: a vehicle that helped us search for and find the site, and a figure for understanding the mediated relationship of a second generation, born elsewhere, to a history

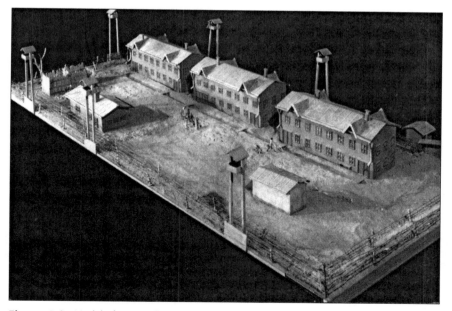

Figure 6.2 *Model of Vapniarka.* Courtesy: Kibbutz Lohamei Hageta'ot Museum.

that has lost its location through the wilful erasures of politics and the inadvertent ravages of time.

The present town of Vapniarka is located some seventy kilometres east of Moghilev, the city on the Dniester river which was both the transit centre for many of the thousands of Jews deported to Transnistria during the war and the location of one of the region's largest wartime Jewish ghettos. For us, Moghilev was the entry point into the region that had been known as Transnistria. There, overlooking the town, in the midst of a sprawling Jewish cemetery holding the remains of an ancient, sizeable and, at one time, thriving Jewish population, is a large, empty, grassy spot, the site of mass graves from the early 1940s. A stone monument, adorned with a large Jewish star, a menorah and a marble plaque in Yiddish and Ukrainian, memorialises the years between 1941 and 1944 when thousands of Jews died here, victims of outright killings, or from hunger, typhus and the ravages of freezing winters. Its placement there by Jewish Holocaust survivors from abroad marks Moghilev's Transnistrian past.

In the centre of the town, set unobtrusively on a sidewalk in front of an ageing, Soviet-built residential block with laundry hanging from its balconies, we found another, smaller monument, also with a bas-relief star of David, a menorah and a Yiddish and Ukrainian inscription. It too was erected by international Jewish organisations. At its base, inscribed in Cyrillic script, are the names of some of the central deportation sites, ghettos and camps in Transnistria. Here, we found the name 'Vapniarka', our intended destination, carved into the marble.

Our drive from Chernivtsi to Vapniarka through Moghilev, on a gloriously beautiful summer day, and on a road edged by grain fields and cattle farms, was relatively easy and quick. Despite a required detour within the southern Ukraine around the northern edge of the Republic of Moldava (for which we had no transit visas), our drive there took no more than six hours – an astounding contrast in time and comfort to the gruelling, torturous, nearly two-week journey in cattle-cars endured by Vapniarka deportees like Arthur Kessler.

And, of course, unlike us, Dr Kessler and the other deportees did not know where they were being taken until shortly before their arrival. Even then, their information was distorted:

Now we learn of our destination. The soldiers are gendarmes who guard the Lager Vapniarka. [Rumours fly:] There are beautiful houses, everything is prepared for 4,000 people, we'll even get food. Vapniarka? There are some who know Slavic languages, and who translate: lime-pit. ... I have to write down the name or I can't retain it. ... In the afternoon we pull into the Vapniarka station. ... The road takes us through a long village, walled in houses with tile roofs, small mud huts with straw roofs, just like our villages, few people, uninterested in guarded trains like ours, dull, jaded.[11]

When we arrived in the small town of Vapniarka, we stopped on its main street and began to search for some signpost to direct us to the site of the concentration camp where Arthur Kessler and so many thousands of others had been incarcerated during the war by Germany's Romanian allies. Not finding any, Luda, our interpreter, approached a middle-aged woman walking with a young child – seemingly a local resident – and in Ukrainian asked her if she might know where the former Lager was located. If not, could she direct us to someone who might help us find its site? The woman shook her head negatively and pointed in the direction we had come from. 'There was never a Lager here', Luda translated her response. 'She says no Lager was here. There was a Jewish ghetto in Tomaspol, twenty kilometres away'.

We drove further through the town's few streets looking for a sign or a memorial marker, or some type of official building where we might inquire and get assistance, and soon found ourselves stopping by a small, cluttered, marketplace near the rail terminal. Although it was already early afternoon the place was still quite busy with customers. But no one Luda approached here to ask about the location of the 'old Lager' or, alternatively, the existence of a Lager memorial or plaque, seemed to know what she was talking about. Repeatedly, we got blank looks, negative headshakes.

We looked around some more. Near the marketplace, on an adjacent square, an old pharmacy was the only open store. Inside, responding to Luda's query, the pharmacist also shook his head negatively, waved his hand dismissively, and pointed a finger in a gesture that implied 'outside of the town'. From their exchange, we made out the words 'Lager' and 'ghetto' and 'Tomaspol'. 'No, no camp was here, never', he told us through Luda. When we showed him the picture of the model of the camp, he glanced at it quickly and repeated, emphatically, 'No camp was here'. He had no other information to give us. If we want more, we should ask someone else, perhaps at the militia building across the street.

That building, however, was locked up. But at the northern edge of the town's main street, opposite the railroad terminal, David Kessler and the two of us had been staring at a set of large, three-storey, brick buildings that we now decided to inspect more closely. As far as we could see, these were the only brick buildings in the town. Could the Lager actually have been here, closer to the centre of the town, in a place that over the years was now incorporated within the town itself? Could the cardboard model of the camp, with its two-storey buildings, have been wrong? The memory of the survivor who constructed it for the Kibbutz museum in Israel could well have been unreliable, faulty, recalling two storeys rather than three. Could we really trust as accurate evidence the photocopy of a

photograph of a model built years later by someone who may have been traumatised in a fascist concentration camp?

We quickly learned, however, that the three-storey brick buildings were built shortly after the war as apartments for older people. A few townsfolk in a group of elderly men and women who were sitting nearby under a large walnut tree told Luda that fact. We had approached them to ask about the Vapniarka Lager and, at first, got the familiar head shaking and pointing in the direction of Tomaspol and its ghetto. But then, almost unexpectedly, when David Kessler showed them the Xerox of the camp model, they provided us with our first positive response. One of the women recognised the buildings in the picture as former army barracks in the nearby military encampment. There was, unfortunately, also bad news: she believed that these buildings had been torn down some years ago. In any case, she gave Russlan, our driver, careful directions to the site of these former barracks. And it quickly became clear to us that without our photocopy picture of the camp model we would probably never have found any traces of the Vapniarka camp in Vapniarka itself. Its very existence in the past and connection to this place was unknown to many (if not most) of the town's present-day inhabitants. Or, suppressed and forgotten, its existence had been erased from memory and the surrounding landscape. Even the one old woman who recognised the buildings as 'former army barracks' did not associate them with the forced labour concentration camp that they had once been – with a time of German/Romanian rule, of the persecution of Jews and political dissidents, of misery and crippling disease. If, as she believed, the buildings had indeed been torn down, our best hope now was that we might perhaps find some bricks in a field. Dejected by this prospect, we returned to our car.

Although Arthur Kessler's memoir had mentioned the 'military city' of Vapniarka, we were amazed when, after a few minutes' drive, we pulled up at the entrance to what appeared to be an enormous and still active Ukrainian army training camp, surrounded by a tall fence. In approaching its large closed gate and guard-post we decided to leave our cameras in the car, convinced that we might be more likely to gain entrance without them. But we brought the photocopy of the model along, hoping to use it as a way to certify the purpose of our presence and the genuineness of our search.

From the memoir of Arthur Kessler, recalling his arrival here:

On the left barbed wire and houses upon houses, an entire city, the military city of Vapniarka. ... A few steps further there is a small and a large gate with wooden doors that leads to an area enclosed by three barbed wire fences where three barracks line up surrounded by several small buildings. This area must be the Lager.[12]

Luda and Russlan approached two young Ukrainian military guards and informed them that we had come from America and were trying to find a Second World War Lager at Vapniarka. They showed them our photocopy. The response: again, negative headshaking, fingers pointing, and some mention of a ghetto in Tomaspol. This is an army base, the guards repeatedly emphasised: the gates are locked, we cannot not go in. But our translators were insistent. They implored the guards to call and consult with their superiors. And, amazingly, they succeeded. After a half-hour wait, two uniformed officers arrived in a vehicle.

They listened to our story, which Luda and Ruslan now jointly recounted, but also started to shake their heads almost immediately. There was never a German camp here, they claimed. In fact, they declared, neither Germans nor Romanians had ever controlled this territory.

From the account of Matei Gall, a Vapniarka inmate:

> We march through a small village with low houses with tile roofs. ... On the side of the streets lie the bronze heads of the broken statues of Lenin and Stalin. At the sight of these fallen bronze heads, I had an uncanny feeling: the statues of the idols that incarnated our ideals lay in the dust of the road.[13]

This had been Soviet territory and, in fact, a Soviet army base continuously since 1918, one of the Ukrainian officers insisted. We respectfully disagreed, pulled out the copy of our Luftwaffe map of Romanian-controlled Transnistria, which included the very place where we now were standing. And we showed them the picture of the camp model. These images were all we had; as tenuous a link as they were able to provide, we had to rely on them to serve as evidence and to authenticate our quest. What is more, we also invoked them with the hope that they might serve as conduits to pull the past into the present, thus saving the past from oblivion. We were just about to give up hope when, suddenly, one of the officers' eyes lit up – he recognised something in the picture. Still insisting that there had been no Lager here, he admitted that there *was* one building inside the base that resembled the three depicted on our photocopy. But the other two had been torn down a few years ago.

This acknowledgement changed the mood. Suddenly everyone seemed friendlier, less forbidding, more relaxed. We retrieved our cameras, and were told we could take photos and video. But the officers still did not know whether we could go inside – after all, it was an army base; we came from the U.S.; there might be secret installations we might have to pass by on our way. We agreed to wait by the gate while they went back inside to inquire.

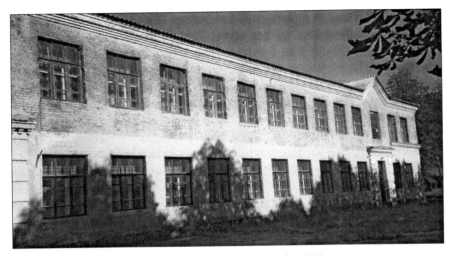

Figure 6.3 *The remaining camp building.* Leo Spitzer. July 2000.

Finally, the two officers, plus a third one, returned, and we were driven into the military base through a back entrance. And there – amazingly – in the midst of a complex of high-rise buildings fronted by lawns, in the vicinity of a children's playground with jungle gyms and clothes lines with hanging laundry, we found a large redbrick building that had been one the three residential structures for inmates in the former Vapniarka concentration camp (figure 6.3). 'This now is our base kindergarten', one of the officers told Luda.

We were allowed to photograph and to videotape it and its surroundings. And as we wandered about, under the bemused gaze of the Ukrainian officers, we tried to imagine the place where we were now standing more than a half-century earlier.

From the memoir of Arthur Kessler:

> The three buildings are neglected, no windowpanes, no window frames, the floors are dirty, broken, doors are missing and even those that are there have no locks. ... There are pipes in two places in the yard, but no water.[14]

Admittedly, we had to work hard to connect what we had read and heard about the camp with the place where we now stood. Time and space seemed out of joint, though David Kessler, standing in front of the one remaining building to have his picture taken – the building in which his father had been interned – tried bodily to enact a link that had so definitively been severed (figure 6.4).

Figure 6.4 *David Kessler by the 'kindergarten'.* Leo Spitzer. July 2000.

Almost reverently, the three of us walked around traces of the demolished foundations of the torn-down camp structures, picked up shards from old bricks, and waited for ghosts to emerge from the cracks in the pavement. As we strained to recapture an ever more distant 1942, daylight was now beginning to fade in the hazy late afternoon.

'Some things you forget. Other things you never do', Sethe says in Toni Morrison's *Beloved.* She goes on:

> Places, places are still there. If a house burns down, it's gone, but the place – the picture of it – stays, and not just in my rememory but out there in the world. The picture is still there and what's more, if you go there – you who never was there – if you go there and stand in the place where it was, it will happen again; it will be there for you, waiting for you.[15]

For Morrison the return to place creates repetition, reenactment. The past is there, in the place, in the present, in the form of a picture. We looked at our photocopy of the camp model, and at the building, still standing, still used in the present. The picture had helped to lead us to the place and to verify its authenticity. Indeed, the place was 'still there', 'waiting for [us]' – for the knowledge we could bring to it and the understanding and feelings we could take away.

Although we had not known about them at the time, we later acquired some remarkably detailed and powerful contemporary images of the Vapniarka camp and Lager – not photographs, of course, but woodcuts and engravings made by inmates – that helped us to visualise and fill out the fragmentary history we had heard and read about, and whose site we had now been able to visit (figures 6.5, 6.6, 6.7, 6.8).[16]

Figure 6.5 *Transport to Vapniarka*. Moshe Leibel. 1943. Courtesy: David Kessler.

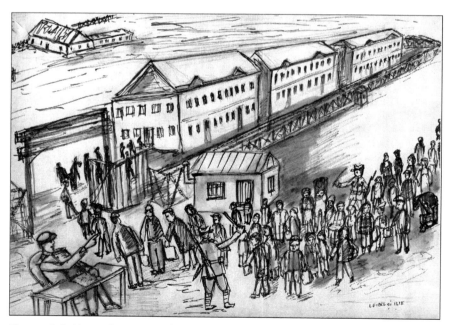

Figure 6.6 *Vapniarka gate*. Moshe Leibel and Ilie. 1943. Courtesy: David Kessler.

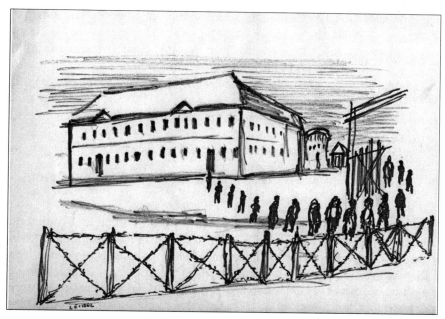

Figure 6.7 *Vapniarka gate.* Moshe Leibel. 1943. Courtesy: David Kessler.

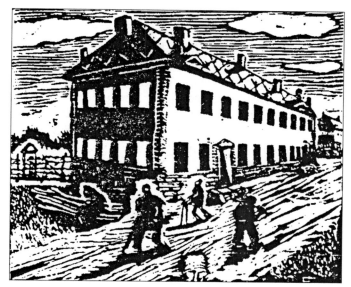

Figure 6.8 *Vapniarka building.* Aurel Marculescu. 1943. Courtesy: Kibbutz Lohamei Hageta'ot Museum.

Vapniarka was first established as a detention camp in Transnistria's Zugastru district in the early autumn of 1941. Some one thousand deportees were initially brought there, mainly from Odessa, including Jews from Bessarabia and the Bukowina who had tried to flee to Russia in advance of the German-Romanian invasion of the Soviet Union. Within a few months of their arrival, about half of these inmates died from starvation, the freezing winter and a typhus epidemic.[17]

Arthur Kessler cites camp commander Major Murgescu:

> As to the people who were here before you, you can see 550 graves on the hill behind the Lager. They died of typhoid. Try to do better if you can.[18]

The remaining inmates from that first group were forced to abandon the camp, marched to the outskirts of the village of Koslova, and shot by Romanian gendarmes. But Vapniarka was again employed not long afterwards to imprison individuals accused of various 'economic crimes' (such as blackmarketeering) and to fulfil what was to become its main purpose: to hold and punish suspected Communist sympathisers, Troskyists, socialists and political dissidents. Nonetheless, the vast majority of those deported to the camp were Jews, and about 20 percent of all the inmates were women – among them a few who were interned along with their children.[19]

In August and September 1942 some twelve hundred Jewish deportees were brought there from Bucharest and other core areas of 'Old' Romania (the Regat), but also from Czernowitz, the Bukowina region and other Romanian annexed areas. Although for the most part arbitrarily arrested, all were considered 'politicals', people who had been active Communists or suspected of Communist leanings, and one of these was Dr Arthur Kessler – whose 'crime' it had been to be the Medical Director of the Czernowitz Hospital during that city's year-long spell (1940 to 1941) under Soviet control.[20]

Conditions at the camp were initially atrocious. Inmates were subjected to extremely harsh forced physical labour; their water supply was shut off at the whim of the camp commander; their daily ration of food consisted of about seven ounces of straw-filled bread and a bowl of soup brewed from chickling peas (grasspea or chickling vetch) that local farmers (even under the worst of circumstances) had only mixed into horse-feed, and then, only in very small quantities. At the end of December 1942, about six weeks after the prisoners had been introduced to this pea-soup diet, the first among them showed the symptoms of a strange illness: paralysis of the lower limbs and loss of kidney functions (figure 6.9). Within a week, hundreds of others were also paralysed. By

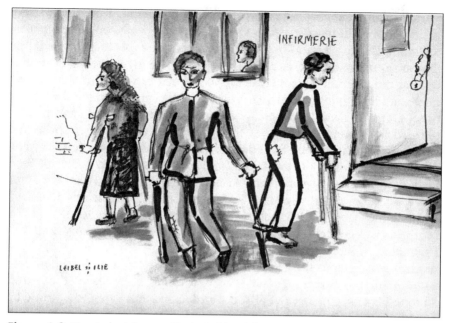

Figure 6.9 *Vapniarka infirmary. Moshe Leibl and Ilie. 1943. Courtesy: David Kessler.*

late-January 1943, some one thousand inmates in the camp were suffering from this disease in its early and intermediate stages; 120 were totally paralysed; ten had died.[21]

It was Arthur Kessler who deduced that the epidemic was directly connected to the peas in the soup ration:

> We are eating poison and we will die of it. Something has to be done immediately. ... As a result of our reports to the outside world, a doctor and friend smuggles a passage from a 13 volume 1936 textbook into the camp. We now know that we have been eating *Lathyrus sativus* fruit and that we are suffering from *Neurolathyrismus*.[22]

It was subsequently revealed that this particular kind of chickling pea was known by local peasants to be toxic for humans and, over a longer term, for animals. Indeed, a steady diet of the *Lathyrus sativus* pea had brought on paralysis in many areas of the world – and recognition of its hazards was fairly widespread among rural peoples in the regions where it grew. As Arthur Kessler later observed:

> In Central Europe, reports about stiff legs following the consumption of bread containing flour from Lathyrus pea, and laws to prohibit such adulteration, date back to the seventeenth century. In India, North Africa (Algier) and in Southern Russia, larger epidemics of lathyrism have regularly been observed in times of famine amongst the poor ... Malnutrition and low temperatures favored the onset of the disease.[23]

It is significant to note that neither Vapniarka's Romanian camp officers nor its military guards were fed the toxic peas – only the inmates. Yet when Dr Kessler and other leaders among the prisoners appealed to the camp command to change their diet and to be given medical supplies to treat the sick, they were ignored. 'What makes you think that we are interested in keeping you alive?' responded the camp commandant at the time, Captain Buradescu, to a delegation of inmate-physicians who pleaded with him. The inmates then embarked on a hunger strike and would perhaps have been forced to make the 'choiceless choice' between paralysis, poisoning, or starvation had the camp, coincidentally, not been visited by the governor of Transnistria, Georgiu Alexianu. Alexianu's tour of Vapniarka eventually led to the confirmation of Dr Kessler's diagnosis and to some efforts to halt the epidemic. By the end of 1943, with the war in Eastern Europe turning increasingly against Germany and the Romanian military suffering massive casualties, Romanian authorities began to reevaluate their support of the Third Reich and to moderate some of their policies against Jews and other 'enemies of the state'. Among the consequences of this, it was decided that Vapniarka would be closed down. Dr Kessler and other surviving inmates were then 'released', either immediately or in the course of the next few months, but were forced to remain in Transnistria – placed in 'ghettos' or other camps throughout the territory (figure 6.10).[24]

What, no doubt, had contributed immensely to the ability of Vapniarka's inmates to resist and to survive the deprivations of the camp

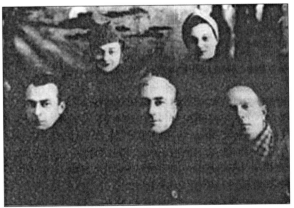

Figure 6.10 *In Bucharest, after their liberation from Vapniarka and Transnistria. Front, left to right: Dr Arthur Kessler, Dr Moritz, Ing. Davidovici; 2nd row, l to r: Polya Dubs, Dr Dora Bercovici. From Matei Gall, Finsternis: Dürch Gefängnisse, KZ Wapniarka, Massaker und Kommunismus. Ein Lebenslauf in Rumänien, 1920–1990. Konstanz: Hartung-Gorre Verlag, 1999.*

and the epidemic that threatened them with paralysis and agonising death, was the effectiveness and power of their internal organisation. Largely because so many of the camp's inmates were political prisoners – Communists and others who had once been active in underground activities and who were highly educated, politically and academically – it was perhaps easier for them to organise within the camp and to maintain discipline among their fellow prisoners. An underground political committee, composed of former political activists and political leaders, in effect 'ran' a significant segment of the camp in a *sub rosa* manner, instituting measures to distribute food fairly, control against lice and the reappearance of typhus, staff the makeshift infirmary, and repair the broken-down inmate residential buildings. They were eventually also able to establish contact with people outside the camp and, through them, with Jewish community authorities in Bucharest. Indeed, the internal organisation of Vapniarka camp attested to the fact that even in a case of extreme physical and mental brutality and danger such as this, disciplined resistance by inmates could in some rare instances break through the walls of despair and depression within which captors attempted to crush them. And yet their acts of resistance have been largely forgotten, even by the communist state that evolved from the movements of which so many of them had been a part.[25]

As we drove back from Vapniarka towards Chernivtsi, our emotions were mixed. We were excited by our adventure, by the impression that we might have been the first to visit this place since the war, and by the sense that we might well be the last outsiders to see the one remaining building that housed inmates in the former concentration camp. This structure, the three of us agreed, will surely also be demolished in the not too distant future. And yet our ability to locate that last standing Vapniarka building, and to gain admission to what had been the camp itself, clearly filled us with a sense of satisfaction, if not elation. We travelled there; we found the place; we saw it, and we touched it.

When we returned home to the United States not long after, however, we began to wonder what our trip had actually accomplished. In visiting the region that had been Transnistria, we had intended to connect memory to place. But we visited places so *emptied of memory* that our object seemed a failure. No one we encountered during that long afternoon in Vapniarka asked us anything about the history of the Vapniarka concentration camp. The Ukrainian officers accepted our gift of the photocopy of the Luftwaffe map for the army base museum, but they were remarkably incurious about the details of a past whose existence they were still reluctant to acknowledge. At best, we might think of our appearance as an intervention, an act of witnessing in

retrospect. If, through our visit, we brought the memory of its past back to the place, then that gesture was as evanescent as the hazy daylight that summer afternoon. It was an act, a performance that briefly, fleetingly, re-placed history in a landscape that had eradicated it. But can that one-time act in itself be remembered? Does our telling the story, writing about it, confirm and concretise that encounter and memorialise it?

Photography helped us to perform and carry out such a memorial act. We recorded our visit in still image and video. Even when the last remnant of the camp is removed, our pictures, together with a narrative version of this account, can serve as testimony to the lives of those who were interned there, and to our own effort to understand and transmit their stories. Our photos and videos, however flat, partial and fragmentary, however limited by their frame, do record and memorialise the fleeting reconnection that transpired between memory and place. They prove our 'having been there', as Roland Barthes might say.[26] And they provide some small compensation for the images that could never have been taken of the camp itself.

And yet, for us, even this indexical connection seemed not to be enough. Upon leaving Vapniarka, the three of us – David, Marianne and Leo – each took a stone along. Now a stone from one of the torn-down

Figure 6.11 *The memorial stone. Leo Spitzer. September 2000.*

buildings of the camp is in our house in Vermont (figure 6.11) and another is in David's house in Rochester, New York. We did this unthinkingly, and when were writing this chapter we asked ourselves what this gesture meant to us. When Jews visit a gravesite they customarily place a small stone on it. Symbolically, this is meant both to help the dead to rest by 'aiding' their return 'to dust', and to mark the fact that someone has been there. In our case, instead of leaving a marker of our visit, we carried a fragment of the place *away with us*. If through our fleeting presence there we could not hope to *re-place* its history into the landscape, we made a gesture to *displace* it. We brought a physical fragment from the demolished camp back to our present world to serve, along with the photographs and the videos, as concrete evidence – substantiation both of a past we want to memorialise and of our own efforts to locate that past. Together, these physical testimonial remnants reflect our transformation into co-witnesses, carriers of a memory we have adopted – a memory we ourselves will now transmit and hope to pass down.

Notes

1. Claude Lanzmann, *Shoah: An Oral History of the Holocaust: The Complete Text of the Film*, 1st U.S. edn, New York: Pantheon Books, 1985, p. 3.
2. Lanzmann, *Shoah*, p. 6.
3. Lanzmann, *Shoah*, p. 9.
4. Julius Fischer, *Transnistria: The Forgotten Cemetery*, New York: T. Yoseloff, 1969.
5. For additional references consulted see Jean Ancel, ed. *Documents Concerning the Fate of Romanian Jewry during the Holocaust*, 12 vols, New York, Yad Vashem Studies, 1986 and 1993; Siegfried Jagendorf, *Jagendorf's Foundry: A Memoir of the Romanian Holocaust, 1941–1944*, New York: Harper Collins, 1991.
6. Arthur Kessler, 'Ein Arzt in Lager: Die Fahrt in's Ungewisse. Tagebuch u. Aufzeichnugen eines Verschickten', (typescript memoir, David Kessler Collection), pp. 3–4. All Arthur Kessler quotes in this essay are from his memoir, based on notes taken in the camp and written not long after the war. An English translation by Margaret Robinson, Marianne Hirsch and Leo Spitzer, edited and with an introduction by Leo Spitzer and Marianne Hirsch, is in preparation.
7. Approximately forty thousand Jews were deported from Czernowitz, but some, deemed necessary for the continued functioning of Czernowitz, including civil engineers like Carl Hirsch, were authorised to remain in the city to maintain its essential services. They were initially moved to a section of the city marked off as a Jewish ghetto but were later permitted to return to their homes.
8. For an expanded discussion of postmemory, see Marianne Hirsch, *Family Frames: Photography, Narrative and Postmemory*, Cambridge, Massachusetts: Harvard University Press, 1997.

9. Videotaped interview with David Kessler, Suceava, Romania, July 2000.
10. We are grateful to Michael Renov for this formulation.
11. Kessler, 'Ein Artzt in Lager', pp. 12, 13.
12. Ibid., p. 13.
13. Matei Gall, *Finsternis: Durch Gefängnisse, KZ Wapniarka, Massaker und Kommunismus. Ein Lebenslauf in Rumänien, 1920–1990*, Konstanz: Hartung-Gorre Verlag, 1999, p.111 [our translation].
14. Kessler, 'Ein Artzt in Lager', p. 14.
15. Toni Morrison, *Beloved*, New York: Knopf, 1987, p. 36.
16. At the time of our journey we had read Arthur Kessler's memoir, the short account about Vapniarka (largely based on Kessler's memoir) in Avigdor Shachan, *Burning Ice: The Ghettos of Transnistria*, trans. S. Himelstein, Boulder: East European Monographs, 1996, pp. 241–245. Also see a translated segment (from Romanian) of Ihiel Benditer, 'Vapniarca', in *Shattered! 50 Years of Silence: History and Voices of the Tragedy in Romania and Transnistria*, ed. Felicia Carmelly, Toronto: Abbeyfield Publishers, 1997, pp. 181–202; and for the brief account of the camp see Radu Ioanid, *The Holocaust in Romania*, Chicago: Ivan Dee, 2000.
17. Gall, *Finsternis*, pp. 119–121; Kessler, 'Ein Artzt in Lager', p. 13; Jean Ancel, 'Vapniarka', in *Encyclopedia of the Holocaust*, vol.4, Israel Gutman, ed., New York: Macmillan, 1990, p. 1560.
18. Arthur Kessler, 'Ein Artzt in Lager', p. 15.
19. Nathan Simon, *'Auf allen Vieren werdet ihr hinauskriechen': ein Zeugenbericht auf dem KZ Wapniarka*, Berlin: Institut Kirche und Judentum, 1974, pp. 64–65; videotaped interview with Polya Dubs, Rehovot, Israel, September 2000; Gall, *Finsternis*, p. 121. According to Simon, *'Auf allen Vieren werdet ihr hinauskriechen'*, p. 64, they were shot by members of an SS Einsatzkommando.
20. Ihiel Benditer, 'Cattle fodder for the victims', p. 187; Simon, *'Auf allen Vieren werdet ihr hinauskriechen'*, p. 64; Gall, Finsternis, p. 115; Polya Dubs, interview, September 2000.
21. Kessler, 'Ein Artzt in Lager', p. 45; Simon, *'Auf allen Vieren werdet ihr hinauskriechen'*, p. 65; Gall, Finsternis, p. 136.
22. Kessler, 'Ein Artzt in Lager', p. 45.
23. Arthur Kessler, 'Lathyrismus', *Psychiatrie und Neurologie* 112, no. 6, 1947, pp. 345–376.
24. Kessler, 'Ein Artzt in Lager', pp. 43–44.
25. Ibid., pp. 21–27; Gall, *Finsternis*, pp. 122–123, 129–130.
26. See Roland Barthes, *Camera Lucida*, trans. Richard Howard, New York: Hill and Wang, 1972.

Chapter 7

The Space Between

Photography and the Time of Forgetting in the Work of Willie Doherty

Andrew Quick

The photograph itself is in no way animated (I do not believe in 'lifelike' photographs),
but it animates me: this is what creates every adventure. (Roland Barthes)[1]

A few years ago I stumbled across an exhibition of British art in Sydney,
Australia. I did not plan to visit the gallery but had intended to 'take in'
the city: the practice of the well-seasoned traveller. I felt confident in an
urban environment described in my guidebook as being safe, able, at
first, to locate myself in the water-front walkways and often familiar
shops that appeared to reflect a global culture that, if not always
European, is constantly Western in its configuration. My retreat into the
space of the gallery, at least in my recollection of this visit, was provoked
as much by a sense of anxiety that had built up during my walk about the
city as by the desire to get to 'know' Australia culturally.

This anxiety undoubtedly drew its energy from the fact that everything
around me felt both known and alien at the same time. Perhaps it was the
haunting of a British colonial past that unnerved me: a sense that
everything I was encountering felt familiar – in the design of public
buildings, in the accent and lilt of people's speech, in the appearance of
the British monarch's head on banknotes that were washable but could
not be folded, in the constant reference to a history which, for a certain,
seemingly dominant section of society, begins with James Cook's
'discovery' of Australia in 1770. Perhaps, it was the confident assertion
of a nation's identity with reference to a version of a colonial past that
made me feel uncomfortable. It is an unease that might arise from the
realisation that the investment in national identity has been so
problematic in Europe and the fact that the often enforced creation of

nation states by European powers is regularly seen to be the cause of many of the last century's major political conflicts, the most recent of which has raged so terribly in the lands formerly known as Yugoslavia and seems always ready to ignite in Northern Ireland.

In retrospect, my sense of discomfort at being in these surroundings could be connected to the felt but unthought-through purpose of my visit to Australia – a journey which, under the aegis of research, was as much to do with creating the space and time to reflect on my career as an academic, to distance myself from the immediacies of my everyday circumstances in Britain, to imagine myself anew, as it was to give papers and attend conferences. What better place for a person in their late thirties to re-think and re-form themselves than in a land as far from home as possible, a land which in all its familiarity (at least in its urban zones) appeared so different and alluring with its seeming endless self-confidence and assurance, its eye always looking to the future with a supposedly secure knowledge of the past? It is a country in which to be re-born or at least re-invented – why else did people from Britain emigrate there in large numbers in the 1950s and 1960s for the payment of £10? Even its non-urban hinterland – its deserts, outback, rain forests and Great Barrier Reef – promises sites for contemplation and self-revelation – places of, and for, dreamtime.

These traits are, I am only too aware, born of and borne by the colonist, the very heritage of which I saw imprinted in the buildings that I came across in the city and sought escape from in the supposedly white blank space of the modern art gallery. Perhaps I felt that the gallery might offer a site of refuge, freeing me from an anxiety provoked by unfamiliar familiarity, because, as Georges Bataille so memorably describes, the museum is constructed to celebrate the apparent intelligibility of the human order, being the 'colossal mirror in which man finally contemplates himself in every aspect, finds himself literally admirable, and abandons himself to the ecstasy expressed in all the art reviews'.[2] Of course, I was mistaken in thinking that this space could offer some sort of stability, a place in which I might order myself, put myself back together, a place to properly *be*; since, as Bataille indicates, the very practices of mirroring are themselves as much founded upon excess, 'the ecstasy', as creating it. Indeed, if my search for some sort of stability and security was the force that drew me into the gallery in the first place, then my first encounter with the work of Willie Doherty in the exhibition dislocated me further as I saw myself literally fractured in the glossy reflective surfaces of his photographic works – works that depicted the landscapes of the city of Derry and its surrounding countryside within the context of the war in Northern Ireland, a conflict euphemistically known to many in the U.K. as 'The Troubles'.[3]

This sense of fracture and dislocation was not only an outcome of the technology of photographic reproduction – although I am certain that the highly reflective surface of the photographs is an integral part of Doherty's project to position the viewer as an active participant within the operation of the artwork, to place the onlooker within the frame of the scenes that he depicts. Fracture and dislocation are also integral dynamics negotiated within the artworks themselves, which portray, in often opaque ways, the highly charged conflict in Northern Ireland. What Doherty appears to be exploring and, perhaps more importantly, *staging* as spectatorial practice, are the operations of place, space and territory; and how these are configured in a highly mediatised culture to create a violence that has become the central response to the desire for, and the demand of, autonomy itself. This is a form of violence that is further fuelled (given energy) by a form of paranoia that occurs as a result of the *failure* to create and fully establish such autonomy for particular individuals and/or groups of citizens who locate identity not only with particular religious beliefs but also, equally importantly, with place itself.

In his essay 'Paranoiac Space', Victor Burgin argues that paranoiacs are unable to distinguish themselves from other people and things with any sense of clarity. This failure to differentiate is reflected in their use of language, where there is a dislocation between speech and identity. Consequently, Burgin observes, paranoiacs 'speak as if they were an other, or simply an object in a world of objects. They have lost the illusionary but necessary sense of transcendence that would allow them to position themselves at the centre of their own space'.[4] This loss of transcendence is reflected not only in the use of language but also in a lack of corporeal unity that the paranoiac experiences. In her discussion of French sociologist Roger Callois, Elizabeth Grosz notes that the body is the locus of subjectivity. She writes:

> For the subject to take up a position as a subject, he must be able to situate himself as being located in the space occupied by his body. This anchoring of subjectivity in *its* body is the condition of coherent identity, and, moreover, the condition under which the subject *has a perspective* on the world, becomes the point from which vision emanates.[5]

Paranoia occurs as a result of failure to unify the subject, to suture self and body, so that a perspectival viewing point becomes impossible. In such cases, Grosz observes, the 'primacy of one's own perspective is replaced by the gaze of another for whom the subject is merely *a* point in space, and not *the* focal point around which an ordered space is organised'.[6] The paranoiac is lost, disembodied in both corporeal and linguistic terms, lacking a centre from which to construct and know the self and to recognise others.

Doherty presents landscapes which, through their negotiation of place and of the relationship of identity to place, indicate that the centring of perspective is deeply problematic. As such, he implies that corporeality itself is in a state of crisis. Indeed, bodies rarely appear in his works, and if they do they are seen as fleeting glimpses, blurred figures, as parts (an arm, a hand, a leg, a section of the head) or as silhouettes. More often than not, his photographs are images of places where bodies have been evacuated: empty burned-out cars, broken windows, empty roads, views across fields, derelict houses and factories. Perhaps more astutely, these photographs are made up of images of objects that contain the imprint of abandoned human activity: old mattresses left on wasteland, tyre marks on the road, peopleless pedestrian bridges, litter-strewn balconies and stairwells. The image stripped of corporeality (accompanied as it usually is by traces of human activity) seems to be an act of violation, the objects and vacated landscapes hinting at narratives of conflict and human catastrophe that result in the final erasure of the body.

The body's very negation feels like an act of violence, its disappearance an outcome of the desire for, or history of, territorialisation, the victim in, and of, the establishing of a boundary. In 'The Other Side' (1988), for example, the perspective needed to locate oneself in the landscape is distorted by a superimposed text that appears to contradict what is being seen, and the logic of co-ordination breaks down. Framed within a view of the landscape of Derry and the Foyle valley, two captions reveal the city's contradictory geography (figure 7.1). WEST IS SOUTH is written over the nationalist side, while EAST IS NORTH is placed over the loyalist part of the city. Here location, the finding of one's place, is grounded in relation to the other rather than in the abstract 'rules' of spatiality from which maps are constructed; these rules are also reflected in classical landscape painting – a genre to which Doherty is clearly alluding.

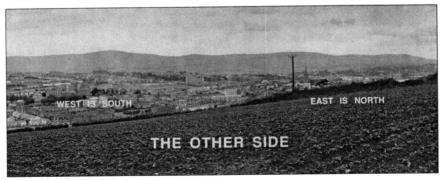

Figure 7.1 *The Other Side*. Willie Doherty, 1988. Courtesy: Willie Doherty.

Derry is a place where naming is deeply problematic, an activity that both includes and excludes depending on whom or what is being referred to. Giving out the wrong name in the wrong place becomes a life-threatening activity. As Doherty articulates in an interview with Joan Rothfuss:

> For me, the idea of how the terrain works here and one's relationship and position within it is something that's extremely self-conscious, which also may be related to not wanting to be in the wrong place at the wrong time. So we're constantly making decisions that involve a whole series of coded movements. Where you chose to live, the road you chose to travel, the places you visit, the space that you organise as a safe area – all these are very conscious decisions. In that sense the area of movement on the road, the relationship between a place and an idea of identity, is fundamental to the work.[7]

Rather than securing meaning, naming is seen as a process that produces disorientation. It is important to understand that this disorientation manifests itself in movement, whether it be the sense of stilled motion frozen in the process of photography itself, or the movement of my eye across and between photographs placed in relation to each other in the gallery space, or the movement between image and text in the photographs themselves. Doherty's juxtaposition of the caption and image generates an acute sense of displacement, working against its conventional use in the media where, as Maite Lorés explains, the linguistic text is used to secure the image, 'to impose a specific linguistic message on an otherwise denoted sign'.[8] To survive, Doherty seems to be implying, one needs to know exactly who and where one is. However, in my encounter with these photographs the rules that would permit such a secure subjectivity are turned on their head as I am unable to anchor a stable viewing position.

The singular image appears to make the demand that I know my position as a subject. The implication of the failure to achieve this is to face violence and possibly death: the disappearance of my body. Interestingly, I often catch my body ghosting in Doherty's photographs, reflected and distorted in their glossy surfaces. Seen as individual photographs they appear to affirm the spatial rules that would create the autonomous subject, the perspective from which the individual might separate itself from others. I need to have a detailed knowledge of the landscape and of my own identity to understand where my points of safety exist, to locate the community to which I belong. On the other hand, experienced as sequences of images in the gallery, the photographs make it impossible for me to secure for myself the condition under which I might have a perspective on the world. Importantly, what Doherty foregrounds is the violence implicated in the creation of subjectivity: the violence that might exist as the outcome of the loss of self, of community; and conversely the possibility that the effect of the establishment of identity, whether communal or national, *is* conflict.

In 'Last Bastion' (1992) I am confronted with the walls of Derry and impelled to consider in whose last bastion am I implicated – from which side of the walls am I looking, and within which side I think I am situated (figure 7.2). In the diptych 'Strategy: Sever/Isolate' (1989) I am driven to consider whether I am severing or isolating, practising inclusion or exclusion, as I move between and across the images – images that in turn reflect my own activity of looking and my own relationship to the conflict in Ireland (figure 7.3). It is a process in which my eye can find no point of rest as I struggle to locate myself in the frames of the photographs. Similarly in 'Protecting/Invading' (1987) I am forced to consider alternate positions as I switch between the two photographs (figure 7.4). Who is invading and who is protecting? Is invasion a form of protection and protection a form of invasion? The polarity that might be established by having a single point of view is actively dislocated as I am both directly implicated in the ideological positions that the captions activate and pulled into the disturbance of these positions that occurs as a consequence of the movement across the two images. In the space between I am forced not only to re-think my specific (English and colonial) relationship to the particularities of this conflict and to the histories that make up my knowledge of this part of Ireland/Britain, but also to question the very processes that allow subjectivity to make its place, processes that might be considered as being the source of the conflict itself.

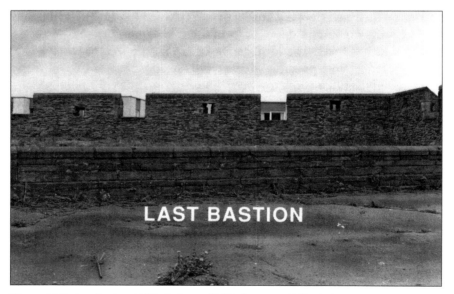

Figure 7.2 *Last Bastion*. Willie Doherty. 1992. Courtesy: Willie Doherty.

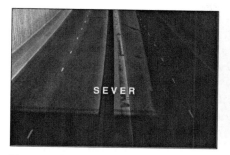 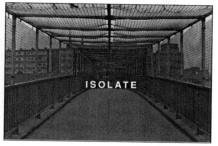

Figure 7.3 *Strategy: Sever/Isolate.* Willie Doherty. 1989. Courtesy: Willie Doherty.

In these photographs, while I feel Doherty's own sense of identity haunts the images presented (he states in the interview with Rothfuss that he is from the nationalist community), I cannot locate the reassurance of the artist's intention, the hidden meaning or subtext. These are images that push me to consider what lies beyond the city wall, the wire fence; to speculate upon what might lie ahead of or behind the roadblock. In Doherty's landscapes objects (mattresses, burned-out cars, detritus) and body parts invoke narratives rather than belong to them, feed possible storylines rather than become their only substance. In the light of the conflict in Northern Ireland and of the media images that have negotiated it, these objects and body parts become saturated with significance, and this overloading of possible meaning causes anxiety as everything becomes touched with potential violence. Even though I have never been to Derry, most of the images of the landscape are in some way immediately recognisable and familiar as single items, operating within a mediatised version of rural landscape, city architecture and urban decay. Yet the juxtaposition of images, and of image and text, and the positioning of photographs as series and the composition within the images themselves, dislocate any comforting sensation that familiarity

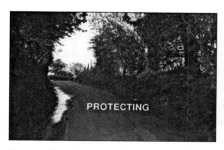 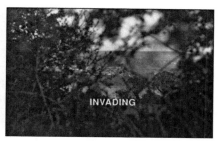

Figure 7.4 *Protecting/Invading.* Willie Doherty, 1987. Courtesy: Willie Doherty.

provides. It is this process of 'placing against', and the absence of an authorial voice, that generate the air of menace and the feeling of violence that these images exude. It is as a direct consequence of forcing me to move between images that Doherty destabilises a sense of place, even as I attempt to secure it for myself in my encounter with this work. This implicates me in the political effect the demand for the secure place might have, an effect especially disturbing in the context of the history of the conflict in Northern Ireland.

In *The Practice of Everyday Life*, Michel de Certeau repeatedly reminds us that place and the mechanisms of its creation inaugurate identity; that the institutions of knowledge and power operate through placing to create the individual, the body, the city and the state.[9] These institutions, he points out, always seek to confine, control and establish 'the proper' – the basis of the autonomous place. The proper, de Certeau argues, is 'a mastery of places through sight'. This marking out of space, this capacity to divide, partition and re-order, is a panoptic practice which, he tells us, 'proceeds from a place whence the eye can transform foreign forces and objects that can be observed and measured'.[10] Those forces and bodies that resist the strategic operations of place become homeless entities, refugees, waiting for the moment when they might assert their own place, their own ground (topos) in which to 'properly' be. The dynamics that create the autonomous place either consume everything other to it or force another autonomous place (individual, community, city, state) to exist in separation or stand in opposition. This is the contradiction inherent within a politics of place and is perhaps why we should always question our investment in its formation.

Interestingly, in *The Practice of Everyday Life* de Certeau focuses his attention on the spatialising practices of writing rather than the more obvious spatialising practices of cartography and architecture – although the metaphor of the city as an ordering and hierarchising environment, in which time and space are partitioned and converted into place, is often invoked both as something to be resisted and also as being the site in which the practices of resistance might be enacted. These practices are described as 'pedestrian processes' in which the body is always on the move, making contact with other bodies, creating what are identified as 'trees of gestures': bodies that refuse to stay still for the fixing necessary for the establishment of the proper place, for the creation of the intelligibility necessary for the dynamics of institutionalisation and political control.[11] As de Certeau points out 'to walk is to lack a place', so that 'the moving about that the city multiplies and concentrates makes the city itself an immense social experience of lacking a place'.[12] Of course, this movement, maintained in order to enact a resistance to unintelligibility, destabilises the

very concept of the body as a single entity, as a corporeal vessel that can be fully known, contained, mapped and thus possessed. The body might be recognised and lived, as Grosz articulates, as matter and form, but it is a matter and a form which constantly change depending on the body's spatial and temporal location.[13]

One outcome of such corporeal dispossession would be the loss of selfhood, which often signifies 'madness' in our culture – a loss that results in the renewal of order through the forms of institutionalisation or medical prescription. Indeed, the acts of violence that have occurred in Ireland and on the mainland of the UK are often described in the media as being the evil actions of insane people, and as Martin McLoone has analysed, there is a long history to the British perception of the Irish as being primitive and monstrous.[14] For Doherty, however, there can be no distanced, scientific view of monstrosity seen from the security of autonomous separation. This would be contradictory, since Doherty describes the very dislocatory experience of surveillance in much of his work. Video installations such as 'Blackspot' (1998) and 'Control Zone' (1999), for example, use images of everyday urban activity as seen through security cameras (figure 7.5). What disturb are not so much the

Figure 7.5 *Blackspot.* Willie Doherty, 1997. Courtesy: Willie Doherty.

specific geographical sites that are the object of surveillance (although to people with a knowledge of Derry they will have a profound significance[15]), but the fact that the images could be taken from any city in Europe. If specific tropes of surveillance are disturbing in themselves, then our everyday experience becomes imbued with a sense of disquiet and potential violence in Doherty's installations: the quotidian becomes grotesque. In encountering these works, despite seeing the world through the distanced image, I am unable to secure the stable viewpoint that perspective establishes as I am implicated not only in the process of observation itself but also in becoming the object of surveillance.

The inability to locate a place to secure a viewpoint is often doubled in Doherty's work. It marks the inherent failure that exists in a politics of security that would control situations through an ocular mastery which, as noted earlier, leads to a sense of paranoia where subjects succumb to a brutal transformation into little more than points in space for those that would regulate them. The result of this process is not only the violence of control that is inflicted on those that are seen as a threat to security, but the violence that arises as a reaction to such control. However, more pertinently Doherty also explores how those who would be in control are caught up in the very process that would have given them the power of mastery, how they in turn are transformed into paranoiacs, becoming merely objects in a world of objects. This is the spectatorial practice that Doherty forces on the gallery viewer. Through the attempt to see so much, the points of differentiation become blurred and, as in the visceral experience of encountering Doherty's photographs, the self is mirrored and reflected back in the actual act of looking. This mirroring disrupts the attempt to create the distance the self needs in order to establish its autonomy, since it is always implicated in the very space that it seeks separation from in order to secure its sovereignty. Both controller (subject) and controlled (object) are caught in the trap that the ocular process, necessary to the formation of subjectivity, creates: a trap where the self can neither be fully known (autonomous) nor able to recognise others (differentiating).

Doherty's video installation 'The Only Good One is a Dead One' (1993) negotiates the sets of contradictions that I am attempting to describe. The piece is played out across a series of oppositions: two projection screens are placed in a darkened room facing each other; one set of images is taken by a static camera, the other is hand-held and moving; on one screen are night-time images of a street-lit residential area; on the other are images of a country lane seen through the windscreen of a moving car and lit by its headlights. The spoken voice switches abruptly between the point of view of a person fearing sectarian violence and someone preparing to assassinate their victim, the voice-over apparently connected to both visual sequences.

According to Doherty the work attempts to move between two seemingly irreconcilable points of view:

> the viewer is asked to identify both with the person who is planning the assassination and with the person who fears being assassinated. I'm interested in breaking down those two apparently unbridgeable positions both in terms of making what might be an interesting work, but also in terms of relating that back to the political dynamic here, where often we're given no choice. You're either a victim or you're an aggressor ... [16]

What is crucial for Doherty is the breaking down of the processes of identification in order 'that what looks like an apparently easy choice becomes more difficult and even contradictory as you get involved in it'.[17]

It is important to note, however, that Doherty dramatises his 'unbridgeable positions' around the operations of observation and reflection (as thought process). Observation is configured through the point of view invoked by the camerawork, where the static shot would seem to reflect the activity of surveillance and the shot through the windscreen of the car the action of pursuit or escape. The spoken text articulates a mental process that is difficult to fasten down as it moves between two states of anxiety: the fear of the pursued and of the pursuer. Indeed, as images and voice overlap, the series of opposites and the meaning invested in them begin to break apart in a continuous movement of momentary coincidences and disconnections. Here the oscillations between watching and being watched, between victim and perpetrator, self and other, movement and stillness, create an unbearable tension as the identity of the narrator appears to collapse in a breakdown that is mirrored in my own failing attempt to render the piece 'readable'. The dynamic of the pulling together and pushing apart of the unbridgeable points of view that occur across the repeated loop of the installation ensures that my moments of identification are momentary as I am forced to work in the spaces between that Doherty opens up. It is work that unsettles the pre-established modes of my thinking, work in which I am impelled to consider the politics of place itself and its internal operations.

De Certeau's conceptualisation of place is founded on an essential transformation of temporality, where 'time and movement are thus reduced to a line that can be seized as a whole by the eye and read in a single moment'. Consequently, space is flattened out and, echoing Grosz, 'the temporal articulation of spaces' is reduced to a 'spatial sequence of points'.[18] According to de Certeau, place is the realm of stasis and the open 'aporetic' temporality of the event is always excluded from its operations. Arguing that place is constructed upon the erosion of time, de Certeau foregrounds modes of spatial practices (these include walking, speaking, storytelling, dwelling, cooking: everyday practice) that engage

in a guileful utilisation of time. Jean-François Lyotard similarly invokes a temporality that both intervenes in, and radically disrupts, the smooth workings of the representational economies which shore up capitalism and its regulating practices; practices which attempt to limit and direct experience back toward the representational system itself, thus ensuring that its particular ordering and conceptualisation of the world remain unchallenged. According to both these thinkers, time in such systems is managed, given direction and rendered commodifiable. In short, time is made readable; it is transformed into knowledge, and made material for exchange. This is capitalism's way of 'saving time'.

However, according to Lyotard, particular forms of contemplation, of thinking, work against this conceptualisation of time, because time's very 'energy' or 'force' relies on a modality that is in itself both unaccountable and irretrievable to consciousness.[19] He infers that time is always tied to a process of loss, and that it is through the process of thinking that time is unfastened from the conceptual order as thought itself. Indeed, he indicates that thought undermines the conceptual certainty, the accountable time, that capitalism relies upon to sustain itself. He writes 'In a universe where success is the gaining of time, thought has one incorrigible fault – making time be lost'.[20] For Lyotard, the concept of total knowledge is not only impossible but must also be actively resisted. Time disperses knowledge, picking away at any structure of coherence. Time is configured as a 'postponement' that disrupts the full synthesis of what he describes as 'the moments or positions the mind crossed through in approaching a cloud of thoughts'. According to Lyotard, 'time is what blows a cloud away and compels thinking to start again on a new enquiry, which includes the anamnesis of former elucidations'.[21] As such, Lyotard infers, it is forgetting, or at least an openness to the forgotten, that propels thinking in new directions.

In Doherty's 'How it Was' (2002), which I saw at the Harris Museum in Preston in February 2002, the radical unaccountability, the 'postponement', of time is actively negotiated. Two large screens placed at different depths in the gallery space depict video footage of what appears to be a garage or lock-up in which three figures, two men and a woman, attempt to recount what might have happened there. This account is made up of disconnected phrases that alternate between the men's and the woman's voices, fading in and out at different volumes:

The light plays different tricks at that time of day
There was a hammer on the wall
I was there and I have doubts
There was a TV set in the small office, I'm not sure if it was on

As far as I was concerned I was alone and I could take as much
time as I needed
It all happened a long time ago, it's like a different world
I did what I could under the circumstances
I remember it as a grey space, as if everything was covered in dust
There was no going back to check. Everything is changed

These phrases are heard as the camera traverses the garage space.
However, the viewer is denied the singular point of view. In one instance
the camera appears to be observing the figures moving in the garage, and
then suddenly the image jump-cuts to a point-of-view shot or a shot
which includes the back of a head. My eye not only moves between the
two screens, but as I walk though the space the image nearer to me looms
large in my field of vision, the other retreating as I move forward.
Perspectives shift; there are no clearly defined points of view despite the
fact that something in this set of visual representations reminds me of the
structure of those crime-based television documentaries that attempt to
deal with events in a forensic manner.

In retrospect I cannot but 'negotiate' this piece in the light of the
Saville Enquiry that is investigating 'Bloody Sunday' and will conclude
its findings in 2005, an enquiry in which scientific evidence and the
testimony of witnesses will combine to create a 'true' account of what
really happened in Derry in 1972. In 'How it Was' Doherty seems not
only to be working through the impossibility of this task but also, perhaps
more importantly, to be questioning the very character and validity of
such processes of recollection and re-creation. The authoritarian regime,
as indicated earlier, relies on the mastery of time to differentiate itself
from those that would challenge its authenticity and legitimacy. Time is
converted into readable space. In this way the past can and must be
accounted for. Events that trouble and destabilise a regime become
negotiable through representational systems, through historical account,
through judicial process, through legal and political enquiry. As a result
of such systems everything becomes retrievable via the operation of a
certain version of remembering that works to transform past events into
a discernable present.

For the figures in Doherty's 'drama', however, the past appears to be
irretrievably lost: 'There was no going back to check. Everything is
changed'. 'It all happened a long time ago, it's like a different world'.
Here memory fails in its attempt to retrieve something tangible from the
past, and what is witnessed is the struggle and failure of remembering
itself. This struggle is articulated through the structure of the installation,
which is constructed from intricately looped visual images and recorded

voice-overs. The continuous repetition of the visual image and the spoken text creates a mise-en-scene in which the act of remembering is never allowed to be anchored as (and translated into) the remembered. In 'How it Was', the act of replaying fails in its attempt to resurrect the past and I am left to participate in the pain and labour of remembrance itself. Indeed it would appear that, far from bringing closure to the traumatic event, the attempt to go back and make an account for what has happened in the past produces a new trauma in its wake. The fleeting images and phrases that Doherty presents create a landscape that is imbued with a sense of violence. With little specific detail available to my eye and ear, my mind is set free to contemplate and imagine what might have happened in this space. Tools and cables on the wall become instruments of torture, clutter and debris the effect of some terrible incident.

In 'I Was There and I Have Doubts' (2001), the series of photographs that accompany the installation, Doherty draws me into a further disturbing speculation as I attempt to identify the objects that the individual photographs seek to depict. Despite their apparent focus on specific items and materials (wires, saws, oil-drums, stairs, a trolley wheel, metal pipes, an oil-stained kettle, a filing cabinet drawer handle), these high-contrast photographs, in which dense black backgrounds appear to overwhelm the details in the foreground, indicate that there is a limit to the photograph's capacity to capture and retrieve. What is more, these photographs seem to replay the operation of a failing memory (anamnesis) in the act of technological reproduction itself. Far from transparently rendering experience, these digitally produced photographs re-present an engagement with the world in which things float in and out of consciousness and are never clearly or cleanly given up for our contemplation.

The photographs that make up the series 'I Was There and I Have Doubts' indicate that certain material elements that are necessary for the creation of place resist being synthesised as form. In other words, the spatial operations of place and its employment of time are never in complete control of space, of temporality, of bodies, of things, which are corralled in order to institute the subject-producing site of place itself. Doherty's photographs inevitably participate in the act of repetition and inscription that all photography engages with – the stilling of a particular moment in time and space – that replays and reasserts, as de Certeau observes, the inauguration of subjectivity. Yet these works also provoke an unnerving contemplative play, a process of thinking that endeavours not only to account for the past but to present the happening now of the mind's struggle to recall the past: the act of remembrance itself. Doherty's

photographs bear not only the imprint of the lost event, but also that of the occurrence, the event, *that constitutes remembering.*

Lyotard observes that events always desolate the mind, that they invoke the 'suffering of thinking' which, he reminds us, is a 'suffering of time, of what happens'.[22] This desolation sweeps away the mastery the mind needs to shore up subjectivity, to embody place. Lyotard writes, 'That something happens, the occurrence, means that the mind is disappropriated. The expression "it happens that ... " is the formula of non-mastery of self over self'.[23] Of course, in this opening up to the suffering of thinking, the form of the photograph must also suffer in order to bear the mark of the mind's disappropriation. Hence the play of light and dark in this series of photographs, in which specific details – which inevitably provoke particular narratives (of work, of violence, of criminal activities) – are always under the threat of being overshadowed and obliterated by the large areas of grey and black. Is not this play of light and dark the very play of memory itself, indicative of a remembering that fails to find a form in which to inscribe the remembered?

Of course, what might be at stake here is a questioning of the documentary value of photography itself. After all, photography is always engaged in the freezing of time and the stilling of the movement of all that the photograph fixes within its frame. In this sense, photography is one of the most effective tools in a culture that is increasingly obsessed by memorisation, through the capturing and the subsequent transformation of past events into objects for consumption. As Lyotard observes, a remembering that takes no account of the forgotten 'implies the identification of what is remembered, and its classification in a calendar and a cartography'.[24] This begins to explain why Lyotard places such emphasis on a radical forgetting, what he defines as anamnesis – that is neither the forgotten nor the remembered but rather the moment between these two states. Anamnesis is a product of the encounter, the happening now, that resists both the inscription of memory itself and also the erasure that would ensue if the encounter were entirely forgotten. This is not an incentive to give up on inscription: such a move is impossible. 'One cannot escape the necessity of representing', Lyotard tells us. Rather, one must attempt to account for the 'remainder', 'the unforgettable forgotten', that representation always seeks to suppress.[25]

According to Lyotard, photography is a product of industrial and post-industrial technoscience, which seeks to objectify everything in what he calls a 'programme of metapolitical ordering of the visual and the social'.[26] The cost of this pursuit, he points out, is the destruction of the indeterminate, the accidental, the remainder of all that constitutes the complex materiality of experience itself. As noted earlier, Doherty's work

directly engages in the ways in which photographic and televisual images participate in such metapolitical orderings, which are often savagely exposed in the specific political struggles and eruptions of violence that take place in Northern Ireland. However, unlike Lyotard, Doherty reveals how the indeterminate nature of experience can be generated in the encounter with the photograph, in the movement (of eye and of mind) that technologically produced images induce. If the photograph, like memory, always participates in a process of gathering and fastening together, then Doherty's work constantly moves us to encounter the forgetting, the postponement of time, that is produced when his visual images disturb us into specific modes of contemplation.[27] In Doherty's photographs the forgotten operates to displace readable notions of space and time and debilitates the processes that create and shore up subjectivity.

If, as de Certeau describes, the spatial ordering of perspective enables the construction of the autonomous place to be established through the 'mastery of time', then the re-introduction of an 'untamed' temporality, the time of the occurrence, the space between (the *lapse* of time, the time of *forgetting*), would begin to undermine its operations. This is why Doherty's photographs, in the practices of looking that the encounter with the work in the gallery generates, resist the homogenising processes of spatiality within the form of the still life of photography itself. These works do not give themselves up to the gaze of the disembodied eye. I am impelled to experience a corporeal encounter where a violence to the body is always implied, a violence that is felt in the reflection of the spectator as I move across and between photographs, between text and image, between filmic image and voice-over, between areas of light and dark. Perhaps the resonance of this work operates for me in the apparent contradictory negotiation of subjectivity that Doherty explores: a resistance to the being partitioned by colonial forces that would create him as other, and the demand for otherness that might empower his sense of identity to take its place as an act of resistance and liberation: a demand that necessitates the practice of partition that would in the first instance be resisted. This is the double bind of identity politics.

The encounter with a notion of Britishness, a leaky body at the best of times, stumbled upon and into during my visit to Sydney, inevitably jolted me into a sense of contemplation and reflection. Something in the encounter with this familiar unfamiliarity brings me back to the immediacy of the various bodies out of which I feel impelled to construct and create myself – the physical body, the body remembered and the broader cultural body of nationality and region (there will of course be other bodies that I cannot name) – all of which are narratives given flesh

by language. In the encounter with Doherty's work I am forced to look with a corporeal eye: I am unable to find a position from which to look with authority, with a resting point; unable to mark out the 'autonomous place' de Certeau describes as being necessary for the creation of replete subjectivity; unable to recall a language that describes, without reinventing it, the experience of being before the artwork and of accounting for its effect upon me. In short, I am dispossessed.

This dispossession is not part of a process of flattening out, a sort of disappearance of a body with its various contexts into some depoliticised zone of endless transformation where the materiality of gender, sexuality, race and class might be erased or forever reconfigured. Rather, it is a dispossession, a forgetting, most likely momentarily, of the rules by which I think I might know myself and hence others. It is a forgetting that forces me to practice a mode of judgement, what Lyotard has called indeterminate judgment, in the scene of this meeting of something else, something other – a scene in which I am impelled to recreate or re-face myself to construct myself anew. To return to the epigram that opens this chapter, is not this the animation that Barthes so wonderfully describes, the adventure that he extols?

Notes

1. Roland Barthes, *Camera Lucida*, New York: Hill and Wang, 1972, p. 20.
2. Georges Bataille, 'Museum' in *Rethinking Architecture: A Reader in Cultural Theory*, ed. Neil Leach, London: Routledge, 1997, p. 23.
3. This exhibition was called *Pictora Britannica: Art from Britain* and was held at the Museum of Contemporary Art, Sydney in 1997. Willie Doherty is an internationally renowned artist based in Derry in Northern Ireland. Short-listed for the Turner Prize in 1994 and 2002, Doherty's photographs and installations negotiate the still life, the documentary image and media representations of the conflict in Ireland.
4. Victor Burgin, *Indifferent Spaces: Place and Memory in Visual Culture*, Berkeley, California: University of California Press, 1995, pp. 128–129.
5. Elizabeth Grosz, *Space, Time and Perversion*, London: Routledge, 1995, p. 89.
6. Ibid., p. 90.
7. Kathleen McLean, ed. *No Place Like Home*, Minneapolis: Walker Arts Centre, 1997, p. 47.
8. For an excellent analysis of Willie Doherty's work in relation to the media see Maite Lorés, 'The Streets Were Dark With Something More Than Night: Film Noir Elements in the Work of Willie Doherty', in *Willie Doherty: Dark Stains*, ed. Maite Lorés and Martin McLoone, San Sebastian: Koldo Mitxelena Kulturunea, 1999, pp. 110–117.

9. Michel de Certeau, *The Practice of Everyday Life*, Berkeley: University of California Press, 1984.
10. Ibid., p. 36.
11. Ibid., especially pp. 92–102.
12. Ibid., p. 102.
13. Grosz, *Space, Time and Perversion*, p. 93.
14. See Martin McLoone's 'Caliban and Other Primitives: British Images of the Irish', in *Willie Doherty: Dark Stains,* pp. 117–121.
15. In 'Blackspot' the view is from the city walls, a space that marks the division, both geographical and political, between the two communities; 'Control Zone' videos the road bridge over the River Foyle in Derry – the crossing point not only between the two communities but also between the two Irelands.
16. McLean, *No Place Like Home*, p. 51.
17. Ibid.
18. de Certeau, *The Practice of Everyday Life*, p. 34.
19. See Jean-François Lyotard, *Heidegger and 'the Jews'*, Minneapolis: University of Minnesota Press, 1990, p. 16.
20. Jean-François Lyotard, *The Postmodern Explained to Children: Correspondence 1982–1985*, London: Turnaround, 1992, p. 47; note that this translation was adapted from Bill Readings, *Introducing Lyotard: Art and Politics*, London: Routledge, 1991, p. 132.
21. Jean-François Lyotard, *Peregrinations: Law, Form, Event*, New York: Columbia University Press, 1988, p. 7.
22. Jean-François Lyotard, *The Inhuman: Reflections on Time*, Stanford: Stanford University Press, 1991, p. 19.
23. Ibid., p. 59.
24. Ibid., p. 51.
25. Lyotard, *Heidegger and 'the Jews'*, p. 26.
26. Lyotard, *The Inhuman: Reflections on Time*, p. 120.
27. Of course, Doherty's work resituates his media-derived images (drawn from advertising, documentaries, television dramas and cinema) within the contemplative space of the gallery, a space that, as Bataille tells us, is not immune to the effects of metapolitical ordering.

Chapter 8

Displaced Events

Photographic Memory and Performance Art

Nick Kaye

> The reproduction of a painting or object, however perfect, is always, definitively, its betrayal. And that betrayal is that much greater when it involves not objects or paintings but whole spaces (Daniel Buren).[1]

In conceptual and performance art in the late 1960s in North America and Europe the photograph's displacement and 'betrayal' of its object were closely linked to experimental art's approach to ephemeral and time-based processes. Here, as part of a broader, well documented impulse toward the 'de-materialisation' of the art object,[2] the emphasis in conceptual art on the use of text, photographs, scores or instructions offered *in place* of conventional media and forms frequently intersected with the tactics of performance art. Where conceptual art sought, as the artist Dennis Oppenheim has suggested, to 'radicalise the making of sculpture'[3] by privileging a shaping of the viewer's conceptual engagement over the aesthetics of material form, performance art invariably stressed ephemeral events, qualities and experiences which neither the object nor the image could adequately represent. Indeed, in the work of key figures within North American Body Art, including Vito Acconci and Dennis Oppenheim, whose work emerged as an address to the material and image of the artist's body in the context of Minimalism; as well as highly influential European artists such as Michelangelo Pistoletto, the contradictions that the photographic documentation of ephemeral events make evident became a key means of engaging with core concerns that, ostensibly, lay beyond the terms of the photographic image itself. For Acconci and Oppenheim, the documentary photograph provided a paradoxical means to address the 'presentness' of agent or 'actor', of the site, work, performer and viewer. Here, foregrounding the photograph's function as documentation, as a visual record of a work

rather than the work itself, brought into question the capacity of the artistic medium – be it video, sculpture or photography – to resolve an ephemeral practice into a fixed form. Indeed, such 'documentary' images were frequently the principal means by which the performance of a Body Art work would be made available, precisely in order to emphasise that the ephemerality of an act is always encountered in its remains – in its trace image, relic or sign. In this context, although this essay is not primarily concerned with the site-specific practices of French artist Daniel Buren, it is concerned with his concept of 'betrayal' as a mechanism in the photographic documentation of performed practices.

Since 1965, Buren has worked systematically to define his work exclusively through the installation of an ostensibly simple visual scheme: vertical bands which are 'always the same [x,y,x,y,x,y,x,y,x,y,x ...]',[4] manifested and deployed in a wide variety of institutional and public circumstances and locations. Working in a critical relationship with Marcel Duchamp's earlier interventions in the ideological contexts in which art is produced,[5] Buren's application of his scheme in the varying conditions of specific sites works to pose the question of its relationship to existing art practices and discourses. Here, through systematic but oblique references to the formal properties of painting, sculpture, performance, conceptual art and the eclecticism of 'intermedial' practices, Buren's installations construct dislocated relationships to their various points of reference in attempts to interrupt the formal and ideological discourses in which they are produced and received. In this context, Buren widely disseminates photographic documentations of his 'site-specific' installations through 'photo-souvenirs'[6] in the form of book publications, postcards and other ephemera. Providing a visual record of Buren's seemingly arbitrary variations of his scheme through its installation in 'whole spaces' that have included galleries, architectural facades, private buildings, transportation spaces, public squares, advertising hoardings and even city streets through peripatetic demonstrations or 'ballets', these souvenirs purposefully point to Buren's work in its 'betrayal' of the original, emphasising instead the status of photographic documents as relics or tokens. In announcing their fragmentary nature, their *failure* to explain, Buren's many photo-souvenirs act as reminders of the contingent nature of any *particular* application of his scheme, while offering yet another variation or 'repetition of differences'[7] without an explanation and so a resolution of his practice.

In Body Art, too, the status of the photograph as recollection, as an image defined in its separation from an 'original work' that is no longer available, provided a means of radically extending a 'de-materialisation'

of the art object and a questioning of dominant modes of producing and receiving art. Thus, for Dennis Oppenheim, with regard to Body Art's ephemerality, the very unavailability of the 'original' work itself served to counter 'major canons of traditional art' through the fact that 'you can't see the art, you can't buy the art, you can't have the art'.[8] Here, too, fundamental aspects of live performance, including engagements with 'real time' and 'real space' and the simultaneous presence of performer and viewer, became aligned to experimental art's critical interrogation of the terms and conditions under which visual art takes place.

Indeed, it is the *question of presence* that haunts Vito Acconci's early work for the 'literal page-space',[9] which drew on poetry, notation and sculpture, and that is addressed in his departures into photography, film, video and 'live' work. It is a question evident, too, in his ambivalence towards the very notion of 'performance'. Reflecting on 'Performance After the Fact' in 1989, and recalling his entry into performance in 1969, Acconci noted that '[w]e hated the word "performance"' because '"performance" had a place, and that place by tradition was a theatre'. A theatre, he argues, is a place which, in providing 'a point you went toward' and 'enclosure', could only be 'abstractions of the world and not the messy world itself'.[10] In fact, in his earliest work Acconci's impulse towards *action* was explicitly linked to practices *embedded* in the world, where 'performance' indicated a 'real time' incursion into a place already occupied and *acted in*. In this context, for 'Room Piece' (1970) Acconci transferred the contents of one room of his apartment to the Gain Ground gallery, producing a situation in which:

> Each weekend my living space extends for eighty blocks, between apartment and gallery. Whenever I need something that's stored at the gallery, I go uptown to get it, bring it back to my apartment where I can use it, and return it to the gallery when I've finished with it.[11]

Here, Acconci's scheme for action is ruled by the demands of his 'everyday' living in order that it might extend beyond the confines of the gallery to the streets between the Gain Ground and his apartment, and even into his apartment itself. In support of this, the gallery visitor encounters 'Room Piece' through the exhibition of a 'checklist' of objects and activities that marks, reframes and gives context to Acconci's sporadic and functional appearances.

In 'Rubbing Piece' (1970), an event at Max's Kansas City Restaurant in New York in May 1970, Acconci's 'project' consisted simply of '[s]itting alone at a booth, during the ordinary activity at the restaurant. Rubbing my left forearm for one hour, gradually producing a sore'.[12] In seeking to embed his performance in such occupied places, he concludes, 'we wanted ... a region that was a section of the accustomed world that

everybody knows and that you simply as a matter of course passed by'.[13] In this context, Acconci's entry, from 1969, into 'Activities' – schemes for actions realised in everyday contexts without the presence of an audience and disseminated through their documentation – frequently deferred to an oblique presence: a presence felt at the margin, in activity that shadows the text or image rather than offers itself to be reproduced, received or explicitly resolved into a theatrical act or photographic image.

Such approaches to actions embedded in the world, and the attempt to shadow the document with the presence or trace of activity, are evident in Acconci's work in 1967 and 1968 as a poet, work which directly set the terms for his entry into performance. Here Acconci sought, in part, to find an analogy to the minimal art object's 'theatricality', a sensibility defined in Michael Fried's celebrated attack on 'Literalist' art, which he considered antithetical to the Modernist ideal of the self-legitimating artwork. First presented in 1964 and the 1965, the 'Minimalist' objects by artists such as Robert Morris, Donald Judd and Frank Stella explicitly rejected the idea that art was autonomous and that its meaning and value were to be derived from its own internal dynamic. Placed in the conventional 'White Cube' gallery space, these predominantly geometrical sculptural forms, which were exhibited individually or in repetitive or progressive series, served to provoke the viewer's self-reflexive awareness of the 'literal' circumstances and contingencies in which the object was encountered. Here, Fried argued that:

> Literalist sensibility is theatrical because, to begin with, it is concerned with the actual circumstances in which the beholder encounters literalist work … . Whereas in previous art 'what is to be had from the work is located strictly within (it)', the experience of literalist art is of an object in a situation – one that, virtually by definition, includes the beholder.[14]

In response, Acconci attempted to find a parallel structure and engagement with 'real' space and time through his use of language on the page. Where, Acconci recalls, Minimalism 'was the art that made it necessary to recognise the space you were in' and so the 'relation between whatever it was that started off the art and the viewer',[15] the use of language in his 'literal page-space' was concerned not so much with the page itself as with 'questions of movement' across it: '[w]ays to go from left to right of the page. Ways to go from one page to another'.[16] In this context, Acconci's early works such as 'RE' (figure 8.1), which uses language to prompt, interrupt and map the act of reading, explicitly provoke the reader's self-reflexive awareness of relationships between text, space and eye movement. Rather than realise a 'work' as 'performance', such strategies defer between performance and its documentation, between image, text and action, so provoking the reader's

```
(here) (          ) (      )
(      ) (there) (                              )
(      ) (              ) (here and there—I say here)
(                      ) (I do not say now) (          )
(I do not say it now) (          ) (          )
```

Figure 8.1 *RE.* Vito Acconci, 1968. Courtesy: Vito Acconci.

awareness of the text as a ground for a *performed activity* that remains *embedded within* reading.

This approach to the page as a surface that provokes an awareness, *in reading*, of the reader's 'performance' of text and page, led directly to Acconci's early engagement with 'Activities', in raising the question: '[i]f I was using the page as a field for movement, there was no reason to limit that movement I might as well be moving my body outside',[17] so leading towards 'schemes that would give me reasons to be in space'.[18] In this context, Acconci's early strategies focused upon the occupation of, and activity in, 'found' locations, where another agent, an individual or individuals acting in the world, provided a possible ground for action. Thus, for 'Following Piece', which took place from 3 October to 25 October 1969 (figure 8.2), Acconci determined that for each day during the duration of the exhibition he would

> pick out a different person, at random, in the street, any location: I follow that person as long as I can, until he/she goes off into a private place – home, office, etc.
> A following episode might last two or three minutes (a person gets into a car, I can't grab a taxi in time, I can't follow); a following episode might last seven or eight hours (a person goes into a restaurant, a person continues his/her evening by going to a movie ...).[19]

Such processes immediately raise issues around how to present 'embedded' or performed practices. For 'Following Piece', Acconci disseminated his 'Activity' through photographic documentation, a visual and textual diary exhibited and published in a variety of excerpts and forms which, in themselves, seemed to eschew any obvious aesthetic interest. Here, the photograph seems casually taken and composed; the text briefly notes the character of some episodes and typical durations. These strategies were also linked to photography's ambivalent connection to the 'real world': to the photographic image's uncertain status as 'art form', 'document' and 'snapshot'. In many works, these uncertainties regarding form, status and purpose were compounded through the performed act's simultaneous dissemination through a variety of media. Thus, while the 'Activity' remains ephemeral and, by implication, unique and unavailable, that which Oppenheim proposes as performance's 'residue'[20] might be

Figure 8.2 *Following Piece.* Vito Acconci. 1969. Courtesy: Vito Acconci.

FOLLOWING PIECE
"Street Works IV" sponsored by the Architectural League of New York
October 3–25, 1969
Activity
New York, various locations
23 days, varying times each day

Each day I pick out at random, a person walking in the street.

I follow a different person everyday; I keep following until that person enters a private place (home, office, etc.) where I can't get in.

(The terms of the exhibition, "Street Works IV" were: to do a piece, sometime during the month, that used a street in New York City. FOLLOWING PIECE, potentially, could use all the time allotted and all the space available: I might be following people, all day long, everyday, through all the streets in New York City. In actuality, following episodes ranged from two to three minutes – when someone got into a car and I couldn't grab a taxi, I couldn't follow – to seven or eight hours – when a person went to a restaurant, a movie …)

presented, variously, as video, film, text and, commonly, photographic images derived from video recordings. Such variations and 'secondary' images serve to emphasise the photograph's indexical function, its *removal* from its object and its 'unfinished', *incomplete* status.

Yet here, too, in the context of the concern for ephemerality, Acconci's pursuit of a presence that resisted *being placed* or *fixed* also led towards radical revisions of the role of the image and document in performance. Where his poetry had approached 'performance', so his early exhibitions and photographic work sought to blur oppositions between text, image and action in an address to the dynamics operating between performer and viewer, private and public, the act and its documentation. Indeed, here Acconci's texts provide a means of *producing* performance that remains 'embedded' within the 'real time' and 'real space' of viewer activity. Thus, for 'Proximity Piece' (1970), which Acconci describes simply as '[s]tanding near a person and intruding on his/her personal space',[21] the 'ground for action' becomes the awareness of private and public spaces informing the behaviour of the visitors to the room in which it is met. Now relocated to the wall of the gallery, Acconci's text describes the conditions under which this 'Activity' will take place, acting as a spur to the experience of the performance even in the performer's absence. Thus, Acconci recalls, this intrusion could occur under three conditions:

> One possibility was that I could be present at the museum everyday [*sic*] from opening to closing time The second was that a substitute could perform the piece in my place. The third possibility was that if I wasn't there, then the written description of the piece which had been posted on the museum wall presented the possibility of the piece being enacted.[22]

In this third possibility:

> If a person who was looking at an exhibit had read the statement and someone happened to be close to him, he might quickly assume that the piece was being acted out. I know it worked out that way because I got calls from people I didn't know saying they had seen me at the museum on days when neither I nor the substitute was there.[23]

'Proximity Piece' elides the opposition between action and text, extending Acconci's address in 'RE' to the relationship between reading and the performance of everyday life. Indeed, here the reading of Acconci's scheme for activity in the gallery serves to *produce* its performance through its provocation of a spatial and proxemic self-consciousness on behalf of the gallery visitor.

It is these concerns and mechanisms that directly inform Acconci's most explicitly photographic works, where the photograph is shadowed by the *photographic act*. Again linked to Acconci's attempt to approach

Figure 8.3 *Throw*. Vito Acconc. 1969. Courtesy: Vito Acconci.

THROW
November 23, 1969; afternoon
Photo-Piece
Kodak Instamatic 124, b/w film
Vandam St., between Greenwich and Hudson, New York

Holding a camera, aimed away from me and ready to shoot, while going through the motions of throwing a ball.

Reach back as if to throw: snap photo 1.

Throw and follow through: snap photo 2.

the specificities of the time and place of embedded action, 'Photo-pieces', such as 'Throw' (figure 8.3) play between performance, site and photographic record by foregrounding the production of the image *in action*. Furthermore, Acconci's description of this work recalls his scores for performance. Thus 'Throw', he notes, consisted on 'November 23, 1969; afternoon' of:

> Holding a camera, aimed away from me and ready to shoot, while going through the motions of throwing a ball.
> Reach back as if to throw: snap photo 1.
> Throw and follow through: snap photo 2.[24]

Similarly, 'Blinks' (figure 8.4), executed on the same occasion, is comprised of:

> Holding a camera, aimed away from me and ready to shoot, while walking a continuous line down a city street.
> Try not to blink.
> Each time I blink; snap a photo.[25]

Figure 8.4 *Blinks.* Vito Acconci. 1969. Courtesy: Vito Acconci.

BLINKS
November 23, 1969; afternoon
Photo-Piece
Kodak Instamatic 124, b/w film
Greenwich Street, New York

Holding a camera, aimed away from me and ready to shoot, while walking a continuous line down a city street.

Try not to blink.

Each time I blink; snap a photo.

The outcomes of specific, prescribed activities, these 'Photo-pieces' defer to the *performance* of photography itself, implicitly claiming a status as 'documentation' in order to produce a movement between the photograph and the photographic act by which it is shadowed.

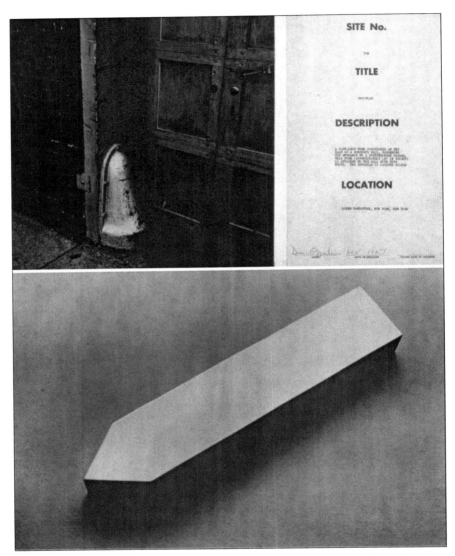

Figure 8.5 *Sitemarker #10*. Dennis Oppenheim. 1967. Courtesy: Dennis Oppenheim.

Description: A cast-iron form positioned at the base of a concrete wall, bordering the entrance to a subterranean garage. This form (approximately 18" in height) is attached to the wall with five bolts. The exterior is painted silver.
Location: Lower Manhattan, New York, New York.
November, 1967.
Photography and text, milled aluminium marker.
Document 14" × 24" Marker 1" × 2" × 9½"

Courtesy: Dennis Oppenheim

Where this work by Acconci addressed relationships between text, image and the performed act, Dennis Oppenheim's early presentation of photographic work was shaped by his critical engagement with the studio ideology of the gallery. Linked to his influential Land and Earth Art, in which he intervened into, marked or changed 'found' sites, as well as his Body Art performance, Oppenheim's presentation of documentary images taken from video or film worked to displace the centrality of the gallery and its objects. In 'Sitemarker #10' (figure 8.5), his first exhibited work, Oppenheim designated a series of specific sites around New York,[26] showing a photographic image, a record of each location and an aluminium marker engraved with the site's number. 'One Hour Run' (figure 8.6), produced as a video and series of photographic images, extended this attempt to counter the artwork's conventional autonomy. For this piece Thomas McEvilley recalls that Oppenheim had 'parodied action painting by cutting snowmobile tracks intuitively or expressively in the snow for one hour',[27] so inscribing a signature mark of Modernist painting over a specific locality that might admit unpredictable references or contents into the field of the work. 'For me', Oppenheim argued in a key interview with the critic Willoughby Sharp in 1971, 'activity on land is charged, not passive like processed steel. Land holds traces of a dynamic past, which the artist may allow to enter his work if he so wishes'.[28] Thus, where Acconci's 'photo-pieces' pointed towards past activities that evaded the terms of the still image, Oppenheim's photographic documentation of Land Art evidenced his transposition of the dominant signs and practices of visual art into 'real world' contexts that might disrupt or even corrupt their purity and abstraction. In this context, Oppenheim's photographic account of 'One Hour Run' not only recalls his parodic simulation of action painting, but also through its enlargement and exhibition extends this reference toward the celebrated 'spatial field' of the abstract expressionist canvas. In this exchange, and in the photograph's explicit recollection of a temporary configuration outside the gallery, Oppenheim positioned the photographic image as the documentation of a meeting of contexts and connotations that might exceed the terms of dominant, gallery-based practices.

Oppenheim's subsequent entry into Body Art extended this impulse towards an engagement with 'real' contexts and events that might surpass or disrupt the reception of the conventional art object or image. Thus, he notes, in his work the expanded field of Body Art, occurring in the wake of the 'de-materialised' object, 'invaded one's home. It took in your family'.[29] Emphasising that 'one of the most catalytic aspects of Body Art [...] was this connection with the real world'.[30] Oppenheim sought, through 'events' such as 'ROCKED CIRCLE – FEAR' (figure 8.7), to

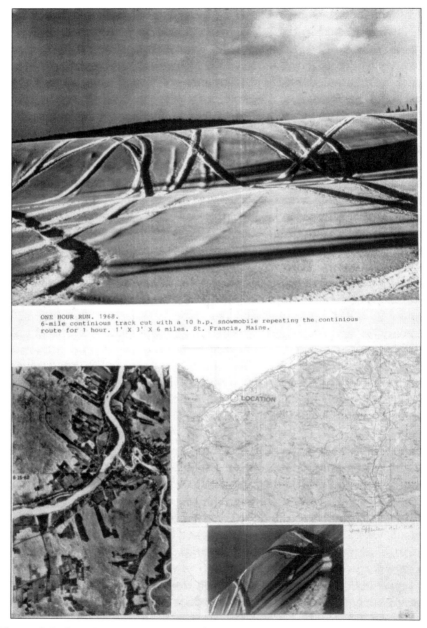

Figure 8.6 *One Hour Run.* Dennis Oppenheim. 1968. Courtesy: Dennis Oppenheim.

6-mile continuous track cut with a 10 h.p. snowmobile repeating the continuous route for an hour, 1' × 3' × 6 miles. St. Francis, Maine (U.S.A.). Photodocumentation: Black and white photograph, topographic map 80" × 180".

Courtesy: Dennis Oppenheim

present his work in the remains of 'authentic', ephemeral acts that might effect a disruptive incursion of conventionally 'non-art' activities into ostensibly sculptural processes. Concerned, in this piece, he recalls, 'with turning the face into raw material, like plastic, then creating an external situation that was going to change the face, the way it looked', so forcing 'a configuration that represented fear',[31] Oppenheim's scheme for performance placed him within a situation in which:

> As I stood in a 5' diameter circle, rocks were thrown at me. The circle demarcated the line of fire. A video camera was focused on my face. The face was captive, its expression a direct result of the apprehension of hazard. Here, stimulus is not abstracted from its source. Fear is the emotion which produced a final series of expressions.[32]

Yet, despite his apparent emphasis on 'authenticity' in which, he notes, this emotion 'wanted to be real in the simple sense of the word',[33] like much of Oppenheim's Body Art 'ROCKED CIRCLE – FEAR' is never 'present' as a performance to an audience, but is met in the mediation of an act undertaken once only. Such tactics explicitly defer attention to that which has occurred or which, by implication, cannot be present to the document or image. Yet for Oppenheim it is precisely this deferral towards the object's periphery which prompts his incursion into the 'dematerialised zone'[34] of performance, while the resulting 'work' operates in its recollection of past activity. In these modes of work, he stresses:

> in spirit, there was the feeling that these activities were charges to activate the periphery of things. There was a tendency to see even discrete performances and works as being charges that opened up doors that were not going to be found on the paper that you were presenting the work to.[35]

This pressing towards contents operating at the limit of the conventional artwork inverts, in Oppenheim's Body Art, the usual and expected relationship between performance and documentation – the event and its record. Here, documentation is positioned at the centre of the work precisely in order to defer attention to the peripheral charge in its removal from an event whose 'realness' is explicitly 'betrayed'. This tactic exposes and acts in a common understanding of the condition of representation that is often exploited in postmodern work. In his influential discussion of 'The Photographic Activity of Postmodernism', for example, Douglas Crimp notes that '[t]he desire of representation exists insofar as it can never be fulfilled, insofar as the original always is deferred. It is only in the absence of the original that representation can take place'.[36] It follows, of course, that in his pursuit of 'the real', Oppenheim inevitably seeks to capture that which evades not only the photograph but the signs of performance itself. Indeed, it is in the context

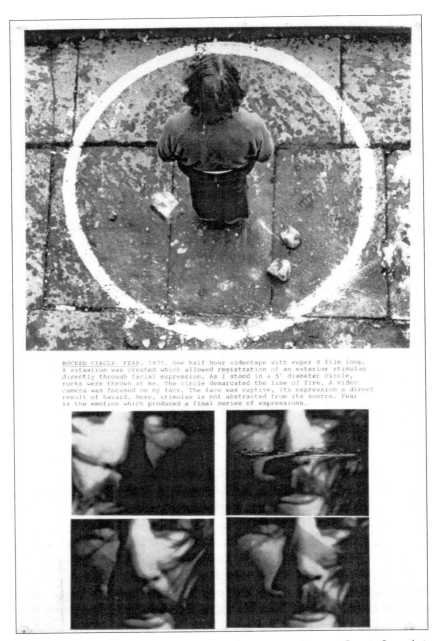

ROCKED CIRCLE- FEAR. 1971. One half hour videotape with super 8 film loop. A situation was created which allowed registration of an exterior stimulus directly through facial expression. As I stood in a 5' diameter circle, rocks were thrown at me. The circle demarcated the line of fire. A video camera was focused on my face. The face was captive, its expression a direct result of hazard. Here, stimulus is not abstracted from its source. Fear is the emotion which produced a final series of expressions.

Figure 8.7 *Rocked Circle – Fear*. Dennis Oppenheim. 1971. Courtesy: Dennis Oppenheim.

One half hour video tape / with Super 8 film loop. Photodocumentation: Colour and black and white photograph, topographic map 60" × 40"

Courtesy: Denis Oppenheim

of this evasion of the implicitly theatrical act that Oppenheim's Body Art is most frequently and often exclusively encountered in its recollection, in the absences explicitly foregrounded by the photographic image.

In this work, analogously to Acconci's play between language, image and action, performance functions in memory and recollection, or is encountered at the periphery of the text or object in allusions to the ephemeralities associated with 'the real'. Here, too, in Oppenheim's practice, danger and risk become keys to the work, serving to further heighten an awareness of the photographic image's indexical function and so its lack. Without risk, Oppenheim notes, 'the results often had certain problems of authenticity, certain problems of the calibre of the pursuit', yet, he suggests, 'with that element of danger, one's work, in every way, became more substantial. It seemed to satisfy the urges within this whole programme to raise the work and raid the real'.[37]

In Oppenheim's work, this relationship of performance to documentation, of act to image, is further extended in the intertwining of Land Art and Body Art. Indeed, in this context Oppenheim frequently positioned the body itself within a process of documentation. By 1970, Oppenheim had completed a series of actions equating activities on the body with activities on land. Here, in acting out a direct physical exchange with a site or material in which his body is scarred or marked, Oppenheim would 'correlate a specific body surface to an exterior location'.[38] Thus, in 'Land Incision' (1969) Oppenheim sought 'to correlate an incision in my wrist and the slow healing process with a cut or large ditch in the terrain'.[39] In 'Arm and Wire' (figure 8.8), he went further, constructing the body as means, material and place of the work, while making, in its documentation, implicit visual reference to his earlier action on land, 'One Hour Run' (1968). 'Arm and Wire', which has been presented as both film and documentary photograph, incorporates, Oppenheim notes:

a very close shot of my arm rolling across electrical cording, receiving the impression on the skin … . The impressions produced by the expenditure of downward pressure are returned to their source and registered on the material that expends the energy.[40]

As this correspondence implies, in significant ways Oppenheim's approach to the body in these works fulfils the impulse behind his earlier photographic documentations of actions on land. In acting out of 'the idea of the artist literally being in the material',[41] Oppenheim documents the body, in action, as the site of the work, where, as Oppenheim argues, land is 'not passive', so here he approaches the body's quintessential condition as *active* and *in activity*. In this sense, in approaching the body as always already *in performance*, his realisation of these Body Art works

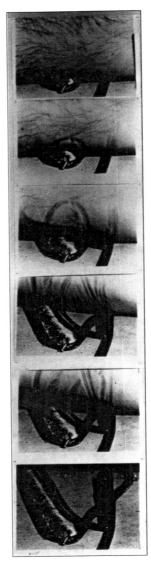

Figure 8.8 *Arm and Wire.* Dennis Oppenheim. 1969. Courtesy: Dennis Oppenheim.

Dennis Oppenheim/Bob Fiore 8 min. 16mm silent Sept. 1969.

'I did four films with Bob Fiore all dealing with process. One showed my arm rolling over this cording, leaving the imprint. It was about using elements that go into manual conditioning of form, like in this case, downward pressure. The artist became the instigator and victim of his own act. At the time I was rolling my arm across the cord, I was registering the indication of its pressure, its own exertion. The body was seen as subject/object'. D.O.

Courtesy: Dennis Oppenheim

as photographic images further emphasises a process *arrested,* positioning the photograph as the secondary record of the body's own documentation of its *past* activity.

Where Oppenheim's photographic documentations of Body Art works defer attention to an act that has passed, Michelangelo Pistoletto's later installations incorporate the photographic image into explorations of the complex role of anticipation and memory, as well as present experience, in the approach to 'real space' and 'real location'. A principal proponent, and shaping influence, of the *arte povera* movement emerging in Turin, Milan and subsequently Rome in 1966 and 1967, Pistoletto substantially developed his work in the 1960s and 1970s through explorations of real space in installations employing mirrors and Plexiglas. Taking as his point of departure notions of the present tense of real space, Pistoletto's first mirror pictures articulated spatial disjunctions through the presence of the figure. First realised in 'Il Presente' ('The Present') of 1961, in which the life-size image of a male spectator facing away from the viewer is laid over the surface of a mirror leant against the gallery wall, the mirror picture explicitly opens up questions concerning the relationship between fundamentally different, but interdependent, orders of space. Producing, the critic Bruno Cora argues, a 'relationship of instantaneousness between the painted figure, the viewer of the painting, and his or her reflection in it',[42] this 'picture' creates the scene for a series of intrusions: for the 'virtual' and 'real' viewers' mutual occupation of and displacement from each other's spaces. Writing, in his profoundly influential book, *The Production of Space,* of this relationship between spaces, the philosopher Henri Lefebvre asks:

> What term should be used to describe the division which keeps the various types of space away from each other … ? Distortion? Disjunction? Schism? Break? … . [T]he term used is far less important than the distance that separates 'ideal' space, which has to do with mental (mathematico-logical) categories from 'real' space, which is the space of social practice. In actuality, each of these two kinds of space involves, underpins and presupposes the other.[43]

Subject, Pistoletto suggests, to 'a perpetual present movement',[44] the mirror picture, as it combines the viewer's presence and space with that of the painted figure, is constituted in this spatial disjunction, where virtual and real spaces are continually seen through and in one another, yet always *in* this disjunction. In his subsequent development of this work, Pistoletto's approach to the 'real' and 'virtual', to relationships between spaces, actions and images, came to deploy processes of documentation as instruments in marking and recollecting a *passage* of time in which 'real space' and 'real location' are defined.

Graz, 5–10–1975

THE ROOMS

The idea of holding this exhibition came to me on seeing the three rooms of the Stein Gallery in Turin last Spring.

The rooms open directly into one another, along the same central axis. The dimensions of one of the 'doorways' are those of my mirror pictures (125 × 230 cm.) and thus I imagined a mirror surface placed on the wall of the end room, as a virtual continuation of the series of openings from one room into the next.

Until I saw this new gallery, I had never found a reason for exhibiting a mirror surface alone, without any form of intervention on my part. In my mirror pictures there is one aspect which is constant: the relationship between the static image, as fixed by me, and dynamic images of the mirroring process: in the case in point, the static image is pushed right up to the outer edges of the picture, whose perimeter represents the outline of the doorways which precede it physically and which proceed in the reflection.

There are many things I could say about this work; for example, that it cannot be transported elsewhere without relegating it again to the status of a mere mirror; that it 'magnetizes' all the space within the gallery by immobilizing it (by virtue of the fact the gallery immobilizes the mirror for the duration of the exhibition).

I could go on to speak of the spectator, and formulate a hypothesis about the immobility by which he would find himself surrounded (even if he were to move) should he realize that his relationship with the phenomenon is only one of 'registration'.

For his point of view in relation to the picture is immaterial, in that each and every point of the three rooms has been considered in perspective.

The particular point on which I should like to focus attention is the fact that there are three 'doorways' which become seven through reflection.

Only recently scientists discovered the law that all phenomena can be verified in mirror form, except one. Whenever we arrive at a discovery via the instruments of art, it is never microscopic or macroscopic, but always in a *human* dimension.

Figures 8.9–8.10 From Michelangelo Pistoletto, *LE STANZE (THE ROOMS)*. 1975. Courtesy: Michelangelo Pistoletto.

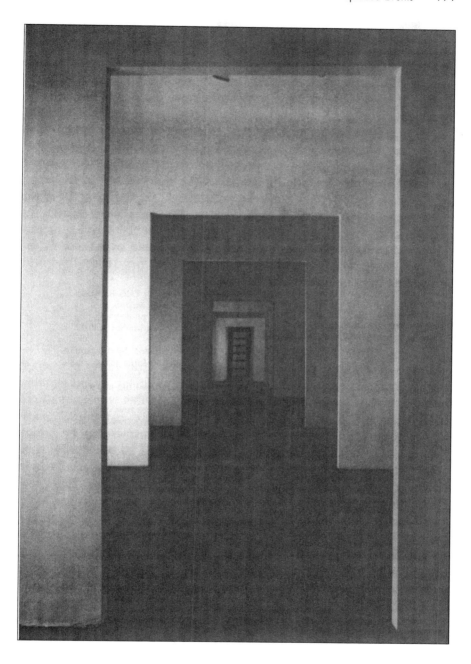

In 'LE STANZE (THE ROOMS)' (figures 8.9–8.10), twelve consecutive installations occupying the spaces of the Christian Stein gallery in Turin from October 1975 to September 1976, each for one month, Pistoletto presented the mirror, for the first time, without intervention onto its surface, in a further articulation of the complex overlaying of virtual and real spaces. Exposing the conditions in and under which this work, as it unfolds, is always in the process of being anticipated, produced and remembered, where 'real space' is subject to being 'written over' by experience and imagination, Pistoletto traces out a series of complex relationships between the real and the virtual spaces of the rooms and their various reflections. In the first of these relationships, Pistoletto's mirror, as a surface which articulates the interdependency of real and virtual spaces, occupies a series of real doorways in the gallery whose dimensions coincide with those of the mirror pictures. The rooms of the Stein gallery, Pistoletto notes in writing of the first installation (figures 8.9–8.10),

> open directly into one another, along the same axis. The dimensions of one of the 'doorways' are those of my mirror pictures (125 x 230 cms.) and thus I imagined a mirror surface placed on the wall of the end room.[45]

In this context, the twelve successive monthly exhibitions proceed to mark a rhythmic passage of time, introducing anticipation and memory into the experience of both the 'real rooms' and their representations. Indeed, just as the virtual spaces of the work write over the 'real space' of the rooms, so this process in time is an instrument by which Pistoletto's installations anticipate, remember, and so write over, each other. Yet, in this work, each representation in space, time or recollection is characterised by the attempt to recover the 'real' rooms. Here, too, Pistoletto presents both written and photographic documentation as an explicit instrument *in* and *of* the work, as he notates his own anticipation, memory and loss of the series of installations that make up 'LE STANZE'. Each month a photograph of the previous installation, accompanied by a statement, is posted as an invitation to the next. At the end of the twelve months, the photographic and textual documentation of ' LE STANZE' is 'complete'. Yet, paradoxically, the 'real rooms' can only be recovered as the antithesis of this writing over, as that which *becomes absent*, or is 'betrayed', in the very spaces of the imagined, anticipated or remembered rooms.

In this sense, as the instrument in which the real rooms, and this process, are remembered, Pistoletto's photographic and textual documentation of 'LE STANZE' is no less the work than any other moment in this passage of time away from their 'real spaces'. Reflecting,

in 'THE ROOMS, SECOND PART' (figures 8.11–8.12), on the installation, in the 'real rooms', of a full-size photograph of the first exhibition, Pistoletto observes that in this recording 'the mirror has thus been "trapped" by the camera, which has forced it to reproduce 'THE ROOMS' in definite form; that the real rooms have become virtual, in that they have been shut off behind their own photograph'.[46] Yet, paradoxically, Pistoletto proposes that in this very loss may lie the key to the real spaces from which this record departs, for 'the impact with the present flatness of the subject (which we were able previously to enter and to explore halfway) makes us perhaps more sensitive to the previous experience'.[47] In this photographic process, 'documentation', insofar as it 'writes over' and yet is *seen through*, acts as a form of palimpsest. Thus, with regard to the second installation's *representation* of the first, Pistoletto concludes, 'in "overturning" a medium to serve creative expression, it not only becomes useful, but also declares its limits, its fragility, its precariousness' such that it might make us 'more sensitive to the previous experience'.[48]

Through 'LE STANZE' Pistoletto addresses Lefebvre's paradox: that real space and virtual space are defined only *in* each other. Here, real space must be approached in its *absence*, at the limit or disruption of the work's virtual spaces, for to 'conceptualise' real space is precisely to mark its loss in representation. To this end, in 'LE STANZE', Pistoletto approaches the 'real' rooms in *the limits* of documentation. Such site-specific work incorporates documentation precisely in order to address the paradoxical relationship between its construction of a work and the site it seeks to uncover, as if it might simultaneously announce and exploit the 'betrayal' of the 'real rooms' in their reproduction. Indeed, through 'LE STANZE', Pistoletto addresses a paradox that implicitly plays within Acconci's and Oppenheim's engagement with documentation: that real space and virtual space, like performance and its representation, are defined only *in* each other.

In these examples of Acconci's, Oppenheim's and Pistoletto's use of the photograph, the photographic documentation foregrounds its own limits, its implication in a process of loss and remembering. In this context, the photograph's *lack*, its explicit deferral of the original, is employed to direct attention toward the limits of representation and, specifically, toward the *absences* in which its signs function. Yet, in these works, the 'real' activity, or the 'real' space or site approached in documentation and so in recollection, is not simply assumed to have *been present* to a place and time now past, or necessarily to *be absent* from the texts and images that remain. It is for this reason, for example, that in 'LE STANZE' Pistoletto approaches the 'real rooms' *in* the limits of

Sansicario, 5–11–1975

THE ROOMS, SECOND PART

I have written elsewhere that my mirror pictures cannot be reproduced: that is, they cannot be transformed into another medium, for that would mean the elimination of the dynamic which is their essential aspect. I feel the same is true for this exhibition of THE ROOMS: the only proper medium for its documentation is the living eye which registers it. The spectator moves forward with the light which floods in through and which gets dimmer from room to room.

The experience of the visitors consists in walking up to the mirror (in the furthest and dimmest of the rooms) to find that in it he is almost flat up against the light from the exit he has just entered by: it seems that if he were to take another step forward, he would become as one with the mirror surface, with no body and no reflection.

But the irreproducibility of this experience will emerge with THE ROOMS II, in which the spectator will see the same exhibition as a *reproduction*.

Indeed, through the first doorway (printed life-size in a photograph placed directly over the opening) we see the reproduction of the space we moved through previously.

The observer will note that the mirror has thus been 'trapped' by the camera, which has forced it to reproduce THE ROOMS in definite form: that the real rooms have become virtual, in that they have been shut off behind their own photograph (which thus becomes the only tangible datum); and the impact with the present flatness of the subject (which we were able previously to enter and to explore halfway) makes us perhaps more sensitive to the previous experience.

However, apart from these and other observations and suggestions, I should like to stress a *third* moment, which follows on from the two exhibitions: i.e. publication. For, in deciding to publish the image of the operations, we realize that the same photograph will do equally well for both.

In any piece of research, each single datum is precious.

We should not therefore ignore the fact that in 'overturning' a medium to serve creative expression, it not only becomes useful, but also declares its limits, its fragility, its precariousness.

Since 1964 I have been working with different media, modifying in every case, their conventional use. Each of them, in the course of my research, is made to determine and define the weight and the force of artistic concept. I do not allow my ambition to coincide with the unhesitating acceptance of the idea that the mass media are the message of today.

And this in itself is enough to allow me to use the same media as movers of other messages.

Figures 8.11–8.12 From Michelangelo Pistoletto, *LE STANZE (THE ROOMS)*. 1975. Courtesy: Michelangelo Pistoletto.

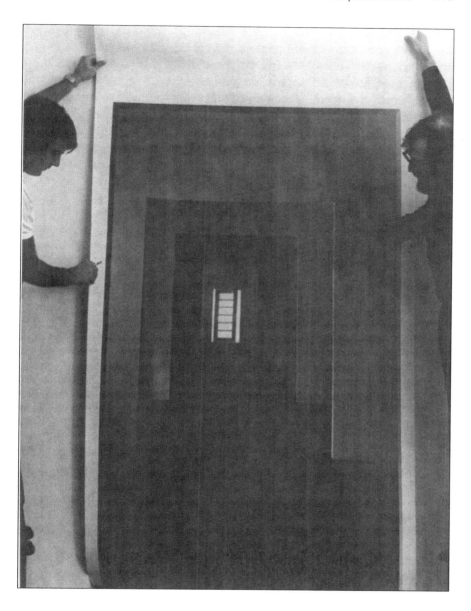

photographic documentation rather than simply announcing its loss, just as Acconci and Oppenheim explore the ephemerality of performance in its photographic remainder. Indeed, through their documentations these artists *stage* the photographic act and its images' betrayal of 'whole spaces' or of 'real events' precisely in order to imply, and so approach, the 'real' times, spaces and acts that representation necessarily elides. In this work, finally, it is the failures of photographic memory, and the incompletions and disappearances that it effects, that provide a means of speculating upon the ephemeral event and the act of performance.

Notes

1. Daniel Buren, *The Square of the Flags*, Helsinki: Helsinki Museum of Contemporary Art, 1991, p. 19.
2. See, for example, Lucy R. Lippard, *Six Years: The Dematerialisation of the Art Object from 1966 to 1972*, reprint edn, Berkeley: University of California Press, (1973) 1997.
3. Nick Kaye, ed., *Art into Theatre: Performance Interviews and Documents*, Amsterdam: Routledge/Harwood, 1996, pp. 60–61.
4. Daniel Buren, *Five Texts*, London: John Weber Gallery and John Wendle Gallery, 1973, p. 13.
5. See, for example, Nick Kaye, *Site-Specific Art: Performance, Place and Documentation*, London & New York: Routledge, 2000, pp. 184–185.
6. See, for example, Daniel Buren, *Buren: Photo-Souvenirs 1965–1988*, Turin: Umberto Allemandi & Co., 1988.
7. Daniel Buren, *Five Texts*, p. 17.
8. Kaye, *Art into Theatre*, p. 66.
9. Vito Acconci, *Vito Acconci*, Luzern, Switzerland: Kunstmuseum, Luzern, 1978, n.p.
10. Gloria Moure, ed. *Vito Acconci: Writings, Works, Projects*, Barcelona: Ediciones Poligrafa, 2001, p. 353.
11. Ibid., p. 84.
12. Vito Acconci, 'Rubbing Piece' in Kaye, *Art into Theatre*, p. 65.
13. Moure, *Vito Acconci*, p. 353.
14. Michael Fried, 'Art and Objecthood', in *Minimal Art: A Critical Anthology*, ed. Gregory Battcock, New York: E.P. Dutton, 1968, p. 125.
15. Vito Acconci, *Recorded Documentation by Vito Acconci of the Exhibition and Commission for San Diego State University* (audio cassette), San Diego: San Diego State University, 1982.
16. Acconci, *Vito Acconci*, np.
17. Vito Acconci, cited in *Vito Acconci – A Retrospective: 1969 to 1980*, ed. Judith Russi Kirshner, Chicago: Museum of Contemporary Art, 1980, p. 10.
18. Acconci, *Vito Acconci*, np.
19. Vito Acconci, cited in Kirshner, *Vito Acconci* , p. 13.
20. Kaye, *Art into Theatre*, p. 60.

21. From Acconci's unpublished notes for *Room Situation (Proximity)*, ca. 1970.

22. Cindy Nemser, 'An Interview with Vito Acconci', *Arts Magazine*, March 1971, p. 20.

23. Ibid., pp. 20–21.

24. Vito Acconci, cited in Moure, *Vito Acconci*, p. 64.

25. Ibid., p. 60.

26. Alanna Heiss, ed., *Dennis Oppenheim: Selected Works 1967–90*, New York: Harry N. Abrams Inc. and Institute for Contemporary Art, 1992, p. 8.

27. Thomas McEvilley, 'The Rightness of Wrongness: Modernism and Its Alter-Ego in the Work of Dennis Oppenheim' in Heiss, *Dennis Oppenheim*, p. 20.

28. Willoughby Sharp, 'Dennis Oppenheim Interviewed by Willoughby Sharp', *Studio International* 182, no. 938, November 1971, p. 188.

29. Dennis Oppenheim, cited in Kaye, *Art into Theatre*, p. 57.

30. Ibid., p. 58.

31. Ibid.

32. Ibid.

33. Ibid.

34. Ibid., p. 66.

35. Ibid., p. 63.

36. Douglas Crimp, *On the Museum's Ruins*, London: MIT Press, 1993, p. 119.

37. Dennis Oppenheim, cited in Kaye, *Art into Theatre*, p. 67.

38. Dennis Oppenheim, cited in Sharp, 'Dennis Oppenheim Interviewed by Willoughby Sharp', p. 187.

39. Ibid.

40. Ibid.

41. Ibid., p. 186.

42. Bruno Cora, 'Michelangelo Pistoletto: From the Mirror Paintings to Progetto Art. The Artist as Sponsor of Thought', in *Pistoletto: Le Porte di Palazzo Fabroni, Michelangelo Pistoletto*, Milan: Charta, 1995, p. 43.

43. Henri Lefebvre, *The Production of Space*, Oxford: Blackwell Publishers, 1991, p. 14.

44. Cora, 'Michelangelo Pistoletto, p. 43.

45. Michelangelo Pistoletto, 'LE STANZE (THE ROOMS)', in Kaye, *Site-Specific Art*, p. 62.

46. Ibid., p. 64.

47. Ibid.

48. Ibid.

Part III

Reframings

Chapter 9

Vietnam War Photography as a Locus of Memory

Patrick Hagopian

Although commentators have frequently referred to the Vietnam War as the first 'television war', with images broadcast into the public's living rooms, it might more accurately be called a celluloid war. The images that constitute the visual archive of the war – in books, documentaries and the recollection of commentators – are not moving images but still photographs. And everyone who refers to them generally agrees what those images include. A typical summary of this photo gallery reads as follows: 'Unlike previous wars, Vietnam was a war of images, most of them horrible: Buddhist monks setting themselves on fire; General Loan shooting a VC suspect in the head; bodies lying in the garden of the US embassy; a naked child screaming in pain from napalm burns; four students lying dead in Ohio'.[1] In addition to these images, other commentators cite Ron Haeberle's photograph of the My Lai massacre and a handful of others.[2] Of the millions of photographs taken by war photographers and journalists, these are the ones that are now selected by documentary-makers and writers and are the ones that first come to mind for inclusion in documentaries and books.[3]

This essay examines the immediate impact and the afterlife of these photographs. It discusses the extent to which the photographs changed or influenced events during wartime. It will also investigate the way in which the photographs retain their significance after the war; how they can attain new layers of meaning after the fact, and how their importance may, indeed, grow. The photographic act does not end with the tripping of the shutter and the exposure of the film; nor with the creation of the image in the processing lab. Nor even does it end with the first publication of the photograph. The photographic act is mirrored to infinity with each new publication of the photograph and each new viewing.

Photographs, like other textual artefacts, are consumed without being destroyed. Frequently reproduced photographs become part of a self-reinforcing feedback circuit. Images that are published again and again are those that first come to mind when lay people, writers or documentary producers think about the historical events that they depict. Even if an editor or film producer has a wider knowledge of the photographic archive of the Vietnam War, they plump for the familiar images because those are the ones that encapsulate the war for ordinary viewers. These photographs are chosen because they have been chosen many times before.

Photographs serve as powerful evocations of historical experiences because of the way they leave an imprint on their viewers. Unlike a piece of moving film, which viewers process in real time, a photograph allows the viewer to stare, to turn from the picture and then return to it. Perhaps short sequences of moving images – such as the newsreel footage of a napalmed Vietnamese girl running towards the camera, also captured by Nick Ut's famous photo – fix themselves in viewers' memories in the same way. But photographs have the advantage of enabling sustained or repeated viewings without any apparatus other than the turn of a page or the concentration of a gaze.

Photographs at once fix and disseminate memories of the past at the nexus of social, neurological and cognitive processes. They achieve their insistent force by leaving an imprint first on the retina, then on neurons, condensing meanings but setting off further associations. The endless reproducibility of the image does not explain why one image rather than another is chosen. This must be explained by reference not only to the content of the image itself but to its aptness in relation to the larger historical experience it depicts – how does the scene captured by the photograph relate to prevailing interpretations of the historical experience? This question must be addressed by examining the relationship between particular war photographs and contemporaneous judgements of the war. How, then, does a photograph retain its relevance – or assume a new relevance – through shifting interpretations of the war over time? In this instance, too, we cannot consider the photograph alone, but must also decipher how it retains – perhaps gaining or losing – power over time. One photograph may gain in power and relevance because of its cogency to emerging interpretations of the past. Another may dissipate its strength because the meaning it seemed once vividly to illustrate begins to appear false or irrelevant. Thus, it is not enough merely to remark that photographs succeed by being successful, and that the most well known photographs are endlessly reproduced because they are well known. The questions this essay will explore are why *these* photographs were chosen; and whether their meanings have changed. To address these, we have to consider the photographs in all their aspects – visual, psychological and political.

The furore greeting images published in May 2004 of prisoner abuse in Iraq's Abu Ghraib jail reminds us of the political impact of wartime photography and provides a contemporary correlative of the public shock when photographs of the My Lai massacre were published in 1969. In both instances, photographs provided evidence of crimes that had long been rumoured and even substantiated by authoritative witnesses. However, it was not until the photographs pushed these realities into the face of the public, and until the reaction to them forced policy-makers into an institutional response, that these crimes became politically consequential. Why did the publication of these photographs have this effect?

Photographs of the torture of prisoners at Abu Ghraib were published in *The New Yorker* magazine, accompanying articles by the investigative journalist Seymour Hersh (who, thirty-five years earlier, had broken the news of the My Lai massacre to newspaper readers).[4] The photographs caused a sensation, sending shockwaves through the U.S. government as, published around the world, they prompted Americans and others to ask what the United States was doing in Iraq.[5] Although international organisations had reported 'abuse' and 'mistreatment' of prisoners and although the political and military authorities administering the occupation of Iraq had received these reports, these officials stated that it was not until they saw the photographs that they realised the extent of the problem.

The significance of the photographs was twofold. First, they made vivid such terms as 'abuse' and 'mistreatment', terms that ought to compel revulsion but that, as mere words, did not seize the consciences of their readers. Surrounded by pages of reports on the treatment of prisoners, the words remained vague or abstract until they were given a specific facticity by the photographs. The photographs made the abstract real. U.S. Senator Patrick Leahy said that the treatment of prisoners in Afghanistan was as bad as it was in Abu Ghraib, 'but because there were no photographs ... they have not received enough attention'.[6] It was as if the torture did not enter public awareness when it was formulated as a report or as words: only when it became visible as pictures.

Officials' responses to the photographs were also predicated on their anticipated reception by the public. If verbal complaints of 'abuse' and 'mistreatment' had not demanded an urgent response on the part of officials, they had made no impression whatever on the sensoria of much of the public. Such allegations were easily dismissed as propaganda produced by opponents of the allied invasion of Iraq. No public outcry had greeted the violation of rights and allegations of mistreatment of prisoners in Afghanistan and at Guantánamo Bay, Cuba. Officials realised that, if released to the public, the photographs of prison abuse at

Abu Ghraib would make vivid the treatment of prisoners and might shock a public accustomed to regard atrocities as the province of the U.S.'s enemies, not of its own troops. The officials' response to the photographs, before their publication, was conditioned by the reflected image of the photographic scenes as viewed by a shocked and disappointed public. The response was, therefore, to suppress the photographs. When they were eventually leaked, the US public's support for the occupation of Iraq sank, just as officials had anticipated.

The journalist Leonard Doyle predicted that the damage to the United States's reputation would be lasting and that the pictures of the abuse would persist in people's memories. The historical parallel he drew came from Vietnam – specifically, the photograph (by Nick Ut) of the napalmed Kim Phuc running down a road (figure 9.1).[7] Yet the more apt comparison might be with the photographs of the My Lai atrocity, which graphically revealed to Americans unpalatable truths about their armed forces' efforts.

On 16 March 1968, Charlie Company, a unit of the American Division, entered the village of Son My in Quang Ngai province. Primed to expect

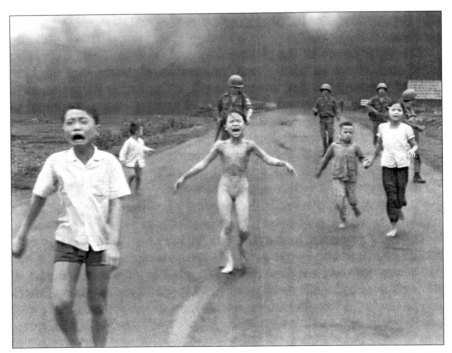

Figure 9.1 *Kim Phuc after Napalm Strike, Highway 1, Trang Bang, June 8, 1972.* Nick Ut. Courtesy: AP/Wide World.

heavy resistance from the Viet Cong forces, they encountered no armed enemies. Yet they spent the morning gathering groups of villagers and mowing them down with automatic weapons and grenades. They also committed other atrocities, including rape, the wanton mistreatment of the civilians in their custody and the mutilation of corpses.

Ron Haeberle, an army photographer assigned to Charlie Company during the assault on My Lai, had taken photographs of the massacre. In addition to some unexceptional black-and-white photographs documenting the operation, Haeberle disclosed to the army investigator in August 1969 that he had secretly taken colour photographs recording the massacre of civilians. News of the massacre began to filter into the media with the reporting of court-martial charges against William Calley, a Charlie Company platoon leader who was eventually tried and found guilty of killing and ordering the deaths of unarmed civilians. The news had little public impact, though, until the press published interviews with participants in the massacre illustrated by Haeberle's photographs.[8] On 20 November 1969, the *Cleveland Plain Dealer* published some of the photographs on its front page, and CBS News showed the paper's photo spread as the lead item of its nightly news broadcast. Four days later, CBS television screened reporter Mike Wallace's live interview with veteran Paul Meadlo. Meadlo described lining up women, children and old men, and shooting them. Wallace asked how he could have shot babies, and Meadlo answered, 'I don't know. It's just one of them things'. He described his recurrent dreams. 'I see the women and children in my sleep. Some days ... some nights, I can't sleep. I just lay there thinking about it'. After listening to his confession on television, his mother, Myrtle Meadlo, said, 'I raised him up to be a good boy and I did everything I could. ... He fought for his country and look what they done to him – made a murderer out of him, to start with'.[9]

One of the photographs shows a cluster of frightened women and children on a path where they have been led or intercepted by American soldiers. They huddle with frightened expressions and hold each other (figure 9.2).[10] Haeberle tells us that after taking the photograph, he turned and walked away but then heard gunfire. When he looked back, he saw that the soldiers had shot the women and children, who fell where they had stood moments before. Haeberle returned and photographed the corpses.[11] These photographs are heart-wrenching because we know that the presence of Haeberle's camera temporarily protected the villagers from the soldiers, who did not want to shoot the villagers while the camera was trained on them. The photograph preserves one of the final instants of their lives before the other, unseen watchers killed them. We become witnesses to a crime and bystanders impotent to prevent it.

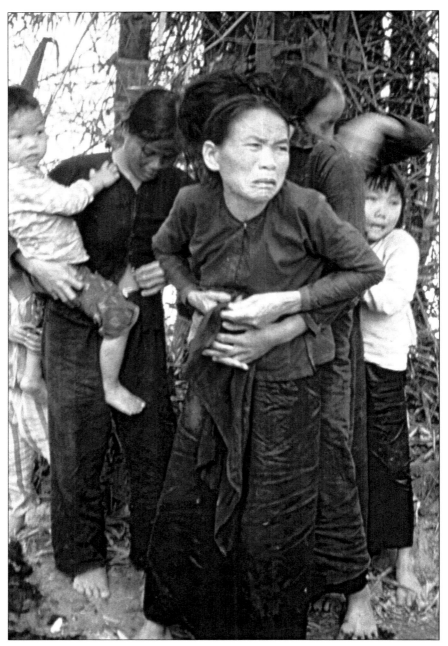

Figure 9.2 *Civilians on a Path at My Lai.* Ron Haeberle. 1969. Courtesy: Ron Haeberle/ Life Magazine.

Photograph after photograph documented the cruelties the villagers suffered. A woman's corpse stares at the ground as her mouth lolls into a fallen conical hat. An old man lies on his back, his head tilting back into a pool of blood, a red stain on his throat. On a path, a child lies on its stomach, one leg smeared with blood, the other pointing towards the body of an adult lying sprawled sideways at the path's edge, a lidded basket alongside them. A young boy tries to shield his companion with his body, before both are shot again. The veteran who killed them, Varnado Simpson, said in the documentary *Remember My Lai* that these images were always in his mind: 'that's my life', he explained.[12]

Despite the photographic evidence, the reaction of much of the public to the first reports of the massacre was disbelief. Americans refused to accept that their soldiers could have massacred unarmed civilians. In debating the issue of 'recovered memory', Theresa Reid has proposed that in cases of epistemological uncertainty, there is a great temptation for people to make 'a summary judgment in favor of the least painful argument'.[13] This observation may also apply to the responses to the My Lai massacre, where the difficulty for the public lay not so much in uncertainty about the facts as in the dissonance between the facts and the governing assumptions about the moral integrity of U.S. armed forces. Many people provided fabricated rationales for the soldiers' behaviour: the civilians must have been armed, the soldiers must have been fired on, the photographs of the dead must not be authentic, and were perhaps staged for anti-war propaganda purposes. One person described the event as incredible because 'it's contrary to everything I've learned about America'. Others dismissed the massacre as the sort of incident that is 'bound to happen in a war'.[14] Indeed, far from calling the soldiers, their commanders, or the country's political leaders to account for the events in My Lai that March day in 1968, much of the public criticised the media for bringing the massacre to light. A Cleveland woman defended the shooting of children by saying, 'It sounds terrible to say we ought to kill kids, but many of our boys being killed over there are kids, too'. A salesperson in Los Angeles refused to believe the massacre happened, arguing that the 'story was planted by Viet Cong sympathisers and people inside this country who are trying to get us out of Vietnam sooner'. The vast majority of responses to the publication of the My Lai photographs by the *Cleveland Plain Dealer* and the interviews of My Lai veterans by CBS News's Mike Wallace criticised them not for how they reported the story but for reporting it at all.[15]

If both the Abu Ghraib and the My Lai photographs horrified those who saw them, what they depicted was not entirely news. Members of the anti-Vietnam War movement had long claimed that the U.S. war effort

involved atrocities. Bertrand Russell and Jean-Paul Sartre had gone so far as to hold a 'tribunal of enquiry' into alleged U.S. war crimes; before the My Lai massacre occurred, the journalist Jonathan Schell had reported abuses, including the indiscriminate killing of civilians, in Quang Ngai province.[16] So, too, the Abu Ghraib abuses in Iraq fitted the pattern of illegal U.S. conduct. By the time these photographs came to light, the United States had already been criticised for ignoring the rights of prisoners in Afghanistan and Guantánamo Bay, Cuba; it had refused to recognise the jurisdiction of the International Criminal Court over its citizens and troops; and its Secretary of Defence, Donald Rumsfeld, had refused to recognise the applicability of the Geneva Conventions to alleged terrorists in U.S. custody. Both the My Lai and Abu Ghraib photographs were therefore consistent with long-standing criticisms of U.S. actions, and with allegations of systematic criminality on the part of U.S. troops.

To grasp the impact of the photographs, one must see how they closed a circuit between two absolutely inconsistent psychological and moral postures both of which were available to the U.S. public and international observers. In both cases, political and military leaders had assured their own public and the world that the United States was a benign force, in South Vietnam protecting a fledgling democracy from totalitarianism and in Iraq bringing freedom to a benighted corner of the Arab world. These claims were consistent with the preferences of those who *wished* themselves to be allied with a force for good or to be citizens of a virtuous nation. However, critics drew attention to the moral failings of that nation's military forces and cast doubt on the worthiness of its actions. Anyone who was not entirely convinced by the claims of the defenders or critics of U.S. policies must have experienced a degree of dissonance or managed, with whatever discomfort it caused, to perform the trick of simultaneously maintaining two mutually exclusive ideas in their minds. Those exposed to these inconsistent ideas must have retained both provisionally as possible interpretations of events. The photographs challenged this tendency to sustained uncertainty, forcing unavoidable facts onto the consciousness of viewers and forcing those who had so far suspended judgement into making up their minds. It was not that the photographs confirmed settled truths that people already knew; nor that from a clear blue sky they brought unexpected possibilities into brutal facticity. Rather, the photographs brought home uncomfortable truths that people had long had reason to suspect but which did not need to be confronted as long as they remained unproven. This, I propose, is the necessary violence of the photographic act.

Photographs of the My Lai massacre, of the murder of a Viet Cong suspect by a South Vietnamese general, and of a napalmed girl, Kim

Phuc, became emblems of all that was wrong with the Vietnam War. But criticisms of the war had already prepared the ground for the photographs by establishing the idea that the United States's cause was unjust and that its troops and its allies were fighting brutally. The photographs illustrated and reinforced the uneasy truths in the political criticisms that undermined the U.S.'s cause in Vietnam. This presents us with difficulties in measuring the effect of the photographs as distinct from other representations of the war. Numerous commentators have suggested that the photographs themselves had an enormous impact on the way people felt about the U.S. war effort in Vietnam, just as I have offered an account of the way that they dissolved a psychological comfort zone bounded by various competing and inconsistent views of the world. But the extent to which the photographs exerted independent influence – and how a photograph can do that – remains to be demonstrated. Is the historian correct who judges that the photographs changed the course of events?

Always included in lists of the most important photographs of the Vietnam War are Malcolm Browne's photograph of the immolation of a Buddhist monk, Thich ('the venerable') Quang Duc, in June 1963 (figure 9.3) and Eddie Adams's photograph of a South Vietnamese general shooting a prisoner in the head in February 1968 (figure 9.4). The photographs' importance is confirmed not just by the number of times that commentators cite them as explanatory factors in changing attitudes

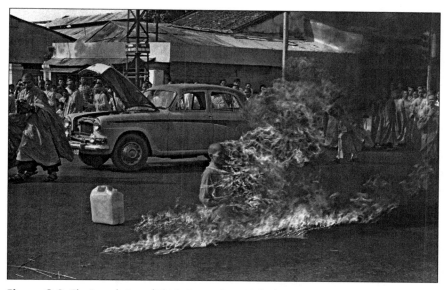

Figure 9.3 *The Immolation of Thich Quang Duc.* Malcolm Browne. 1963. Courtesy: AP/Wide World.

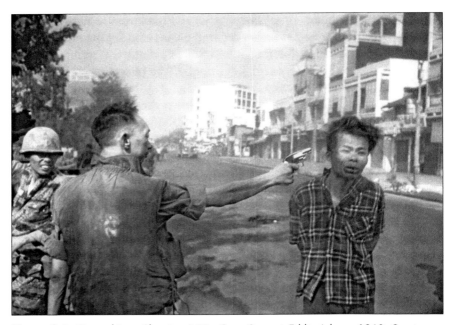

Figure 9.4 *General Loan Shooting A Viet Cong Suspect.* Eddie Adams. 1968. Courtesy: AP/Wide World.

to the conflict, but by their subsequent appearances in books and documentaries about the war. Something that links these photographs and distinguishes them from the Abu Ghraib and My Lai photographs is that they are not the sole visual evidence of the events: there also exists film footage of the both the monk's burning and the shooting of the prisoner. In film and television documentaries, one therefore often sees moving images as well as stills of these events. Yet it is the still photographs that most people remember – so much so that one commentator who ought to have known otherwise denied that film footage of the monk's death existed.[17] What was the political impact of these two photographs and why did these, rather than the moving images, impress themselves most clearly on viewers' minds?

The extraordinary photograph of the self-immolation of Thich Quang Duc, showing the monk sitting in the lotus position and engulfed in a pyramid of flame, appeared on the front pages of newspapers around the world. Until then, Vietnam had been a rather obscure corner of the post-colonial struggle between the international forces of Communism and capitalism. It had been on the agenda of U.S. policy-makers since they had tried to shore up the French colonial regime in the early 1950s and then attempted 'nation building' by supporting their chosen leader of

South Vietnam, Ngo Dinh Diem. But only a few thousand U.S. 'advisers' were present and, although Vietnam concerned government leaders, the vast majority of U.S. citizens were unaware that such a place existed, far less that they had national interests there.

The photograph of Thich Quang Duc setting himself on fire in protest against the anti-Buddhist repression by the Catholic Diem government changed everything and set the stage for a reconsideration of the United States's support for Diem. Those who witnessed the scene, even at the remove of the photographic image, asked themselves why the United States was supporting a regime that was so dreadful that this monk felt compelled calmly to burn himself to death in protest against it. Malcolm Browne, a reporter for the Associated Press news service, turned up at an ordinary-looking street corner in time to see the monk's helpers pour petrol on him. Browne watched in disbelief as the cross-legged figure struggled with a lighter to ignite his fuel-soaked robes. The flames licked around the silent Thich Quang Duc and began to consume him, filling the air with the smell of burning petrol and roasting flesh; Browne was awe-struck but remembered why he was there. A day after his finger clicked his camera's shutter, the photograph flashed around the world, transmitted by the AP news wire. The picture won for Browne the Pulitzer Prize.

The burning had not been a spontaneous gesture but was one that Quang Duc had proposed weeks earlier to his superiors. His Buddhist supporters had made a point of inviting Malcolm Browne and a film crew, who captured the whole of the event, including the burned body eventually toppling over. They had prepared a sort of press release: a biography of the monk, with a copy of his plea to Diem to show 'charity and compassion' to all religions.[18] The photograph 'touched a big chord' with intellectuals and policy-makers in the United States. As the journalist Charles Mohr remarked, there was 'really no parallel up until then of the fanaticism of a guy burning himself to death'. Mohr said that the U.S. public asked themselves, 'What is all this? Who are the Buddhists? What are they mad at? Burning yourself to death was so alien … '.[19]

Malcolm Browne's photograph had a tremendous shock value but it did not appear in a vacuum. Lines of fate linked the progress of the 'Buddhist crisis' in Vietnam that led to the monk's self-sacrifice with machinations in the U.S. government. By the summer of 1963, some U.S. policy-makers had despaired of the Diem regime's changing sufficiently to gain the support of the majority of South Vietnam's people and to win the war against the Communist Viet Cong. At the same time, journalists such as Browne were beginning to ask tough questions about the competence and moral worth of the Diem government.[20] It was this critical stance that encouraged the Buddhists to invite Browne to witness

the self-immolation. The 'Buddhist Crisis', dramatised by Browne's photograph, hardened the attitude of U.S. policy-makers critical of the regime and drove them to shift Diem from the scene, to be replaced by South Vietnam's U.S.-trained military officers who would prosecute the war more effectively. A few months after the crisis summer, these generals received the green light from Washington: the CIA's contact with the coup plotters told them that the USA would support any government that would take up the fight against Communism in Southeast Asia.[21] This signed Diem's death warrant. In the coup effected by the generals at the beginning of November 1963, Diem and his brother Nhu, the chief of the security apparatus, were killed in the back of an armoured vehicle.

Four years later, Vietnam was engulfed in another crisis for which Eddie Adams's photograph documenting the murder of a Viet Cong prisoner became a lasting emblem. To coincide with 'Tet', the Chinese New Year, at the end of January 1968 the Viet Cong launched simultaneous attacks in cities across the length and breadth of South Vietnam. Adams, an Associated Press photographer, came upon a scene that, like the monk's self-immolation, was to have repercussions around the world. Brigadier General Nguyen Ngoc Loan approached a captured Viet Cong prisoner as Adams stood with his camera, ready to shoot a picture. As Loan raised his pistol to the prisoner's head, so Adams's camera came up; and Loan pulled the trigger at the identical moment that Adams tripped the shutter. The extraordinary result was that Adams's photograph shows the exact moment when Loan's bullet entered the prisoner's skull – one can see the physical impact of the bullet force a grimace on his face – but before the first trace of blood. Adams's shot, radio-photoed by the Associated Press, appeared on front pages around the world. Anticipating the political impact of a picture clearly depicting a war crime by a U.S. ally, newspapers considered running a 'balancing' story about Communist atrocities; but they realised that this would be an attempt at a forced and artificial equivalence because no photograph of the other side's crimes had the immediacy of Adams's photograph of the event as it was being enacted. Adams's photograph ran on the front page of the *New York Times* and the *Washington Post* without any such pairing.[22] Once again, the effect was to cast doubt on the worthiness of the ally that the U.S. was supporting. The historian Alan Brinkley said of the shooting, 'No single event did more to undermine support in the United States for the war'.[23] Millions saw the film footage on television – an estimated twenty million viewers saw the first television broadcast alone. Yet within a few days it was the photograph rather than the film footage whose impact was said to be decisive. Senator Robert Kennedy said: 'The photograph of the execution was on front pages all

around the world – leading our best and oldest friends to ask … what has happened to America?'[24]

Eddie Adams himself always tried to downplay the moral significance of the photograph. Ironically, he sympathised with General Loan (despite the general's reputation as a homicidal monster who made threatening visits to the National Assembly during critical votes and had a habit of playing with a loaded pistol during meetings with government officials).[25] In numerous forums, Adams explained that the general told him, 'They killed many of my people'. Adams feels that the criticisms of Loan's actions were very 'one-sided' but, once released into the world, the photograph assumed a power independent of its producer's volition.[26] Whereas Adams never ceased to rationalise Loan's act, much of the world treated Loan as a pariah.

As with the Browne and Adams photographs, the most famous, and most frequently reproduced, image of the war, Nick Ut's photograph of the napalmed Kim Phuc running down a road, shows a scene that has also been recorded by a movie camera. And yet once again the common cultural reference point is the still picture, not the movie footage. The book about the photograph and the life of its subject is entitled *The Girl in the Picture*, not 'the girl in the film clip'.[27] Why do commentators mention the still photographs, and not the moving images, of the Tet shooting and the monk's death? The film footage is intrinsically memorable. In the footage of Thich Quang Duc's death, we can see the whole scene and the entire event more clearly than we do in the photograph, including the reactions of the assembled audience and the astonished passers-by. We see the stillness of the monk's figure against the roaring flames, and we see smoke rise as his body topples sideways. The footage of the Tet shooting displays horrors which the photograph spares us: we see the prisoner collapse, his body twitching, as a fountain of blood arches up from his temples and then slows to a trickle.

I would argue that the power of the still image lies in its very stillness. Because it exists in space but not in time, it can endure for the viewer. We can fix on a particular configuration of forms and we can hold it in our gaze. We can possess it as we stare at it. In contrast, the moving image exists in both space *and* time. Its verisimilitude may be enhanced by movement, and its content multiplies with the micro-movements within each successive frame. Unless we forensically pull apart each frame (as in the slow-motion replays of the Zapruder film in the feature film *JFK*), unless we see a film still or freeze-frame, we experience the film in real time.[28] Compared with the time we can spend studying a photograph, the existence of a moving image is a fleeting thing.

Moreover, we see the still image in more contexts and more frequently. It appears in films and television documentaries as well as in books and in a host of other forms and genres that do not depend on the cinematic or televisual apparatus. The film footage plays a supporting role, enhancing the significance of the photographs because each time we see the footage, we may remember the photograph. Photographs become the common currency of recollection because they endure, because of their endless reproducibility, and because they are therefore shared by many viewers. And the more often they are seen, the more their status as common cultural reference points is reinforced, so increasing the likelihood that editors and documentary-makers will select them again in future. The photographs' role as memorable images of the war can therefore *increase* even as a thousand other facts and images are forgotten.

The photograph 'South of the DMZ, Vietnam, 1966' by Larry Burrows (figure 9.5) functions as a paradigm of the process by which photographs may retroactively *become* meaningful in relation to new interpretations of past events rather than *establish* the meaning of those events. The photograph, taken during Operation Prairie, a Marine operation from September to October 1966, shows a wounded African American soldier, his head bandaged, stumbling towards a wounded white soldier, caked with mud, staring up with unfocused eyes as he leans backwards on the

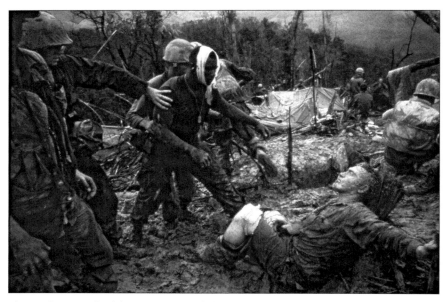

Figure 9.5 *'South of the DMZ'*, [Wounded Soldiers in a Muddy Battlefield]. Larry Burrows. 1966. Courtesy: Time/Life.

ground.[29] The photograph was not in fact published when Burrows sent it to Horst Faas, his editor at *Life*, soon after Burrows accompanied the Marines on the operation. It was only after the photographer's death in 1971 that Faas began to look through a drawer full of Burrows's unpublished photographs and selected this image for publication.

Larry Burrows was one of the most famous of the Vietnam War photographers; some commentators have indeed called him 'the greatest of all war photographers'.[30] He never failed to go where the action was. But as well as documenting battle scenes, he captured the emotions of battle with a powerful immediacy – grief and exhaustion figure in his work as well as violence and terror. An early supporter of the U.S. war effort in Vietnam, Burrows worked for *Life* magazine, whose publisher, Henry Luce, was a leading supporter of the 'China Lobby' and an avid opponent of Communism in Asia. Burrows's own uncritical attitude to the war sat easily with *Life*'s editorial policy. One of his most famous series of photographs appeared in a story entitled, 'With a Brave Crew on a Deadly Flight', which he shot in 1965 and which won him the 1966 Robert Capa Award.[31] The first photograph shows a helicopter, *Yankee Papa 13,* going into action. The helicopter receives fire and one of its pilots is killed. Burrows photographs the mortally wounded man as he lies on the floor of the helicopter; then documents the despair and grief of his comrade, the helicopter's crew chief, after they have landed. The photographs express Burrows's sympathy for the war effort, his regard for the U.S. troops' courage and his respect for their sacrifices.

By the time of his death, attitudes to the war – including Burrows's own – had changed. The prospect of a U.S. victory had dwindled; the withdrawal of troops under the 'Vietnamisation' policy was well under way. And the U.S. war effort had been discredited by the publication of the photographs of the My Lai atrocity. Burrows had published a photo-essay with an accompanying text in which he recorded his own growing disillusionment with the war.[32] And by the time of the photographer's death, Henry Luce, *Life*'s fiercely anti-Communist publisher, had also died and the magazine had shifted its editorial posture. Among the most remarkable indications of *Life*'s more critical stance was the photo-essay on one week's dead, which showed the names and faces of the 242 Americans who had died in Vietnam in a particular week, assembled on the page as if in a high-school yearbook.[33]

When Faas saw again the photograph of the wounded troops in a morass, it had by then taken on a new meaning and it jumped out at him. Previously it had been a rather disorganised image. The African American soldier partially obscures a couple of soldiers behind him, confusing the outlines of their figures. With the desultory figures in the

background paying no attention to the drama being played out in the foreground, the photograph's central event seems a fugitive and inconspicuous moment undeserving of special attention. There is a large area of dead space in the centre of the frame occupied by mud and sagging tents. It is clear why the photograph was not published in 1966 – the disorder in the composition did not have a correlative (at least not as far as *Life*'s editors believed) in interpretations of the war. But by 1971, the features that had once made the photograph unsuitable for publication made it capture perfectly the sense of waste that now permeated popular sentiments about an increasingly unpopular war. As the journalist Wallace Terry explained, the scene in the foreground now took on Biblical resonances, the mortally wounded soldier on the ground appearing a sacrificial figure.[34] Others have remarked on the way that the image echoes European religious art.[35] The mud sucking at the soldiers' boots and caking the face and uniform of the dying man now became a materialisation of what critics had long called the Vietnam War: a quagmire.[36] The outlines of the photograph encapsulated a vision of the war as chaotic and sacrificial, and it assumed greater authority the more sharply this interpretation of the war came into focus in the imaginations of viewers.

All of the photographs considered here had long afterlives, which took several forms: protest posters, popular-cultural reproductions, uses in documentaries and books, and appropriations in fine arts. Photographs finally count not because of the number of times that they are reproduced or seen but because of the effect that they have on viewers. An ubiqituous photograph that is universally ignored counts for little or nothing; a photograph seldom seen but which transforms those who have seen it counts for a lot. The photographic act is not complete until the viewer becomes involved. The imprint of the images in the minds of viewers is, however, not readily available for study except through anecdotal evidence. Audience research has its place but it cannot assess the impact of images, especially with the passage of time and shifts in political discourse. (It can, however, yield interesting results: students in a course on the 1960s at the College of William and Mary in Williamsburg, Virginia in 1994 to 1995 were generally familiar with the Eddie Adams photograph but were far less sure about who was shooting whom.) Material instances of the photographic act in various settings can therefore provide evidence at least of the *currency* of these photographs, if not of their *effect*.

After their initial publication by news outlets, the photographs were immediately appropriated by the creators of anti-war protest posters

(figure 9.6). Protest posters used the My Lai photographs (figure 9.2), the photograph of Kim Phuc (figure 9.1) and John Filo's photograph of a student killed by the Ohio National Guard at Kent State University.[37] The same photograph of the My Lai massacre was used in successive anti-war posters (figure 9.7), the caption updated to reflect the changing historical context.[38] Another photograph, showing a badly burned Vietnamese infant, moved swiftly from newspapers to protest posters and ultimately to the book jacket of a scholarly work about the war.[39] These posters use the facticity of the news photograph to present undeniable reality to viewers, duplicating the initial shock effect of the photographs while making them familiar: the growing familiarity of the images risks de-sensitising the viewer but it also amplifies the photograph's impact, entrenching it in popular memory. Now, the photograph projects itself into the viewer's sensorium in unexpected places – for example, flyposted on a wall. The war appears as a violent rupture of the visual field, jarring America's domestic scene and preventing viewers from putting the distant scene of injury out of their minds.

Popular imagery that appears in less overtly political contexts than anti-war posters amplifies this double effect of banalisation and violence. Bruce Franklin has demonstrated that Eddie Adams's Tet photograph (figure 9.4) has lived on in Hollywood film and comic strips.[40] Malcolm Browne's photograph of Thich Quang Duc's self-immolation (figure 9.3) has remained in the public's awareness through a range of reproductions: it appears in a Billy Joel video, for example, and it is the sleeve photograph of a record by the band Rage Against the Machine. But these reappearances seem anodyne when one considers that another mode of re-enactment took place in the real world, with burning flesh as its

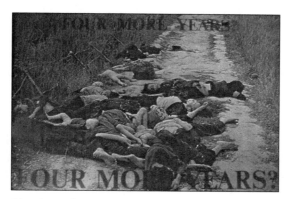

Figure 9.6 *Four More Years*, [Anti-war poster reproducing Ron Haeberle's photograph of Massacred Civilians on a Path at My Lai]. Art Workers' Coalition. 1972. Courtesy: Collection of the Division of Political History, National Museum of American History, Smithsonian Institution.

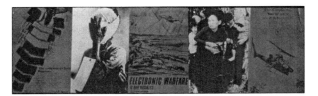

Figure 9.7 *Electronic Warfare Is Our Business,* [Anti-war poster reproducing Ron Haeberle's photograph of Civilians on a Path at My Lai and Philip Jones Griffiths's photograph of a Victim of War in Quang Ngai Province]. Courtesy: Collection of the Division of Political History, National Museum of American History, Smithsonian Institution.

medium. Other monks requested and were granted permission to burn themselves sacrificially in protest against the Diem regime in the summer of 1963; in turn, protesters in the United States, frustrated at their inability to affect their government's policy, burned themselves, to prove that there were U.S. citizens who were equally outraged to the point of self-sacrifice.[41]

All these images are widely reproduced in documentaries, starting with *Hearts and Minds,* directed by Peter Davis in 1972; followed by the WGBH documentary series, *Vietnam: A Television History,* produced by Richard Ellison in 1983; and the 1985 HBO production, *Dear America,* directed by Bill Couturie in 1987. They appear again and again in books.[42] Notably, Larry Burrows's photograph (figure 9.5) has been in particular frequently reproduced. Once ignored, for some editors it has now become the representative example of his oeuvre.[43]

Why do these photographs have such a lasting set of echoes and resonances? One explanation is simply that they remain important because they *were* important: they changed people's minds about the war or crystallised their thinking about why the war was wrong. But the question remains, how did they change people's minds? The photographs did not impugn the war on their own; moral condemnations of the war had sensitised the public so that the photographs ratified uncomfortable truths that it already knew but found it difficult to accept. Moral critiques of the Vietnam War framed the photographs as well as responding to them. In contrast, the Abu Ghraib photographs may not have the same lasting impact if the U.S.A.'s political leaders succeed in sweeping the torture of prisoners under the rug by assuring the world that these were isolated incidents, and if the U.S. public tacitly approves casting the events into oblivion. The photographs will then disappear without trace from page, screen and perhaps memory, as the U.S. public's need for psychological comfort reasserts itself.

If this complex relationship between the photographs and the reality they depicted is true, and if it is also true that the impact of the photographs and moral judgements of the Vietnam War reacted on one another reciprocally, it can be argued that the same complexity surrounds attempts to make historical judgements about whether and how the photographs affected public opinion. During wartime, the photographs encapsulated larger truths expressed through a multiplicity of other sources, but they may have been accorded more significance than they merited because they served as shared cultural reference points. In retrospect, they may be accorded disproportionate significance because, as other discourses about the war fade from recollection, the emblems of the war's wrongness live on. In keeping with this interpretation, the shared repertoire of images by which we remember the war may well shrink over time. Of the thousands of photographs taken during the war, the ones that are most often seen are the ones that are best remembered; and vice versa. Hence the photographic act is re-enacted with each editorial choice, reproduction and viewing. It coalesces our recollections into a virtual gallery distributed across the neural networks of millions of minds, and in the myriad books, films and pictures that succeed the fatal moment when the shutter clicks and photo-sensitive platelets react to light.

Notes

1. Kate Beaird Meyers, 'Fragmentary Mosaics: Vietnam War "Histories" and Postmodern Epistemology', *Genre* 21, Winter 1988, p. 548.
2. Michael Carlebach, 'Michael Carlebach', in *From Camelot to Kent State*, eds Joan Morrison and Robert K. Morrison, New York: Times Books, 1987, pp. 96–97; Vicki Goldberg, *The Power of Photography: How Photographs Changed Our Lives*, New York, London and Paris: Abbeville Press, 1991; Robin Wagner-Pacifici and Barry Schwartz, 'The Vietnam Veterans Memorial: Commemorating a Difficult Past', *American Journal of Sociology* 97, no. 2, September 1991, pp. 376–420, fn. 7 pp. 388–389.
3. For another discussion of the photography of the Vietnam War, see Susan Moeller, *Shooting War: Photography and the American Experience of Combat*, New York: Basic Books, 1989.
4. Seymour Hersh, *My Lai 4: A Report on the Massacre and Its Aftermath*. New York: Random House, 1970, pp. 193–194; Seymour Hersh, 'Torture at Abu Ghraib', *The New Yorker*, 10 May 2004, retrieved 21 June 2004, http://newyorker.com/printable/?fact/040510fa_fact; Seymour Hersh, 'Chain of Command', *The New Yorker*, 17 May 2004, retrieved 21 June 2004, http://newyorker.com/printable/?fact/040517fa_fact2.

5. Frank Rich, 'It Was the Porn That Made Them Do It', *The New York Times*, 30 May 2004, Section 2, p. 1; Susan Sontag, 'What Have We Done?', *The Guardian* G2, 24 May 2004, pp. 2–5.

6. Duncan Campbell and Suzanne Goldenberg, 'US Tortured Afghanistan Detainees', *The Guardian*, 23 June 2004, p. 1.

7. 'International Correspondents', CNN News, 29 May 2004. Leonard Doyle is the foreign correspondent of the British daily newspaper *The Independent*.

8. Wayne Greenhaw reported the charges in an article in the [Montgomery] *Alabama Journal* on 12 November 1969, the day before Seymour Hersh's report for Dispatch News Service was carried by *The New York Times*, *The Washington Post* and other newspapers nationwide. See Wayne Greenhaw, *The Making of a Hero: The Story of Lieutenant William Calley Jr*, Louisville, Kentucky: Touchstone Publishing Company, 1971, p. 40.

9. Michael Bilton and Kevin Sim, *Four Hours in My Lai: A War Crime and its Aftermath*, London: Viking, 1992, pp. 260–263.

10. This is the cover photograph for Bilton and Sim, *Four Hours in My Lai* and James S. Olson and Randy Roberts, *My Lai: A Brief History with Documents*, Boston and New York: Bedford Books, 1998.

11. Haeberle describes the sequence of events in *Remember My Lai*, a documentary that was produced by Michael Bilton and Kevin Sim of Yorkshire Television and broadcast on the U.S. Public Broadcasting Service's 'Frontline' series in 1989 and in *Vietnam: The Camera at War*, broadcast 7 November 1997 on BBC2.

12. Bilton and Sim, *Remember My Lai*.

13. Theresa Reid in debate with Frederick Crews, *New York Review of Books*, 12 January 1995, p. 42.

14. Telford Taylor, *Nuremberg and Vietnam*, Chicago: Quadrangle Books, 1970, pp. 154–155. Taylor summarises and quotes from Edward M. Opton, Jr and Robert Duckles, *My Lai: It Never Happened and Besides, They Deserved It*, Berkeley: Wright Institute, 1970; Edward M. Opton, Jr and Robert Duckles, 'It Didn't Happen and Besides, They Deserved It', in *Crimes of War: A Legal, Social, and Psychological Inquiry into the Responsibility of Leader, Citizens, and Soldiers for Criminal Acts in War*, eds Richard A. Falk, Gabriel Kolko and Robert Jay Lifton, New York: Vintage Books, 1971, pp. 441–444.

15. Seymour M. Hersh, *My Lai 4*, pp. 151–152; see also Myra MacPherson, *Long Time Passing: Vietnam and the Haunted Generation*, New York: Signet Books, 1985, p. 589.

16. Jonathan Schell, *The Real War: The Classic Reporting on the Vietnam War*, New York: Pantheon Books, 1987; the book reproduced essays originally published in *The New Yorker* in 1967 and 1968.

17. Charles Mohr, quoted in Kim Willenson, *The Bad War: An Oral History of the Vietnam War*, New York: New American Library, 1987, p. 174.

18. For an account of Thich Quang Duc's decision to burn himself, see David Chanoff and Doan Van Toai, *Portrait of the Enemy* [republished as *Vietnam: A Portrait of Its People at War*], New York: Random House, 1986, pp. 141–43; Stanley Karnow, *Vietnam: A* History, New York: Penguin, 1997, pp. 277–281.

19. Mohr, quoted in Willenson, *The Bad War*, p. 174.

20. See Barry Zorthian, quoted in Willenson, *The Bad War*, p. 218. Barry Zorthian was the spokesman for the Joint US Public Affairs Office, the propaganda arm of the U.S. mission in Vietnam.
21. Lawrence J. Bassett and Stephen E. Pelz, 'The Failed Search for Victory', in Robert J. McMahon, *Major Problems in the History of the Vietnam War*, 2nd edn, Lexington, Massachusetts: DC Heath and Co., 1995, p. 191.
22. Peter Braestrup, *Big Story: How the American Press and Television Reported and Interpreted the Crisis of Tet 1968 in Vietnam and Washington*, abridged edition, New Haven and London: Yale University Press, 1983, pp. 347–348.
23. David Culbert, 'Television's Vietnam and Historical Revisionism in the United States', *Historical Journal of Film, Radio and Television* 8, no. 3, 1988, p. 257.
24. Senator Robert F. Kennedy, 'Speech of February 8, 1968', in *Major Problems in the History of the Vietnam War*, ed. Robert J. McMahon, 2nd edn, Lexington, Massachusetts and Toronto: D.C. Heath and Co, 1995, p. 343.
25. W.W. Rostow, 'Memorandum for President Johnson, 30 November 1967', p. 8, retrieved from the Virtual Vietnam Archive, http://archive.vietnam.ttu.edu/star/images/001/0010225002.pdf.
26. Al Santoli, *To Bear Any Burden: The Vietnam War and Its Aftermath in the Words of Americans and Southeast Asians*, New York: Ballantine Books, 1985, p. 185; see also Willenson, *The Bad War*, p. 186.
27. Denise Chong, *The Girl in the Picture: The Remarkable Story of Vietnam's Most Famous Casualty*, London: Simon and Schuster, 1999.
28. *JFK*, dir. Oliver Stone, 1991.
29. Jorge Lewinski, *The Camera at War: A History of War Photography from 1848 to the Present Day*, New York: Simon and Schuster, 1978, p. 213; Julene Fisher, *Images of War*, Boston: The Boston Publishing Company, 1986, p. 9; Horst Faas and Tim Page, *Requiem: By the Photographers Who Died in Vietnam and Indochina*, London: Jonathan Cape, 1997, pp. 176–177; Larry Burrows, *Vietnam*, London: Jonathan Cape, 2002, pp. 164165; Larry Burrows, *Larry Burrows: Compassionate Photographer*, New York: Time/Life, 1972.
30. Lewinski, *The Camera at War*, p. 214.
31. Norman B. Moyes, *Battle Eye: A History of Combat Photography*, New York: MetroBooks, 1996, p. 110; Burrows, *Vietnam*, pp. 100–123.
32. Larry Burrows, 'A Degree of Disillusion', *Life*, 19 September 1969.
33. See *Life*, 27 June 1969.
34. 'Decisive Moments: Photographs That Made History', broadcast on BBC2, 1 November 1997.
35. Editors of Phaidon Press, *The Photography Book*, London: Phaidon, 2000, p. 77.
36. David Halberstam, *The Making of a Quagmire*, New York: Ballantine Books, 1965.
37. Examples of other such posters can be found in the collections of the Division of Political History, National Museum of American History, Smithsonian Institution, Washington, DC; the Centre for the Study of Political Graphics, Santa Monica, California; and the AOUON ['All of Us or None'] Archive in San Francisco, California.
38. Versions of the poster can be found in the collections of the National Museum of American History and the Centre for the Study of Political Graphics.

39. The photograph is by Felix Greene (AP/Wide World photos, 1968). It was reproduced in a poster captioned 'Johnson's Baby Powder, Made in the USA', found in the Centre for the Study of Political Graphics, Santa Monica, California, and appears on the jacket of James William Gibson's book, *The Perfect War*, New York: Vintage Books, 1988.

40. H. Bruce Franklin, *M.I.A. or Mythmaking in America: How and Why Belief in Live POWs Has Possessed a Nation*, New Brunswick, New Jersey: Rutgers University Press, 1993, p. 47.

41. A chrome peace symbol at the University of Pennsylvania's College Green marks one such sacrificial death; for an account of another protester's action at the Pentagon see Paul Hendrickson, *The Living and the Dead*, London: Papermac, 1996.

42. Photographs including those of My Lai, Kent State, General Loan and the Viet Cong suspect, the Buddhist monk immolating himself and Kim Phuc are seen repeatedly in books on the Vietnam War. For example, see the book cover and pages 1, 213, 227, 231, 232 and 238 in Vicki Goldberg's book *The Power of Photography: How Photographs Changed Our Lives*, New York, London, Paris: Abbeville Press, 1991; also see Fisher, *Images of War*, pp. 9–11.

43. See *The Photography Book*, p. 77.

Chapter 10

Speaking the Album

An Application of the Oral-Photographic Framework

Martha Langford

A photographic album is a repository of memory. A photographic album is an instrument of social performance. On these two, one might say, *countervailing* functions, photographic specialists, cultural theorists, social scientists, psychologists, semiologists, philosophers and historiographers all tend to agree. That the photographic album, a common source of Western photographic experience, has attracted scholarship from these various disciplines should not surprise us, though the cohesiveness of the results might. The photographic album seems to lower disciplinary inhibition. Indeed, attention to the photographic album since the mid-1960s can be said to constitute in itself a model 'thought community', an idea of album sustained by interdisciplinarity.[1] Photographic studies of albums as material culture range between statistical analysis and historical contextualisation. In this marriage of sociology and social history, the typicality of the album is often stressed as a function of its collective authorship – compilation by agreement, rather than individual authorship.[2] Historiographers and photographic theorists follow suit, speaking of the *family* album, rather than the mother's or the aunt's memoir of family life.[3] Thus photographic analysis echoes sociologist Eviatar Zerubavel's recognition of 'remembrance environments', realms that exceed autobiographical or personal memories, and yet help to preserve them, though in ways that are not always very clear.[4]

When it comes to the autobiographical album, many sociologists and psychologists take the position that albums *encode* memories, or camouflage them behind social rituals or psychological screens.[5] Indeed, some photographic theorists have argued that the construction of alternative realities is the personal album's main function. Sociologists

acknowledge the mysteries of all personal documents, advising that albums are virtually useless unless examined in the company of their compilers, or at least with members of their circle, who can interpret the social arrangements and signs. On the basis of these encounters, they report that photographic albums preserve a wealth of stories – photographic memories that are revived in the telling and can be preserved on tape.[6] But anthropologists, folklorists and cultural theorists add a certain complication, stating that no recounting of an album, however close to the source, should be considered as fixed because individual and collective life-stories evolve over time, depending on the storyteller and the listener.[7]

These composite perspectives, and others, are met in a theory about the nature of photographic compilation which I developed in *Suspended Conversations: The Afterlife of Memory in Photographic Albums*. The book deals with albums that have been translated from the private to the public realm – albums whose 'remembrance environment' has been radically changed. *Suspended Conversations* argues that the photographic album can nevertheless be understood by recognising its original function as a mnemonic device for storytelling and situating it in the realm of orality. The study demonstrates that, while the album looks like a book and may include the written word, its translation of experience into memory follows a model that far predates the rise of the novel, the written memoir, or the family Bible. The album's roots in oral tradition explain its resistance to literary models of criticism, though attention to Bakhtin's notion of the dialogical construction of community goes quite a long way. For I want to insist that *speaking the album* is not merely the supplement of photographic and textual reading, but the discovery of the album's ordering principle. Separation of the album from its community casts it into an unnatural silence. The contents, structure and presentation of a photographic album are the vestiges of its oral scaffolding.

I came to this understanding while conducting research at the McCord Museum of Canadian History where I had access to over two hundred personal albums: collections, travelogues, memoirs and family sagas.[8] Forty-one albums, representing the range of the collection, are discussed in *Suspended Conversations*, one of them in substantial detail. The theoretical backdrop is a correlation of orality and photography, a merging of two interdisciplinary streams. The oral flows from anthropology, ethnography, psychology, folklore, linguistics and literature, and is condensed in an illuminating study by Walter Ong, *Orality and Literacy*.[9] The photographic derives from Western photographic history, criticism and cultural studies, concentrating on albums, but also considering the nature of photography and photographic

spectatorship. There are striking similarities between what Ong calls the 'psychodynamics of orality' and photographic experience, beginning with the evanescence of sound and photographic instantaneity, and continuing in the album's predictable patterns of content, structure and presentation.[10] These patterns form what I have termed the 'oral-photographic framework', a correlation of orality and photography based on the workings of memory. The most salient features of the framework are the following.

In an oral culture, tellers and listeners need memorable and accessible recitations. Variations on narrative tropes, rather than novelties, work best – they are readily recalled by the teller; they stick in the listener's mind. Such formulaic images should be simple, casting individuals and scenes in absolute clarity. Heroic figures and reprehensible monsters are easily remembered; praise formulas and blame formulas fix these figures in memory. The settings of stories are either very familiar or remarkably strange. Translated to the contents of photographic albums, we observe patterns of social and physical types. This is the well known levelling effect of the *carte-de-visite* – kings, tradesmen and exotic human specimens photographed in the same style and placed in the same album. This effect is perpetuated in the snapshot – there is significance beyond habit in its compositional clichés. The carte-de-visite and the snapshot both generate 'heavy' characters through photographic strategies – pose, lighting, vantage point and so on. Repetition is another mnemonic fixative. Albums are full of repetitions: situations are revisited or recreated with slight variations; actual images are often repeated in different arrangements.

In oral compositions, patterns of organisation are *driven* by the need for repetition; formulas are not only typical, but are recycled within the same recitation. Repetition serves memory and also camouflages its gaps. An oral composition is shaped by intense engagements between legendary characters whose merits and demerits must be clear. For photography, this means copious, comparative description: albums show us the same things from many angles; we also see the same angle on many things. The syntax of an oral composition is additive. Likewise, a photographic album fits together like a kit of parts, by systems of association that tellers and listeners know well and readily supply during the album's presentation.

Oral recitation, or storytelling, follows the rules of performance. Empathy and participation are essential, the performer and audience surrendering to, absorbed in, the pooled experience of the community. In Ong's words, it is a matter of 'getting with it'.[11] Memories are stirred, especially the memories that connect to current conditions. In oral

societies, there is a tendency to slough off memories that have lost their relevance. The past must be viable in the present, for the purpose of storytelling is to keep the community alive. What this means for the album is a shift from the absolute solidity of material culture to a state of in-between, fully realisable only in performance. The album is a meeting place, not an encyclopedia. When we sit and look at an album together, we do not necessarily look at every image. As we converse – as we tell the album's story to each other – we glide over certain images, and linger on others. Memories stir emotions; happiness, pride, grief, or possibly anger. Not everything will be shared, or even consciously experienced. Even in its original 'remembrance environment', an album's telling includes many lapses into reflective silence.

Suspended Conversations includes a detailed case-study of an anonymous snapshot album donated to the McCord Museum in 1992 – an acquisition justified as a lively illustration of Quebec family life in the 1930s and 1940s. The cataloguer noted styles of dress and consumer goods in the pictures, as well as recreation areas mentioned in the brief captions. The album was otherwise undocumented and there was little expectation of discoveries about the compiler. Indeed, as noted above, the album was valued for its typicality. Over the better part of a year, I studied and interpreted this album, following a three-stage process. The first was a rigorous application of the Museum's own cross-indexing system for retrieval by subject matter: a complete list of inscribed place names and dates, including captions, written information in the pictures and notations on the back of the prints. The second level of description was a process of close visual comparison informed by social-historical research. The objective was to situate the album in its slice of history, determined by the entrance and exit of its autobiographical account. If albums were, as Pierre Bourdieu assures us, 'in chronological order, in the logical order of social memory', this process would have been simple.[12] But this album, like most albums I have examined, was not organised chronologically; its start- and end-dates were buried in the mix. To impose chronological order, the album figuratively had to be torn apart, and completely reorganised. A facsimile was made, then dismembered, so that the pictures could be displayed on a chronological story board. Only then could one begin to see the pattern of picture-taking, its cycles through high and low seasons, and begin to conjecture about increases and interruptions in activity, as well as changes in direction.

The third approach carried the gains of the first two methods into the realm of orality. One could say that stages one and two reconstructed some of the personal data and collective memories of the compilers – what Catherine Whalen calls the 'back story', details 'once known to [the compiler's] contemporary viewers, but now obscure'.[13] Stage three then

explored the compiler's expression of autobiographical and collective memory through image selection, annotation, organisation and presentation. Respecting the compiler's choices and trying to understand them, then working imaginatively to narrate their presentation, brought out the performative aspects of the album, thus restoring its original function of keeping memory alive in the present. This three-stage process described what was truly memorable about the album: a deep and loving relationship between the principal subjects, two sisters; and their particular definition of 'family'. In broader terms, the study proved that images selected and organised *in anticipation* of storytelling preserved visual memory in a framework of oral consciousness.

Since publishing these findings, I have been asked quite reasonably how the oral-photographic framework might be used by researchers in a museum or archive for the interpretation and cataloguing of album-objects. This question prompted me to put the framework to another test. The challenge was to commit more fully to 'the psychodynamics of orality': by reversing the order of things (the three-stage process just described); by shifting the focus of inquiry from *identification* (the detective-work of naming and listing) to *process* (looking and talking); by really changing one's habits of attention to make orality and photography – the oral-photographic condition – the nucleus around which other states of awareness and epistemological projects would be grouped. This proved an interesting challenge. Literacy's habits are impossible to break, difficult even to set aside temporarily. Photographic theorists do not live in an oral society, nor is the photographic album a pure product. The photographic album is a syncretic object, its narratives of life-stories, both transitory and inscriptive. Removal from the private sphere to a public collection tips the balance towards inscription by cutting the performative cord. Most attempts to read this alienated object, and here I mean literacy in the broadest sense, have led us to consider the album as a closed text. Left alone with the album in the Museum's vault, I knew that I would fall back into my literate habits. To delay that inevitability, I resolved to reopen an album through conversation.

Returning to the McCord Museum, I asked the archivist to show me an album that had not been part of my original study group. She brought out an album that had just come to the museum.[14] This chapter focuses on that object: an anonymous snapshot album, c. 1920 to 1940, of forty pages with three to nine photographs per page (accession number MP 1999.3.2). By 'anonymous', I mean that the actual compiler of the album was unknown. The donation of the album had been arranged by one of the Museum's longtime volunteers. The volunteer knew the family, and presumably someone in the family knew whose album this was. Within

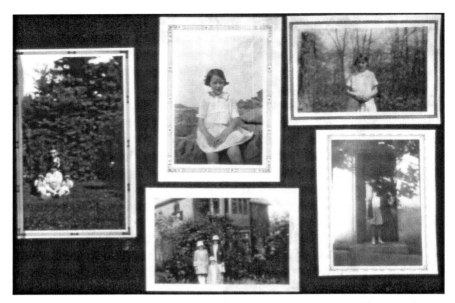

Figure 10.1 *Margery Paterson snapshot album, 1925–1945, page 1 with 5 snapshots.*
Courtesy: Notman Photographic Archives, McCord Museum of Canadian History, Montreal,
MP-1999.3.2.1-5.

the Museum, however, the object was well on the way to becoming a
family album, this in the face of a recurring caption attached to the figure
of a young girl: 'Me' (figure 10.1). The object had been processed for the
acquisition committee: the contents had been listed, based on inscriptions
and visual identification. Our methods of classification, the habits of
literacy which bias interpretation, lead us to make lists. In oral societies,
as Ong stresses, there is no such thing as a list, and when we look at an
album, we can see why.[15] Nevertheless, the album had been parsed for the
acquisition committee, with a list of subjects that would subsequently be
entered into the museum's searchable database (list 10.1).

List 10.1

Page(s)	Subjects
1–2–3	Gardens
4–5	Picnics
6–7	Joyce Tetley, Metis Beach, Bird and cage
8–9	Manoir Richelieu, Enderby family
10–11	Beaches and bathers; Pollock family, The Alpine Inn
12–13	Kennebunk, Peters family
14–15	Sixteen Island Lake
16–17	'Intermediate camp' tents
18–19	Redfern family
20–21	R.H. McMaster House, Canorasset, St Sauveur
22–23	Rosigil

24–25	Camp Ouareau
26–27	Costume parties
28–29	Scarff family, Ivry, Lake Manitou
30–31	The Study School, school girl groups
32–33	Sports Day on Mount Royal 1937
34–35	Nantel; Study School graduation groups
36–37	Girls sunbathing, Durnford family
38–39	Val Morin 1938, 1939
39–40	Royal Tour 1939; Elgin House, Muskoka
42–43–44	Rummy the dog

This list may sound strange, but it is in fact a good example of an index created from an album that has been acquired for its subject matter. These search words have been chosen to make the album available to researchers looking for illustrations of Montreal society in the 1920s and 1930s. Such details as family names are the joy of genealogists. The names of private schools, summer camps and resort areas, as well as key words, such as 'garden', 'picnic' and 'costume', have their obvious utility to social historians and novelists. Perhaps only 'Rummy' is a mis-cue, raising the hopes of a medical researcher who would expect an alcoholic outcast, not a pampered cocker spaniel. The rest of the list is functional and highly resonant within the community that produced the album and deemed it worthy of preservation. The list is also interesting in terms of omissions. On pages 3 and 4 are snapshots of uniformed nursemaids, identified as Cecile and May. Such portraits are rare in family albums, but photographic search requests by former servants must be even rarer, if the cataloguer fails to make a note.

What the list preserves with authority is the justification for the acquisition, which is the anticipated use of the album. Behind the list, a conversation has already taken place, between the donor and the institutional representative who has asked: what is the album about? What this question means is: what is the social context of this album, or what is its value to a museum of Canadian social history based in Montreal, with a long tradition of caring for the material culture of its ruling class? For while this mission is being redefined to reflect changing power structures and sources of support for public education, and while the museum's programme and interpretative tools make this reorientation quite clear, a collection largely built on donations, like an ocean liner, does not turn on a dime, having built up expectations for receptiveness to certain types of objects and exhaustiveness in certain collecting domains. This album, as described, fits within the collective memories of the communities for whom the McCord Museum has traditionally mattered and functioned as a meeting point. We can imagine these communities as descendants of the two founders of the photographic collection: a nineteenth-century collector, philanthropist and exponent of public education (David Ross

McCord, 1844–1930) and a nineteenth-century founder of a highly successful photographic studio (William Notman, 1826–1891).[16] It was to representatives of those 'remembrance environments' that I turned to conduct my little experiment.

Five women were interviewed. This number may have been implanted by the first page of the album, with its five pictures of 'me', though I was not conscious of this at the time. My goal was to keep the project within very tight limits, a small number of interviewees and short meetings, with a view to developing strategies for custodial institutions where the common complaint is no staff, no time – certainly no time to design and conduct a survey for every object that enters the collection. Four participants in my study live in Montreal, within ten miles of the museum, and three of those women were born and raised there. The fifth lives in Victoria, British Columbia, though with close relations in Montreal and interests in both family photography and Canadian social history. Their ages at the time of the interview ranged from fourteen to the early fifties. Three of the women belong to one family, a mother and her two daughters: I spoke to them separately. Family structure was an important factor in my choosing these women; social status, photographic interest, historical knowledge and imagination also factored. I had certain hunches about the album and its compiler, and I was curious to see whether the other women felt the same. I devised a set of questions to structure the interview, but I was also hoping to stimulate conversation about the album, to see what women of different ages and family backgrounds would make of it, how their different perspectives would cast my intuitions and biases into relief.

The women knew that they were going to look at an album, or a copy of an album, from the McCord Museum. As we sat down, I handed it over and asked them to look through it from beginning to end. I told them that I would then be asking them some questions, but that they would have the album in their hands to answer them. In other words, as I said, this was not a cognition test of their visual acuity or memory; it was a chat. One woman talked continuously and digressively as she looked at the pictures; two commented occasionally; the woman in her twenties named a few things that she identified; and the teenage girl looked through the album in silence. As I worked through the questions, the tenor of each meeting quickly shifted from interview to conversation in which the women automatically affiliated themselves with the compiler, answering my questions in that person's stead. In other words, they presented the album to me.

The questions were organised according to the oral-photographic framework, moving from first impressions into the contents, then into their organisation. This album is dominated by portraits, so modes and

tropes of portraiture were the main themes. As the women turned the pages, I was impressed by how quickly the identification game was abandoned. When places were recognised, they were mentioned in passing: 'Oh, there's such and such a place … '. Not recognising locations caused no concern. That the album contained a story, or stories, about the subjects was assumed, and this assumption led to questions about types of characters, their situation and their importance to the compiler. We talked about emphasis ('importance') through devices of repetition. We explored levels of clarity and obscurity ('Which pictures tell you things immediately? Which ones are more mysterious?') Finally, having established a version of the album's backstory, we talked about memory. First, I asked: 'When you look at this album, does it stir up memories? Do you relate to these characters at all, or do you see them simply as people from the past?' Then the respondents were asked to give a little performance: 'I would like you to imagine that I have lost my memory, and that all I have that seems to belong to me is this album. Assuming that this is my album, what can you tell me about my life?'

Space does not permit me to report the individual responses to each question; and in fact, the five women's answers had much in common, in both content and tone. They differed over the particulars, and each contributed her own illuminating anecdotes. In response to the first question, 'What kind of story, or kinds of stories, do you see emerging from this album?' they answered as one. The album was the story of a young woman's coming of age, from girlhood through adolescence into womanhood, from her own perspective. Family and friends figured throughout, but the main character, repeatedly identified as 'Me' in the first third of the album, never left centre stage. Whatever was pictured, the album was by her and about her. It was her memoir, that hybrid form of history and confession. The teenage respondent noted that certain parts of the life were missing: we did not see the main character in class, for example; but to her, these gaps were only the 'little parts' – the essence was there. The forty-something respondent, the mother of two young women, sensed something missing; she commented on the consistency of the album; she found it very static.

Asked to list the types of characters in the album, the respondents began to cut their own paths: they differed dramatically on the composition of the main character's family, and understandably so, for its description is very vague. While the album creates a family atmosphere ('lots of family'), its members cannot be accounted for. Identification depends on very small signs of intimacy. The first picture in the book, a child sitting cross-legged on the grass between the legs of a young man wearing a Montreal-area private school uniform, 'Me & Ross', seemed to

indicate a brother or cousin, but this fellow is never seen again. The respondents tended to place the girl in a family of girls: a picture on page 7, 'Me & Dad & Jean', in which Dad holds the adolescent Jean very tightly around the waist, suggests an older sister, or cousin, coming and going in the younger girl's life. The importance of the extended family, as well as a network of family friends, is confirmed by the group photographs that mark visits and holidays, and by the page-titles and captions. Asked to characterise the main figures, three of the respondents immediately ranked them in socio-economic terms as a close-knit family of the upper-middle class; the teenager saw them as 'friendly'; while her mother detected a lack of critical judgement in this unquestioning view of 'old Westmount money', 'the privileged enjoying their privileges'. The representation of people we might think of heroic, or at least, important to a young girl – her parents, or older siblings – is strikingly limited. As a photographic subject, the mother is remarkably remote. When first identified on page 6, photographed from behind doing *petit point*, the compiler must make a point of identifying her (figure 10.2). The mother

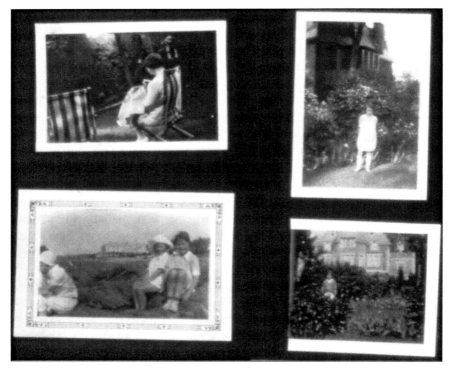

Figure 10.2 *Margery Paterson snapshot album, 1925–1945, page 6 with 4 snapshots.* Courtesy: Notman Photographic Archives, McCord Museum of Canadian History, Montreal, MP-1999.3.2.5006.

then reappears mainly in family groups or with her husband. Around 1936, there are a few snapshots of the parents at a cottage. The girl is by now about sixteen. She and her mother take turns with the camera, and we begin to feel that the role of family photographer is being passed from mother to daughter. The father, a willing subject, is more prominent in the album: he poses arm-in-arm with his daughter; he lounges, he clowns.

In the realm of repetition, the respondents noticed the same subjects and similar occasions photographed again and again, the sole meaningful difference being the subject's age – this influenced the prominence given to pets, family and friends, as well as the pose. The teenage respondent found the album somewhat 'jumpy', as it moved from site to site. But asked to identify any photographs or passages that seemed mysterious, all five women were at a loss. The album was to them transparent, and as they looked in vain for anything they might have missed, I realised that the first pages of the album had been critical in establishing the terms of this photographic experience. The album was about 'Me'. The women accepted its limits as sufficient and did not to seek imaginatively cross them. There were a few images that *intrigued* them, given the vague outline of the compiler's family. One young woman who posed with her arms around the compiler – was she an older sister, a cousin, or an adolescent crush? (figure 10.3). In the psychology of the 1930s, the word 'crush' might seem to fit.

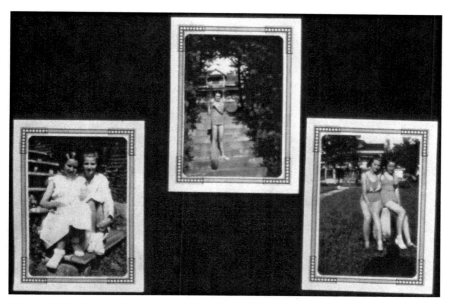

Figure 10.3 *Margery Paterson snapshot album, 1925–1945, page 14 with 3 snapshots.* Courtesy: Notman Photographic Archives, McCord Museum of Canadian History, Montreal, MP-1999.3.2.5014.

Mary Chadwick attributes a girl's adolescent '*crush* or *G.P.*' on a teacher, or some other mother-substitute, to the girl's need for maternal guidance and concurrent need to cut herself away from the past. A poor relationship with the mother or some rupture between them is the probable cause.[17] Whatever the circumstances, the lack of inhibition in these loving female arms around the girl made this cluster of images memorable.

Crushes aside, all five of the respondents had memories 'in common' with the compiler: their empathy emerged in digressions, in questions directed at me. Looking at the pictures of Camp Ouareau, one asked: 'Did you go to camp?' The woman who asked me that question had only bad memories of her camping experience. She had been sick the whole time, hated camp, never went back. She offered her experience in contrast with our compiler who liked Camp Ouareau well enough to return for a second year. There are pictures of the director and the counsellors, as well as her campmates, some old friends, some new. The camping experience was evidently extended when six or seven high-school seniors converged on the 'Durnfords' family cottage, to loaf around, sunbathe and listen to 78rpm records (figure 10.4).

The compiler's self-presentation appeared to the respondents as complete. My reminder that these scenes of languid prosperity were

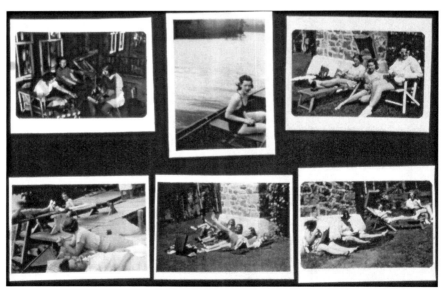

Figure 10.4 *Margery Paterson snapshot album, 1925–1945, page 37 with 6 snapshots.* Courtesy: Notman Photographic Archives, McCord Museum of Canadian History, Montreal, MP-1999.3.2.5037.

taking place at the height of the Depression only confirmed the respondents' intuitive sense of the compiler's security – they did not wonder what she herself thought of world events or other people's conditions. In fact, the only psychological insight into the girl was that she was not a very deep thinker. Her world was, and proved still to be, immersive when opened to other women of a similar social and economic background. Before the mirror of the album, the three older women evinced a slight degree of restlessness; the recently married twenty-year-old, a twinge of nostalgia, a persistent sense of belonging; the younger girl, who paid more attention to place than to time, looked at the compiler as a version of her peers.

I had selected these five women to interview because of their gender, social and educational backgrounds, and, without saying so, because of their positions in their families. Two had been their parents' only child; one was an adopted child, with adopted siblings. The two sisters offered another interesting relationship. The elder of the two had lived the life of an only child until adolescence, when her parents suddenly had two more children, a boy and a girl; the youngest informant was that much younger sister. Knowing these women's perspectives on family, I wanted their help in determining the compiler's situation. The 'Me' in this album seemed to me to be a lonely child, apparently an only child of older parents. I saw a child alone with her 'Dicky' bird, alone with her nursemaid. The fleeting presence of the putative 'older sister' meant no more to me than the child's play-acting with a doll's baby carriage. She wished for siblings; she did not have them. To my surprise, the five respondents gave the child her wish. They wove her into a nest of loving relations, basing their ideas on the sheer copiousness of the portraits, the child with this person and that person. Conducting these interviews, the most curious thing to me was a pattern of what one might call 'a will to separation'. In constructing a family for the child, all family arrangements were entertained save the one closest to the respondent's own. One only child was adamant on this point; there *were* siblings, possibly three children in the family, the older two off at school. The other only child believed that this little girl's dynamic sense of *who she was* suggested that she was positioning herself in relation to siblings. My own contribution to this discussion was no more reasoned. As the youngest in a family of four, separated by a gap of six to ten years from the siblings I adored, I felt that the compiler's situation was different from mine; I had my own explanation for the older girl posing with Dad: she was certainly not his daughter. In short, our responses were guardedly empathetic: faced with this hypertrophic ego, none of us was prepared to surrender our own inner child, or the uniqueness of our

adolescent experiences. Neither was our compiler: the album was in fact the inner child's preserve.

My meetings with women over the album, their efforts to extract the compiler's identity, and the nuances that they brought to their performances of the album when asked to tell it as a life story, forced me to consider my own visual habits and blind spots. They also forced me back to the album, whose narrative remained rather thin and imprecise. A large gap, as far as I was concerned, was the role of the mother, assumed by one respondent to be the primary source of the early pictures, the family historian and the dedicated observer of her daughter's transformation from child to adult. If this was the case, the album did everything possible to hide it. Indeed, there were clear signs of tinkering with the record. In the final version, the pictures were glued down, but traces of earlier arrangements remained, pictures removed, old captions incompletely covered. This physical evidence, and the lively discussion that had arisen around the mother's absence, prompted me to think about the sources of the images from which the young woman had compiled this expression of identity-in-formation.

The first page is very telling (see figure 10.1). Five photographs, the young girl featured in every one, but also five formats distinguishable by the borders on the snapshots … five separate occasions … five perspectives on this child. Each moment is important, but the cumulative effect of the page is more important still. When its compiler, this young female subject, looks at this page, she sees herself, and more importantly, she remembers herself as subject to five different gazes. What the respondents felt so keenly to be her implantation in a family could also be construed as the emergence of an identity that reflects a multiplicity of familial and social looks.[18] Formulaic, copious and superficially quite clear, the varieties of photographic experience presented on this first page alone are very striking. 'Me & Ross' describes and provokes feelings of affection and physical intimacy between a child and an older male relative or friend. I have mentioned that he is never seen again, and when I dismantled a copy of the album and grouped the pictures according to format, I realised that the photographic format was also unique; the print must have been a gift. There are many different photographic formats in this album. So to the girl's roles of subject and narrator, we need to add curator, for she is very free with this personal archive, breaking it up and playing with its chronology, to present the fullness of 'Me'.

Thus on this first page, we have centred an appealing portrait: a picture of the girl sitting on rocks at a beach. To whom is she appealing? Most likely to the parent of a friend, Joan Daniels, identified in two similar pictures. A very blurry Joan has been placed on page 2, beside a very

blurry snapshot of a squirrel, and 'Joan' sitting on the beach beside 'Me' is on page 6. Two more pictures from this group are on page 12: the father with three children; the father and mother, she adjusting her cloche hat or perhaps concealing her face.

The top right portrait on page 1 has only one other mate in the album, while the picture bottom right of the same page, 'Me at the Phi Delta Theta House', belongs to a largish group of pictures: eleven at this early stage, and another twenty later.[19] Prominent in this group is Ethel Enderby. The two girls played together, held one another's pets and attended the same private school; though separated when the compiler went to camp, they were 'inseparable'. This is probably an Enderby family picture.

The last picture on page 1 to be considered, the portrait of three children before a house, also belongs to a large group, this one quite possibly from the compiler's family. There are sixteen images of this format in all, half of the little girl ('Me') in her garden, presenting pets or posing in front of the tulips, as well as the mother seen from the back. Another closely related group – portraits in gardens, flowers – might actually be attributed to the mother as photographer. But the photographic attention paid to this child comes from many quarters; the pictures with the nurses have distinctive borders, thus constituting a group of photographs processed at the same time – which might have been taken by the nurse. As the compiler begins to take pictures at camp, cottages and school, photographs are exchanged. A constant presence is Ethel, copiously described in photographic praise-formula; she is there through thick and thin description, from the first passage to the last. Significantly, she is connected with home in the opening and closing images of the album. Just as the girls were once photographed by elders, the teenagers photograph one another, often holding cameras. Photography is the coin of the affective realm: photographs are comparable in this respect to valentines or autographs.

How does an awareness of the compiler's process shape our understanding of this album? By attending to the disparate sources of the photographs, we become conscious of the compiler as a highly specialised curator of photographs and photographic experiences – we look at a composite version of her life that she has arranged to create certain effects and contain certain messages. In terms of photography and photographic experience, the breakdown of the album into the various streams of production, and the recognition that clusters of photogenic events and places – holidays, camp, graduation – have been successfully combined into a first-person narrative of fourteen years, exemplify the workings of memory, and our ability to rehearse its processes through

collective photographic reception. Conversations about the album flow naturally from the means of its creation which are themselves a composite view from distinct social and psychological perspectives.

Stepping back from this individual life-course into the broader psycho-social context, we might see in this album patterns of middle-class behaviour that prompted psychologists to isolate a distinct notion of adolescence, distinct from childhood and adulthood, and insistently subdivided by gender. Psychologist G. Stanley Hall's groundbreaking study of adolescence was then relatively fresh.[20] Its application to the particular problems of modern girls was only just emerging, with an essentialist perspective and advice on sublimation – the girls' camp movement can be seen as a direct result.[21] In 1924, American psychoanalyst Phyllis Blanchard urged that girls be furnished with 'efferent channels' to 'drain the waves of sexual emotion'.[22] Outdoor exercise is one such channel and 'Sports Day on Mount Royal, June 1937' is also a prime photographic opportunity. The event forms a double-page spread of pictures from different rolls of film, and pictures from the same day are sprinkled in reprise throughout the rest of the album, with another important cluster close to the end. *Pace* Blanchard,

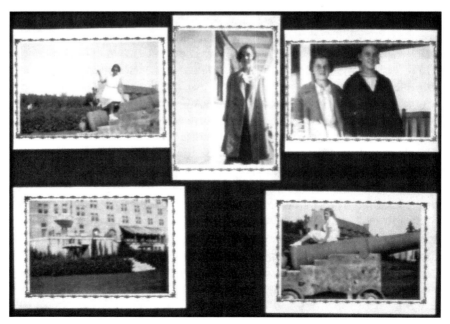

Figure 10.5 *Margery Paterson snapshot album, 1925–1945, page 9 with 5 snapshots.*
Courtesy: Notman Photographic Archives, McCord Museum of Canadian History, Montreal, MP-1999.3.2.5009.

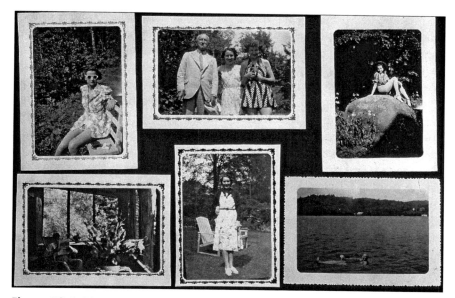

Figure 10.6 *Margery Paterson snapshot album, 1925–1945, page 38 with 6 snapshots.* Courtesy: Notman Photographic Archives, McCord Museum of Canadian History, Montreal, MP-1999.3.2.5038.

isolation of girls is another way of draining 'the waves'. Ross, pictured on page 1, is the only adolescent boy on view. Throughout this album, the little girls pose on cannons and rocks for the grownups (figure 10.5); by the end, they are flashing their legs for each other (figure 10.6). Attention to such repetition corresponds to Mary Chadwick's study of adolescent behaviour, first published in 1932, in which she examines the mores of adolescent same-sex relationships:

> They behave very much the same as the majority of older, heterosexual lovers … . It is not so much that the girls are imitating the more adult men and women, but *they* who are repeating their own former adolescent behaviour when they fall in love later; because a great deal of the play and amusements of love-making is a direct repetition of childish or adolescent manifestations.[23]

The album literally illustrates this behaviour, though in a truncated form, because the later stage of adult love-making is not shown.

The album ends rather abruptly. The McCord Museum acquisition record calls the album 'unfinished' because there are many blank pages at the end. The organisation of the album suggests the opposite, that the story has come full circle from the little girl holding her cats and caged birds in the garden to the young debutant, holding her dog, or photographing her father playing with the dog. To the respondents, the

ending seemed perfectly natural, a process concluded, a coming of age. The pictures showed them what they explained to me as a journey from the island of family to the continent of society, with myriad physiological and psychological changes along the way. And indeed, the last scenes are pregnant with the woman's possibilities, her father the surrogate husband, Rummy their surrogate child (figure 10.7). Repetition is a very strong factor here. The ending rehearses the poses and motifs of the beginning, and yet there is a sense of incompleteness, a curtain pulled down over the uncertain future. A social historian might point out that it is wartime, so that the 'natural progression' of this social group from the company of young women into marriage and children has been interrupted. The older respondents speculated that the compiler had been drawn into the war effort and set the album aside as a childish thing. Or, she married and started a courtship-into-marriage album, a plausible theory since there are numerous examples of lives broken up into 'unfinished' photographic albums in the collection of the McCord Museum. As Zerubavel notes:

> the process of mnemonic socialisation also continues beyond the family, and entering a new thought community (such as when we get married, start a new job, convert to another religion, or emigrate to another country) usually entails reinterpreting our personal recollections in light of some new *mnemonic tradition*.[24]

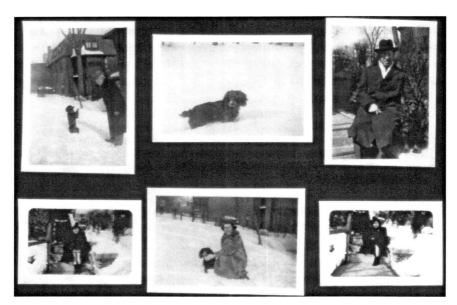

Figure 10.7 *Margery Paterson snapshot album, 1925–1945, page 42 with 6 snapshots.* Courtesy: Notman Photographic Archives, McCord Museum of Canadian History, Montreal, MP-1999.3.2.5042.

Can such a transition be detected here, in a suite of pictures catalogued 'Rummy the dog?' These are summer and winter views combined; time is oddly compressed. Ethel and the compiler's father pose with a black cocker spaniel, a lively visual presence, especially against the snow. The community shrinks back to father, best friend and family pet. The widening conversation suddenly stops. What happened to Rummy's mummy?

She lived and died as Margery Paterson (1921–1998), the daughter of Ruby and Jack, the much younger sister of Ross who inherited her first and only album, then donated it to the McCord Museum. On graduating from high school, she developed tuberculosis and went to a sanitarium. Her recovery was very slow, though she ultimately went on to part-time study at McGill University where she would later work. What we see, therefore, is not the retreat of a gregarious girl into marriage and motherhood, but her removal from the community due to her illness. Reconsideration of her childhood photographs may well have occurred in the grey light of the sanitarium. I learned the facts of Margery Paterson's early life from the volunteer who had arranged for the album to come to the McCord. Although she had brokered this gift, she was frankly surprised at my interest in its genesis. She saw the compilation as a family album of a not very prominent family – the father, no captain of industry; the mother, not very bright. After some sixty years of acquaintance with the family, she had given little thought to Margery, always the afterthought child.

To help with the cataloguing of the album, this museum-minded woman came prepared to add a few names and places to the list. Looking at the album in light of my project, she remembered Margery's nickname, Little Mozart; she remembered the child's piano lessons and the teasing she took from her brother, Ross. Surprised by how little else she knew, she went away to call a friend. More conversations ensued, and the story of Margery's illness emerged. Now we have a very different 'Me', quite another family album, and the case is not closed.

Tuberculosis is an illness, not a metaphor – this is Susan Sontag's point. It is an illness whose treatment before 1944 involved the cessation of daily routine and isolation from community. Sontag weaves the disease into Romanticism's cult of the personality:

> It is with TB that the idea of individual illness was articulated, along with the idea that people are conscious as they confront their deaths, and in the images that collected around the disease one can see emerging a modern idea of individuality that has taken in the twentieth century a more aggressive, if no less narcissistic form.[25]

Here we find this process articulated in a photographic vernacular, as an isolated young woman constructs a composite self-portrait of identity

formation that was stopped, abruptly, and diverted to another course. As though to counter that movement, the young woman's claim to her place in the collectivity is not just documented, it is forcefully articulated by photographic arrangements that show her at the centre of an imagined community of picture-takers, then gradually situate her in a crowd (figure 10.8). She *did* make friends. She *was* on Mount Royal for Sports Day. She *did* go to Camp Ouareau. She *did* graduate with her class. *She* was *part* of these things. The album can be understood in this way, as an additive articulation of memories that accrue to a sense of self in the continuum of belonging.

Margery Paterson's album teaches us a simple lesson, one that is hard for institutions to absorb. There is no such thing as a family album, but only personal albums concerned with, or situated within, a particular configuration of family and community. In this case, we have an album formed in parallel with, or quite possibly influenced by, early twentieth-century theories of female adolescence – its socialisation and its control. But this is only the first level of instruction. For Margery Paterson's album also insists that, if our interest in collective memory is genuine, we

Figure 10.8 *Margery Paterson snapshot album, 1925–1945, page 40 with 5 snapshots.* Courtesy: Notman Photographic Archives, McCord Museum of Canadian History, Montreal, MP-1999.3.2.5040.

are going to have to attend to Maurice Halbwachs's essential definition: 'While the collective memory endures and draws strength from its base in a coherent body of people, it is individuals as group members who remember'.[26] In the absence of the original 'remembrance environment', another group presents itself: six women, myself included, who noticed certain qualities of the album ('static') and especially *felt* its strong appeal to community ... *Forget me not*. Suddenly, we have an album that spotlights the conditions of girlhood and adolescence from the perspective of a young woman exiled by her illness, and photographically reliving the freedom and promise of her younger years. An application of the oral-photographic framework restores Margery Paterson's agency, gives her back her voice.

Notes

An earlier version of this paper was delivered at the College Art Association Conference in February 2002 in a session on albums chaired by Catherine Whalen who then revealed that she herself had done extensive research on a found album, compiled by another 'Me'.

1. The term is borrowed from Eviatar Zerubavel, 'Social Memories: Steps to a Sociology of the Past', *Qualitative Sociology* 19, no. 3, 1996, p. 284.
2. Pierre Bourdieu, *Photography: A Middle-brow Art*, trans. Shaun Whiteside, Stanford: Stanford University Press, 1990; Susan Sontag, *On Photography*, New York: Farrar, Straus and Giroux, 1978; Jaap Boerdam and Warna Oosterbaan Martinius, 'Family Photographs – A Sociological Approach', *The Netherlands Journal of Sociology* 162, 1980, pp. 95–119; Richard Chalfen, *Snapshot Versions of Life*, Bowling Green, Ohio: Bowling Green State University Popular Press, 1987; Richard Chalfen, *Turning Leaves: The Photograph Collections of Two Japanese American Families*, Albuquerque: University of New Mexico Press, 1991.
3. Julia Hirsch, *Family Photographs: Content, Meaning and Effect*, New York: Oxford University Press, 1981; Graham King, *Say 'Cheese!': Looking at Snapshots in a New Way*, New York: Dodd, Mead and Co., 1984. For a refreshing consideration of the singular perspective of the family chronicler, see James C. A. Kaufman, 'Photographs & History: Flexible Illustrations', in *Reading Into Photography: Selected Essays, 1959–1980*, eds Thomas F. Barrow, Shelley Armitage and William E. Tydeman, Albuquerque: University of New Mexico Press, 1982, pp. 193–199.
4. Zerubavel, 'Social Memories', p. 284.
5. Anne Higonnet, 'Secluded Vision: Images of Feminine Experience in Nineteenth-century Europe', *Radical History Review* 38, 1987, pp. 16–36; Marilyn F. Motz, 'Visual Autobiography: Photograph Albums of Turn-of-the-Century Midwestern Women', *American Quarterly* 41, no. 1, March 1989, pp. 63–92; Jo Spence and Patricia Holland, eds, *Family Snaps*, London: Virago Press,

1991; Marianne Hirsch, 'Masking the Subject: Practicing Theory', in *The Point of Theory: Practices of Cultural Analyses*, ed. Mieke Bal and Inge Boer, Amsterdam: Amsterdam University Press, 1994, pp. 109–124; Serge Tisseron, 'L'inconscient de la Photographie', in *La Recherche Photographique* 17, Automne 1994, pp. 80–85; Annette Kuhn, *Family Secrets: Acts of Memory and Imagination*, London and New York: Verso, 1995; Marianne Hirsch, *Family Frames: Photography, Narrative and Postmemory*, Cambridge, Massachusetts and London: Harvard University Press, 1997.

6. Chalfen is especially strong on this point. For a very interesting counterpoint, see Catherine Whalen, 'Finding "Me"', *Afterimage* 29, no. 6, May/June 2002, pp. 16–17.

7. Karin B. Ohrn, 'The Photoflow of Family Life: A Family's Photograph Collection', *Folklore Forum* 13, 1975, pp. 27–36; Amy Kotkin, 'The Family Photo Album as a Form of Folklore', *Exposure* 16, no. 1, March 1978, pp. 4–8; Pauline Greenhill, *So We Can Remember: Showing Family Photographs*, CCFCS Mercury Series, no. 36, Ottawa: National Museum of Man, 1981; John Berger and Jean Mohr, *Another Way of Telling*, London: Writers and Readers Publishing Cooperative Society Ltd, 1982; Liza McCoy, 'Looking At Wedding Pictures', in *The Zone of Conventional Practice and Other Real Stories*, ed. Cheryl Simon, Montréal: Optica, 1989, pp. 69–76; Johanne Lamoureux, 'L'Album ou La Photographie Corrigée par son Lieu', *Trois* 6, nos 2–3, Hiver/Printemps 1991, [Montréal: Dazibao, 1991. Corriger les lieux après la photographie de voyage, exh. cat.], pp. 185–191.

8. The development of the photographic collection of the McCord Museum is discussed in my publication *Suspended Conversations: The Afterlife of Memory in Photographic Albums*, where I acknowledge this history's bearing on the study, stating that the translation of an album from 'a private situation to the public sphere does not deprive it of a context, but substitutes one set of viewing conditions for another. An institutional setting, however impersonal, is never neutral; just as there is no generic compiler, so there is no standard museum'. See Martha Langford, *Suspended Conversations: The Afterlife of Memory in Photographic Albums*, Montreal: McGill-Queen's University Press, 2001, p.18. Working with a museum collection, I could only anticipate reviewer John A. Stotesbury's comment that the study was 'culture-bound'. See John A. Stotesbury, 'Martha Langford, Suspended Conversations: The Afterlife of Memory in Photographic Albums', *Biography: An Interdisciplinary Quarterly* 26, no. 1, Winter 2003, pp. 143–147. This is undeniable; in fact, I would argue that one of the strengths of the final case study is its recognition of its producers' quiet acts of assimilation and resistance, and the function of such an album in the context of a museum once considered 'the attic of English Montreal'. See Langford, *Suspended Conversations*, p. 203. At the same time, one must beware of anachronisms, such as Stotesbury's binding of the women to a 'minority francophone identity'. Religion is a much stronger force in these women's lives, one that cuts across linguistic barriers. The album preserves their piety, their language and their customs, as well as the day-trips, picnics and other little rituals that constitute their 'white, middle-class idyll'. Clearly, these points could have been writ larger for non-Canadian readers. The present study seeks to make the

cultural boundaries of the object and its institutional setting very clear, as part of the album's mnemonic community.

9. See Walter Ong, *Orality and Literacy: The Technologizing of the Word*, London and New York: Methuen, 1982. Important sources also include Jan Vansina, *Oral Tradition as History*, Madison: The University of Wisconsin Press, 1985; Jack Goody, *The Interface Between the Written and the Oral*, Cambridge: Cambridge University Press, 1987; Ruth Finnegan, *Oral Traditions and the Verbal Arts: A Guide to Research Practices*, London and New York: Routledge, 1992. Ong's study draws on a wealth of studies; Finnegan's guide to research practices is enormously useful to anyone interested in oral tradition.

10. Here I must stress that these characteristics are a correlation of Ong's 'psychodynamics of orality' with photographic theories of production and reception. To understand precisely how the framework has evolved, and especially its debt to oral-formulaic theory, anthropology, ethnography, sociology, psychology and literature, see Langford, *Suspended Conversations*, pp. 122–157.

11. Ong, *Orality and Literacy*, p. 46.

12. Bourdieu, *Photography: A Middle-brow Art*, pp. 30–31.

13. Whalen, 'Finding "Me"', pp. 16–17.

14. This seems an appropriate point to acknowledge the generous collaboration of the McCord Museum staff, and especially, the custodians of the Notman Photographic Archives, a department which includes all the museum's photographic holdings.

15. Ong, *Orality and Literacy*, p. 42.

16. The Notman Studio was not only successful, but highly versatile (the two qualities are often linked in business). Photographic historians pay less attention to the lucrative portrait trade, than to the engineering records; views of city, country and wilderness; composite portraits and theatrical tableaux. For students of portraiture, the Notman Studio records are an incomparable resource, preserving the names and repeat orders of his clients.

17. Mary Chadwick, *Adolescent Girlhood*, New York: The John Day Company, 1933, pp. 222–223.

18. The dynamic of familial gazes and familial looks is thoroughly examined by Marianne Hirsch in *Family Frames* and further extended to private and public photographic works in Hirsch's edited collection, *The Familial Gaze*.

19. At this point, I undertook the exercise of copying the album, dismantling the copy and organising the pictures by format, i.e., by print size and border motif.

20. G. Stanley Hall, *Adolescence: Its Psychology and its Relations to Physiology, Anthropology, Sociology, Sex, Crime, Religion and Education*, vols 1 and 2, New York: D. Appleton and Company, 1904–1905.

21. The one featured in this album is Camp Ouareau, the oldest private girls' camp in Canada, founded in the early 1920s by Dorothy Percival, the much photographed Miss Percy.

22. Phyllis Blanchard, *The Adolescent Girl*, revised edn, New York: Dodd, Mead and Company, 1924, pp. 133–137.

23. Chadwick, *Adolescent Girlhood*, p. 243.

24. Zerubavel, 'Social Memories', p. 286.

25. Sontag, *Illness as Metaphor*, New York: Vintage Books, 1979, p. 30.

26. Maurice Halbwachs, *The Collective Memory*, trans. Francis J. Ditter Jr and Vida Yazdi Ditter, New York: Harper & Row, 1980, p. 48.

Chapter 11

Talking Through
This Space Around Four Pictures by Jeff Wall

Jerry Zaslove and Glen Lowry

> If you can believe in its depictorial quality, a photograph can be a valuable
> means of a thesis, antithesis and communication. It has a clear language,
> one that speaks openly not only about its subjects, such as people,
> architecture, and landscape ... but also very much about the attitude of the
> photographer toward these things. In this regard, a photograph is always objective.
> Thomas Struth[1]

> What has been formed cannot be lived unless what
> has fallen apart is gathered up and taken along.
> Siegfried Kracauer[2]

The following dialogues are part of an ongoing exchange of ideas developing out of our collaboration as editors of *West Coast Line*, a Vancouver-based cultural/literary journal that chronicles and develops interdisciplinary cultural production relevant to the vanguard traditions of our West Coast – the western region of Canada and (cultural) watershed feeding into the Pacific Ocean, roughly the province of British Columbia. These dialogues come out of our shared interest in photography and cultural memory that has involved various projects, including a recent series of interviews with Jeff Wall and Fred Douglas on photography in Vancouver.[3] The four sections below have been distilled from approximately six hours of transcribed discussion spanning three meetings that took place during October 2004 in the office of the journal *West Coast Line*, at Simon Fraser University in Canada.

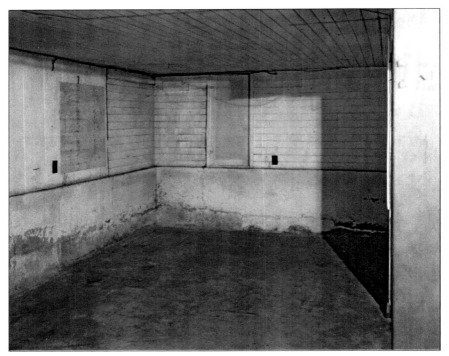

Figure 11.1 *Swept.* Jeff Wall. Transparency in lightbox, 216.2 × 174.8 cm. 1995.
Courtesy: Jeff Wall.
A colour reproduction can be found at the following address:
http://media.macm.org/biobiblio/Wall_j/wall-swept-bib.htm

I

GL: *There appears to be a fundamental shift in Jeff Wall's work, notably in the work in his exhibition at the Museum Moderner Kunst Stiftung Ludwi, Vienna and in the book by the Hasselblad Center (both titled* Jeff Wall, Photographs*). A key aspect of this shift, for me, has to do with an increasingly 'photographic' bent in Wall's work.[4] In particular, images that Wall made during the mid-to-late 1990s – the 'Diagonal Composition' series, 'Clipped Branches, E. Cordova St., Vancouver' and 'Swept' (figure 11.1) – suggest a movement away from the earlier, more cinematic or painterly work for which he is famous towards something that suggests a direct engagement with the early history of photography. As such, this work presupposes a different way of relating to history and to cultural memory. Paradoxically, it seems much more personally invested and immediate. As a lead into our discussion of this work, I wonder if you might say something about 'Faking Nature and Reading History' and about some of the changes you see in the critical climate surrounding*

Wall's work? Looking at the reproductions in Jeff Wall 1990 *and 'Faking Nature', it seems to me that the images that were under consideration are of a different type or category from the ones we're talking about here. 'Swept', for example, is much harder to relate to conceptual art, or to an 'art historical' discussion of Wall's work. In a profound way, this work seems to initiate a complex dialogue with scholarship or epistemology vis-à-vis the relationship between history and art making. I'm interested in the way his work negotiates with the irony you set up: that after Adorno one has to be 'mindful' of memory formations while, at the same time, there is a proliferation of 'memory work' across disciplines and cultural locations.*

JZ: 'Faking Nature and Reading History' argued that, with the Enlightenment's break with the neo-classicism and the 'illusionistic' representation of opulent capitalism (for example, Jacques-Louis David's post-revolution French paintings) and its claim to fresh subject matter (in the paintings of Delacroix and Géricault, for instance), a new stage of modernism had emerged. Already with Brueghel, then with Goya, Manet and Courbet, new subject matter brought new framing devices – forms – that brought the spectator into a critical, self-reflective, *empathic* position in regard to the origins of art in social controversies. Following this, photography brought on the emergence of a new realism that focused memories of revolutionary violence and the violence of the everyday as new, formative cultural forces. Baudelaire, Dostoevsky, then Freud and Proust gave this cultural force, simmering on the surfaces of the nineteenth century's millennial fevers, a new grounding in the dialectics of the mimetic powers inherent in memory-based art making. This fuelled the effort to recall a violent past through new, consciousness-breaking formations and new meaning. Photography's capacity to simulate reality, copy it, gave the mimetic impulse a sense of invasiveness that threatened the integrity of reality. We might say that if reification is a form of forgetting, then photographic depictions of reality provide a form of remembering how reification works *at* us, in front of us, facing us. I argued that photography had to be 'mindful' toward reality because, not only did it bring about a new mode of realistic depiction, but it also brought the spectator into the magical world of re-presentation in a manner that broke with its yearning for origins and fixed beginnings.[5] In this sense, Emmanuel Levinas writes:

> The presentation of the face, expression, does not disclose an inward world previously closed, adding thus a new region to comprehend or to take over. On the contrary, it calls to me above and beyond the given that speech already puts in common among us. What one gives, what one takes reduces itself to the phenomenon, discovered and open to the grasp, carrying on an existence which is suspended in possession – whereas the presentation of

the face puts me into relation with being … [E]verything that takes place here 'between us' concerns everyone, the face that looks at it places itself in the full light of the public order, even if I draw back from it to seek with the interlocutor the complicity of a private relationship and a clandestinity.[6]

When I wrote the 'Faking Nature' essay, the wars around monuments, memorials and commemorations had not yet hit us the way they have today. Today, the uses and abuses of the memory wars dominate much of the discussion of cultural politics, yet it appears that, as spectators, *we* are indulging in the architectonics of memory (remembering) without a very deep knowledge of the way memory works as a dramatic representation of the images in the unconscious. We seem to be telling stories about memory without always or clearly understanding that memory is not a trustworthy representation of chronology in history. Memory is asynchronous.

We might connect this to Wall's particular form of image making, his use of lightboxes, which you suggest in your monograph engage the audience by illusionistically making surfaces disappear. Standing in front of Wall's large-scale lightboxes, one tends to slip into the space of the photograph, becoming tangled up in a very authoritative way in its aesthetic production. I think this is the reason some people are resistant to Wall's work: in front of his images, you are unwittingly brought into the space of representation in an unnerving way. Through their seductive texture, the lightboxes script us in; in so doing, they destabilise our relationship to the cultural object, or to the quotidian particulars the object appears to represent. Contrary to the theatrical performance depicted in many of the larger works (many of which use Vancouver or the West Coast as a backdrop, forcing us to recall specific streets, buildings and personae, often already carrying a politics with them into the photograph), an image like 'Swept' depicts a different relation to space, one that has been swept clean of human subjects or obvious geographical references. 'Swept' (see figure 11.1) looks like a crime scene to me – the photographer cleaning up after himself. It presents an obsession with orderliness that I am tempted to relate to the artist's historical specificity or being and at the same time it moves in much more closely on the subject matter, divorcing it from a larger social context. 'Swept' reeks of the psychological energies that would go into producing such an image. At the same time, it gestures towards more conventional notions of photographic media – silver prints, smaller photographs, found images – that rely on a different psychic drama connecting viewer, image-maker and object.

This is a terrifying picture. It's a dirt floor that really can't be swept clean. This room will never be clean. This picture smells. Its sensual surface is

musty, dank. This picture is also about the play of light. It is a Spartan image about the problem of origins, which, as I have suggested, is very much the problem of cultural criticism. The problem of origins is by definition a problem of how a generation identifies itself with the past. It therefore fits into the institutional struggles we've been talking about. It's not only disappearing, it's gone: Wall's craft has cleared the space. And the catharsis is in the clearing.

This space is waiting for the arrival of something. It's ready for the next tenant – tenants being a key motif in Wall's work. While I'm struck by the austerity of this image, I worry about my own interest in these photographs that are empty of personae. There seems to be a dangerous safety in moving away from representations of individuals (and of their social relations with other subjects). But I'm not sure that this is what's happening here. In fact, I see the reverse happening: in emptying the frame of personae, the image allows in the subjects – Wall's, the viewers' – in an immediate way. In this sense, 'Swept' explores in a new way the question of surface discussed earlier: yet it does so by becoming a space of play of subjectivities that are more and less historically determined.

The daringness of this image is the risk it is taking with your sensibilities. There's a kind of aggressive or violent aspect to it. The invasion of the integrity of the person is a quality of this work. In Wall's work in general, this kind of violence is connected with Nietzsche's sense that if we are going to start modernity all over again, if nihilistically ethnicity has to start all over again and gender sensitivity has to start all over again, then cultural criticism has to start all over again. This is not a sublime act: it is a repressive act. You have to start thinking in hard terms about what you are doing and whom you are affecting. In terms of cultural criticism, the implications of what you are doing are crucial: in art, one can be much more aggressive. That's why I am suggesting Wall establishes an empathetic-empathic relationship with the form: in experimentation one experiences form. The work assimilates the subject matter, even if it's horrific. The location of memory depends on an orientation to the familiar cultural objects in one's world. Proustian reveries are a form of free-associating: the early Picasso or Cubism provides a rough engagement with memory as a violent disengagement with traditional forms of representation. Likewise with photography it was more difficult to come to terms with form or innovations in form, because as Kracauer suggests, photography is like a sponge that absorbs too much of the world, placing the viewer in a reciprocal relationship with distance and closeness – the memory problem.

If certain photographic images demand a knowledge of the history of photography, then, in terms of your expressed desire to develop a psychoanalytic approach to Wall's work, might we not also say that the photographer, as opposed to this other figure of the artist who uses photography, is better suited for psychoanalytic readings? A photographer is an embodiment of the technology, whereas the artist who uses photography still has a distance from it. For the conceptual artist the mode of seeing is not the photographic per se. *But when you start to think of Wall as a photographer, respecting the depth of his knowledge and engagement in photographic praxis and history, then desire and a much closer relationship between the machinery and the individual become more entangled.*

I would agree with that, but the way you get at the identity question, which again goes back to the invasion of the person by technology as well as the prosthetic extension of the person into the real, is that you start by acknowledging that the person is made up of multiple selves. I mean this is why the dream analogy is so interesting in terms of memory work.

II

The notion of sweeping up – of simultaneously remembering and forgetting the relationships between the photographer or spectator, or photographic subject and object – is also at the core of Wall's remarkable image 'Morning Cleaning, Mies van der Rohe Foundation, Barcelona' (figure 11.2). It seems to me that this categorically different type of image brings together many of the issues we've been discussing – international modernism, labour, social history, cultural location or position, representation, globalisation – while returning to a number of Wall's important ideas or themes.

This picture has the same depictorial qualities as 'Giant', where the interior of a public space, an architecturally opulent space, brings international modernism right into ordinary view. Like 'Swept', it depicts a space cleansed of any people. The architecture has a neo-classical and yet baroque quality, which might be strange to think about, but this is Wall's trickery – it works against and with the illusion of inside and outside. The image connects with Wall's earlier pictures where mirroring and doubleness are given primary significance as the plane in which the viewer is shocked into feeling a kind of disorientedness. There is the utter ordinariness of the scene. It hasn't got a lot of drama. But there is also this amazing texture of the walls and, again, a consciousness about the light: as

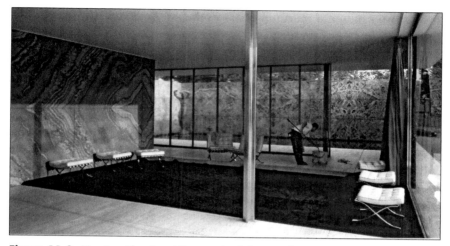

Figure 11.2 *Morning Cleaning, Mies van der Rohe Foundation, Barcelona.* Jeff Wall.
Transparency in lightbox, 206 × 370 cm. 1999. Courtesy: Jeff Wall.
A colour reproduction can be found at the following address:
http://www.tate.org.uk/modern/exhibitions/jeffwall/rooms/room12.shtm

in many of his interiors, it sweeps across the scene (here, from left to right). For Wall, who does not take many pictures of architectural interiors, this image is uncanny: it evokes the return of the repressed. In the way Freud uses the term, the uncanny is a place where the home, the hearth and the secret come together. In German, *unheimlich* means secret. It also means homely and mysterious. It is a place near you where you tell and make up stories for children. You would teach them about another world – of gremlins and spirits and so forth – with the uncanny.

Your point about this being a space for stories raises an interesting question about the function of this room. It is one of those wonderfully modernist spaces that is almost dysfunctional in its functionalism. The chairs are too far apart, the design of the room is too rational. In the scene depicted here, the conversation is no longer taking place. Juxtaposed with the work of the cleaner, the nature of last night's discussion exists as a secret, hinging on a separation of an administrative class from the labourer who arrives in the morning and is gone before anyone notices his presence. Against the austerity of this artificial space, the cleaner's body and labour represent something of a secret or unacknowledged aspect of its design. On another level, the long vertical line splits the scene while connecting the domestic worker and the statue of a nude woman. The image balances the labourer with the abstracted female form in a manner that suggests an uncanny haunting of the rational order of this room. What is outside this room and looking in on

it is both the material relations of the work and the sexualised image – the labourer's body and an idealised female form.

Conversation is a place where the uncanny resides in the comfort of home. In Freud's wonderful essay on the double meanings of words, he suggests that words carry archaic meanings – as in the word *unheimlich* that has reversible meanings of home and secret. For Freud and early psychoanalysts, including Melanie Klein or even Jung, the Unconscious was a field of prelinguistic forces. The relevance here is that the Unconscious is symbolic as well as animistic, insofar as it calls into existence, through poetic language or the act of naming, objects whose use and function can change with the name changing. In other words, language does change reality. In fairytales and fables, language is constantly mutating and disappearing. The notion that when you change language you change reality is one the basic principles of therapeutic analysis: the repressed returns in a context that is normal. This relates to what I think is going on here at the level of reification, social change, social exchange of space and image. It is a process that started out with the displacement of space into image – in the contemporary world a commodity which you can do anything with.

That idea of language changing reality is also a Marxist concept and might be a point of intersection between the psychoanalytical and the sociological, which in relation to Wall's work – this photograph and 'Swept' – seems to be a border that you and I are moving across. Figuratively, this image is about the skirting or framing of the gaze. In this sense, this line enacts a separation of sociological and psychological elements of the work. On one side, there is the cleaner; on the other, behind the veil of the window washing, the statue. Semiotically, this photograph breaks itself in two.

One of the gaps in the literature on Wall's work is an interest in his deep understanding of the social history of art. As a Hauserian,[7] I'm fascinated by the use of intelligence in his work, its connection with those artful historians who see the social through the holes in the history of Modernism: Alois Riegl, Herbert Read, Arnold Hauser, Meyer Shapiro, Michael Baxandall, T.J. Clarke and Michael Fried, each a social historian and an art historian.[8] Once you denude the photograph of social history, you lose the belief systems that function historically and that lie behind its creation of audience. I am speaking of the sociological tradition of Simmel, Kracauer, Weber or, for that matter, Hegel. In Wall's pictures, it

is not only art history but an art history of photography, and it is the mindfulness to its new dialogical values that need to be brought out.

This room is mausoleum-like: as you have suggested, it is space of social death. Yet, this is very specifically named. We know it is 'Barcelona'. And we are looking at the Mies van der Rohe-designed German Pavilion for the 1929 World Exposition, a building that had no practical purpose: 'No functional programme determined or even influenced its appearance. No part of its interior was taken up by exhibits: the building itself was the object on view'.[9] These famous Barcelona chairs, which were designed specifically for this building (as a throne for the Spanish Royalty during the opening ceremony), are the only 'objects' in the building. And in a sense, this building doesn't really have an inside: its secret past is that it has never housed anyone or anything. The question about who is more at home here is really useful: after all, is it not the figure of the cleaner who actually inhabits the space? This ironic turning inside out of the monumental built environment invests it with life and memories, but with those of the cleaner, who might be connected historically with globalisation and the movement of bodies from the Americas back to Europe.

Wall's black-and-white photograph 'Housekeeping', which depicts a maid on the threshold of a hotel room, is another image about a domicile or shelter. This image depicts a room that is so reproducible; it represents every motel room anywhere. Again it suggests something of domestication carrying out the logic of the secrets, but it is also demystifying the secrets by making them public, talking about them. It is important to remember that the home is the place of political economy: the household is the economic core of all social systems. So if there's intrusion from the outside to the 'inscape' of the home, this has to be contained. In classic Marxism, you have to ensure that the surplus that is created at home through craft, not factory work, cannot be alienated, estranged; which is another way of talking about the uncanny, as maintaining the economic at home without having it robbed of its meaning.

There is an element of defamiliarisation in the cleaning being depicted in these works. In the making strange of these images we are reminded of domestic labour in a space that is supposed to be sanitary already, untouched by human hands. The presence of the housekeeper reminds us of the lives and memories of others – their dirt and disorder, our own mixing it – which must be forgotten each night. In this way, inhabiting a hotel room is analogous to taking and looking at family photographs, which depend on

our ability to see ourselves or take ourselves out of the flow of social habits
– to see ourselves at home in the utterly clichéd snapshot.

This is similar to the notion that dreams give you a sensual relationship to
the spatial; that they're infused with touch. You can feel them because
they're in your body. It's a body-based insight that comes out of the
experience that you had before. Your temperature goes up and your heart
beats. Dreams simulate real life. Your point is really a good one. How do
you alienate something that's already alienated in this way? Maybe one has
to say that this is a cultural location, a place in which cultural, artistic and
architectural activities take place; where you build culture, a laboratory for
modern culture. The irony is that it was a style that became a vision of the
modern at a time when the modern was being destroyed by fascism.

What I see in some of this later work is that the photograph itself, even
though it always already was a gesture, a gesture of gestures, is
displacing itself into the social act of making the image. I read this image
as a more personal, but incredibly nuanced, understanding of the
photographic gesture and consequently of remembering.

There's a mistake in thinking that classic Freudian dream theory is only
visual. In a dream there is the illusion of mortality and time, as well as
spatial material. Freud differentiated between the manifest and the latent
content of a dream: the manifest is what we talk to ourselves about in
everyday life; the latent content is interpretable in dream work. In dreaming
and talking about *the mental event* of the dream when you wake up, you
have a sense of something having happened to you which, even
philosophically, is an event. A dream is haptic; it also has rhythm, a pulse,
emphasis and blank moments. If you try to recreate the dream by writing it
down, you lose its auditory quality, which still exists in talking about it. You
need to have a voice, your voice, speaking the dream; otherwise, it remains
fully internalised with the qualities of feeling hiding out – we mistakenly
call this 'invisible' because we are so used to thinking 'optically'. Thus,
Freud developed the 'talking cure' as a way of recreating voice through
talking about dreams or memories, recreating the voice of one's parents. In
the process, one is actually projecting a voice that may or may not be one's
own, but may have echoes of other people in one's intimate life. This idea
is important for memory work because it involves the three stages of
memory: remembering, repeating and working through. Remembering in
classic psychoanalysis is really best translated as insight or 'inscape' (the
German is *Erinnern*), bringing into your body images and thoughts that
have been floating; we make them repeatable.

So in this sense, the photograph, or more precisely the point of intersection it provides between the act of photographing and looking at the photograph – which is also between the psychic and the social – bridges the gap between remembering and repeating. In the case of 'Morning Cleaning', this process might be said to be an uncanny event because it remembers and repeats something that wasn't supposed to be seen happening. It shows us something of the quotidian, internal, almost secret life of the foundation.

The third phase is the working through – the phase of transference in classic Freudian analysis. This involves thinking beyond concepts, not reducing the dream to simple ideas or themes that allow one to say, 'Well I had a dream. I know exactly what it meant'. You can't know what it meant, because you can't entirely commit the dream to consciousness. You may have some ideas about what it meant, but it doesn't mean that you have actually come to terms with it. Working through means you come to terms with the dream structure; the actual specific meanings of those dreams might be ultimately irrelevant. The objective of dream work is to have some affective response to the process, to have a sense that you've got to where you want to be. Demystifying the structure, you are no longer in it: in working through, you're in a process of working on totality in Adorno's sense that 'all reification is a forgetting'. You begin to see the relationship of the totality of the dream process, the dream structure, to an experience of totality, but not in its *reified* form. Thus, the room in this photograph is a perfect representation of an overdetermined vision of style or design. Wall may see a certain kind of beauty in the space, but for me this image depicts an alienated totality or beauty. I could sit in this room and talk, but it's not a very comfortable environment. The gestural aura is forbidding and aggressively modern. Your words will echo.

The traces of desire – of individual intention, perhaps – seem to me to mirror very complex social memories and Wall's engagement with history. The history of this building, for example, suggests a link between the built environment this image places us in and the desire to reconstruct a modernist past. The building was disassembled after the 1929 Expo and then reconstructed in the 1980s. Its existence performs a kind of historical rewriting that not only glosses over the radical shifts in how and what the Pavilion means, but also over the historical rupture between the building and the rebuilding. After the Spanish Civil War, Franco, World War II, the Cold War and the emergence of globalisation, its rebuilding frames a radically different geo-historical reality. What is the link between international Modernism and the material history alluded to

in the image? How do we read parallels between the arrival/position of the labourer in this structure and the remembering of Wall's image? This image grapples with abstraction – as opposed to or in addition to mimesis – as an aesthetic process, a physical process or as bodily gestures. This image, in a sense, demands a stronger questioning of embodiment, of the particularity of the photographer's embodied eye, or his subject.

This is what I mean by empathy with form. Internalising is the more appropriate word for remembering in the psychoanalytic context, because it is more closely linked to knowing. Knowing means regaining some affect over the memory: not as an abstraction, that's the wrong word, but by making it particular again, which you can't do automatically because the 'consciousness-raising' aspect of memory requires this repeating of form. Freud's concept of memory needs the word *wiederholen*, which is to 'call back again'. It's oral: a call back, which means to literally 'go and get the voice': to call. We go over a memory again and again because it is opaque: this type of repetition may be a compulsive act. We go over the same dream until it feels part of our character – and we don't know why. It is habit, as in the German sense of *Erfahrung* – experience: it happens to you and you are digesting it, constantly assimilating it. You historicise because that's the process of memory. You take a hundred photographs, snapshots and the repeating wards off the image. Rather than taking one picture and looking at it again and again because it's meaningful. I think this is the 'creative will' inside Wall's pictures: they approach the sense of a painting, as one picture you go back to again and again, and you're not exactly sure why, but it has such important signifying qualities because it has a depth, it is in part 'haptic'.

III

Wall's work offers complex interpretations of the gaze, but it does so in reference to highly specific social situations. In a number of images, Wall more or less provokes the viewer, demanding a critical engagement with the politics of looking, his and ours. Faced with well-known images like 'Picture for Women', 'Woman and her Doctor', 'Diatribe' and 'The Drain', which represent women and girls in relation to psychoanalytic themes; 'Mimic', Trân Dúc Ván', 'Outburst', which engage with the culturally charged representation of racialised subjects; or 'The Storyteller' (figure 11.3) and 'Bad Goods' (figure 11.4), which enter into questions regarding aboriginality, one is forced to think about the relation of the artist to the subject matter. But in so doing, we need to pay attention to the disjunction between the visual and the oral/aural.

Figure 11.3 *The Storyteller.* Jeff Wall. Transparency in lightbox, 229 × 437 cm. 1986. Courtesy: Jeff Wall.
A colour reproduction can be found at the following address:
http://www.tate.org.uk/modern/exhibitions/jeffwall/rooms/room4.shtm

According to the classic Freudian view of the dream work, voice is translated into visual material in the dream but the voice is never gone. In my reading of Lacan, the voice is gone and the universality of method prevails, whereas in classic Freudian analysis there is more room for culturally specific contexts. The speaking voice in the psychoanalytic dialogue is gone in Lacan and what is left is primarily 'opticality', or mirroring. But we know the importance of voice already through observing mothers with children. One assimilates the voice of the other into one's body. But in the translation process from opticality to seeing, to listening, to recognising, there's a crucial disfiguration underlying the transparent surface. Seeing is a distancing mechanism, listening is much more intimate. One vital aspect of the psychoanalytic break from psychiatry, which used hypnosis, water cures and other violent therapies that made the patient look crazy, was the decision to actually listen to individuals' words. Lacan was good at understanding displacements, condensations and reflections, but not at listening. In terms of film, we might say he was interested in the words that bounced off the screen, but not the words that penetrated it. I think this is why film critics pick up on Lacan so wonderfully. In the traditional psychoanalytic paradigm, the radical act was the listening act, which would obviously entail watching the body gestures to understand what the Unconscious was doing. In that respect – this is something I feel very strongly about – psychoanalysis never did translate very well from one culture to another. Psychoanalysis

had to invent new founding myths wherever it went: whether in Italy, Argentina, Japan or France, it almost had to reinvent itself in the terms of each new culture. Thus, the problem with Lacan, at the level of theory, is that it appeals to the universal, rather than a cultural, matrix. It does not appear to translate well into a cultural political framework.

We might say the same about photography as memory work: it reinvents itself as it moves across borders, cultures and times. Jeff Wall's work demonstrates, almost obsessively, the paradox of photographic representation: his extremely high-resolution images record a richness of realistic detail / information even as they empty it of temporal and spatial specificity. Thus his images hinge on an almost instantaneous remembering and forgetting of historical time. To put it another way, they foreground and destabilise the space of reception and the act of viewing. This is a point that you suggest needs to be understood in terms of social history – of art, but also as art. I would add that it is this aspect of Wall's work that seems to have dramatically shifted in the past decade. Time seems to be propelling Wall's oeuvre into an ever more complex engagement not only with the illusionist practices of renaissance and baroque painting but also, as I have suggested, with the history (and prehistory) of photography itself. It provides a return to the relationship between representation and one's experience of the photographic act. The question of aura invoked by these images is linked to the auditory/aural space – to what is no longer being heard or spoken. Drawing attention to the intersection of public and domestic spaces – the ironic issue of 'housekeeping' or 'cleaning' as public acts – his images raise fundamental questions about the specificity of cultural interpretation. I'm fascinated with how particular images function for those of us working and living on the West Coast, for whom the issues of First Nations' entitlements and anti-Asian/anti-Asian Canadian racism (to pick two recurrent themes in Wall's work) are deeply embedded in both the social history and academic cultures of this place. Wall's work actively depicts the problematic of remembering and representing colonial anxieties of settlement and aboriginality, anxieties which have been both fed and mediated by a long history of photographic ethnography that dates back to the 1850s and the beginnings of photography itself. I have in mind the (in)famous images of Edward Curtis, but also those of early Chinese-Canadian and Japanese-Canadian frontier photographers, such as C.D. Hoy in Barkerville or the Hayashi/Kitamura/Matsubuchi Studio in Cumberland.[11] Images like Wall's 'The Storyteller' (figure 11.3) or 'Bad Goods' (figure 11.4) seem extremely important in this light, especially in the way they bring

something akin to what you have referred to as folkloristic time into collision with modernity, international traffic, or commerce.

Social reality is always in dispute in great pictures. Some of the most compelling discussions are around Dutch painting and its social history; as in, say, Rembrandt's 'Anatomy Lesson of Dr. Tulp' and his still lifes like 'Slaughtered Ox', where the role of the beholder is depicted in the picture. The experience of storytelling, of 'facticity', is related to Walter Benjamin's famous essay 'The Story Teller'. Benjamin writes, 'the storyteller was at home in distant places as well as in distant time', embodying 'two archaic types' – 'resident master craftsman' and 'itinerant journeyman'[12] – his story is infused with 'both the lore of faraway places … and the lore of the past, such as is manifested most clearly to the native inhabitants of a place'.[13] Through the storyteller, we become enmeshed in a nexus of disparate times and spaces. The figures in Wall's image are dressed in a way that suggests they are in modern time, but they have gathered in this almost ghettoised place beneath the bridge – it is a beautiful bridge, by the way – suggesting that they are part of another, perhaps archaic, time. To add to this, a Bakhtinian notion of genre reminds us that where you tell the story, as well as to whom you are telling it, changes the story's life-world. That's a positive dimension of Wall's pictures and I don't know to what extent it has been talked about. Although it might be seen as a kind of sentimentality, or an overly romantic interpretation of the situation, it's vital to remember that traditionally stories change depending on who is telling it and who is listening.

As in 'Morning Cleaning', the 'The Storyteller' depicts a complicated segmentation of space. There are various listening groups, making it difficult to locate the story or point of focus. Above it all, this bridge, which functions as a trope of a dominant modernist time and a well developed network of spatial relations, suggests the provisional nature of a much older scene. The elements of image – the clothes and bridge design – placed as they are within a depiction of the all but lost craft of the storyteller, destabilise the dream of modernity, symbolised by the bridge. I say it is a dream, because there is this unique obsession, prevalent here on the West Coast, with modernity as something that never really takes place historically. In terms of the cultural history of this place, remnants of modernity remain as reminders of the incomplete incorporation of this colonial space into the temporal logic of a dominant nationalism. This beautiful bridge might frame the discourse, but what's interesting is happening just below and off to the side of it. In terms of globalisation and the cultural struggles that persist here, one might say

that this image can also be read as a reminder of the failure of colonialism, of the nationalist project that grows out of it, of modernity's claims to completely subsume the contradictions of the past into the look of the present. Aboriginal peoples and their cultures survive. In terms of the cultural politics of British Columbia, the question of ownership, property and land claim has everything to do with the relationship between story and fact, aurality and textuality. It is not too reductive to say that culture is owned by those who govern time and that the creation myths owned by the First Nations, for example, might provide the basis for juridical knowledge and action. At the same time, storytelling, as an alternative mode of knowledge production and distribution, exists at the limits of bourgeois culture and capital. The notion that stories are property or, conversely, that ancestral lands might be other than property in the sense that real estate is, these are concepts bourgeois culture has never been comfortable with here. They are antithetical to bourgeois notions not only of land, but also of the future. Thus, I might place 'Bad Goods' in relation to memories of the potlatch ceremony, which in colonial British Columbia represented an outrageous practice of abundant giving that has now been lost, elided beneath the rationalisation (or naturalisation even) of 'trade' as a universal practice.

Typically, in the Freudian paradigm, or even in a Marxist paradigm, the taboos that appear to be so petrifying to bourgeois society also exist in archaic societies. However, in a craft-based agricultural society, fear of the other tends to be more commonplace and less traumatic unless placed under the spell of violence. In modern society, these fears are much more worrisome and are part of the memory wars. Just think of the controversies over monuments to the holocaust or the Vietnam War Memorial. This is something in Wall's pictures: the taboos – let's say sexual taboos, restrictions, obstacles – that appear to fall away as in a dream and liberate us from the power of institutional forces, always come back again, albeit in many other forms. Today we have the pursuit of memory by a generation that did not participate in the horrors of the wars: the holocaust, Hiroshima, or Vietnam. Yet the repressed memories come back again in another form, as if they have changed, but they may not have changed. Or then again, the experience of seeing them comes back again, which can liberate us from their powerful attachment. The phantasmagoria of memory may depoliticise the present! This is something that I think interesting about Lacan and which I think these images suggest about the compulsion to repeat and the preoccupation with memory as a lingering of death. But I think, in terms of memory work, it might be better to consider more classical approaches to analysis,

such as D.W. Winnicott's or Melanie Klein's work, that deal with the power of transitional objects. Stories, as transitional objects, might be then connected to how we establish new relationships. To properly deal with the ogre, parent or powerful institution, one must begin to deconstruct it and through telling or listening to a story we defuse the originally overwhelming experience. Thus, the transitional object is a very important aspect of our postmodern world. When a new group intersects with dominant or solidified ethnic or racial identities, it reminds us that the world may itself have become a transitional object by virtue of new people who are threatening. Society does all sorts of scrambling and dancing around to make sure that they're not going to be heard without first paying the price of repressive tolerance.

IV

'Bad Goods' (figure 11.4) highlights the way that whiteness in the space of British Columbia has been a source of intense anxiety since its transition from a British Colony to a province of Canada in 1877.[14] What's remarkable about Wall's depiction of space – the geography he seems so compelled to represent (I wonder how European audiences

Figure 11.4 *Bad Goods.* Jeff Wall. Transparency in lightbox, 229 × 347cm. 1985. Courtesy: Jeff Wall.
A colour reproduction can be found at the following address:
http://projects.vanartgallery.bc.ca/publications/75years/exhibitions/
?mod=2&sub=1&artist=45&accc=85.89

might understand this differently) – is that it resonates with the repressed memory of white settlers. They never managed to establish the pure 'white colony' they so fervently desired.[15] The First Nations did not 'die out' with modernisation; instead they have used the Canadian legal system to make land claims and demand compensation for the abuse that three generations of their children have undergone at Christian residential schools. Non-European migrant workers did not return to their homelands after they finished building the province's economic infrastructure from the late 1800s to the mid-1950s: instead they stayed on in what was to become a multicultural Canada.

I'm interested in going back to your comments about the return of the repressed, but specifically I'm interested in how 'what returns' has in fact actually been present throughout the cultural history of this province.

The repressed returns in a context that is always normal – the more normal, the more irrational the return of the repressed feels. If the dominant culture understands this as, in the Nietzschean sense, the eternal return of the same, which is the bourgeois way of recapitulating history as the eternal development of something they've always owned, then the return of the repressed would be experienced as class struggle (if we were to put it in a European framework). However, in terms of exile and the nomadic lives of people, we might say that on arriving at the shores of a new dominant culture, some European immigrant groups found that, contrary to their expectations, they could not escape the repressed of their homelands. Instead, 'difference' kept 'returning', but from the origins of a history they never owned. Many European peoples who came here believed that they were making history in a way that it had never been made before; but in another sense, depending on their class, religion or the persecutions they fled, they were just recapitulating European history. When they met others from Asia or South America, or when they begin to share the spaces with Native peoples, history became a problem: there was no coherent story they could fall back on. It is important to remember, however, that many immigrants to Canada had a sense of history from an exilic position: the Ukrainians in the prairies or Scots in Ontario who had an exilic relationship to their past as ethnic outcasts from dominant nations, Russia and England.

The fragmented persistence of folkloric time that is carried forward in the historical anxieties of the European subjects who have settled here seems to be linked to Wall's intricate engagement with twentieth-century vanguard art and the histories underwriting it. When we talk about Aboriginal subjectivities within the history of a Canadian nation, there is

a long tradition of resistance to the temporality of European history, to the documentation of European history and its means of historicising. I'm interested in the way Wall's work resonates with this other socio-political consciousness.

If you look at the image carefully, you'll see that the box says this is 'iceberg lettuce from Salinas California, product of the USA', suggesting issues of large-scale industrialisation, or even globalisation. The figure is choreographed to stand in such a way that his face is neutral, looking straight at the viewer. Together, we approach 'the goods' in the centre of the frame in a kind of 'face-off', as Kaja Silverman has suggested.[16] Yet when this picture was made, the problematic epistemology of colonialism and modernity had already been exposed. We know everything we need to know about this kind of exploitation. So why are we looking at it again? What is new and why this is a great picture goes back to voicelessness; to our inability to penetrate the gaze of this subject, to use Lacanian terminology, to find (or place) its voice.

To return to your discussion about modern time – in Lacan and Freud, the Unconscious has no explicitly developed concept of time, and it is questionable whether it has a notion of space. Arguably, Lacan gives the Unconscious a notion of space based on language and the delusions of the optical, but to understand this relationship one would have to interrogate his notion that it is structured like language. For Freud, however, language is a culturally specific condition imposed by the superego in the name of culture – not just of the father – and of the ego's defence mechanisms that reify culture. As such, language cannot be ontologically separated from the institutions of family, school, culture and so on. Future work on memory needs to go back to questions of time and space, because without the principle of time there is no psychoanalysis of space. Time brings with it all of the experiences, fragmented as they may be, that make up the life of the individual subject.

The argument that you are making is not simply that you want to open up Wall's work to new psychoanalytic interpretations. Instead you are saying that this work might challenge the basis of psychoanalytic theory. In terms of the bigger project of the 'location of memory' this suggests to me that if we are going to go back and reclaim psychoanalysis or Freudian engagements with the issues of temporality, then time has to be re-spatialised or re-historicised within different geo-historical and epistemological terms. It seems to me that we are moving towards a number of key questions about how scholarly discourse and art practice are linked. In the fallout of the Cold War and the dissolution of the nation

state as a dominant cultural-economic order, notions of interiority and exteriority have given way to new returns and new thresholds that bring to light troubling incarnations of the uncanny. In this respect, Wall's work is provocative. Memory here, in its most radical form, breaks down binary oppositions that lock the other into rigidly defined caricatures of 'Us' and 'Them'. Here, memory presents other possibilities: the ways that lives cross racial and class boundaries through conflicts and collaborations that neither deny the violence of these interactions nor accept their inevitability. The radicality of this form of memory is spoken in the nuances of Wall's photographic practice and in the critical discussions it seeds.

Notes

We would like to thank the editors of this volume, Annette Kuhn and Kirsten Emiko McAllister, for the opportunity to pursue this topic in what for us has been an enlightening and challenging approach to scholarly work. We are particularly grateful for Kirsten McAllister's initial envisioning of this piece and for her friendly encouragement, without which it might never have been done.

1. Thomas Struth, 'Artist's Statement', quoted in Ann Goldstein, 'Portraits of Self-Reflection', in *Thomas Struth 1977–2002,* New Haven and London: Yale University Press, 2002, p. 166.
2. Siegfried Kracauer, 'Gestalt und Zerfall', in *Aufsätze (1915–1926), Schriften*, Frankfurt: Suhrkamp Verlag, 1990, p. 328 ['Denn das Gestaltete kann nicht gelebt werden, wenn das Zerfallene nicht eingesammelt und mitgenommen wird'.]
3. See Jeff Wall and Fred Douglas. 'Jeff Wall and Fred Douglas: An Interview by Jerry Zaslove and Glen Lowry on *Unfinished Business: Photographing Vancouver Streets 1955–85*', *West Coast Line* 46, no. 39.1, 2005. Jeff Wall (b. 1946) is a Vancouver-based artist of international acclaim. The subject of numerous exhibitions, catalogues and essays, Wall's work has been exhibited extensively in many of the most influential public and private contemporary galleries. In 2002, Wall won the Hasselblad Foundation International Award for Photography. In September–October 2005 his work was exhibited in a solo retrospective at the Schalager, Basel, Switzerland and then at Tate Modern in London. Fred Douglas (1935–2005) is a Vancouver artist whose installations of photographs, tableaux, bookworks and prints have been exhibited and collected at galleries throughout Canada. He taught at the University of Victoria for many years.
4. This point is reinforced in Camiel van Winkel, 'Jeff Wall: Photography as Proof of Photography', in *Jeff Wall Photographs*, ed. Gunilla Knape, Goteborg, Sweden: Hasselblad Centre, 2002, np.; also see Jeff Wall, 'Frames of Reference', *Artforum,* September, 2003.
5. See Jerry Zaslove, 'Faking Nature and Reading History – The Mindfulness Toward Reality in the Dialogical World of Jeff Wall's Pictures', in *Jeff Wall 1990*,

eds Gary Dufour and Jerry Zaslove, Vancouver: Vancouver Art Gallery, 1990, pp. 64–103.

6. Emmanuel Levinas, 'Ethics and the Face', in *Totality and Infinity, An Essay on Exteriority,* trans. Alphonso Lingis, Pittsburgh: Duquesne University Press, 1969, p. 212.

7. See Arnold Hauser, *Mannerism: The Crisis of the Renaissance and the Origin of Modern Art,* trans. Eric Mosbacher, New York: Alfred A. Knopf, 1965.

8. See Alois Riegl, *Historical Grammar of the Visual Arts,* trans. Jacqueline E. Jung, New York: Zone Books, 2004; Herbert Read, *A Concise History of Modern Painting,* London: Thames and Hudson, 1974; Meyer Shapiro, *Theory and Philosophy of Art: Style, Artist, and Society,* New York: George Braziller, 1994; Michael Baxandall, *Patterns of Intention: On the Historical Explanation of Pictures,* New Haven: Yale University Press, 1985; T.J. Clarke, *Farewell To An Idea: Episodes from a History of Modernism,* New Haven: Yale University Press, 1999; Michael Fried, *Art and Objecthood,* Chicago and London: University of Chicago Press, 1998.

9. Martin Pawley, 'Introduction', in *Mies van der Rohe,* ed. Martin Pawley, New York: Simon and Schuster, 1970, p. 15.

10. Theodor W. Adorno and Max Horkheimer, *Dialectic of Enlightenment,* New York: Continuum, 1972, p. 230.

11. Faith Moosang, *First Sons: The Portraits of C. D. Hoy,* Vancouver: Arsenal Pulp Press and Presentation House, 1999; Grace Eiko Thomson (curator), *Sashin: Japanese Canadian Photography to 1942,* Exhibition Catalogue, Burnaby, British Columbia, Japanese Canadian National Museum, 2005.

12. Walter Benjamin, 'The Storyteller', in *Illuminations: Essays and Reflections,* trans. Harry Zohn, ed. Hannah Arendt, New York: Schocken Books, 1969, p. 145.

13. Benjamin, 'The Storyteller', p. 144.

14. On the cultural, ethnic and racial diversity of British Columbia at Confederation, see Adele Perry, *On the Edge of Empire: Gender, Race, and the Making of British Columbia, 1849–1871,* Toronto: University of Toronto Press, 2001; and Wayde Compton, 'Introduction', in *Bluesprint: Black British Columbian Literature and Orature,* ed. Wayde Compton, Vancouver: Arsenal Pulp Press, 2001, pp. 17–40.

15. For a discussion of the history of British Columbia as a 'white man's province' see, among others, Ken Adachi, *The Enemy That Never Was: A History of the Japanese Canadians,* Toronto: McClelland and Stewart, (1976) 1991; Patricia E. Roy, *The Oriental Question: Consolidating a White Man's Province, 1914–1941,* Vancouver: University of British Columbia Press, 2003; Peter Ward, *White Canada Forever, Popular Attitudes and Public Policy Toward Orientals in British Columbia,* 3rd edn, Montreal: McGill-Queen's University Press, 2002.

16. See Kaja Silverman, 'Total Visibility', in *Jeff Wall: Photographs,* English edn, Vienna: Museum Moderner Kunst Stiftung Ludwig, 2003, p. 64.

Bibliography

Acconci, Vito. *Vito Acconci*. Luzern, Switzerland: Kunstmuseum, Luzern, 1978.
———. *Recorded Documentation by Vito Acconci of the Exhibition and Commission for San Diego State University* (audiocassette), San Diego: San Diego State University, 1982.
———. 'Rubbing Piece', in *Art into Theatre: Performance Interviews and Documents*, ed. Nick Kaye, Amsterdam: Routledge/Harwood, 1996, p. 65.
Adachi, Ken. *The Enemy That Never Was: A History of the Japanese Canadians*. Toronto: McClelland and Stewart, (1976) 1991.
Adorno, Theodor W. and Horkheimer, Max. *Dialectic of Enlightenment*. New York: Continuum, 1972.
Ancel, Jean, ed. *Documents Concerning the Fate of Romanian Jewry during the Holocaust*, 12 vols, New York: Yad Vashem Studies, (1986) 1993.
———. 'Vapniarka', in *Encyclopedia of the Holocaust*, vol.4, ed. Israel Gutman,, New York: Macmillan, 1990, p. 1560.
Anderson, Benedict. *Imagined Communities: Reflections on the Origins and Spread of Nationalism*. London: Verso, 1983.
Baer, Ulrich. *Spectral Evidence: The Photography of Trauma*. Cambridge, Massachusetts and London: MIT Press, 2002.
Bal, Mieke. 'Introduction', in *Acts of Memory: Cultural Recall in the Present*, eds Mieke Bal, Jonathan Crewe and Leo Spitzer, Hanover, New Hampshire: Dartmouth College Press, 1997, pp. vii–xvii.
Barnes, Julian. *Cross Channel*, London: Jonathan Cape, 1996.
Barringer, im. 'Sonic Spectacles', in *Sensible Objects*, eds Elizabeth Edwards, Chris Gosden and Ruth B. Phillips, Oxford: Berg, 2006.
Barthes, Roland. *Camera Lucida: Reflections on Photography*, trans. Richard Howard. New York: Hill and Wang, 1972.
———. *Image Music Text*, trans. Stephen Heath. London: Flamingo, 1977.
Bassett, Lawrence J. and Pelz, Stephen E. 'The Failed Search for Victory', in Robert J. McMahon, *Major Problems in the History of the Vietnam War*, 2nd edn. Lexington, Massachusetts: DC Heath and Co., 1995, pp. 176–195.
Bataille, Georges. 'Museum', in *Rethinking Architecture: A Reader in Cultural Theory*, ed. Neil Leach, London: Routledge, 1997, pp. 22–24.
Baucom, Ian. *Out of Place: Englishness, Empire and the Locations of Identity*. Princeton, New Jersey: Princeton University Press, 1999.
Baxandall, Michael. *Patterns of Intention: On the Historical Explanation of Pictures*. New Haven: Yale University Press, 1985.
Beaird Meyers, Kate. 'Fragmentary Mosaics: Vietnam War "Histories" and Postmodern Epistemology', *Genre* 21 (Winter 1988), pp. 535–552.
Becker, Karin. 'Picturing Our Past: An Archive Constructs a National Culture', *Journal of American Folklore* 105 (1992), pp. 3–18.
Benditer, Ihiel. 'Vapniarca', in *Shattered! 50 Years of Silence: History and Voices of the Tragedy in Romania and Transnistria*, ed. Felicia Carmelly, Toronto, Ontario: Abbeyfield Publishers, 1997, pp. 181–202.

Benjamin, Walter. 'On Some Motifs in Baudelaire', in *Illuminations: Essays and Reflections*, trans. Harry Zohn, ed. Hannah Arendt, New York: Schocken, 1968, pp. 155–194.

———. 'The Storyteller', in *Illuminations: Essays and Reflections*, trans. Harry Zohn, ed. Hannah Arendt, New York: Schocken Books, 1969, pp. 83–109.

———. 'Theses on the Philosophy of History', in *Illuminations: Essays and Reflections*, trans. Harry Zohn, ed. Hannah Arendt, New York: Schocken Books, 1969, pp. 253–264.

———. 'The Work of Art in the Age of Mechanical Reproduction', in *Illuminations: Essays and Reflections*, trans. Harry Zohn, ed. Hannah Arendt, New York: Schocken Books, 1969, pp. 217–251.

———. 'A Short History of Photography', *Screen* 13, trans. Stanley Mitchell (Spring 1972), pp. 5–26.

———. *One Way Street and Other Writings*. London: Verso, 1985.

———. 'Little History of Photography', in *Selected Writings: Walter Benjamin,* vol. 2, eds Marcus Bullock and Michael W. Jennings, Cambridge, Massachusetts: Belknap, 1996, pp. 507–530.

Bennett, Alan. 'Uncle Clarence', in *Writing Home*, London: Faber (1986) 1994, pp. 22–29.

———. *The Lady in the Van,* London: BBC Audiobooks, 1994.

Bentley, Paul. *The Poetry of Ted Hughes: Language, Illusion and Beyond*. London and New York: Longman, 1998.

Berger, John. *Ways of Seeing*. London: BBC and Penguin, 1972.

———. 'Drawn to That Moment', in *John Berger: Selected Essays*, ed. Geoff Dyer London: Bloomsbury (1976) 2001, pp. 419–423.

———. *About Looking.* New York: Pantheon Books, 1980.

——— and Mohr, Jean. *Another Way of Telling*. London: Writers and Readers Publishing Cooperative Society Ltd, 1982.

Bilton, Michael and Sim, Kevin. *Four Hours in My Lai: A War Crime and its Aftermath*. London: Viking, 1992.

Blanchard, Phyllis. *The Adolescent Girl*, revised edn, New York: Dodd, Mead and Company, 1924.

Boerdam, Jaap and Oosterbaan Martinius, Warna. 'Family Photographs – A Sociological Approach', *The Netherlands Journal of Sociology* 162 (1980), pp. 95–119.

Bourdieu, Pierre. *Photography: A Middle-brow Art*, trans. Shaun Whiteside, Stanford: Stanford University Press, 1990.

Bowler, Peter J. *The Eclipse of Darwinism: Anti-Darwinian Evolution Theories in the Decades Around 1900*. Baltimore: Johns Hopkins University Press, 1983.

———. *Biology and Social Thought 1850–1914*. University of California Berkeley: Office for History of Science and Technology, 1993.

Boyer, Christine. 'La Mission Héliographique: Architectural Photography, Collective Memory and Patrimony in France, 1851', in *Picturing Place: Photography and the Geographical Imagination*, eds Joan M. Schwartz and James Ryan, London: I.B. Tauris, 2003, pp. 21–54.

Boyes, Georgina. *The Imagined Village: Culture, Ideology and the English Folklore Revival*. Manchester: Manchester University Press, 1993.

Braestrup, Peter. *Big Story: How the American Press and Television Reported and Interpreted the Crisis of Tet 1968 in Vietnam and Washington*, abridged edn, New Haven and London: Yale University Press, 1983.

Briggs, Asa and Burke, Peter. *A Social History of the Media: From Gutenberg to the Internet*. Cambridge, Massachusetts: Polity Press, 2002.

Brooks, Chris and Saint, Andrew, eds. *Victorian Church: Architecture and Society*. Manchester: Manchester University Press, 1995

Buren, Daniel. *Five Texts*. London: John Weber Gallery and John Wendle Gallery, 1973.

———. *Buren: Photo-Souvenirs 1965–1988*. Turin: Umberto Allemandi & Co., 1988.

———. *The Square of the Flags*. Helsinki: Helsinki Museum of Contemporary Art, 1991.

Burgin, Victor. *Indifferent Spaces: Place and Memory in Visual Culture*. Berkeley: University of California Press, 1995.

Burrows, Larry. 'A Degree of Disillusion', *Life* (19 September 1969).

———. *Larry Burrows: Compassionate Photographer*. New York: Time/Life, 1972.

———. *Vietnam*, London: Jonathan Cape, 2002.

Burton, Cosmo. 'The Whole Duty of a Photographer', *British Journal of Photography* 18 (October 1889), p. 682.

Butler, Samuel. *Life and Habit*. London: A.C. Fifield, 1910 [first published in 1877; dated 1878].

———. *The Note-Books of Samuel Butler*, ed. Henry Festing Jones, London: Jonathan Cape, 1921.

Campbell, Duncan and Goldenberg, Suzanne. 'US Tortured Afghanistan Detainees', *The Guardian* (23 June 2004), p. 1.

Cannadine, David. *Ornamentalism: How the British Saw their Empire*. London: Allen Lane, 2001.

Carlebach, Michael. 'Michael Carlebach', in *From Camelot to Kent State*, eds Joan Morrison and Robert K. Morrison. New York: Times Books, 1987, pp. 96–97.

Carmelly, Felicia Steigman, ed. *Shattered! 50 Years of Silence: History and Voices of the Tragedy in Romania and Transnistria*. Scarborough, Ontario, 1997.

Castle, Terry. 'Courage, mon amie', *London Review of Books* 24, no. 7 (4 April 2002), pp. 3–11.

Chadwick, Mary. *Adolescent Girlhood*. New York: The John Day Company, 1933.

Chalfen, Richard. *Snapshot Versions of Life*. Bowling Green, Ohio: Bowling Green State University Popular Press, 1987.

———. *Turning Leaves: The Photograph Collections of Two Japanese American Families*. Albuquerque: University of New Mexico Press, 1991.

Chanoff, David and Van Toai, Doan. *Portrait of the Enemy* [republished as *Vietnam: A Portrait of Its People at War*]. New York: Random House, 1986.

Chong, Denise. *The Girl in the Picture: The Remarkable Story of Vietnam's Most Famous Casualty*. London: Simon and Schuster, 1999.

Clark, Janet. *Greg Staats: Memories of a Collective Reality – Sour Springs*. Thunder Bay, Ontario: Thunder Bay Art Gallery, 1995.

Clark, Steve. '"The Lost Displays": Larkin and Empire', in *New Larkins for Old: Critical Essays*, ed. James Booth, Houndmills: Macmillan, 2000, pp. 166–181.

Clarke, T.J. *Farewell To An Idea: Episodes from a History of Modernism*. New Haven: Yale University Press, 1999.

Clifford, James. 'On Ethnographic Allegory', in *Writing Culture: The Poetics and Politics of Ethnography*, eds James Clifford and George E. Marcus, Berkeley: University of California Press, 1986, pp. 98–122.

Colley, Linda. *The Britons: Forging the Nation 1707–1837*. London: Pimlico, 1994.

Colls, Robert. *The Identity of the English*. Oxford: Oxford University Press, 2002.

Compton, Wayde. 'Introduction', in *Bluesprint: Black British Columbian Literature and Orature*, Vancouver, British Columbia: Arsenal Pulp Press, 2001, pp. 17–40.

Connerton, Paul. *How Societies Remember*. Cambridge: Cambridge University Press, 1989.

Cora, Bruno. 'Michelangelo Pistoletto: From the Mirror Paintings to Progetto Art, the Artist as Sponsor of Thought', in *Pistoletto: Le Porte di Palazzo Fabroni*, Michelangelo Pistoletto, Milan: Charta, 1995, pp. 41–55.

Corcoran, Neil. *English Poetry Since 1940*. London and New York: Longman, 1993.

Crane, Susan A., ed. *Museums and Memory*. Stanford: Stanford University Press, 2000.

Crary, Jonathan. *Techniques of the Observer: On Vision and Modernity in the Nineteenth Century*. Cambridge, MA: MIT Press, 1990.

Crimp, Douglas. *On the Museum's Ruins*. London: MIT Press, 1993.

Crosby, Marcia. 'Construction of the Imaginary Indian', in *The Vancouver Anthology: The Institutional Politics of Art*, ed. Stan Douglas, Vancouver: Talon Books, 1991, pp. 267–294.

Culbert, David. 'Television's Vietnam and Historical Revisionism in the United States', *Historical Journal of Film, Radio and Television* 8, no. 3 (1988), pp. 257–263.

de Certeau, Michel. *The Practice of Everyday Life*. Berkeley: University of California Press, 1984.

Desmond, Adrian. *Huxley: Evolution's High Priest*. London: Michael Joseph, 1997.

Dugain, Mark. *The Officers' Ward*, trans. Howard Curtis, London: Phoenix, 2001.

Dyer, Geoff. *Ways of Telling: The Work of John Berger*. London: Pluto, 1986.

———. *The Missing of the Somme*. London: Phoenix, (1994) 2001.

Editors of Phaidon Press. *The Photography Book*. London: Phaidon, 2000.

Edwards, Elizabeth. 'Beyond the Boundary: A Consideration of the Expressive in Photography and Anthropology', in *Rethinking Visual Anthropology*, eds M. Banks and H. Morphy, New Haven, Connecticut: Yale University Press, 1997, pp. 53–80.

———. *Raw Histories: Photographs, Anthropology and Museums*. Oxford: Berg, 2001.

——— and Hart, Janice, eds. *Photographs, Objects, Histories: On the Materiality of Images*. London: Routledge, 2004.

———, Gosden, Chris and Phillips, Ruth B., eds. *Sensible Objects*. Oxford: Berg, 2006.

Evans, Jessica and Hall, Stuart, eds. *Visual Culture: The Reader*. London: Sage, 1999.

Faas, Horst and Page, Tim. *Requiem: By the Photographers Who Died in Vietnam and Indochina*. London: Jonathan Cape, 1997.

Felman, Shoshana. 'Benjamin's Silence', *Critical Inquiry* 25, no. 2 (Winter 1999), pp. 200–34.

Fentress, James and Wickham, Chris. *Social Memory*. Oxford: Blackwell, 1992.

Finnegan, Ruth. *Oral Traditions and the Verbal Arts: A Guide to Research Practices*. London and New York: Routledge, 1992.

Fischer, Julius. *Transnistria: The Forgotten Cemetery*. New York: T. Yoseloff, 1969.

Fisher, Julene. *Images of War*. Boston: The Boston Publishing Company, 1986.

Foster, Hal. *The Return of the Real*. Cambridge, Massachusetts and London: MIT Press, 2001.

Foucault, Michel. *Power/Knowledge: Selected Interviews and Other Writings 1972–1977*, trans. Colin Gordon, New York: Pantheon Books, 1980.

Fournier, Suzanne and Crey, Ernie. *Stolen From Our Embrace: The Abduction of First Nations Children and the Restoration of Aboriginal Communities*. Vancouver, British Columbia: Douglas and McIntyre, 1997.

Franklin, H. Bruce. *M.I.A. or Mythmaking in America: How and Why Belief in Live POWs Has Possessed a Nation*. New Brunswick, New Jersey: Rutgers University Press, 1993.

Fried, Michael. 'Art and Objecthood', in *Minimal Art: A Critical Anthology*, ed. Gregory Battcock, New York: E.P. Dutton, 1968, pp. 117–147.

————. *Art and Objecthood*. Chicago and London: University of Chicago Press, 1998.

Friedrich, Ernst. *War Against War!*, ed. Douglas Kellner. London: Journeyman Press (1924) 1987.

Fussell, Paul. *The Great War and Modern Memory*. London: Oxford University Press (1975) 1977.

Gall, Matei. *Finsternis: Durch Gefängnisse, KZ Wapniarka, Massaker und Kommunismus: Ein Lebenslauf in Rumänien, 1920–1990*. Konstanz: Hartung-Gorre Verlag, 1999.

Geulen, Eva. 'Under Construction: Walter Benjamin's "The Work of Art in the Age of Mechanical Reproduction"', in *Benjamin's Ghosts: Interventions in Contemporary Literary and Cultural Theory*, trans. Eric Baker, ed. Gerhard Richter, Stanford: Stanford University Press, 2002. pp. 121–41.

Gibson, James William. *The Perfect War*. New York: Vintage Books, 1988.

Gillis, John R. *Commemorations: The Politics of National Identity*. Princeton: Princeton University Press, 1994.

Goldberg, Vicki. *The Power of Photography: How Photographs Changed Our Lives*. New York, London and Paris: Abbeville Press, 1991.

Gomme, George L. *Ethnology in Folklore*. London: Modern Science Library, 1892.

Goody, Jack. *The Interface Between the Written and the Oral*. Cambridge: Cambridge University Press, 1987.

Government of Canada, 'Report of the Royal Commission on Aboriginal Peoples', http://www.ainc-inac.gc.ca/ch/rcap/sg/sgm9_e.html, accessed 17 October, 2004.

Gower, H.D., Jast, L. Stanley and Topley, W.W. *The Camera as Historian*. London: Sampson, Lowe and Marston, 1916.

Green, David. 'Classified Subjects: Photography and Anthropology: The Technology of Power', *Ten 8* 14 (1984), pp. 30–37.

Greenhaw, Wayne. *The Making of a Hero: The Story of Lieutenant William Calley Jr.* Louisville, Kentucky: Touchstone Publishing Company, 1971.

Greenhill, Pauline. *So We Can Remember: Showing Family Photographs*. CCFCS Mercury Series no. 36. Ottawa, Ontario: National Museum of Man, 1981.

Grosz, Elizabeth. *Space, Time and Perversion*, London: Routledge, 1995.

Haddon, Alfred C. 'The Saving of Vanishing Knowledge', *Nature* 55 (1897), pp. 305–306.

Halberstam, David. *The Making of a Quagmire*. New York: Ballantine Books, 1965.

Halbwachs, Maurice. *The Collective Memory*, trans. Francis J. Ditter, Jr and Vida Yazdi Ditter, New York: Harper and Row, 1980.

———. *On Collective Memory*. Chicago: University of Chicago Press, 1992.

Hall, G. Stanley. *Adolescence: Its Psychology and its Relations to Physiology, Anthropology, Sociology, Sex, Crime, Religion and Education*, vols 1 and 2, New York: D. Appleton and Co, 1904–1905.

Harrison, W. Jerome. 'The Desirability of Promoting County Photographic Surveys', *British Association for the Advancement of Science: Annual Reports*, 1906, pp. 58–67.

Hartman, Geoffrey. *The Longest Shadow: In the Aftermath of the Holocaust*. Bloomington: Indiana University Press, 1996.

Haseler, Stephen. *The English Tribe: Identity, Nation and Europe*. London: Macmillan, 1996.

Hauser, Arnold. *Mannerism: The Crisis of the Renaissance and the Origin of Modern Art*, trans. Eric Mosbacher. New York: Alfred A. Knopf, 1965.

Heiss, Alanna, ed. *Dennis Oppenheim: Selected Works 1967–90*. New York: Harry N. Abrams Inc. and the Institute for Contemporary Art, 1992.

Hendrickson, Paul. *The Living and the Dead*. London: Papermac, 1996.

Hersh, Seymour M. *My Lai 4: A Report on the Massacre and Its Aftermath*. New York: Random House, 1970.

———. 'Torture at Abu Ghraib', *The New Yorker* (10 May 2004), retrieved 21 June 2004, http://newyorker.com/printable/?fact/040510fa_fact.

———. 'Chain of Command', *The New Yorker*, (17 May 2004), retrieved 21 June 2004, http://newyorker.com/printable/?fact/040517fa_fact2.

Hight, Eleanor and Sampson, Gary. *Colonialist Photography: Imagining Race and Place*. London: Routledge, 2002.

Higonnet, Anne. 'Secluded Vision: Images of Feminine Experience in Nineteenth-Century Europe', *Radical History Review* 38 (1987), pp. 16–36.

Hirsch, Julia. *Family Photographs: Content, Meaning and Effect*. New York: Oxford University Press, 1981.

Hirsch, Marianne. 'Family Pictures: *Maus*, Mourning, and PostMemory', *Discourse* 15, no. 2 (Winter 1992–1993), pp. 3–29.

———. 'Masking the Subject: Practicing Theory', in *The Point of Theory: Practices of Cultural Analyses*, ed. Mieke Bal and Inge Boer, Amsterdam: Amsterdam University Press, 1994, pp. 109–124.

———. *Family Frames: Photography, Narrative, and Postmemory*. Cambridge, Massachusetts and London: Harvard University Press, 1997.

———. ed. *The Familial Gaze*. Hanover and London: University Press of New England, 1999.

———. 'Surviving Images: Holocaust Photographs and the Work of Postmemory', in *Visual Culture and the Holocaust*, ed. Barbie Zelizer, New Brunswick, New Jersey: Rutgers University Press, 2001, pp. 215–46.

Hobsbawm, Eric. *Age of Extremes: The Short Twentieth Century, 1914–1991*. London: Abacus, 1995.

——— and Ranger, Terence, eds. *The Invention of Tradition*. Cambridge: Cambridge University Press, 1983.

Howells, Richard. *Visual Culture*. Oxford: Blackwell, 2003.

Hoyt, David. 'The Reanimation of the Primitive: Fin de Siècle Ethnographic Discourse in Western Europe', *History of Science* 39, no. 3 (2001), pp. 331–352.

Hughes, Ted. 'Six Young Men' in *The Hawk in the Rain*, New York: Harper and Brothers, 1957, pp. 47–48.

Ioanid, Radu. *The Holocaust in Romania*. Chicago: Ivan Dee, 2000.

Jagendorf, Siegfried. *Jagendorf's Foundry: A Memoir of the Romanian Holocaust, 1941–1944*. New York: Harper Collins, 1991.

James, Peter. 'Evolution of the Photographic Record and Survey Movement, c.1890–1910', *History of Photography* 12, no. 3 (1988), pp. 205–218.

Jencks, Chris, ed. *Visual Culture*. London: Routledge, 1995.

Joyce, Patrick. *Visions of the People: Industrial England and the Question of Class, 1848–1914*. Cambridge: Cambridge University Press, 1991.

———. *Democratic Subjects: The Self and the Social in Nineteenth-Century England*. Cambridge: Cambridge University Press, 1994.

Karnow, Stanley. *Vietnam: A History*. New York: Penguin, 1997.

Kaufman, James C. A. 'Photographs and History. Flexible Illustrations', in *Reading Into Photography: Selected Essays, 1959–1980*, eds Thomas F. Barrow, Shelley Armitage and William E. Tydeman, Albuquerque: University of New Mexico Press, 1982, pp. 193–199.

Kaye, Nick, ed. *Art into Theatre: Performance Interviews and Documents*. Amsterdam: Routledge/Harwood, 1996.

———. *Site-Specific Art: Performance, Place and Documentation*. London and New York: Routledge, 2000.

Kennedy, Senator Robert F. 'Speech of February 8, 1968', in *Major Problems in the History of the Vietnam War*, 2nd edn, ed. Robert J. McMahon, Lexington, Massachusetts and Toronto: D.C. Heath and Co, 1995, pp. 341–344.

Kessler, Arthur. 'Lathyrismus', *Psychiatrie und Neurologie* 112, no. 6 (1947), pp. 345–376.

King, Graham. *Say 'Cheese!' Looking at Snapshots in a New Way*. New York: Dodd, Mead and Co., 1984.

Kirshner, Judith Russi, ed. *Vito Acconci – A Retrospective: 1969 to 1980*. Chicago: Museum of Contemporary Art, 1980.

Kiyooka, Roy. *Mothertalk: Life Stories of Mary Kiyoshi Kiyooka*, ed. Daphne Marlatt, Edmonton, Alberta: NeWest Publishers, 1997.

Knight, Rolf and Koizumi, Maya. *A Man Of Our Times: The Life-History of a Japanese-Canadian Fisherman*. Vancouver, British Columbia: New Star Books, 1977.

Kobayashi, Audrey. 'The Uprooting of Japanese Canadians After 1941', *Tribune* 5, no. 1 (1987), pp. 28–35.

Korte, Barbara. 'The Grandfathers' War: Re-imagining World War I in British Novels and Films of the 1990s', in *Retrovisions*, eds Deborah Cartmell, I.Q. Hunter and Imelda Whelehan, London: Pluto, 2001, pp. 120–134.

Kotkin, Amy. 'The Family Photo Album as a Form of Folklore', *Exposure* 16, no. 1 (March 1978), pp. 4–8.

Kracauer, Siegfried. *Theory of Film*. Oxford: Oxford University Press, 1960.

———. 'Gestalt und Zerfall', in *Aufsätze (1915–1926), Schriften*, Frankfurt: Suhrkamp Verlag, 1990, pp. 324–329.

———. *The Mass Ornament: Weimer Essays*, trans. and ed. Thomas Y. Levin, Cambridge and London: Harvard University Press, 1995.

Krahé, Peter. 'Poetical Reflections: The 1914–1918 War Seen from Hindsight', *AAA – Arbeiten aus Anglistik und Amerikanistik* 26, no. 1 (2001), pp. 27–38.

Kuhn, Annette. *Family Secrets: Acts of Memory and Imagination*. London and New York: Verso, (1995) 2nd edn 2002.

———. *An Everyday Magic: Cinema and Cultural Memory*. London: I.B. Tauris, 2002.

Kuklick, Henrika. *The Savage Within: The Social History of British Anthropology*. Cambridge: Cambridge University Press, 1991.

Kumar, Krishan. *The Making of English National Identity*. Cambridge: Cambridge University Press, 2003.

Lalvani, Suren. *Photography, Vision, and the Production of Modern Bodies*. Albany: State University of New York Press, 1996.

Lamoureux, Johanne. 'L'Album ou La Photographie Corrigée par son Lieu', *Trois* 6, nos 2–3, (Hiver/Printemps 1991) [Montréal: Dazibao, 1991. *Corriger les Lieux après la Photographie de Voyage*, exh. cat.], pp. 185–191.

Langer, Lawrence. *Holocaust Testimonials: The Ruins of Memory*. London: Yale University Press, 1991.

Langford, Martha. *Suspended Conversations: The Afterlife of Memory in Photographic Albums*. Montreal, Quebec: McGill-Queen's University Press, 2001.

Lanzmann, Claude. *Shoah: An Oral History of the Holocaust: The Complete Text of the Film*, 1st U.S. edn. New York: Pantheon Books, 1985.

Larkin, Philip. 'MCMXIV', in *The Whitsun Weddings*, London: Faber (1964) 1990, p. 28.

———. 'The Living Poet', in *Further Requirements*, ed. Anthony Thwaite, London: Faber (1964) 2001, pp. 79–91.

———. 'Down Among the Dead Men', in *Further Requirements*, ed. Anthony Thwaite, London: Faber, (1959) 2001, pp. 215–221.

Lefebvre, Henri. *The Production of Space*. Oxford: Blackwell Publishers, 1991.

Levinas, Emanuel. *Totality and Infinity, An Essay on Exteriority*, trans. Alphonso Lingis. Pittsburgh: Duquesne University Press, 1969.

Lewinski, Jorge. *The Camera at War: A History of War Photography from 1848 to the Present Day*. New York: Simon and Schuster, 1978.

Link, Jürgen. 'Between Goethe's and Spielberg's "Aura": On the Utility of a Nonoperational Concept', in *Mapping Benjamin: The Work of Art in the Digital Age*, eds Hans Ulrich Gumbrecht and Michael Marrinan. Stanford: Stanford University Press, 2003, pp. 98–108.

Lippard, Lucy R. *Six Years: The Dematerialisation of the Art Object from 1966 to 1972*, reprint edn Berkeley: University of California Press, (1973) 1997.

Liss, Andrea. *Trespassing Through Shadows: Memory, Photography, and the Holocaust*. Minneapolis and London: Minnesota University Press, 1998.

Lorés, Maite. 'The Streets Were Dark With Something More Than Night: Film Noir Elements in the Work of Willie Doherty', in *Willie Doherty: Dark Stains*, ed. Maite Lorés and Martin McLoone, San Sebastian: Koldo Mitxelena Kulturunea, 1999, pp. 110–117.

Lyotard, Jean-François. *Peregrinations: Law, Form, Event*. New York: Columbia University Press, 1988.

————. *Heidegger and 'the Jews'*. Minneapolis: University of Minnesota Press, 1990.

————. *The Inhuman: Reflections on Time*. Stanford: Stanford University Press, 1991.

————. *The Postmodern Explained to Children: Correspondence 1982–1985*. London: Turnaround, 1992.

MacDonagh, Michael. 'Introduction', in *Sir Benjamin Stone's Pictures: Records of National Life and History*, 2 vols, London: Cassell, 1906, pp. v–viii.

MacDonald, Robert, ed. *The Language of Empire: Myths and Metaphors of Popular Colonialism*. Manchester: Manchester University Press, 1994.

MacPherson, Myra. *Long Time Passing: Vietnam and the Haunted Generation*. New York: Signet Books, 1985.

Madox Ford, Ford. *The Spirit of the People*. London: Alston Rivers, 1907.

Malraux, André. *Museum Without Walls*, trans. Stuart Guilbert and Francis Price, London: Secker and Warburg, 1967.

Maxwell, Anne. *Colonial Photography and Exhibitions: Representations of the 'Native' and the Making of European Identities*. London: Leicester University Press, 1999.

McAllister, Kirsten Emiko. 'Narrating Japanese Canadians In and Out of the Nation: A Critique of Realist Forms of Representation', *Canadian Journal of Communication* 24 (Winter 1999), pp. 76–103.

————. 'Captivating Debris: Unearthing a World War Two Internment Camp', in eds Jackie Stacey and Sara Ahmed, *Cultural Values: Special Issue on Testimonial Culture* 10, no. 1 (2001), pp. 97–114.

McCoy, Liza. 'Looking At Wedding Pictures', in *The Zone of Conventional Practice and Other Real Stories*, ed. Cheryl Simon, Montréal, Quebec: Optica, 1989, pp. 69–76.

McEvilley, Thomas. 'The Rightness of Wrongness: Modernism and Its Alter-Ego in the Work of Dennis Oppenheim', in *Dennis Oppenheim: Selected Works 1967–90*, ed. Alanna Heiss, New York: Institute for Contemporary Art and Harry N. Abrams, 1992, pp. 23–46.

McLean, Kathleen, ed. *No Place Like Home*. Minneapolis: Walker Arts Centre, 1997.

McLoone, Martin. 'Caliban and Other Primitives: British Images of the Irish', in *Willie Doherty: Dark Stains,* ed. Maite Lorés and Martin McLoone, San Sebastian: Koldo Mitxelena Kulturunea, 1999. pp. 117–121.

McMaster, Gerald. 'Towards an Aboriginal Art History', in *Native American Art in the Twentieth Century,* ed. Jackson W. Rushing, London: Routledge, 1999, pp. 81–96.

McQuire, Steve. *Visions of Modernity: Representation, Memory, Time and Space*. London: Sage, 1998.

Metz, Christian. 'Photography and Fetish', in *The Critical Image*, ed. Carol Squiers, Seattle, Washington: Bay Press, 1990, pp. 155–164.

Miki, Roy. *Broken Entries: Race, Subjectivity, Writing*. Toronto, Ontario: The Mercury Press, 1998.

————, ed. *This is My Own: Letters to Wes and Other Writings on Japanese Canadians, 1941–1948*. Vancouver, British Columbia: Talonbooks, 1985.

———— and Kobayashi, Cassandra. *Justice in Our Time: The Japanese Canadian Redress Settlement*. Vancouver, British Columbia: Talonbooks, 1991.

Mirzoeff, Nicholas, ed. *The Visual Culture Reader*. London: Routledge, 1998.

Mitchell, W. J. T. *Picture Theory*. Chicago and London: University of Chicago Press, 1994.

Moeller, Susan. *Shooting War: Photography and the American Experience of Combat.* New York: Basic Books, 1989.

Moonsang, Faith. *First Son: Portraits by C.D. Hoy.* Vancouver, British Columbia: Arsenal Pulp Press, 1999.

Morrison, Toni. *Beloved.* New York: Knopf, 1987.

Motz, Marilyn F. 'Visual Autobiography: Photograph Albums of Turn-of-the-Century Midwestern Women', *American Quarterly* 41, no. 1 (March 1989), pp. 63–92.

Moure, Gloria, ed. *Vito Acconci: Writings, Works, Projects.* Barcelona: Ediciones Poligrafa, 2001.

Moyes, Norman B. *Battle Eye: A History of Combat Photography.* New York: MetroBooks, 1996.

National Association of Japanese Canadians. *Democracy Betrayed: The Case for Redress.* Winnipeg: National Association of Japanese Canadians, 1985.

Nemser, Cindy. 'An Interview with Vito Acconci', *Arts Magazine* (March 1971), pp. 20–23.

Nora, Pierre. 'Between Memory and History: Les Lieux de Memoire', *Representations* 26 (1989), pp. 7–25.

Ohrn, Karin B. 'The Photoflow of Family Life: A Family's Photograph Collection', *Folklore Forum* 13 (1975), pp. 27–36.

Oikawa, Mona. '"Driven to Scatter Far and Wide": The Forced Resettlement of Japanese Canadians to Southern Ontario, 1944–1949', unpublished MA thesis, University of Toronto, 1986.

———. 'Cartographies of Violence: Women, Memory, and the Subject(s) of the "Internment"', unpublished Ph.D. thesis, University of Toronto, 1999.

———. 'Cartographies of Violence: Women, Memory, and the Subjects of "Internment"', *Canadian Journal of Law and Society* 15, no. 2 (2000), pp. 39–69.

Olson, James S. and Roberts, Randy. *My Lai: A Brief History with Documents.* Boston and New York: Bedford Books, 1998.

Ong, Walter. *Orality and Literacy: The Technologizing of the Word.* London and New York: Methuen, 1982.

Opton Jr, Edward M. and Duckles, Robert. *My Lai: It Never Happened and Besides, They Deserved It.* Berkeley: Wright Institute, 1970.

———. 'It Didn't Happen and Besides, They Deserved It', in *Crimes of War: A Legal, Social, and Psychological Inquiry into the Responsibility of Leader, Citizens, and Soldiers for Criminal Acts in War*, eds Richard A. Falk, Gabriel Kolko and Robert Jay Lifton, New York: Vintage Books, 1971, pp. 441–444.

Patt, Lise, ed. *Benjamin's Blind Spot: Walter Benjamin and the Premature Death of Aura.* Topanga, California: Institute of Cultural Inquiry, 2001.

Pawley, Martin, ed. 'Introduction', in *Mies van der Rohe.* New York: Simon and Schuster, 1970, pp. 7–21.

Perry, Adele. *On the Edge of Empire: Gender, Race, and the Making of British Columbia, 1849–1871.* Toronto, Ontario: University of Toronto Press, 2001.

Piper, C.Welbourne. 'A Photographic Architectural Survey', *Amateur Photographer* 36 (10 July 1902), pp. 32–33.

Pistoletto, Michelangelo. 'LE STANZE (THE ROOMS)' in *Site-Specific Art: Performance, Place and Documentation*, ed. Nick Kaye, London and New York: Routledge, 2000, pp. 59–89.

Presentation House Gallery, 'Past Exhibits 2003', accessed10 December 2004, http://www.presentationhousegall.com/past2003.html

Radstone, Susannah, ed. *Memory and Methodology*. Oxford: Berg, 2000.

———— and Hodgkin, Kate, eds. *Contested Pasts: The Politics of Memory*. London: Routledge, 2003.

Read, Herbert. *A Concise History of Modern Painting*. London: Thames and Hudson, 1974.

Readings, Bill. *Introducing Lyotard: Art and Politics*. London: Routledge, 1991.

Rich, Frank. 'It Was the Porn that Made Them Do It', *The New York Times* (30 May 2004), Section 2, p. 1.

Riegl, Alois. *Historical Grammar of the Visual Arts*, trans. Jacqueline E. Jung, New York: Zone Books, 2004.

Rostow, W. W. 'Memorandum for President Johnson, 30 November 1967', p. 8, The Virtual Vietnam Archive, http://archive.vietnam.ttu.edu/star/images/001/0010225002.pdf.

Roy, Patricia E. *The Oriental Question: Consolidating a White Man's Province, 1914–1941*. Vancouver, British Columbia: University of British Columbia Press, 2003.

Ruskin, John. *The Seven Lamps of Architecture*, (1880) 2nd edn reprint, New York: Dover 1989.

Saint, Andrew. 'Anglican Church Building in London, 1790–1890: From State Subsidy to Free Market', in *Victorian Church: Architecture and Society*, eds Chris Brooks and Andrew Saint, Manchester: Manchester University Press, 1995, pp. 30–50.

Samuel, Raphael. *Theatres of Memory: Volume 1: Past and Present in Contemporary Culture*. London: Verso, 1994.

Santoli, Al. *To Bear Any Burden: The Vietnam War and Its Aftermath in the Words of Americans and Southeast Asians*. New York: Ballantine Books, 1985.

Schell, Jonathan. *The Real War: The Classic Reporting on the Vietnam War*. New York: Pantheon Books, 1987.

Schwartz, Joan M. and Ryan, James R, eds. *Picturing Place: Photography and the Geographical Imagination*. London: I.B. Tauris, 2003.

Sekula, Allan. 'Reading an Archive: Photography Between Labour and Capital', in *Visual Culture: The Reader*, eds Jessica Evans and Stuart Hall, London: Sage, 1999, pp. 181–192.

Shachan, Avigdor. *Burning Ice: The Ghettos of Transnistria*, trans. S. Himelstein, Boulder: East European Monographs, 1996.

Shapiro, Meyer. *Theory and Philosophy of Art: Style, Artist, and Society*. New York: George Braziller, 1994.

Sharp, Willoughby. 'Dennis Oppenheim Interviewed by Willoughby Sharp', *Studio International* 182, no. 938 (1971), pp. 186–193.

Silverman, Kaja. *The Subject of Semiotics*. New York: Oxford University Press, 1983.

————. 'Total Visibility', in *Jeff Wall: Photographs*, English edn, Vienna: Museum Moderner Kunst Stiftung Ludwig, 2003, pp. 60–109.

Simon, Nathan. *'Auf allen Vieren werdet ihr hinauskriechen': ein Zeugenbericht auf dem KZ Wapniarka*. Berlin: Institut Kirche und Judentum, 1974.

Sontag, Susan. *On Photography*. New York: Farrar, Straus and Giroux, 1978.

————. *Illness as Metaphor*. New York: Vintage Books, 1979.

————. *Regarding the Pain of Others*. New York: Farrar, Straus and Giroux, 2003.

————. 'What Have We Done?', *The Guardian* G2 (24 May 2004), pp. 2–5.

Spence, Jo and Holland, Patricia, eds. *Family Snaps: The Meanings of Domestic Photography* London: Virago Press, 1991.

Spiegelman, Art. *Maus: A Survivor's Tale, II, And Here My Troubles Began*. New York: Pantheon Books, 1973.

————. *Maus: A Survivor's Tale, I, My Father Bleeds History*. New York: Pantheon Books, 1986.

Spitzer, Leo. *Hotel Bolivia: The Culture of Memory in a Refuge from Nazism*. New York: Hill and Wang, 1998.

Stacey, Jackie. *Star Gazing: Hollywood Cinema and Female Spectatorship*. London: Routledge, 1994.

Steedman, Carolyn. *Landscape for a Good Woman: A Story of Two Lives*. London: Virago Press, 1986.

Stocking, George. *After Tylor: British Social Anthropology, 1888–1895*. Madison: University of Wisconsin Press, 1995.

Stotesbury, John A. 'Martha Langford, Suspended Conversations: The Afterlife of Memory in Photographic Albums', *Biography: An Interdisciplinary Quarterly* 26, no. 1 (Winter 2003), pp. 143–147.

Struth, Thomas. *Thomas Struth 1977–2002,* New Haven and London: Yale University Press, 2002.

Sunahara, Anne. *The Politics of Racism: The Uprooting of Japanese Canadians During the Second World War*. Toronto, Ontario: James Lorimer, 1981.

Swinden, Patrick. 'Larkin and the Exemplary Owen', *Essays in Criticism* 44 (October 1994), pp. 315–332.

Tagg, John. *The Burden of Representation*. Minneapolis: University of Minnesota Press, 1993.

————. 'The Pencil of History', in *Fugitive Images: From Photography to Video*, ed. Peter Petro, Bloomington: Indiana University Press, 1995, pp. 285–303.

Taylor, John. *A Dream of England: Landscape Photography and the Tourist Imagination*. Manchester: Manchester University Press, 1994.

Taylor, Telford. *Nuremberg and Vietnam*. Chicago: Quadrangle Books, 1970.

Thompson, Grace Eiko, curator. *Sashin: Japanese Canadian Photography to 1942*. Burnaby, British Columbia: Japanese Canadian National Museum, 2005.

————. 'Archival Photographs from Cumberland, BC', *West Coast Line* 43, no. 38.1 (Spring 2004), pp. 57–88.

Tisseron, Serge. 'L'inconscient de la Photographie', *La Recherche Photographique* 17 (Automne 1994), pp. 80–85.

Tylor, Edward B. *Primitive Culture*. London: J. Murray, 1871.

————. *Anthropology*. London: Macmillan's Manuals for Students, 1881.

van Alphen, Ernst. *Caught by History: Holocaust Effects in Contemporary Art, Literature, and Theory*. Stanford, California: Stanford University Press, 1997.

van Winkel, Camiel. 'Jeff Wall: Photography as Proof of Photography', in *Jeff Wall Photographs*, ed. Gunilla Knape, Goteborg, Sweden: Hasselblad Centre, 2002, np.

Vansina, Jan. *Oral Tradition as History*. Madison: The University of Wisconsin Press, 1985.

Wagner-Pacifici, Robin and Schwartz, Barry. 'The Vietnam Veterans Memorial: Commemorating a Difficult Past', *American Journal of Sociology* 97, no. 2 (September 1991), pp. 376–420.

Walder, Dennis. *Ted Hughes*. Milton Keynes and Philadelphia: Open University Press, 1987.

Wall, Jeff. *Jeff Wall Photographs*, ed. Gunilla Knape, Goteborg, Sweden: Hasselblad Centre, 2002.

———, Zaslove, Jerry, Douglas, Fred and Lowry, Glen. 'Dissent, Tree Stumps and Bohemianism in Early Modern Vancouver', *Unfinished Business: Photographing Vancouver Streets 1955–85*, Vancouver: Presentation House, and *West Coast Line* 47, no. 39.2 (2005), pp. 46–67.

Walsh, Andrea. 'Complex Sightings: Active Vision in Artists' Personal Narratives and Institutional Texts', in *On Aboriginal Representation in the Gallery*, eds L. Jessup and S. Bagg, Hull, Quebec: Canadian Museum of Civilization, 2000, pp.247–270.

Ward, Peter. *White Canada Forever, Popular Attitudes and Public Policy Toward Orientals in British Columbia*, 3rd edn, Montreal, Quebec: McGill-Queen's University Press, 2002.

Whalen, Catherine. 'Finding "Me"', *Afterimage* 29, no. 6 (May/June 2002), pp. 16–17.

Willenson, Kim. *The Bad War: An Oral History of the Vietnam War*. New York: New American Library, 1987.

Winter, Denis. *Death's Men: Soldiers of the Great War*. London: Penguin, 1979.

Wood, Nancy. *Vectors of Memory: Legacies of Trauma in Postwar Europe*. Oxford and New York: Berg, 1999.

Yates, Frances. *The Art of Memory*. Chicago: University of Chicago Press, 1974.

Young, James E. 'Toward a Received History of the Holocaust', *History and Theory* 36, no. 4 (1997), pp. 21–43.

Zaslove, Jerry. 'Faking Nature and Reading History: The Mindfulness Toward Reality in the Dialogical World of Jeff Wall's Pictures', in *Jeff Wall 1990*, eds Gary Dufour and Jerry Zaslove, Vancouver, British Columbia: Vancouver Art Gallery, 1990, pp. 64–103.

Zeitlin, Froma. 'The Vicarious Witness: Belated Memory and Authorial Presence in Recent Holocaust Literature', *History & Memory* 10, no. 2 (1998), pp. 5–42.

Zerubavel, Eviatar. 'Social Memories: Steps to a Sociology of the Past', *Qualitative Sociology* 19, no. 3 (1996), pp. 283–299.

Notes on Contributors

Marlene A. Briggs is an Assistant Professor of English at the University of British Columbia who specialises in Modernism, twentieth-century British literature and trauma studies. Her book in progress, *Haunted Armistice*, investigates the transgenerational impact of the Great War in Britain, exploring testimony, commemoration, reconstruction and inheritance in relation to literary figures ranging from Wilfred Owen to Pat Barker.

Elizabeth Edwards is Professor and Senior Research Fellow at the University of the Arts London. Formerly a curator and lecturer in visual anthropology at the University of Oxford, she teaches critical history and theory of still photography, especially in anthropology and crosscultural environments. She has written extensively on the relationship between photography, anthropology and history. Her latest books are *Raw Histories: Photographs, Anthropology and Museums* (Berg, 2001) and a co-edited volume on photographs as material culture, *Photographs, Objects, Histories* (Routledge, 2004).

Patrick Hagopian is a Lecturer in American Studies in the Institute for Cultural Research at Lancaster University. His publications and research focus on public memories of war, most notably the Vietnam War. His work has appeared in *Prospects: The Annual of American Cultural Studies* (Cambridge University Press, 2002) and in *Places of Commemoration: Search for Identity and Landscape Design*, edited by Joachim Wolschke-Bulmahn (Dumbarton Oaks Research Library and Collection, 2001).

Marianne Hirsch is Professor of English and Comparative Literature at Columbia University. Her major publications include *The Mother-Daughter Plot: Narrative, Psychoanalysis, Feminism* (Indiana University Press, 1989), *Family Frames: Photography, Narrative, and Postmemory* (Harvard University Press, 1997) and the recent co-edited *Teaching the Representation of the Holocaust* (Modern Language Association of America, 2004), as well as a number of essays on Holocaust memory, photography and gender. She is currently collaborating on a forthcoming book with Leo Spitzer titled *Ghosts of Home: The Afterlife of a City in Jewish Memory*.

Nick Kaye is Chair in Performance Studies, in the School of Performance Arts, University of Exeter. His publications include *Postmodernism and Performance* (Palgrave, 1994), *Art into Theatre: Performance Interviews and Documents* (Harwood/Routledge, 1996), *Site-Specific Art: Performance, Place and Documentation* (Routledge, 2000) and *Staging the Post-Avant-Garde: Italian Experimental Performance After 1970*, co-authored with Gabriella Giannachi (P. Lang, 2002).

Annette Kuhn is Professor of Film Studies at Lancaster University, an editor of the journal *Screen* and a Fellow of the British Academy. She has written about photographs in *The Power of the Image: Essays on Representation and Sexuality* (Routledge, 1985) and *Family Secrets: Acts of Memory and Imagination* (Verso 1995 and 2002). Her recent publications include *An Everyday Magic: Cinema and Cultural Memory* (I. B. Tauris, 2002).

Martha Langford is an assistant professor of Art History at Concordia University and was the founding director/chief curator of the Canadian Museum of Contemporary Photography in Ottawa (1985–1994). Major works on photography include *Suspended Conversations: The Afterlife of Memory in Photographic Albums* (McGill-Queen's, 2001); an edited collection, *Image and Imagination* (McGill-Queen's, 2005); and *Scissors, Paper, Stone: Expressions of Memory in Contemporary Photographic Art* (forthcoming). Also an independent curator, she was artistic director of the international photographic biennale, Le Mois de la Photo à Montréal 2005.

Glen Lowry has recently taken up a faculty position in Cultural and Critical Studies at the Emily Carr Institute of Art, Design and Media in Vancouver. He co-edits *West Coast Line*. He has written the Afterword to poet-artist-photographer Roy Kiyooka's republished *TransCanada Letters* (NeWest Press, 2005) and is working on *After the End/s of CanLit: Unraveling Race, Nation, and Space*, on the recent past of Canadian literature.

Kirsten Emiko McAllister is an Assistant Professor in the School of Communication at Simon Fraser University. She is currently working on a book, *Remembering the Geography of Racial Erasure*. Her publications in *Cultural Values, CineAction, The Canadian Journal of Communication* and *West Coast Line* focus on memorials, photographs, video and film.

Andrew Quick is a Senior Lecturer in Theatre Studies at Lancaster University. He has co-edited issues of *Performance Research* (Routledge, 2000) and *Time and Value* (Blackwell Publishers, 1998) and is currently completing two books: *The Event of Performance* (Palgrave MacMillan, 2007) and *The Wooster Group Book* (Routledge, 2007). He also works with the performance company, Imitating the Dog.

Leo Spitzer is Kathe Tappe Vernon Professor of History at Dartmouth College and Visiting Professor of History at Columbia University. He has written on West African intellectual and political reactions to colonialism as well as on Holocaust documentary film. His books include *Lives in Between: Assimilation and Marginality in Austria, Brazil, West Africa 1780–1945* (Cambridge University Press, 1989) and *Hotel Bolivia: A Culture of Memory in a Refuge from Nazism* (Hill and Wang, 1998). He is co-editor of *Acts of Memory: Cultural Recall in the Present* (University Press of New England, 1999). He is currently collaborating on a forthcoming book with Marianne Hirsch titled *Ghosts of Home: The Afterlife of a City in Jewish Memory*.

Andrea Walsh is an Assistant Professor in the Department of Anthropology at the University of Victoria. Her research interests are visual anthropology, contemporary art and critical theory; her current work focuses on a collection of aboriginal children's art created between 1931 and 1942 at the Inkameep Day School near Oliver, British Columbia.

Jerry Zaslove is Professor Emeritus of Humanities and former Director of the Institute for Humanities at Simon Fraser University. He is co-editor of *West Coast Line*. His recent publications include 'Geological Poetics' in *Unfinished Business, Photographing Vancouver Streets, 1955–1985* (West Coast Line Books, 2006) and 'The Reparation of Dead Souls – Siegfried Kraucauer's Archimedean Exile' in *Exile, Science and Bildung* (Palgrave/MacMillan, 2005).

Lightning Source UK Ltd.
Milton Keynes UK
28 March 2011

169993UK00002B/37/P